New Art
in the 60s and 70s
Redefining Reality

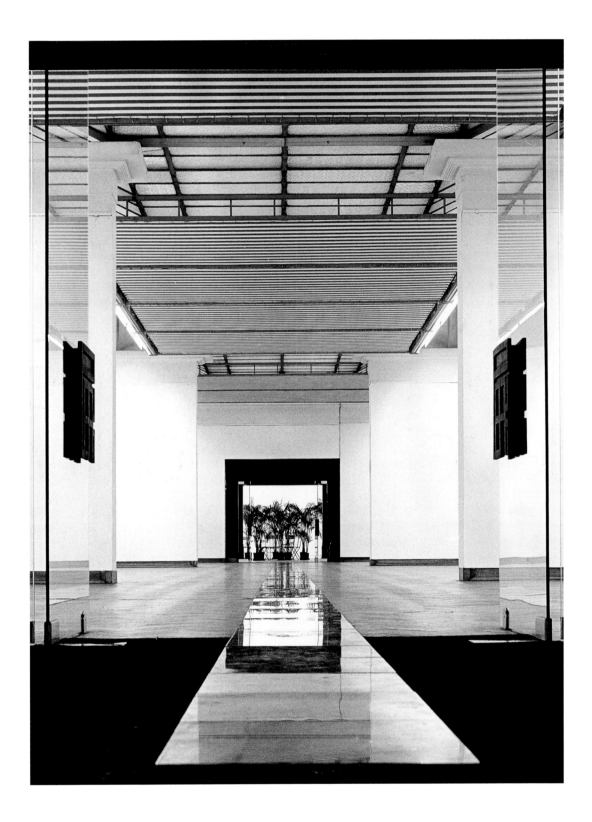

Anne Rorimer

NewArt
in the 60s and 70s
Redefining Reality

With 303 illustrations

Thames & Hudson

First published in the United Kingdom in 2001
by Thames & Hudson Ltd, 181A High Holborn,
London WC1V 7QX

www.thamesandhudson.com

First paperback edition, with revisions, 2004

British Library Cataloguing-in-Publication Data
A catalogue record for this book is available from
the British Library

ISBN 0-500-28471-7

Printed and bound in Singapore by C. S. Graphics

[. . .]
Contents

LAT. 31° 25´ N
LONG. 8° 41´ E

On Kawara **Location** 1965

Preface

The period of innovation examined in this book is remembered outside the field of art for clashes with authority on university campuses in the United States and Europe, for public protests against the Vietnam War, and, more generally, for a defiant counterculture. But, if the utopian desire for social justice and change underlying political activism remains ever elusive, continued transformation as a corollary of sustained visual vitality may be considered the mainstay of modern art practice. Artists of the twentieth century have, generation by generation, contributed to the understanding that art is not simply a literal transcription of the observed world and that revolutionary ideas keep open the channels of perception and thought.

Aesthetic activity from the late 1960s to the end of the 1970s has served self-analytically to ensure that visual art preserve its role as a cognitive conduit between graspable representation and amorphous reality. This book highlights the main issues unifying visually disparate works that have questioned the traditionally defined categories of painting and sculpture. Overall, it provides a framework for regarding the significant developments in aesthetic production that took place concurrently on both sides of the Atlantic after 1965. Through close attention to specific works by a number of the internationally recognized artists who have contributed to the redefinition of art practice, it identifies major areas of shared concern.

The task of threading one's way through a particularly lively and complex decade and a half of activity in North America and Europe is enriched and complicated by the fact that a relatively large number of artists around the world were simultaneously engaged in reassessing accepted approaches to art production. Living in different cities such as Los Angeles, New York, London, Paris, Amsterdam, Düsseldorf, or Turin, for example, individuals were not necessarily informed of one another's aesthetic strategies initially, although later on they would interact with one another extensively. Despite the varied routes each has taken in the cultivation of new ideas, the artists discussed began, simultaneously in the second half of the 1960s, to open up new terrain. For this reason, a linear historical narrative would not have been feasible or even germane to the examination of a broad spectrum of works with a view toward articulating the major ideas being explored throughout a period of heightened innovation.

However imprecise it may be (and actually misleading since all art rests on concepts), the term 'Conceptual' is now used pervasively and loosely by art historians, critics, and curators to refer to non-traditional art forms. While some artists identify closely with this label and have been instrumental in its promotion, others have chafed at it from the start. In this book, it is used in association with a range of works created after 1965. This date serves as an historical marker for the beginnings of Conceptual art as opposed to the beginnings of Fluxus, whose methodology and goals were first defined in the late 1950s. Boundaries between Fluxus and Conceptual attitudes and methods were, of course, by no means impenetrable in a period of ferment characterized by prolific interaction between a large number of individuals engaged in reconsidering the object of art and its making. The oeuvres of certain artists may thus be viewed in light of the performative and irreverent strategies of Fluxus, although their work more pertinently belongs within the scope of Conceptual art.

The book is organized to permit the work of vanguard artists, nearly all of whom remain highly productive, to be seen against the background of the precepts that they themselves first brought to the fore. The careers of individual artists are treated in depth within this scheme

while specific works are discussed within a chronological structure. The intricate web of interlacing personal encounters and ideas fostered by geographical proximity, as well as by curatorial, critical, or entrepreneurial enterprise in the late 1960s, must be disentangled elsewhere. Mainly, it is hoped that the analysis of a range of exemplary practices will offer a step toward further studies of the period and inspire yet other accounts of the work of either those artists included here or the work of their contemporaries who, in equally relevant and compelling ways, chose to break from the previous paradigms of painting and sculpture.

Even though discussion of individual oeuvres is often contained within a single chapter, chapter divisions are by no means airtight. The work of most artists, kept together as much as possible for the sake of continuity, could easily be accommodated under more than one heading. Chapter One is devoted to the critique of painting, while Chapters Two through Six revolve primarily around the replacement of sculptural three-dimensionality with 'non-sculptural' methods of representation. As chapter divisions clarify, these methods embrace linguistic, photographic, numerical, and serial means and/or context-dependent installations. They also incorporate time-based media such as film and video and/or embody performative methods without being defined as performance art.

Although its methods and concerns overlap with those of Conceptual art, performance art – a major aesthetic and historical category unto itself – has not been specifically addressed within these pages. The pathfinding work of an artist such as Joan Jonas, for example, would necessarily be encompassed within a more extended account of the period, an account requiring particular attention to the feminist subject matter more often treated in performance pieces than by Conceptual works. In the interest of manageability, a line – thin, meandering, and broken – has thus been drawn between Conceptual art and performance art with respect to the latter's emphasis on thematic content (related to the body and/or the body politic) conveyed by actions carried out over time by one or more persons. Since events take the place of painted and/or sculpted objects (despite ancillary costumes, props, backdrops, or subsequent photodocumentation), performance art lends itself to enactment rather than to the objectification

characterizing works deemed Conceptual in this study. Furthermore, video art – first defined in the early 1960s as an aesthetic category unto itself – has not been surveyed in its many manifestations. Because of its vital role in performative and installational works, it is woven into the book as a whole.

Conceptual art was initially heralded by inclusion in exhibitions with titles such as 'Art in Series' (1967); 'Language to be Looked at and/or Things to be Read' (1967); 'Earth Art' (1969); 'Anti-Illusion: Procedures/Materials' (1969); 'When Attitudes Become Form' (1969); 'Op Losse Schroeven' (Square Pegs in Round Holes, 1969); 'Conceptual Art and Conceptual Aspects' (1970); 'Conceptual Art, Arte Povera, Land Art' (1970) or 'Information' (1970); and examined in books such as Ursula Meyer's *Conceptual Art* (1972) or Gregory Battcock's *Idea Art: A Critical Anthology* (1973).

At its inception, Conceptual art was not the umbrella term it has come to be. Nor was it ever a precisely defined or totally fixed area of involvement. With the luxury of hindsight, two main strands of contemporaneous aesthetic activity, wound together in exhibitions of the time, have become apparent. One strand most pertinently may be labelled Conceptual while the other answers more readily to the designation 'Arte Povera' (literally, 'impoverished art'). Taken from the title of the seminal exhibition organized in Italy by Germano Celant in 1967, the term Arte Povera is now applied to the work of Italians, including Alighiero e Boetti, Luciano Fabro, Jannis Kounellis, Marisa Merz, Mario Merz, Pino Pascali, Giuseppe Penone, Emilio Prini, and Gilberto Zorio among other celebrated figures. Sharing much in common with Postminimal production to be discussed in the Introduction, Arte Povera artists questioned traditional forms and formulas of sculpture by use of decidedly non-art – and virtually worthless – materials.

The principal contention of this book is that Conceptual art, in contradistinction to Arte Povera with its emphasis on process and materials, has centered on a critique of the stationary, self-sufficient, material object. However, although they reinterpret art's object status, Conceptual works do not reject the notion of the object even when they contain performative elements or are exhibited only temporarily. What Conceptual works have sought to resist in order to fend off illusion, yet nonetheless take account of external reality, is the

Michael Asher **Galleria Toselli, Milan, Italy, September 13–October 8, 1973** 1973

creation of a singular or volumetric object. This has meant discarding not the object per se but its tangible materiality. The Conceptual project, all in all, has therefore been to re-evaluate the autonomous object, which, when hanging on the wall or independently occupying space, does not thematically attend to its surroundings, its viewers, and/or its condition as (a) representation.

The commonly held notion is that, in Conceptual works, the visual is cancelled out and physical realization made secondary. This book is predicated on the idea that visual form and mental formulation are inextricably linked. Although it clearly overturned aesthetic convention, art of the late 1960s and 1970s, which has been called Idea Art, Conceptual art, or has been described as dematerialized, never lost sight of its concern with the visual and the very nature of visualizing, even in the face of the invisible. The success of Conceptual art – with far-reaching repercussions and widespread impact on the art of today – has been its revision of assumptions regarding what was once accepted as being visual and the concomitant replacement of these presuppositions with other criteria for thinking and seeing.

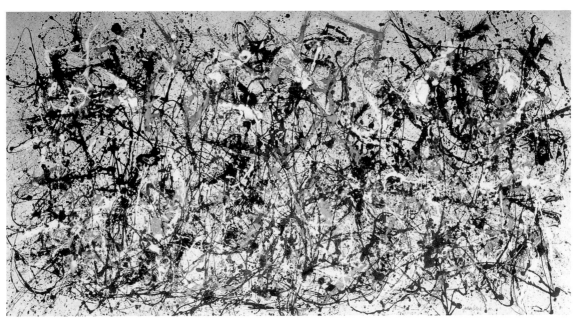

Jackson Pollock **Autumn Rhythm (Number 30)** 1950

Introduction

The art of the late 1960s and 1970s, loosely defined by the word Conceptual and coinciding with years of political protest, took root in the fertile soil laid down by the Abstract Expressionists. The principles set forth in the work of acclaimed artists of the New York School such as Jackson Pollock (1912–56), Willem de Kooning (1904–97), Franz Kline (1910–62), Mark Rothko (1903–70), Barnett Newman (1905–70), and Clyfford Still (1904–80) were already subject to revision by the mid-1950s; but aesthetic responses to the influence of Abstract Expressionism continued to be felt internationally after 1965.

No one label can satisfactorily classify the rhizoidal activity of a period involved in the aesthetic reevaluation, not only of painting and sculpture, but also of theatre, poetry, dance, music, performance, and film. From the mid-1950s through the mid-1960s, these once self-contained disciplines, each with its own methodology and history, were first opened to cross-fertilization. And, toward the end of this ten-year span, video was introduced into aesthetic discourse to play an ever-expanding role as a medium derived from television but independent of it. A brief sketch of the ideas and issues initiated prior to 1965 – often under rubrics such as Pop, Minimal and Postminimal, or Happenings and Fluxus – sets the stage for considering post-1965 innovation, which falls principally under the rubric of Conceptual art.

The era of Postmodernism was launched while Modernism was still in full force. In the specific sense defined by the writings of Clement Greenberg (1909–94), Modernism reached its apogee at mid-century with respect to aesthetic self-referentiality and autonomy. A progenitor of postwar criticism, Greenberg is renowned for his theorization of Abstract Expressionist practice and support of Color Field painters such as Helen Frankenthaler (b. 1928), Morris Louis (1912–62), Kenneth Noland (b. 1924), and Jules

Olitski (b. 1922). Works by these artists, in Greenberg's eyes, fulfilled what he defined as the crux of Modernism: the ability of art to be about itself. 'The essence of Modernism lies, as I see it…,' Greenberg synthesized, 'in the use of the characteristic methods of a discipline to criticize the discipline itself – not in order to subvert it, but to entrench it more firmly in its area of competence.'[1]

Believing the work of art to be an idealist construct, Greenberg argued that it must explore its formal potential within the prescribed limits of painting and sculpture without interference from economic, social, or political reality. Therefore, 'retiring from public altogether' and 'in search of the absolute,' the artist 'tries in effect to imitate God by creating something valid solely on its own terms.'[2] Greenberg proclaimed further that 'content is to be dissolved so completely into form that the work of art or literature cannot be reduced in whole or in part to anything not itself.' Within such a scheme, the representation of recognizable subject matter in painting gives way to the 'abstract' so as to ensure to the greatest extent possible the actual two-dimensionality and 'flatness'[3] of the canvas against the slightest allusion to figuration, since even 'the fragmentary silhouette of a human figure, or of a teacup'[4] leads to associations with false, illusionistic, three-dimensional space. Insofar as sculpture is concerned, being three-dimensional, it 'exists for and by itself literally as well as conceptually.'[5] Transcending the chaos of modern life and the contradictions of society while seeking to attain its own reality within the dictates of its particular medium, the work of art, as Greenberg would have it, is a self-sufficient object that contends with either its two-dimensional or three-dimensional nature as a painting or sculpture.

Measured empirically against art as it actually developed, Greenberg's prescriptive observations, ironically, held true beyond the practices of the artists he

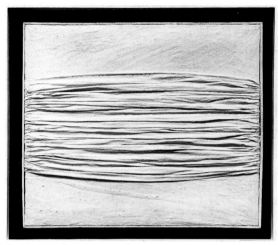

Piero Manzoni | **Achrome** | 1959

aesthetic production, may be examined first in relation to the issues of painting and, later on, in relation to those of sculpture. His first non-color works begun in 1957, which Manzoni called 'Achromes', instead of being painted with a brush, were made from canvas squares that were glued together side by side after being soaked in kaolin (a white, water-absorbent clay). In a quest to produce a 'white surface that is simply a white surface and nothing else,'[6] Manzoni employed a range of materials not previously used for painting, including cloth, fur, and kaolin-covered bread rolls. As expressed in his 1960 text, 'Free Dimension':

> the question as far as I am concerned is that of rendering a surface completely white (integrally colourless and neutral) far beyond any pictorial phenomenon or any intervention extraneous to the value of the surface….
>
> It is not a question of shaping things, nor of articulating messages…. For are not fantasizing, abstraction and self-expression empty fictions? There is nothing to be said: there is only to be, to live.[7]

Through his replacement of paint on canvas with earthy or textured but colorless substances, Manzoni was able to expel representational imagery, composition, and signs of brushwork from his work. The surfaces of his canvases evince a full-bodied materiality marked by inherent roughness and surface irregularity that serves to replace narrative or formal incident. In his manifesto of 1957, 'For the Discovery of a Zone of Images,' the artist maintained:

> We absolutely cannot consider the picture as a space on which to project our mental scenography. It is the area of freedom in which we search for the discovery of our first images.
>
> Images which are as absolute as possible, which cannot be valued for that which they record, explain and express, but only for that which they are: to be.[8]

Manzoni's compatriots, Alberto Burri (1915–95) and Lucio Fontana (1899–1968), were influential to his thinking. As early as 1949, Burri had utilized the remnants of a burlap sack in a painting, and by the early

personally supported or who may have been specifically informed about his writing. Most notably, the call for self-criticism and the annulment of illusion, pivotal to subsequent aesthetic production as well as to his particular way of thinking, has been met in many unexpected ways. But by the end of the 1960s his stipulations – that works of art should neither admit subject matter from observed reality, nor be set autonomously above the fray of life, nor challenge the medium-specific basis of painting or of sculpture – had been nullified on all counts.

From the mid-1950s through the mid-1960s, artists in Europe and America, not necessarily known to one another, began to reconsider the tenets of Abstract Expressionism. Broadly speaking, the Abstract Expressionists had sought to transcend the literal depiction of external reality in order to betoken inner, primordial experience through the gestural or amorphous qualities of paint on canvas. Recognizing the propensity of paint by itself to deliver expressive meaning, artists mounting a critique of Abstract Expressionism endeavored instead to suppress ulterior content and to feature the work of art as a factual entity without residual transcendence. This endeavor led to the creation of exclusively abstract paintings and sculptures on the one hand and, on the other, to paintings and sculptures based on imagery or objects appropriated from the real world.

The work of the Italian artist Piero Manzoni (1933–63), who came to far-reaching conclusions about

part of the next decade was further developing the possibilities of integrating burlap into painting and of combining coarse or torn fabric with thick, gestural brushwork. 'If I don't have one material I use another. It is all the same,'[9] he once stated. Burri's divergence from more typical methods of painting through the importation into painting of non-art fabrics – torn shirts, for example – anticipated Manzoni's rigorous reduction of painting to pure materiality.

Lucio Fontana's series of 'Buchi,' or holes, made by piercing the canvas weave, and his subsequent well known 'Tagli,' or cuts, made by lacerating it, offered him the means to treat painting as a conduit from the experienced, observed space of the front of the canvas to another, hypothetical spatial realm. Adding the word 'attese' (expectation) to his commonly used title *Concetto Spaziale* (Spatial Conception) in 1958, Fontana emphasized the notion of an undefined region that may be thought of as being at the back of the extant canvas. Such a hypothetical space, connected abstractly with the idea of waiting or even suspense, is suggested by the black gauze that the artist glued onto the verso of his paintings, often revealed through the perforations. On the canvas surface, with its evenly applied, monochromatic paint, no image is depicted. Rather than serving as a background for forms or imagery – or as a support for textured, material substances as it does for Burri – Fontana's canvas is meant to provide access to a reality *behind* its surface. At the same time that this surface remains concrete, it introduces a conceivable space that is not perceivable. The slices or punctures in Fontana's canvases confirm the reality of painting's planar surface by virtue of the demonstrated attempt to cut through its unyielding frontality.

Manzoni's contemporary, Yves Klein (1928–62), a central figure among the New Realists in France, likewise sought to gain access to an immaterial reality beyond the limits of human vision. After 1957, having previously produced monochromatic works in green, yellow, white, and red, Klein extensively used the deep, electric, cobalt blue color he himself termed International Klein Blue to engender a profound sense of ethereal depth. Non-referential in a literal way and possessing an immediate, material presence, the blue monochromes of Klein – who early on expressed a wish to claim the sky – refer by means of their own physical presence to an unseen, metaphorical space. For Klein,

Alberto Burri **Sackcloth** 1953

Lucio Fontana **Concetto Spaziale** 1955

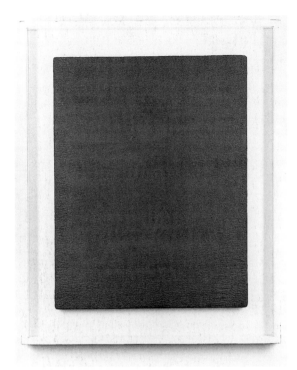

Yves Klein | **Untitled Blue Monochrome** | 1959

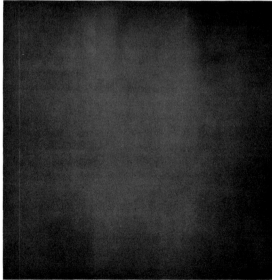

Ad Reinhardt | **Abstract Painting** | 1960–65

who professionally called himself Yves Le Monochrome, the limiting of each painting to a single color allowed him to circumvent the distracting aspects of line and form. In this way, he created two-dimensional objects that are devoid of diverting imagery or painterly gesture.

The concerns of two major American artists, Ad Reinhardt (1913–67), a contemporary of the Abstract Expressionists, and Frank Stella (b. 1936), a generation younger, parallel those of artists such as Manzoni, Burri, Fontana, and Klein inasmuch as they, too, sought to convey the independent, non-illusionistic reality of painting. Reinhardt's decision in 1960 to paint only black, trisected, five-foot-square works was reached gradually over a lifetime devoted to the purification of painting in pursuit of its possible essence. Believing that there is 'no such thing as emptiness or invisibility' and that he needed to 'push painting beyond its thinkable, seeable, feelable, limits,'[10] in 1953 Reinhardt had restricted his paintings to monochrome with the intent of creating an imageless, colorless, and timeless surface that would convey the fact that a painting is an idea as much as it is an object. With the aim of suppressing all points of reference to the mental and physical activity behind a work's production, he maintained that 'a picture is finished when all trace of the means to bring about the end has disappeared.'[11]

A comparison of Reinhardt's use of black and Klein's use of vibrant blue clarifies their otherwise different positions regarding the monochromatic. With the desire to eradicate extraneous and distracting visual elements from painting, Reinhardt, not unlike Manzoni, expunged color from his palette. Extremely subtle differences between the black squares of his Abstract Paintings create a hardly perceptible elision between cruciform and grid so that color, relieved of almost all responsibility for engendering formal or figurative distinctions of any kind, remains even-handed and neutral. Klein, in another spirit, aimed to elevate color to mythical status, having maintained that 'through color, I experience a complete identification with space, I am truly free.'[12] Whereas Reinhardt wrote that 'there is something wrong, irresponsible and mindless about color, something impossible to control,'[13] Klein declared that 'before the colored surface one finds oneself directly before the matter of the soul.'[14] From opposite vantage points, therefore, both artists defined painting as a reality unto itself; Reinhardt wanted to extract its ideational

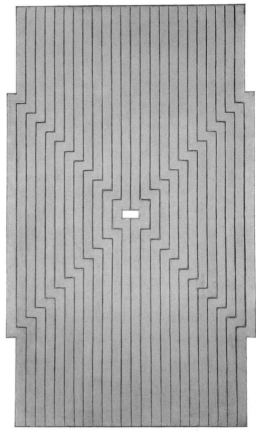

Frank Stella | **Tuxedo Park** | 1960

Frank Stella | **Six Mile Bottom** | 1960

essence,[15] and Klein believed that 'paintings are living, autonomous presences.'[16] Klein thus considered color to be a means for envisioning an infinite, immaterial reality outside of 'the psychological world of our inherited optics.'[17] Reinhardt viewed color as an interference in the presentation of painting as a ground for ideation.

During a famous radio broadcast in 1964, Frank Stella, profoundly influenced by Reinhardt, articulated the fundamental premise of his work, pointing out:

> I always get into arguments with people who want to retain the old values in painting – the humanistic values that they always find on the canvas. If you pin them down, they always end up asserting that there is something there besides the paint on the canvas. My painting is based on the fact that only what can be seen there *is* there. It really is an object.

> Any painting is an object and anyone who gets involved enough in this finally has to face up to the objectness of whatever it is that he's doing… All I want anyone to get out of my paintings and all I ever get out of them is the fact that you can see the whole idea without any confusion…. What you see is what you see.[18]

Stella's early series of large-scale Black Paintings (1958–60), deleting indications of brushwork, comprise parallel bands of black enamel that soaked into the absorbent, raw canvas to yield a matte texture. Equally separated from each other by narrow intervals of unprimed canvas, the bands radiate from central points of the canvas to form a symmetrical overall pattern that, in each case, could be extended indefinitely beyond the painting's edge. Hierarchical composition gives way to

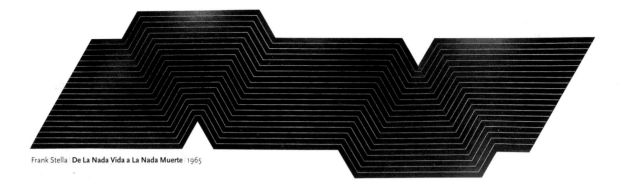

Frank Stella | **De La Nada Vida a La Nada Muerte** | 1965

configurations that wipe out the distinction between foreground and background.

Subsequent to the Black Paintings, Stella continued to propound the idea that a painting is ultimately its own reality rather than a circumscribed flat surface upon which figurative or compositional shapes or signs of painterly gesture predominate. In his series of Aluminum Paintings (1960) and Copper Paintings (1960–61), the work's internal configuration of linear elements matches its surrounding edge in the form of notched or polygonally shaped canvases, which testify to the fact that, before it is a representation of anything outside of or beyond itself, a painting is clearly an object. A slightly later work following these series, *De La Nada Vida a La Nada Muerte* (1965), offers a striking example of Stella's methodology for wiping out figuration, composition, and painterly expression so as to give full credence to the painting's independent reality.

Evenly spaced horizontal lines that change their course at several intervals as they stretch across the 23 ½ -foot expanse of *De La Nada Vida a La Nada Muerte* dictate the shape of the painting's outer limits. Without narrative beginning or end, the painting would seem to have been cut from an endlessly repeatable pattern of parallel, horizontal, linear elements. Rather than being contained within a given rectangular format, these elements serve to define the raised plateaus and notched valleys of their outer edge. A single, continuous entity whose non-illusionistic quality is reinforced by its metallic coloring, the painting sacrifices isolated visual incident for the sake of overall impact. Referring to the kind of metallic surface first used in the Aluminum and

Copper series, Stella recalled that 'it had a quality of repelling the eye in the sense that you couldn't penetrate it very well. It was a kind of surface that wouldn't give in, and would have less soft, landscape-like or naturalistic space in it.'[19]

Having already begun to pursue another route toward the elimination of autonomous painterly gesture, Jasper Johns (b. 1930) and Robert Rauschenberg (b. 1925), for their part, shifted their aesthetic investigations away from self-sufficient abstraction. Honoring the self-referential aspect of painting, Johns's *Flag* (1954–55) and Rauschenberg's *Bed* (1955) signaled a new round in the bout between art and non-art reality being played in different arenas at the same time. Rendered in encaustic paint, *Flag* equates the red-and-white stripes and star-spangled blue background of the American flag with the rectangular format of the canvas. What is represented on the canvas and the canvas' rectangular surface cannot be conceptually separated. In *Bed*, actual bedding – quilt, sheets, and pillow – has been tipped up to hang on the wall and is spattered with paint. The abstract pattern of the real coverlet contrasts with the swaths and drips of paint. Within the frame of a bed, which is superimposed on the frame of painting, paint preserves its independent materiality, while illusionistic representation is averted.

By means of subject matter that has defined them as Pop artists, Roy Lichtenstein (1923–97) and Andy Warhol (1928–87) advanced the idea of giving painting a mechanically produced appearance that would confirm the reality of the canvas surface without depriving it of recognizable subject matter. They achieved this through the depiction of existing flat imagery from the printed

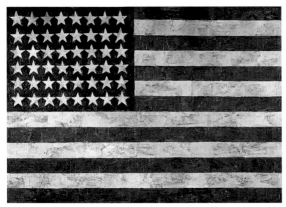

Jasper Johns | **Flag** | 1954–55

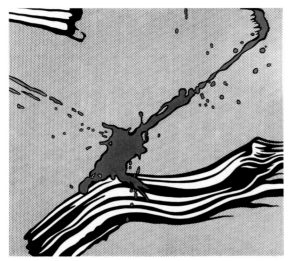

Roy Lichtenstein | **Brushstroke with Spatter** | 1966

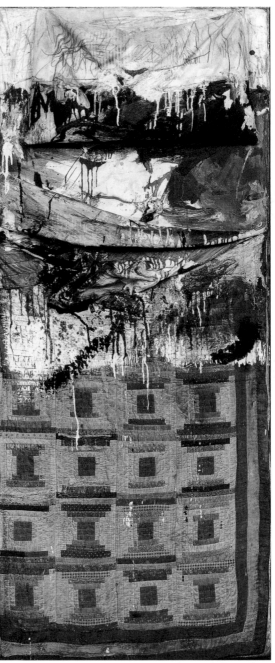

Robert Rauschenberg | **Bed** | 1955

world of popular culture, commercial products, advertising, and the mass media. Known first and foremost in the early 1960s for imagery taken directly from comic books, Lichtenstein articulated the notion of painting's independent reality when he stated that a work by him 'doesn't look like a painting *of* something, it looks like the thing itself.'[20]

The emphasis put by the Abstract Expressionists on paint-handling and its effects forms the basis of Lichtenstein's critique, as it does for Stella. Wanting his 'painting to look as if it has been programmed' and endeavoring 'to hide the record of [his] hand,'[21] he endowed the painted surface with seeming autonomy. Through painted reference to the regular pattern of the minuscule Ben-Day dots that characterize cheap mass-

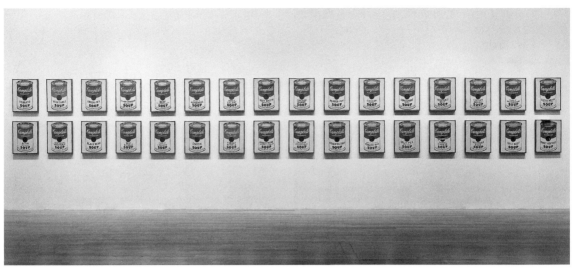

Andy Warhol | **Campbell's Soup Cans** | 1962

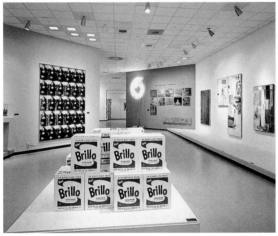

Andy Warhol | **Brillo Boxes (Soap Pads)** | 1964

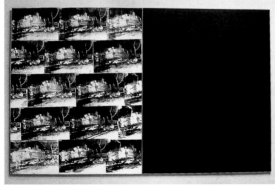

Andy Warhol | **Five Deaths Seventeen Times in Black and White** | 1963

printing techniques, along with the use of pre-existing, mechanically reproduced imagery, he endeavored to cover his authorial tracks. *Brushstroke with Spatter* (1966) specifically parodies the use of gestural brushwork by depicting the means of depiction, the brushstroke, as if it were a magnified detail from a photographic reproduction. The brushstroke image with its accompanying drips, thus isolated for objective scrutiny, assumes a life of its own. Disembodied from association with a descriptive or depictive context, it receives equal representational status within the surrounding field of dots. His series of Stretcher Frame with Cross Bars (1968) further exemplifies how the work's flat imagery confirms and conforms to its two-dimensional pictorial surface. By depicting canvas versos as if they were photographically derived, these works paradoxically refer to the inescapable frontality of painting.

Because of their representation of the dots of printed mass-reproduction, Lichtenstein's paintings indicate that they are meant to resemble mechanical processes. Andy Warhol's paintings likewise give the impression that they were produced by machine rather than by hand. Certain early works, although painted by hand, look as if the image were a duplication of its prototype. For the most part, however, Warhol silkscreened his images as a means to put all signs of the brushstroke in check. His introduction of mass-produced subject matter – from Campbell's soup can labels to tabloid headlines and news disaster photographs, to images of celebrities or popular

icons such as Marilyn Monroe – spared his paintings from being understood as anything but the image itself. Mechanistic technique and subject matter bind together in Warhol's paintings to effect their own reality and deflect interpretational readings 'beneath the surface.' Surface pattern remains paramount because the attributes of painterly expression have been expelled. Through direct appropriation of subject matter – from commercial products, journalistic photos, or famous personalities – Warhol's paintings self-critically reflect on unenterable flatness. As the artist expressed it, 'if you want to know all about Andy Warhol, just look at the surface of my paintings and films and me, and there I am. There's nothing behind it.'[22] Purposefully impassive and emotionally impenetrable, Warhol's oeuvre proffers itself as a symptom of the superficiality of the product-hungry, status-seeking, hero-worshipping society in which it was created and by which it is framed.

The emphasis on the non-illusionistic, self-referential status of painting 'untouched' by authorial expression was accompanied by a parallel search for ways to re-invigorate sculpture. Investigations in the late 1950s and early 1960s pertaining to sculpture's material, formal, and ontological functions prepared the way for the direct challenge in the late 1960s to its materiality and existence in the round.

As in his painting, so in his sculpture, Manzoni offered startling alternatives to traditional three-dimensional materiality. Although his now legendary work was hardly known outside Europe during the artist's lifetime, the ramifications of his ideas have proven to be extensive. Manzoni replaced the established materials of sculpture that is carved, molded, assembled, and so on, with substances that issue from the body. *The Artist's Breath* (1960) is a balloon inflated by air from Manzoni's lungs. *Artist's Shit* (1961), produced in an edition of ninety, is a small, round tin containing thirty grams of 'merda d'artista,' as stipulated on the label of the can.[23] The mechanically sealed tins containing dried excrement were sold according to the day's price and their equivalent weight in gold. These works repudiated the enduring value and obdurate materiality of traditional sculpture, and give ironic meaning to high-minded ideas associated with personal inspiration and expression that accompany notions of aesthetic worth.

Whereas *The Artist's Breath* and *Artist's Shit* result from the conflation of processes of living and processes

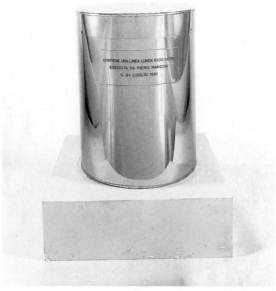

Piero Manzoni **Line 1000 Meters Long** 1961

of aesthetic production, Manzoni's Living Sculptures (1961) enlisted the all-powerful sign of aesthetic validation – the artist's signature. Producing a large number of such sculptures, the artist signed and dated the bodies of living persons, each of whom received a 'certificate of authenticity.' The certificates confirmed their status as works of art in-the-flesh, accrued as a consequence of having been signed and thereby invested with authenticity. Manzoni also wielded his signature on one or more occasions to declare a particular person's shoe a work of art.[24]

Whether falling in the category of painting or sculpture, works by Manzoni deny the fictional by upending traditional materials and methodologies. Thus, *Base of the World* (1961), a rectangular block of iron that sits on the ground and is lettered, upside down, with 'Socle du Monde,' ostensibly supports the whole of life as well as the entire globe. *Line 1000 Meters Long* (1961), a shiny canister, houses an ink line measuring one thousand meters. By actually carrying out the extremely unusual production of the long line but removing it from sight, Manzoni leaves its material reality to perception by the imagination. In this way, sculpture, which by definition normally imposes upon its spatial surrounds, is

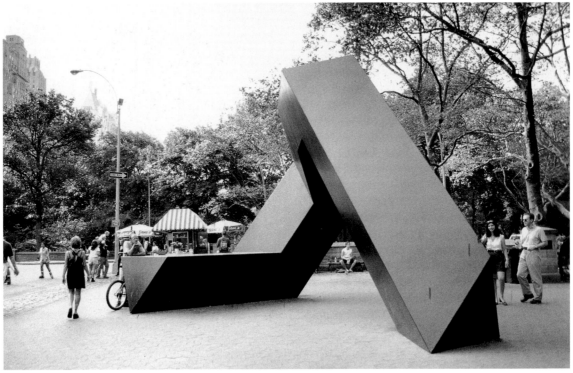

Tony Smith · **Cigarette** · 1961

– in both a literal and metaphorical sense – contained.

Manzoni's art foreshadowed the radical critique of both painting and sculpture that would inform Conceptual art. In a different way, the reappraisal directed toward sculpture's material and formal attributes at the outset of the 1960s by Tony Smith (1912–80), Donald Judd (1928–94), Carl Andre (b. 1935), Sol LeWitt (b. 1928), Robert Morris (b. 1931), Richard Serra (b. 1939), and Eva Hesse (1936–70) – all living in New York or its vicinity – laid the foundations for the ensuing demise of sculpture's long-held three-dimensional materiality. Often categorized by the terms Minimal or Postminimal because of their pared-down, non-referential qualities, works by these artists re-evaluate accepted formulations of sculptural materiality. They detour the normally traveled routes of sculptural production in order to protect themselves against the display of decision-making processes, skillful workmanship, or subjective expressivity on the part of the artist.

Often large and usually darkly-colored sculptures by Tony Smith give the impression that they have come to earth from a planet where the industrial and the organic are inseparable. Smith, who was born in the same year as Jackson Pollock, arrived at his later, sculptural practice by way of an earlier career as a painter and architect. *Cigarette* (1961) evokes thoughts about the non-rational and inexplicable, but its form was generated according to chance operations reminiscent of Surrealist automatism. Open to passage around and under its arched and massive shape, *Cigarette* is a multifaceted, abstract structure. Scaled architecturally for integration into an urban or natural setting, the painted steel sculpture impresses itself upon its surroundings with prepossessing grace and bold eccentricity.

Smith's sculptures are based on the artist's assembly of small-scale cardboard tetra- or octahedral units of identical size. Fitted together to create flat-surfaced volumes, they provided Smith with an open-ended and flexible – yet regulatory – method for the creation of form. The separate polyhedral units suited his purpose of creating unpremeditated shapes through experimentation with how the cardboard clusters seemed to fall into place by themselves. The form of one

work would often lead to the discovery of other forms. Final configurations taken by the clusters occurred without an advance plan or system.[25] Once satisfied with the shape the cardboard modules had assumed, the artist glued them together for eventual enlargement and industrial fabrication.

The sculpture of Donald Judd, Carl Andre, and Sol LeWitt, as well as certain works by Robert Morris, is also constructed from industrial rather than handcrafted materials. Andre's use of individual metallic units, Judd's use of colored plexiglas and galvanized steel, LeWitt's use of baked enamel, or Morris's use of painted plywood preclude the handling of material through carving or modeling. As opposed to Smith's sculpture, however, theirs is not predicated on the subjective authorial unconscious. Rather, the work of art is treated as an unequivocal and literal sum of revealed geometric parts and is not meant to harbor vestigial mystery. Their sculptures are, through and through, intended to be materially and formally self-evident, having moved 'away from illusionism, allusion and metaphor.'[26]

Judd and Andre contributed to an understanding of sculpture as an object that exposes its immediate and incontrovertible relationship to material and spatial reality. Works by Judd (who used the term 'specific object' to refer to his sculpture), exhibited in 1963–64 at the Green Gallery, New York, prefigure the fully developed wall and floor pieces that typify his oeuvre after 1965. The cadmium red objects shown in this solo exhibition look as if they were prefabricated, although they are made of painted wood. Issuing from his earlier concerns related to painting, they hang in three-dimensional relief on the wall or stand free in real space. Made to expose the elements of their construction and accommodating identical units repeated at regular intervals, they assert their non-referential, non-illusionistic nature. As in all of Judd's subsequent work, the surrounding space is not so much displaced as it is defined as integral to the work. Wall or floor sculptures by Judd are either open containers or a compilation of separate units. These units tend to be identical in size, color, and distance from one another. Or, when variations occur, they are derived from mathematical calculations or principles of seriality rather than from judgments made subjectively by eye.

The sculpture of Andre is made up of separate uniform elements that the artist stacks together or

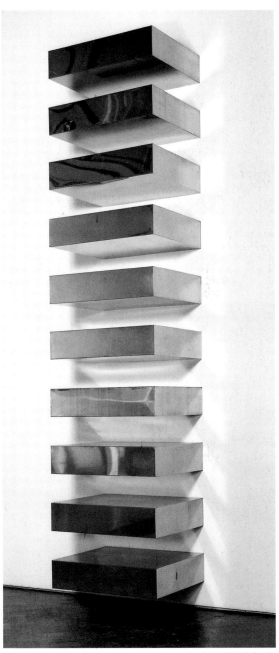

Donald Judd **Untitled** 1969

aligns side by side to form a whole of repeated parts of equal size. Having decided by 1965 that sculpture 'should be as level as water' and should 'cut into' space from a position on the floor or ground, Andre inverts the usual relationship between a sculpture and its surroundings, insofar as his works slice into space without appearing to occupy it volumetrically. The many variants of his works since 1966, composed of standard, prefabricated, unjoined units (including bricks, timbers, and metallic plates), unlike earlier forms of sculpture, consist of identical but individual and unattached elements that cohere as part of a totality. Andre's sculpture, especially the floor pieces on which the viewer is permitted to walk, give precedence to material form over traditional verticality. In lieu of displacing the observer, moreover, they share the space they take by calling attention to and involving their surroundings. 'A place,' the artist himself has claimed, 'is an area within an environment which has been altered in such a way as to make the general environment more conspicuous.'[27]

Speaking of his wall reliefs and free-standing structures of 1965, LeWitt pointed out that 'using acrylic, much work was done to make the surface look hard and industrial.'[28] LeWitt's open white modular cubes, which since 1966 have followed many permutational variations on the three-dimensional grid, similarly maintain an industrial patina whether they are made of painted wood, steel, or baked enamel on aluminum. The decision to apply a consistent ratio of 8.5:1 (with respect to the material and spatial intervals of the structure) to all of the structural parts of his modular cubes ensured against compositional arbitrariness or the dominance of one formal element over another, without discounting numerous possibilities for visual variation. LeWitt's cubes apportion their internal space into equal segments and, in this manner, represent an equal give-and-take between the object and its physical environment. Grasped as single entities without facade, these open, latticed structures invite viewing from all directions. And, although being clearly only cubes and thus notionally simple, they provide the complexity of constantly changing visual phenomena perceived when viewers – who are able to look through, as well as at, the work – successively reposition their gaze.

Robert Morris's plywood sculptures, exhibited in 1964 at the Green Gallery, speak to the major shift in attitude toward sculptural form that had become evident by the mid-1960s. Unadorned, spare, geometric volumes

Carl Andre | **Steel-Aluminum Plain** | 1969

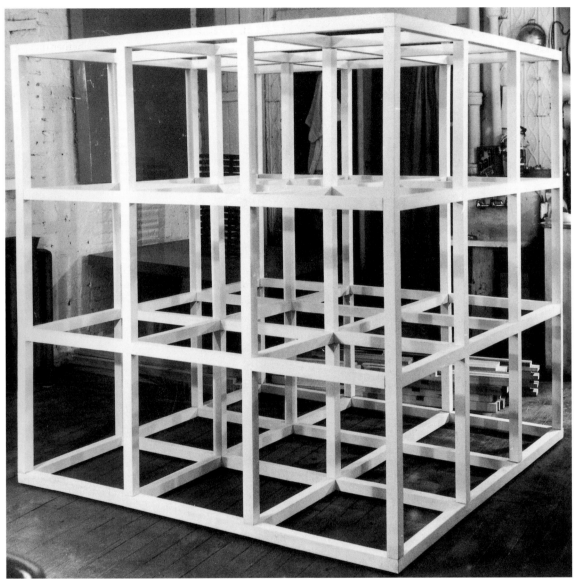

Sol LeWitt : **Modular Cube** : 1966

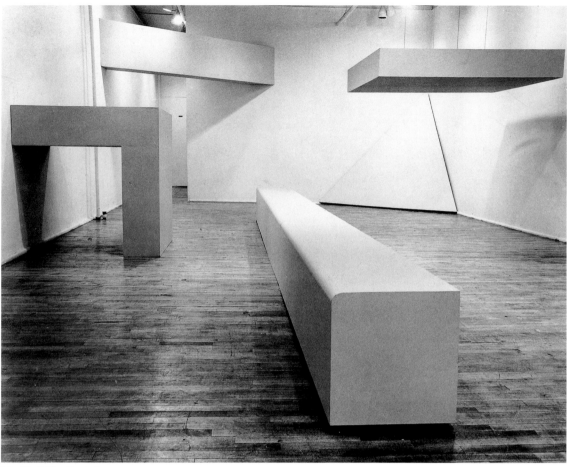

Robert Morris | **Floor Piece** | 1964

painted a matte grey, they aggressively interact with the exhibition space by hanging from the ceiling, jutting out from the wall, spanning an entryway, or protruding into open space from the floor. Comparable with works by Smith, Judd, Andre, and LeWitt, plywood sculptures by Morris confirm the reality of their own formal presence. Or, as Morris phrased it, they make possible the 'apprehension of the gestalt,' meaning the apprehension of the object as an indivisible whole. As well, they intervene directly into the environment into which they are placed without interruption from a supporting plinth or base.

A versatile, protean artist, Morris – already recognized in the early 1960s for works that depended on epistemological paradox and language – further participated in the re-evaluation of sculpture's formal

and material definition initiated at mid-decade by artists often referred to as Postminimal. Morris's wall and floor sculptures, which he began in late 1967 and which are made from heavy, industrial felt, counteract the usual rigidity of sculpture, his own included. They respond to the force of gravity rather than, more typically, resisting it. Significantly, instead of attempting to demonstrate mastery over his materials, the artist cut or folded the felt or otherwise arranged for it to be displayed so that the work's final form would be a clear function of its material specificity, rather than a function of figurative or compositional imperatives.[29]

In early works by Richard Serra, material form follows material function while traditional workmanship by hand gives way to use of the materials of industry and the labor associated with it. *Belts* (1966-67), for example,

is an array of eleven groups of looped and curling strips of vulcanized rubber that are pegged to the wall, the first accented by twisting neon tubing. *Scatter Piece* (1967) covers the floor with scraps of rubber latex. *Bullet* (1968) is a three-foot-wide piece of lead sheeting that has been rolled up like a scroll. His Props from 1968 and 1969 consist of lead tubes that lean against flat sheets of metal to demonstrate that the sculpture is holding itself up. *Casting* (1969), an impermanent work, revealed the process of its own making: at the time of the exhibition 'Anti-Illusion: Procedures/Materials' at the Whitney Museum of American Art, New York, molten lead was thrown into and then peeled away from the angular cavity created by the meeting of the gallery wall and floor to produce irregular strips of hardened lead lying parallel to one another on the ground. *One Ton Prop (House of Cards)* (1969), formed by the balancing of upright lead plates against one another, again exemplifies how Serra's works represent the behavioral properties of the materials that account for their form.

During her brief but intense career, Eva Hesse developed a body of work that thematically manifests the release of sculpture from containment by the practices that previously defined it. Created in the half-dozen years before her untimely death, works in three dimensions destroyed the accepted material and formal qualities of traditional sculpture and replaced them with totally unfamiliar ones. Regarding her method and intent, Hesse relayed in an interview that she was 'interested in finding out through working on the piece some of the potential and not the preconceived,' and that if there were nameable content in her work, 'it's the total absurdity of life… absurdity is the key word. It has to do with contradictions and oppositions.'[30]

Contradiction and opposition are brought to the fore in the sculpture of Hesse; their physical palpability paradoxically and purposefully embodies the idea of their own metaphysical emptiness. Speaking of *Addendum* (1967), the artist suggested that, title and explanations aside, 'the work exists only for itself. The work must then contain its own import.'[31] The work's import is borne out through the unconventional combination of formal elements and materials that yield a narrow, horizontal, light grey, textured wall relief of wood and papier-mâché. Rubber tubing hangs down in parallel strands from the center of each of the relief's seventeen identical semi-spheres. The semi-spheres are arrayed

Richard Serra | **Belts** | 1966–67 (photo: Peter Moore)

Richard Serra | **Casting** | 1969 (photo: Peter Moore)

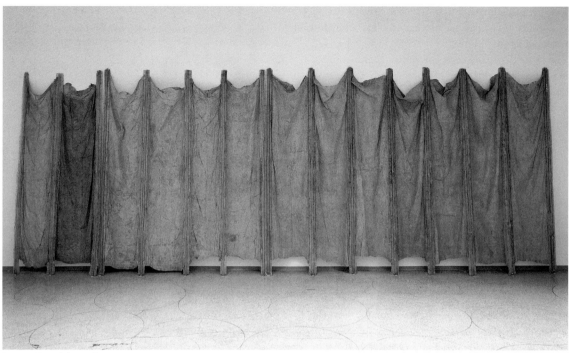

Eva Hesse | **Expanded Expansion** | 1969

side by side along the narrow bar to which they are attached at intervals that increase from left to right in ¼-inch increments. The separate strands of tubing, projecting from the conical spheres, coil together upon reaching the floor. Irregular distancing between semi-spheres diffracts their serial regularity, while the limpness of the rubber tubing deflects the rigidity of the supporting rectilinear bar.

Hesse's discovery, in fall 1967, of latex rubber, which she would use extensively in addition to plexiglas, enabled her to expand her material and formal vocabulary in the ensuing years. She applied this vocabulary toward contradicting the traditional inflexibility of a singular or massive sculptural object. Major works such as *Repetition Nineteen III* (1968) or *Expanded Expansion* (1969) further revoke the reputed characteristics of sculpture. The first work consists of a group of nineteen open, truncated, tubular fiberglass volumes, slightly irregularly shaped, set randomly on the floor. Overcoming strict adherence to uniformity of shape and placement, *Repetition Nineteen III* recognizes the advantages of repetition but avoids compliance with its constraints. *Expanded Expansion* may be described as

an extended curtain composed of latex-on-cheesecloth panels propped against an expanse of wall by a series of supporting fiberglass poles. Unlike a conventional solid sculpture, *Expanded Expansion* is not volumetric, but spreads across and covers the wall with large-scale folds of undulating, rubberized fabric.

Such works suggest how Hesse divested sculpture of the representational and compositional duties traditionally assigned to the singular object. Using materials without an established art-historical lineage, she was able to play materiality off against serial repetition and also to temper the rigidity of a work's underlying geometric or mathematical structure. The form of her sculpture hovers abstractly between the organic-anatomical and the hard-edged industrial. Resisting encapsulation in literal terms, meaning in her work is embedded in and expressed through the resolution of engendered conflicts between material and formal opposites.

Although materially analogous to works by Hesse, the early fiberglass/polyester resin pieces of Bruce Nauman (b. 1941) differ from hers in method. Slightly younger than Andre, Judd, LeWitt, Morris, Serra, and Hesse and

working in California rather than New York, Nauman began his broadly based revision of traditional sculptural practice in 1965. Throughout a career that depends heavily on the use of language, he has embraced a range of materials and media including photography, film, video, and sound installation.

Works by Nauman made prior to 1968 prefigure his greater breach with conventional sculpture. Untitled fiberglass sculptures, dating from 1965 and comparable with works by Morris, Serra, and Hesse, do not stand freely in open space but lean against or project from the wall. Elongated forms, which the artist referred to as 'soft-shapes,'[32] quite literally turn traditional, volumetric sculpture inside out in that the outside of the molds are cast as if they were the rough insides. Certain fiberglass pieces allude to the invisible space that surrounds the contours of the body, for example, the hairpin shape of the space defined by the armpit. Fiberglass sculptures that actively lean or push themselves against the wall and floor, in their critique of figuration, give concrete form to the proprioceptive experience of space engendered by bodily movement.[33]

Following the fiberglass forms, works such as *Platform Made Up of the Space Between Two Rectilinear Boxes on the Floor* (1966) or *Shelf Sinking into the Wall with Copper-Painted Plaster Casts of the Spaces Underneath* (1966) reverse conventional concepts of sculpture by, once again, imbuing the invisible, negative space surrounding objects with material form. In *Composite Photo of Two Messes on the Studio Floor* (1967),

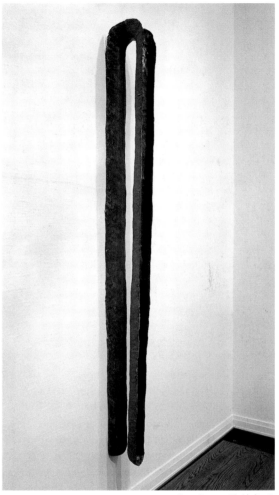

Bruce Nauman **Untitled** 1965

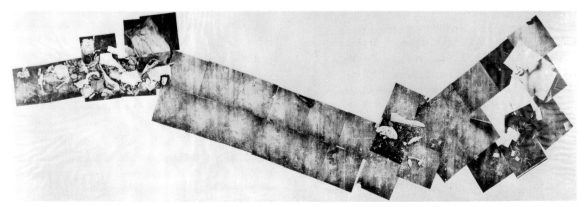

Bruce Nauman **Composite Photo of Two Messes on the Studio Floor** 1967

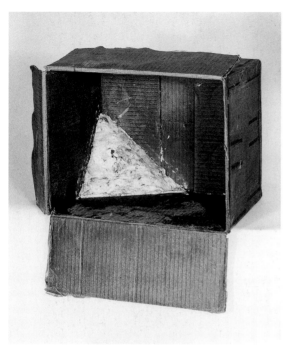

Joseph Beuys **Fettecke in Kartonschachtel (Fat Corner in Cardboard Box)** 1963

the residue of aesthetic fabrication, normally disposed of upon a work's completion, here becomes its subject matter. By thus inverting and commenting upon once unquestioned relationships between material, form, and space, Nauman embarked on his reform of sculptural practice.

Sculpture, in the belief system of the major postwar German artist Joseph Beuys (1921–86), has a redemptive dimension. As opposed to his Minimal and Postminimal contemporaries in the United States, who labored to remove the metaphorical or mystical from their materials, Beuys considered it 'necessary to present something more than mere objects.'[34] Famous for his teaching,[35] performances, installations, and social activism as well as for his objects and multiples, he defined his aesthetic enterprise as Social Sculpture. 'I think of my entire effort under the concept of plasticity,'[36] he said in an interview. Beuys advocated the idea that art and life are not irreconcilable – that, in principle, everyone is an artist – and that aesthetic reform expressly leads to social reform.[37] Averring that 'making art is a means for working for man in the area of thought,'[38] and that 'thought is represented by form,'[39] he attributed symbolic meaning to the hallmark materials of

his sculpture: fat, beeswax, and felt. Lard, for example, in Beuys's system, behaves in analogous manner to thought inasmuch as it, too, can be molded. As he explained it, 'fat in liquid form distributes itself chaotically in an undifferentiated fashion until it collects in a differentiated form in a corner. Then it goes from the chaotic principle to the form principle, from will to thinking.'[40]

According to Beuys, he first used fat in a discussion concerning 'the potential of sculpture and culture,' having decided to take 'an extreme position in sculpture, and [to use] a material that was very basic to life and not associated with art.'[41] The intention underlying *Fettstuhl* (Fat Chair, 1963 or 1964) and his earlier *Fettecke* (Fat Corner) pieces, contrasts with works by Nauman, in which Beuys could not pinpoint 'inner intentions.'[42] Deliberately seeking to expunge such inner intentions or associative value from his materials, Nauman maintained that forms derived from contours of the body – as in works such as *Neon Templates of the Left Half of My Body* (1966) or *Wax Impressions of the Knees of Five Famous Artists* (1966) – 'gave them reason enough for their existence.'[43] In contrast to Nauman's drawing of *Concrete (or Plaster Aggregate) Cast in Corner, Then Turned Up on End* (1966), which describes its own formal exigency in relation to architectural reality, *Fat Chair* by Beuys is imbued with psychological implication. Beuys states that he wedged fat (as he had previously done with the corners of rooms) into the angle of an armless chair so as to clearly present its inchoate qualities. His own description of the work synthesizes the aim to invest materials with meanings beyond their physical and behavioral properties:

> … here the chair represents a kind of human anatomy, the area of digestive and excretive warmth processes, sexual organs and interesting chemical change, relating psychologically to will power. In German the joke is compounded as a pun since *Stuhl* (chair) is also the polite way of saying shit (stool), and that too is a used and mineralized material with chaotic character, reflected in the cross-section of fat.
>
> …without this *Fat Chair* and the *Fat Corners* as vehicles none of my activities would have had such an effect. It started an almost chemical process among people that would have been impossible if I had only spoken theoretically.[44]

Fat Chair, one of a great many objects produced by the artist over several decades, suggests the way in which Beuys sought to stimulate processes of association regarding the human condition rather than, like his contemporaries, to quell them. Critical response to Beuys's methodology, vulnerable to skepticism in its claims to reach mystically beyond empirical reality by way of material form, has been diverse. Significantly, various facets of Beuys's career – based in performance as well as in materiality – express a desire to forge a social agenda from a sculptural one.

Speaking further about *Fat Chair*, Beuys insisted that 'the presence of the chair has nothing to do with Duchamp's Readymades, or his combination of a stool(!) with a bicycle wheel.'[45] Nonetheless, the idea that common, non-art objects could be extracted from daily use for aesthetic ends was first given theoretical and practical application by Marcel Duchamp (1887–1968) in the early part of the twentieth century. The appellation 'Readymade' occurred to Duchamp as a means to describe 'these things…to which no art terms applied.'[46] *Bottlerack* (1914), for example, consists of what was simply a household object used for drying bottles at the time that the artist signed it. Duchamp's submission of *Fountain* (1917), a urinal signed 'R. Mutt' and turned upside down, to the 1917 Independents' Exhibition in New York is by now a familiar story. His response to the jurors, who had rejected the work, articulates the idea that what is done in the name of art is more important than the technical skill brought to bear upon its creation. As Duchamp expressed it:

> Whether Mr. Mutt with his own hands made the fountain or not has no importance. He CHOSE it. He took an ordinary article of life, placed it so that its useful significance disappeared under the new title and point of view – created a new thought for that object.[47]

Duchamp's rejection of painting upon completion of *Nude Descending the Staircase* (1912) led to his lifelong effort to 'reduce the idea of aesthetic consideration to the choice of the mind, not to the ability or cleverness of the hand.'[48] His multifaceted and seminal investigation of art as an intellectual yet mysterious and ultimately undefinable construct rather than a retinal phenomenon was founded upon, but hardly limited to, the concept of

Marcel Duchamp | **Bottlerack** | 1914

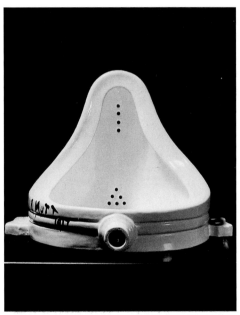

Marcel Duchamp | **Fountain** | 1917

Claes Oldenburg | **The Store** | 1962

Claes Oldenburg | **Alphabet/Good Humor** and **Clothespin** | 1975

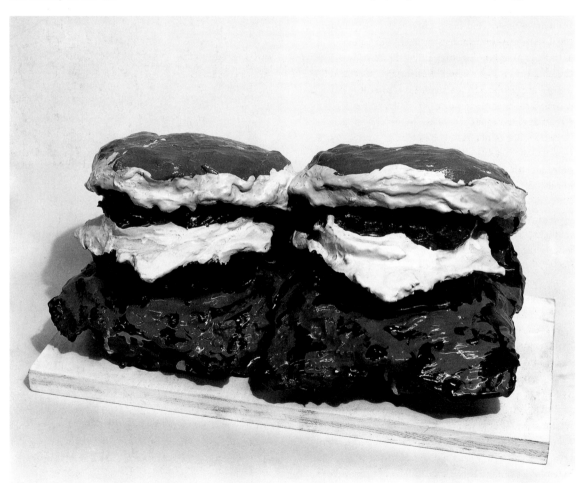

Claes Oldenburg | **Two Cheeseburgers with Everything (Dual Burgers)** | 1962

the Readymade. The fruits of this investigation, however, had their full impact on other artists only after 1955. As Willem de Kooning prophetically recognized as early as 1951, Duchamp, whose influence in the second half of the twentieth century has been inestimable, was 'a one-man movement… a movement for each person and open to everybody.'[49]

Giving material form and scale to everyday items of use and consumption, Claes Oldenburg (b. 1929) celebrates the common object. In a manner related to other Pop artists and similarly not without debt to the Readymade, Oldenburg initially turned to the street and subsequently to the world of mass production and consumption. Exhibited in New York (first at the Judson Gallery and then, more commodiously, at the Reuben Gallery) as an environment, *The Street* (1960) brought the usually unshown underside of city life into the gallery. Noting that 'a refuse lot in the city is worth all the art stores in the world,'[50] Oldenburg fabricated a motley array of street characters and objects out of cardboard, newspaper, burlap, and other such lowly materials and limited his palette to browns and black.

By the time of his fall 1962 exhibition at the Green Gallery, Oldenburg's critique of the high-art prerequisites for sculpture had become clearly defined. For example, painted plaster food items (made for exhibition and sale as part of *The Store* in 1961) or lifesize, hand-sewn cloth objects such as *Floor-Burger* (1962) stood for mass cultural 'taste'. The artist's lengthy personal manifesto from this time gives the full flavor of his desire to metaphorically disengage art from its pedestal.

> I am for an art that is political-erotical-mystical, that does something other than sit on its ass in a museum…. I am for an art that takes its form from the lines of life itself, that twists and extends and accumulates and spits and drips, and is heavy and coarse and blunt and sweet and stupid as life itself.[51]

In 1965, the date of his first Proposed Colossal Monument drawings, Oldenburg initiated the genre of public sculpture with which he is identified. Whereas Minimalists and Postminimalists endeavored to purge all signs of figuration from their sculpture through the decomposition of material form, Oldenburg endowed recognizable objects of daily life with an heroic

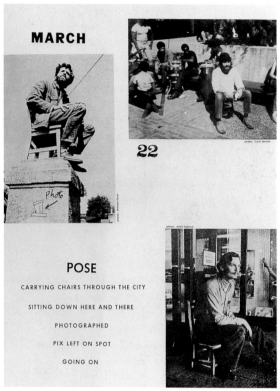

Allan Kaprow **Pose (Carrying Chairs Through the City…)** 22, 23 March 1969

aspect. By giving anthropomorphic, eroticized form to the household appliance, the teddy bear, the hot dog, etc., Oldenburg was able to poke fun at aggrandizing monumentality by means of monumental sculpture itself.

During the late 1950s and early 1960s, Oldenburg also participated in events spearheaded by Allan Kaprow's (b. 1927) Happenings.[52] At the same time that established modes of painting and sculpture were being subjected to scrutiny on different representational, formal, and material levels, the possibility of substituting time-based actions for stationary objects was being explored. The Happening, in Kaprow's case, evolved from his invocation of the merits of junk as a means for bringing art down from the high-minded plane of Abstract Expressionist painting so as to base it firmly in real life.[53] The growing interest in assemblage (a word coined by the French artist Jean Dubuffet (1901–85) in 1953 to refer to three-dimensional works comprised of untransformed non-art objects and materials, and related to the terms collage or

photomontage used for two-dimensional work) coincided with Kaprow's Environments, as he termed them, and his Happenings.[54] As Kaprow has explained: 'The assemblage was the first step towards the happening. To put it simply, I began to pull all the garbage in the world into art. Garbage is… interesting because it doesn't last, it rots after a while.'[55] Kaprow's Happenings, like his Environments, but constructed within a temporal rather than spatial framework, took art off the easel to purge it of mandatory permanence and preciousness.

The vanguard activities of those associated with Fluxus also centered on the attempt to bring art into line with ordinary life. Following almost immediately upon the advent of Happenings, Fluxus cast a wide net during the 1960s and 1970s. 'Fluxus' was the name given by George Maciunas (1931–78), an artist and art historian who had emigrated from Lithuania to New York, to a magazine for which he had begun to assemble material in 1961. Through his subsequent organization of performance programs and publishing ventures under the name of Fluxus, Maciunas, a self-elected, controversial and impassioned firebrand, gave a sense of international collectivity to a body of independent, geographically far-flung, like-minded artists, poets, filmmakers, and musicians.

The Fluxus *Manifesto* (1963), written by Maciunas, suggests the nature of his ideological contribution to a sphere of activity whose participants turned their backs on the creation of unique and precious objects. Maciunas exhorts in this handwritten document:

> *PURGE* the world of bourgeois sickness, 'intellectual,' professional & commercialized culture, PURGE the world of dead art, imitation, artificial art, abstract art, illusionistic art, mathematical art, – PURGE THE WORLD OF 'EUROPANISM'!
>
> …
>
> PROMOTE A REVOLUTIONARY FLOOD AND TIDE IN ART.
> Promote living art, anti-art, promote *NON ART REALITY*, to be ~~fully~~ grasped by all peoples, not only critics, dilettantes and professionals.
> *FUSE* the cadres of cultural, social & political revolutionaries into united front & action.

The revolutionary tone of the manifesto expresses the iconoclastic engagement with the concept of 'art' underlying the great range of Fluxus activities. A number of individuals, shortly before coming into contact with Maciunas, had attended the class taught in the late 1950s at the New School of Social Research in New York by the highly influential composer John Cage (1912–92). Undeterred by traditional media boundaries, they benefitted from Cage's experimental attitude and rule-breaking approach to music founded upon chance operations, real sounds, and ambient noise.

Early Fluxus concerts and events were marked by efforts to demonstrably extricate art from its ivory tower and free it from traditional constraints. A concert or event typically gave responsibility to the performers and ran its particular course rather than being controlled by its author. Some works, influenced by the ideas of Zen Buddhism, are contemplative, while others call upon humor, pranks, game-playing, and outrageous or raucous behavior, or revolve around a common or communal activity such as a meal.[56] *Winter Carol* (1959) by Dick Higgins (1938–98) describes how it is to be played out in real time and place.

> Any number of people may perform this composition. They do so by agreeing in advance on a duration for the composition, then by going out to listen in the falling snow.[57]

Drip Music (Drip Event), 1959–62, by George Brecht (b. 1925) brings heightened awareness to the unmomentous, momentary, mundane occurrence. The score ('For single or multiple performance') stipulates:

> A source of dripping water and an empty vessel are arranged so that the water falls into the vessel. Second version: Dripping.

Or, in the instructional mode characteristic of many Fluxus pieces, La Monte Young (b. 1935) gives directions in *Composition 1960 # 10 to Bob Morris* (October 1960) to

> Draw a straight line
> and follow it.

Piano Piece for David Tudor #1

Bring a bale of hay and a bucket
of water onto the stage for the
piano to eat and drink. The
performer may then feed the piano
or leave it to eat by itself. If the
the former, the piece is over after
the piano has been fed. If the
latter, it is over after the piano
eats or decides not to.

October 1960

Piano Piece for David Tudor #2

Open the keyboard cover without
making, from the operation, any
sound that is audible to you.
Try as many times as you like.
The piece is over either when
you succeed or when you decide
to stop trying. It is not
necessary to explain to the
audience. Simply do what you
do and, when the piece is over,
indicate it in a customary way.

October 1960

Piano Piece for David Tudor #3

most of them
were very old grasshoppers

November 14, 1960

Composition 1960 #7

to be held for a long time

La Monte Young
July 1960

Composition 1960 #10
 to Bob Morris

Draw a straight line
and follow it.

October 1960

Composition 1960 #13
to Richard Huelsenbeck

The performer should
prepare any composition
and then perform it as
well as he can.

November 9, 1960

Composition 1960 #15
to Richard Huelsenbeck

This piece is little whirlpools
out in the middle of the ocean.

9:05 A.M.
I December 25, 1960

La Monte Young **Compositions 1960** from *An Anthology* (New York 1970)

With direct assimilation of daily life, *#2 – Proposition* (21 October 1962) by Alison Knowles (b. 1933), which premiered in London at the Institute of Contemporary Arts, instructs:

Make a salad.

Soon after the first European tour of 1962–63 organized by Maciunas, Fluxus began to assume its identity as an international community of artists from America, Europe, and Asia working in a similar vein. Whereas some thirty pieces had been performed in museums or concert halls abroad, back in New York many events took place in the street for lack of official venues. Announced to oblivious passers-by, the street pieces 'fit in so perfectly with George Maciunas's values; no cost, no waste, and lots of surprises.'[58] The street events, moreover, significantly bypassed the need for presentation within an institutional framework.

Fluxus publishing, a major facet of Maciunas's organizational assiduity, was motivated by the goal to create modestly priced works that, produced in multiple, would offer an antidote to the idea of the priceless object fit for a museum. Fluxus production underscores its own insignificant, quotidian, or ephemeral nature and seeks to undermine expectations surrounding the concept and experience of art as a high-value commodity disassociated from life. As witnessed by the entries of the 600-page *Fluxus Codex*, a catalogue compiled by Jon Hendricks of hundreds of Fluxus objects and publications, 'the lion's share of Fluxus work assumes the form of transient pieces of paper – handbills and broadsides or boxed thematic accumulations.'[59] As well, objects by an artist such as Robert Watts (1923–88), bearing a direct comparison with Pop art and the Readymade, in ironic manner raise the unheroic to a new plateau. For example, *Whitman's Assorted Chocolates* (1963) consists of chrome-plated bronze 'chocolates' that, cast from real candies, sit in their original paper wrappers within an actual Whitman's box. They belong to a group of other Chromed Goods, including a toothbrush, pencil, and egg carton with a dozen eggs, that mimic the shiny industrial surfaces of automobile trim.

Whereas Duchamp's Readymade was conceived as an interrogational lever by which to raise questions about the meaning of authorial presence in art production,

lowly and humorous Fluxus objects assault the notion of authorial prowess head on. Not directly concerned, as is the Duchampian Readymade, with challenging assumptions pertaining to physical versus intellectual labor, Fluxus works specifically contest the idea of art's monetary worth. Understanding this to be a function of rarity and the display of manual ingenuity and originality, they aim to erase these indices of commercial value.

The publishing initiatives of Maciunas, first coming to fruition in 1963 with La Monte Young's *An Anthology*, expressed the anti-art (i.e., anti-unique, costly object) stance of Fluxus through editions and multiples. Of special note is the unorthodox format given to publications whose contents were not confined to the bound or printed page. *Fluxus 1* (1963–64) contains varied materials including scores, photographs, essays, etc. by twenty-four different artists, mainly from America but also from Europe and Japan. The items are accommodated in unconventional ways in that they are stuffed into envelopes, printed on unusual papers, and bolted together. Identified as a 'yearbox' and serving more as an almanac of recent production than simply as a magazine, *Fluxus 1* was accommodated in a wooden box, which replaced traditional methods of binding and was used as a mailer. *Flux Year Box 2* (1966–c.1968) is a compartmentalized box containing objects and 8mm film loops as well as a range of different kinds of printed matter.

Not confined to a rigid set of principles or carried out in a single geographical location, Fluxus attitudes and methodology had begun to seep into the culture internationally by the mid-1960s. Exhibiting a community of purpose, but never possessing a fixed roster of members, it may, most pertinently, be defined by the single-minded desire to put art and life on the same plane. In this regard, it was marked by a rebellious spirit; an intermedia approach including bookworks, film, and video; a reliance on language; the adoption of performative means; the definition of alternative presentational contexts such as the box and use of the mail for distributional purposes; use of rubber stamps in lieu of the hand-drawn; and a critical awareness of the commercialism afflicting art and society. Although, generally speaking, Fluxus was not an overtly political movement, as was, for example, the nearly contemporaneous Situationist International founded

in Europe in 1957, it was rooted in the utopian principle that art might take part in the fight for an egalitarian society. 'The value of art-amusement,' Maciunas proposed in 1965, 'must be lowered by making it unlimited, massproduced, obtainable by all and eventually produced by all.'[60]

Democratic precepts revolving around the idea that a work of art is a commodity impelled the aesthetic innovation which germinated in the mid-1960s and was reaped throughout the 1970s. Artists broadly identified under the heading of Conceptual art (not to be confused with 'Concept Art'), in contrast to their immediate Fluxus predecessors, have approached their aesthetic production from a slightly different point of view. Substituting performance and publishing activities for engagement with both the material and materialistic concerns of painted or sculptural form, they have endeavored to undermine the art object *qua* object.

In contradistinction to those involved primarily with Fluxus, the artists discussed in this book have not altogether disqualified the object from their production, but have redefined its former material and formal nature. Not specifically involved with narrowing the gap between art and life, they have focused on the relationship between art and reality. Their paramount aim has been to apply art to the dissolution of illusion, either from a perceptual standpoint or in connection with ideologically motivated mystification.

Conceptual artists notably have benefitted in many instances from the linguistic or performative methods of Fluxus, its reappraisal of institutional or distributional means of presentation, and, more generally, from its revolutionary and socially oriented stance. Having absorbed the lessons of the Pop and Minimal/Postminimal period, they were able to overthrow established notions of painting and sculpture and/or to thematically question these disciplines without banishing the object from their production. Different from their immediate contemporaries who have been more aligned with Postminimal materiality or who have been principally associated with the Arte Povera movement by virtue of their untraditional use of lowly or non-art materials, so-called Conceptual artists have transformed earlier approaches to painting and sculpture along with long-held ideas about the art object.

Through their concerted challenge to traditional representational and material modes, the artists in this book retain the self-referentiality of the object that was so emphatically articulated by Pop, Minimal, and Postminimal artists alike. Like their immediate predecessors, who evolved methods by which to revoke authorial signs of painterly gesture or hierarchically structured compositions, artists of the late 1960s and the 1970s have dealt with the issue of authorial agency. Conspicuous intervention by the artist is concealed in Conceptual works, just as it is in Pop or Minimal/Postminimal production, in order to confirm the idea that a work is grounded by its own reality instead of arising from subjective concerns. For many artists after 1965, effacement of the indicators of an authorial presence serves not so much to literally counteract art's commodity status – as in the case of seemingly art-less Fluxus or Arte Povera works. Rather, such effacement serves within and as part of the thematic structure of the work.

With attention to the many facets of their representational nature, Conceptual works address their own condition as materially and contextually defined objects. Toward the realization of such an agenda, artists who may be considered Conceptual have enlisted language, photography, representational means such as maps or numbers, and time-based media. They also have incorporated performed actions into non-performative works, constructed room-based installations, and occasioned the idea of site-specificity. Often acknowledging the presence of viewers within an institutional, social, economic, or political context, Conceptual works of art, with few exceptions, have discarded the former properties and defining characteristics of the enframed static painting or the spatially detached sculpture.

1970

1960 Popart

1950

 Neo-dada

 Informale

 Tashisme

 Astrattismo

1940 Espressionismo

1930

 Surrealismo

1920

 Dada

 Pittura metafisica

 Costruttivismo

 Neoplasticismo

 Cubismo sintetico

 Orfismo

 Futurismo

1910 Pittura astratta

 Cubismo analitico

 Espressionismo tedesco

 Fauvismo

 Impressività

1900

Giulio Paolini **174** 1965

Painting at issue after 1965

The term Conceptual art has primarily described the work of artists who abandoned traditional modes of painting and sculpture altogether. Nonetheless, questions regarding painting, posed in the oeuvres of those who, after 1965, continued to work within this rhetorical construct, may be addressed at the same time as works that definitively forsook this flat, enframed medium.

By the mid-1960s, Niele Toroni (b. 1937), Gerhard Richter (b. 1932), On Kawara (b. 1933), Blinky Palermo (1943–77), and Giulio Paolini (b. 1940) were in the early stages of their careers. Working in different cities of Europe (Paris, Düsseldorf, and Turin), with the exception of Kawara, who had come to New York from Japan, they were not at first known to one another, although Richter and Palermo, both living in Germany, were friends.

What links these artists together is the comparable goal of keeping illusion at bay by maintaining painting's proven self-referentiality while simultaneously addressing the world outside its borders. To this end, they introduced new possibilities for painted content in the process of questioning accepted means and methods for its delivery.

Because of the more pervasive decision by Conceptual artists to work with media other than paint, the 1970s are often associated with painting's demise. Although painting waned as a medium of choice for many artists working after 1965, it might be suggested that the termination of painting was not an end in itself, as it was notably for Aleksandr Rodchenko (1891–1956). A major figure of the Russian avant-garde in the earlier half of the twentieth century, Rodchenko believed his *Pure Red Color*, *Pure Yellow Color*, *Pure Blue Color* (1921) to be the ultimate – and thus final – statement that could be made about painting. Writing in 1939, he affirmed:

I reduced painting to its logical conclusion and exhibited three canvases: red, blue and yellow. I affirmed: it's all over.

Basic colors.

Every plane is a plane and there is to be no representation.[1]

Rodchenko's three monochromatic, easel-sized oils actually augured the continued vitality of painting rather than its end. As witnessed by developments in the latter half of the century, painting would continue to sustain itself as an ideational and representational enterprise. Whereas Rodchenko, it might be suggested, had deliberately closed the door on painting, a number of artists in the late 1960s injected it with new life by turning its propensity for self-analysis to further advantage.

The work of Toroni, Richter, Kawara, Palermo, and Paolini may be viewed in relationship to the production of New York-based contemporaries, which, like theirs, is founded on a close-range, self-conscious scrutiny of specific attributes of painting. For pre-eminent artists like Robert Mangold (b. 1937), Jo Baer (b. 1929), Brice Marden (b. 1938), and Robert Ryman (b. 1930), who emerged on the cusp of Minimalism, painting has provided a forum and format for the creation of concrete apperception in relation to the a priori condition of planarity. Their works, often large in scale, are a tribute to the idea that elemental components of painting such as color, line, or surface quality afford infinite possibilities for visual variation. Singled out by the artist for consideration in their own right, such elements perform independently of discrete shapes or recognizable forms that are subordinated to a compositional structure and/or held within a rectangular border.

With the recognition that painting's 'unique quality, its flatness' is its only constraint, Robert Mangold had decided by 1965 to meet the challenge of achieving 'all at onceness' in two dimensions.[2] What impressed him in the late 1950s with regard to Abstract Expressionist painting and, specifically, with regard to the work of Clyfford Still, was the way in which 'painting [had] shed its frame and took on a scale that separated it from the tradition of easel painting.'[3] In his own work, Mangold has explored methods by which to cast off or mitigate the restraints of rectilinearity. Having shied away from continuing the shaped monochromatic reliefs cut from actual wall sections, which he was making in 1964, because of their overt sculptural tendency, he developed numerous solutions for defining the picture plane as a ground for the interplay between color, line, and form in unison with the shape of the work as a whole. From the reductiveness of his early Area paintings to the complexity and intensified color of ensuing works, Mangold has managed to ensure that neither a work's interior configuration nor its rimmed form as a totality echo or dominate but that both remain in constant dialogue.

Mangold's paintings, sometimes segmented into more than one panel, assume a variety of geometric or eccentric shapes that often combine both straight and curvilinear edges. Curved and/or straight pencil lines demarcating their matte pictorial field vie for equal attention with their background at the same time that they pay heed to – while attempting to overcome – the fact they are bounded. They thereby question to what degree, if any, they might be interpreted as part of an extended, external reality and therefore not subject, in a thematic and ultimate sense, to (en)closure. The artist considers his paintings, unlike any other objects in his studio, to be 'like portable walls and [also] like gateways.' As he has further elaborated, they 'exist in some kind of in between state. This flat picture plane, existing before you like a wall, that you could neither enter or treat as an object, is for me painting's essence.'[4]

Internal content and surrounding-shaped container, in Mangold's work, though visually and thematically

Robert Mangold ½ **Manila Curved Area** 1967

intertwined, are nonetheless separate considerations. Without rejecting rectilinearity, the work of Jo Baer from the 1960s also deals with the relationship between interior configuration and bordering edge. Sympathetic with Mangold on the issue of flatness and frontality, Baer similarly chose to contend with framed planarity rather than to take Frank Stella's definition of painting-as-object too literally, and thus too far, in the direction of sculpture. As she articulates with direct reference to Mangold in a recent text titled 'I am no longer an abstract artist,' her 'paintings from 1962 to 1975 also engaged and occupied a strong position in the dialectic of object versus sleight-of-hand.'[5]

Baer's paintings define the terminating edge of the canvas as the work's 'central' concern. In 1967, in reply to Robert Morris's denigration of painting, she described her method of combating illusion:

> A painting is an object which has an emphatic frontal surface. On such a surface, I paint a black band which does not recede, a colour band which does not obtrude, a white square or rectangle which does not move back or forth, to or fro, or up or down; there is also a painted, white, exterior frame band which is edged around the edge to the black. Every part is painted and contiguous to its neighbour: no part is above or below any other part. No part looks like it is above or below any other part. There is no hierarchy. There is no ambiguity. There is no illusion. There is no space or interval (time).[6]

The black and colored bands paralleling the margins of Baer's paintings give equal prominence in all respects to the unobstructed areas of white (or grey) canvas within their confines. Of special import is the way in which the artist created relationships between the black and colored bands, which appear to be straight but were not drawn with a ruler, and the white or grey expanse of the rest of the canvas. These relationships rely on a physiological phenomenon known in perceptual psychology as 'Mach bands.' The result of a retinal reflex triggered by contrasting intensities of light and dark, they possess a luminescent quality that serves to keep all elements of the canvas on the same visual plane by preventing darker colors from dominating lighter ones. As Baer explained in 1970, her 'paintings were made to

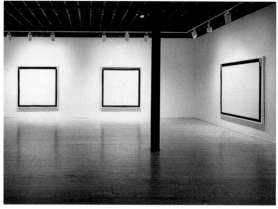

Jo Baer **Untitled** 1962; 1962; 1963 (installation Rhona Hoffman Gallery 1989)

Jo Baer **Brilliant Yellow #9** 1964–65

Brice Marden | **Rodeo** | 1971

Brice Marden | **Red, Yellow, Blue Painting # 1** | 1974

work through boundary and luminance phenomena.'[7] An enframing aureole results from the light-dark contrast of black and colored paint. This aureole sets rectangular canvases – often shown as a pair or a group – apart from non-art reality without severing the art object from the refulgence of the visible world.

Abstract, reductive, and lacking internal configuration, the work of Brice Marden also retains painting's traditional rectangular format. The principle area of focus for Marden is neither canvas shape vis-à-vis pictorial field nor pictorial field vis-à-vis bordering edge. Quite specifically, it is the unalterably flat frontality of the rectangle's *painted* field. 'As a painter I believe in the indisputability of The Plane,' his statement in the exhibition catalogue for 'Eight Contemporary Artists' reads, and 'the image becomes the plane.'[8] Marden's earliest group of paintings, begun in 1965 and shown in 1966 at the Bykert Gallery, New York, are each of a slightly different earthy, muted tone. A couple of years later Marden introduced a greater range of hue into his work and by 1974 was using primary colors. By 1968 he had changed from a horizontal to a vertical format and had shifted from one-panel to two- and three-panel paintings. The separate colors of each single-colored panel, abutted together, are visually held in the same plane so that they do not appear to advance or recede in relation to one another.

The consistency of paint as a substance combined with the technique used by the artist to apply it account for Marden's success in exhibiting the rectangular painted plane/panel as an unembellished and impassable surface. To obtain a thick, non-gloss finish Marden added beeswax and turpentine to oil paint. First applied to the canvas with a brush, the colored paint mixture was spread evenly over the surface of the painting. At this point the artist would work the paint with spatula and knife. Although variables between one painting and the next occur, Marden tried 'to keep the surfaces in one painting constant and total.'[9] On each of the single-colored, single-panel paintings, moreover, the artist drew a line a quarter of an inch from the work's lower edge. The painted area, except for residual drips, stops short of the bottom of the canvas as a reminder of the unarticulated blankness beneath the painted surface of the canvas (also recalling paintings such as *Tennyson* [1958] by Jasper Johns). Totally devoid of imagery or any form of abstract demarcation, the smooth, dull, and

opaque monochromatic surfaces of Marden's early production have nothing to do with vacancy. They express, instead, the irrefutable surface of painting in all of its extant fullness.

Despite affinities with the paintings of Marden in its comparable lack of concern for figurative form or abstract shape, the work of Robert Ryman has followed a separate agenda with regard to the painted surface. In the mid-1950s, Ryman entered his life-long inquiry into painting as both a medium and verb; that is, as viscous material that performs on a given support. The 'image' in Ryman's oeuvre is the paint(ed) surface itself and the manner in which paint has been applied to the canvas or other material support. 'What the painting is, is exactly what people see,'[10] he remarked in a relatively early interview. With greater emphasis on the 'see' than on the 'is' – and thus in differentiation from the often quoted statement by Stella regarding the 'object' of his painting – Ryman later elaborated on his basic thesis:

> We have been trained to see painting as 'pictures,' with storytelling connotations, abstract or literal, in a space usually limited and enclosed by a frame which isolates the image. It has been shown that there are possibilities other than this manner of 'seeing' painting. An image could be said to be 'real' if it is not an optical reproduction, if it does not

Jasper Johns | **Tennyson** | 1958

Robert Ryman **Untitled** 1959

symbolize or describe so as to call up a mental
picture. This 'real' or 'absolute' image is only
confined by our limited perception.[11]

Ryman's aesthetic practice is characterized by the artist's
observation in the late 1960s that 'there is never a
question of what to paint, but only how to paint. The
how of painting has always been the image – the end
product.'[12] For his part, he has 'wanted to make a
painting getting the paint across,'[13] meaning across the
canvas literally and, more idiomatically, as an idea.

Engaged from the outset with methods by which to
demonstrate the behavior of paint on a surface, Ryman's
approach is the reverse of Marden's. Whereas the latter
labors to suppress signs of paint application in order to
speak about the impermeability of the canvas support,
Ryman has sought to activate – however subtly – the
paint(ed) surface on the one hand, and to approach the
painting's support as if it were a proscenium rather than
an impenetrable backdrop. Except for *Untitled (Orange
Painting)* (1955 and 1959), which the artist considers his
first mature painting, Ryman's works use white paint.
And, throughout the 1960s and 1970s, they have mainly
been contained within a square. The exclusion of other
hues and the equalizing of all sides of the support have
served to enhance the importance of the paint as an 'area'
for full attention.

One of Ryman's earliest paintings, *Untitled* (1959), is
indicative of the artist's overriding interest in imbuing
paint with the power to act on its own behalf.
Multidirectional, interwoven, overlapping brushwork
and residual globules of paint signify paint's own
performance rather than evincing anything beyond its
physicality and behavior in response to the brush.
Moreover, the painted 'RRyman' of the artist's name,
which is vertically up-ended, intervenes in the overall
activity of paint. According to Ryman, his signature, 'an
accepted element of all painting,' saliently functions here
as a line meant to avert symbolism or being mistaken for
the painting 'trying to say something.'[14] Simultaneously
a painted and an authorial sign, the signature is engulfed
as part of the all-encompassing field of paint. Close in
color to the orange-yellow tint of the work's raw cotton
canvas, the signature-cum-line-as-physical-paint
mediates between the entirety of the painted field
and its partially revealed cloth support underneath.

The type of paint used by Ryman since the 1950s has
varied immensely with respect to its viscosity and the
kind of finish produced, whether glossy, semi-glossy,
matte, or dull. The many possibilities of paint quality
along with the multifarious methods for paint handling
interact with one another in concert with the nature of
the painting's support, which is also a variable of each
work. With his introduction in 1976 of hardware that
visibly holds work to wall, Ryman gave overt
consideration to the symbiosis between painted
and supporting mural surface. Never entirely
obliterating – but insisting upon – the distinction
between painting as an idea and painting confined to
a physical support, Ryman's later works fully express
the idea that the relationship of paint to support, though
born of material practicality, is ultimately sustained by
the ideational capacity of painting to look at itself. For
Ryman, whose paintings detail different possibilities for
the application of paint, painting remains an ongoing
reflection on painting.

The works of Mangold, Baer, Marden, and Ryman
illustrate the shift from the symbolically sublime
component of painting articulated by Abstract
Expressionism towards an abstraction which confirms
painting's independence from subjectivity or spirituality.
The Swiss artist Niele Toroni, who lives in Paris, began
his formulation of how to express painting in terms of
its hypostatic, auto-critical capability in the mid-1960s.

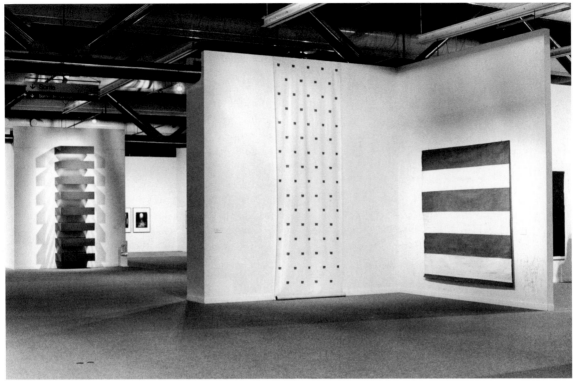

Niele Toroni **Imprints of a no. 50 brush repeated at regular intervals of 30 cm** | 1967
(between works by Donald Judd and Michel Parmentier)

Whereas Ryman has been concerned with presenting paint application in relation to a support as the work's subject matter, Toroni has defined painting to be a generic act on a generic support. From his first public exhibition at the beginning of 1967 to the present, he has given the same title to all of his works: *Imprints of a no. 50 brush repeated at regular intervals of 30 cm.* As this title makes clear, his working method has always involved placing the same sized, rectangular brushmarks on a specified surface at the same distance apart. Toroni plots this constantly maintained interval in advance and, working from left to right, does not diverge from the decision to set each brushmark at an identical distance from the previous one and from the line of brushmarks above it. As color is meant only to be a factual, and not a compositional, component of the work, separate series or fields of brushmarks retain the same hue throughout – usually black or a primary color.

Toroni's participation in the activities of what subsequently came to be called the BMPT group, an ad hoc and brief collaboration between himself and Daniel Buren (b. 1938), Olivier Mosset (b. 1944), and Michel Parmentier (1938–2000), expressed the polemical spirit of protest underlying the desire for change in art production. Faced with the omnipresence of the School of Paris, the BMPT members represented a generation seeking transformative change. In their eyes, painting had reached a nadir, having lost the force of its original expressionistic impulse and lapsed into mere gesture. Youthful demonstrations echoing Fluxus methodology, but not meant to be art as such, signaled the burgeoning polemic already in progress on both sides of the Atlantic.

The 1967 series of impromptu events staged by BMPT began in January at the '18e Salon de la Jeune Peinture,' where, acting unofficially, Buren, Mosset, Parmentier and Toroni jointly set forth their respective agendas to wipe clean the slate of painting. At the opening of the exhibition, the four artists prepared their works in front of the public rather than installing them beforehand on the wall. Buren's painting consisted of a series of alternating vertical red-and-white bands measuring 8.7 cm wide printed on fabric. The white, outer stripes were

Niele Toroni **Imprints of a no. 50 brush repeated at regular intervals of 30 cm** 1972

given a coat of white paint to clearly identify the work as belonging to the tradition of painting. Mosset's painting consisted of a single, centralized black circle on a white background; Parmentier's of broad, alternating horizontal bands of grey and white; and Toroni's of a series of eighty-five blue imprints of a flat brush repeated at 30 cm intervals on a white 2.5 square meter surface. Furthermore, the artists removed their works from the gallery at the end of the first day and replaced them with a statement on the wall that explained they were not exhibiting: '*BUREN, MOSSET, PARMENTIER, TORONI N'EXPOSENT PAS.*' A recording played throughout the opening day in three languages urging viewers 'to become intelligent.' Leaflets metaphorically described the depths to which they felt painting had sunk in its contemporary condition as 'a game,' 'a trampoline for the imagination,' or a function of subjects other than painting – from flowers and women to the Vietnam War. In brief, the four artists stated, '*Nous ne sommes pas peintres*' (We are not painters).'[15] The BMPT artists continued their polemics in June at the Musée des Arts Décoratifs where an invited audience sat for an hour in the museum's auditorium looking at a single painting subdivided into four equal quadrants. Leaflets eventually handed out told the members of the assembled audience to take note of the paintings by Buren, Mosset, Parmentier, and Toroni. Another staged event was held at the '4e Biénnale de Paris' in September, this time in the form of a repeated slide presentation of diverse images – city views, animals, nudes, etc. – accompanied by a sound loop about the illusionistic nature of art. After each completed sequence of slides, a spotlight focused on their painting(s), treated again as a single work. A pronouncement then was heard: 'Not the painting of Buren, Mosset, Parmentier, Toroni.' In conclusion, the assertion was made that 'Art is distraction; art is false. Painting begins with Buren, Mosset, Parmentier, Toroni.' Further collaborations on several ensuing occasions in 1968, either between Buren, Mosset, and Toroni, or between Buren and Toroni alone, included the painting of each other's paintings and exhibiting under the title '*Buren, Toroni ou n'importe qui*' (Buren, Toroni or it doesn't matter who). By participating in activities of this sort, the artists publicly verbalized their shared purpose of endeavoring to separate painted subject matter from intimations of subjectivity. They sought, in this way, to promote non-authoritarian, yet authoritative,

aesthetic meaning free of authorial whim or manipulative virtuosity, which conflict with painting's own self-reflexive message.

Toroni encapsulates his way of approaching his art in a formulaic statement that outlines his 'Method of Work:'

> On the given support a brush no. 50 is applied at regular distances of 30 cm
> N.B. support: canvas, cloth, paper, oil-cloth, wall, ground…, generally white surfaces.
> to apply: to place a thing upon an other one so as to cover it and stick on it, or leave an imprint.
> brush no. 50: flat paintbrush 50 mm wide.

As specified, a given support – normally white – may consist of any material surface but the application of the painted imprint remains unvarying and regularized. It might therefore be said that Toroni produces *painting* more than actual paintings.

The significance of Toroni's imprints, which are created by the controlled manipulation of a standard brush filled with enough liquid paint to be pressed against a surface without dripping, rests in the fact that the artist obtains only the image left by the brush's bristles. No one imprint takes precedence over another since there is no differentiation between them in their color or positioning. Barely noticeable variations among the separate imprints preserve the singularity of each brushstroke, which, in their consistent repetition, mimic the mechanical aspect of reproduction.

With the intention of discovering a way to disassociate painting from emotional expression, compositional invention, referential illusion, or transcendental subject matter, Toroni arrived at the decision in the latter months of 1966 to systematically generate equidistant and repeated imprints. In the 'attempt to do something that was left possible after Pollock,'[16] he began his research with paintings of 1965 that paid homage to Paolo Uccello's *Battle of San Romano* (c. 1457) with its array of horses. Referred to by Toroni as the Attacks, they used the image of the horse from Uccello's battle scene as a modular unit and substituted prefabricated linoleum flooring for canvas. Toroni placed the horses individually in the separate squares of the linoleum's checkerboard grid, which he had rotated on a 45 degree angle to produce diamond shapes.[17] He thereby obtained a pattern of repeated and equidistant shapes that bore no thematic reference to his hand in the work.

Upon completion of the Attacks, Toroni turned his attention to the linoleum squares, recognizing that they formed an overall non-hierarchical composition. Using the visual structure of the linoleum grid pattern, which he turned, as before, on a 45 degree angle, he produced a number of two-toned, checkerboard works with diverse color combinations such as blue and white, yellow and white, or pink and black. His purpose, he has explained, was 'to erase all previous ideas' from his painting.[18] By making use of a given set of elements, he endeavored to define paint application purely as the indication of the fulfillment of an aesthetic task and to eradicate vestiges of authorial invention pertaining to compositional arrangement.

Thus seeking to reduce his painting to objective fact, in 1966 Toroni arrived at the idea of dispersing the white brushmarks of a no. 50 brush across the surface of variously colored backgrounds in as evenly spaced a manner as possible. With the linoleum pattern obviated, he noted that an average distance of approximately 30 cm between brushmarks had become evident. Upon the completion of these works, Toroni assigned the space of 30 cm to be the distance between the imprints of his brush so that they would follow an unimpeded, predetermined course and register nothing more than the marks of painting's standard implement. The imprint serves both as an anonymous sign and, paradoxically, as a personal signature, with the former standing in and replacing all but the commercially driven need for the latter.[19]

For his first solo gallery exhibition, at the Yvon Lambert Gallery, Paris in 1970, Toroni stressed the seemingly self-sufficient existence of the imprints by not announcing his name on the mailed invitation card. The exhibition was held in three installments, in March, April, and July. At the artist's request, only the dates of the exhibition and the description of the work on view were mentioned on the mailer. Literal anonymity of this kind, Toroni has pointed out, '*ne serait malheureusement plus possible aujourd'hui*' (unfortunately would no longer be possible today).[20]

On a handout printed for an exhibition at the MTL Gallery, Brussels in the spring of 1970, Toroni made two significant stipulations about the work on view: (1) '*Ce*

travail est le fait de Toroni, mais ce travail peut être le fait de n'importe qui…' (This is the work of Toroni, but it could be the work of anyone) and (2) *'L'empreinte n'est pas image, idée, illusion d'empreinte mais bien empreinte réelle d'un pinceau no. 50.'* (The imprint is not the image, the idea, the illusion of an imprint but the real imprint of a no. 50 brush).[21] And, for an exhibition the following year at the Michael Werner Gallery, Cologne, he again stressed the theme of authorial anonymity. A letter he wrote to the gallery owner for visitors to read spelled out the major premises of his aesthetic production. It stated that the work on the wall was *'eine Arbeit von X* (a work by X).[22]

Toroni's imprints could be made by anybody. However, the artist's regard for the role of personal labor in the making of his art may be considered a corollary to, and not a contradiction of, his aesthetic production, which condenses the idea of mark/labor (the two French words *tache* and *tâche* mean 'spot' and 'task' respectively) into one concept. By means of the anonymous-looking imprints, personal fabrication and personal labor are generalized through their absorption into the thematic content of the work. In this respect, Toroni considers himself 'a painter rather than an artist,'[23] since he is the motivating and physical force behind emphatic and systematized brush(work).

With entirely different visual results from Toroni, whose painting is about the act of paint application, Gerhard Richter has made painting the subject of painting in other ways. In Richter's oeuvre, painting addresses its history as a representational mode that, over centuries, has changed stylistically and has been adapted to specific genres. If Toroni's work is grounded in repetition that changes only according to its surface, Richter's expresses the idea that, despite constant changes of image, stylistic approach, or genre, his painting may ultimately be reduced to the fact of its existence as painted representation and nothing else. Richter has treated a wide range of subjects and employed a great variety of means. Throughout his prolific career, which began in 1962, he has shifted from one mode of painting to another and alternated between the figurative and the non-figurative. He has dealt with the classic academic genres of history painting, landscape, the nude, portrait, and still life on many occasions, while abstraction became his primary area of focus after the late 1970s. Although during the 1980s and 1990s he mainly devoted himself to densely layered,

thickly painted, colorful canvases, he also produced works with recognizable imagery, including a monumental series based on photographic reportage.

In order to maintain the oil-on-canvas tradition as a form and a forum for ongoing aesthetic renewal, Richter has striven to reconfirm the immediacy of painted representation. His work gives credence to the idea that, irrespective of figuration or abstraction, reality presented on the picture plane is necessarily differentiated from the reality outside its borders. *Table* (1962), the first work in the artist's own chronological registry, contains the seeds from which Richter's entire aesthetic pursuit evolved. This painting was copied from a newspaper photograph. Its image – a table – is partially obscured by a paint smear, suggesting that a painted object and a paint smear possess equal status on the picture plane. Neither is more or less 'real' than the other. Although on a narrative level the smear attempts to obliterate the table, the table stands its painted ground.

Richter has articulated his ideas in many interviews and insists that he 'know[s] nothing about the real, reality. The only important thing… is the translation.'[24] Each shift in his manner of working marks another 'translation' wherein reality is neither duplicated nor interpreted but, without being lost to memory, is reinstated in pictorial terms. Richter's first subjects were copied from newspaper images and magazine ads. Having projected and enlarged the photograph onto a blank canvas, Richter painted its contents with a brush while 'endeavor[ing] to change as little as possible.'[25] Comparable to the Pop art methods of Roy Lichtenstein and Andy Warhol, the use of existing printed and photographic imagery exempted Richter from compositional invention, authorial interpretation, and illusionistic rendition. Photographs found in the media, according to the artist, did not possess 'all those conventional criteria… There was no style, no composition, no judgment.'[26]

Richter added amateur photographs to his repertoire of found imagery in 1964, which further broadened the already wide spectrum of his subject matter.[27] As with the news and advertising photographs, the banality and non-professionalism of snapshots suited his purpose of making 'paintings which had nothing to do with art.'[28] Such photographs 'liberated [him] from personal experience,'[29] since someone other than he already had captured a moment or aspect of reality by having

snapped a person's image, recorded a family gathering, taken a typical travel view, or documented a news item.

Richter's subjects are blurred by means of painted streaks to mimic the fuzziness that tends to result from hand-held camera shots. His observations in this regard encapsulate the nature of his endeavor:

> Paintings are different, they are never blurred.... Since paintings are not made in order to compare them with reality they cannot be indistinct or inexact or different (different from what?). How can color not be sharp on a canvas, for example?[30]

The question 'different from what?' underscores the guiding principle of Richter's aesthetic production, with its goal to clarify painting's differentiation from directly perceived or experienced reality. His work points decisively to the ultimate lack of equivalency between the real and the painted, while it nonetheless acknowledges points of convergence between the thing represented – a figure, a face, a landscape, an object, etc. – and the concept of representation.

If Stella demonstrated the idea that a painting is first of all a non-illusionistic object, and Ryman has featured the activation of the material surface of a painting as its very image, Richter has set himself the task of verifying painting's utter objectivity. Amateur and reportage photographs, which, as found objects, belong in the tradition of the Readymade,[31] supplied Richter until the mid-1970s with images fixed in a single moment of time. Whatever the nature of the image – whether of fighter planes in *Mustang Squadron* (1964), the family groupings in *Christa and Wolfi* (1964), the figure in evening attire stepping down a staircase in *Woman Descending the Staircase* (1965), or the chair in *Kitchen Chair* (1965)[32] – each picture remains simply an isolated instance from a story external to it. Information beyond what is given in the image at a particular moment in time (the wartime suffering inflicted by bombers, the occasion for the woman being on the stairs, etc.) cannot be gleaned from within the picture. Despite the possibility of outside knowledge of surrounding events being brought to bear on the subject by a viewer, Richter's subjects tacitly retain their signifying function but remain thematically non-judgmental. The bombers in the sky, in this regard, bespeak no more nor less than the chair, referring only to their own depiction. By means of news, advertising, and

Gerhard Richter **Christa and Wolfi** 1964

Gerhard Richter **Woman Descending the Staircase** 1965

Gerhard Richter **Mustang Squadron** 1964

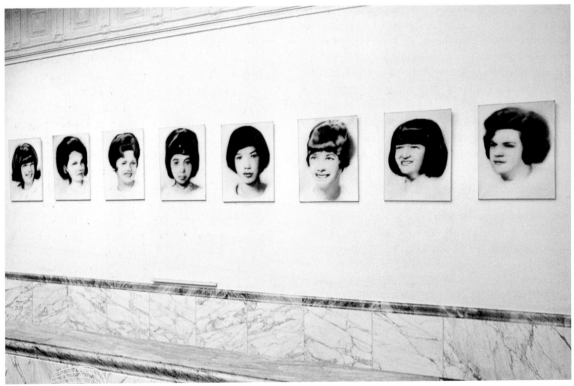

Gerhard Richter **Eight Student Nurses** 1966

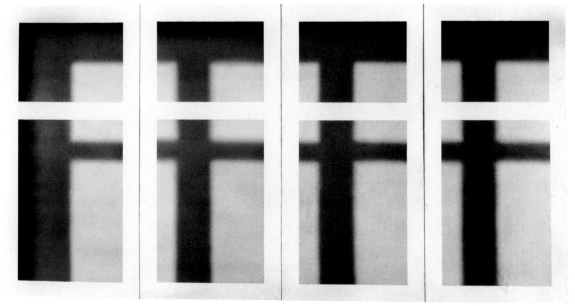

Gerhard Richter **Window** 1968

amateur images in association with the painted medium, photographic fact in Richter's production is churned by the artist to yield the ineffable fiction of painted fact.

Two major black-and-white portrait series stress how Richter's reliance on photographic models operates to reveal how the reality of the face of the canvas and the individual facial features represented on it coincide. *Eight Student Nurses* (1966), consisting of eight separate canvases of the same size, is based on a press clipping pertaining to the 1966 murder of young women in Chicago. The source material for *Forty-Eight Portraits* (1971–72), conceived for exhibition in the German Pavilion of the 36th Venice Biennale, was extracted from an encyclopedia illustrating influential figures of the modern era. Richter's selection includes authors, thinkers, scientists, and musicians such as Franz Kafka, William James, Albert Einstein, and Igor Stravinsky. Both portrait series communicate the likeness of each visage without fostering any further distinctions between one person and another. Characteristics determined by facial features or hairstyles emerge as a matter of differentiation in surface patterning, bereft of marks expressing inner life or character. Portraits without 'depth,' these separate, but complementary, series relinquish any reference to the personal adversity or individual accomplishment of their respective 'sitters.'

In favor of conveying the facture of painting alone, both submit their respective subjects to the unifying agency of the paint brush. Neither series – the one of women, the other of men – singles out one figure over another according to gender or purposes of social commentary.

A series of Windows from 1968 – which issued from a series of Curtains begun in 1964 – were given a photographic look without being based on actual photographic models. In *Window* (1968), for example, a grid of hard-edged white mullions is echoed by a grid of soft-focus grey shadows 'behind' it. While it depicts an architectural division between interior and exterior, Richter's window does not represent anything in front of or beyond itself. The implied space between the grid of the mullions and the grid of their shadows, moreover, alludes to the photographic without engendering illusion. Although the mullions look as if they were on top of the shadows, perspectival depth is evoked, but not invoked. The window is pictured as an opaque object that, merged with the canvas, is not transparent.

Richter's multiple variations on the theme of painting manifest the idea that existing reality and painted reality are not mutually interchangeable. By 1968 he was already in the midst of analyzing the nature of painting in this regard. Although continuing to use found photographs, he also began to use his own as a source of

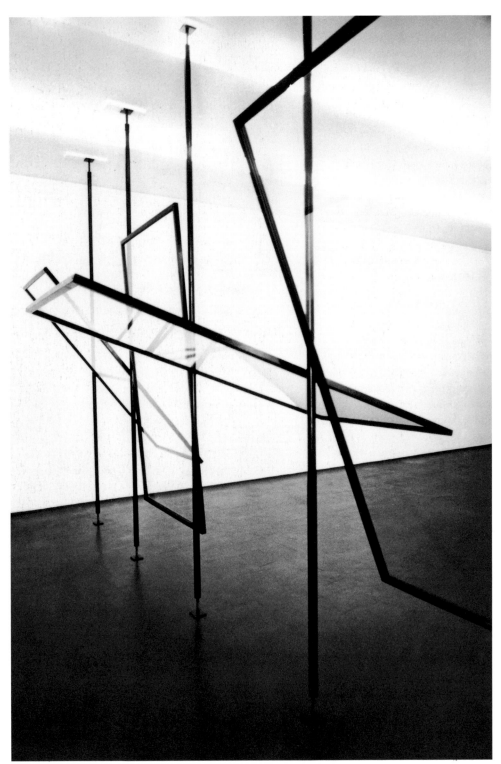

Gerhard Richter | **Four Panes of Glass** | 1967

imagery and, additionally, to produce works possessing no specific photographic reference points at all.

Avoiding the term 'painting' when he does not wish to confuse subject matter with the matter of painting, Richter has labored to uphold his belief that 'a picture shows nothing, just a picture.'[33] In order to free painting from a false dependence on reality in all of its elusiveness and, by extension, from recourse to prior solutions to painting, he constantly has devised methods for ruling out subjectivity, having stated:

> I want to understand what is… I want to avoid all aesthetics, in order not to have obstacles in my way and not to have the problem of people saying: 'Well, this is how he sees the world. This is an interpretation.' … I refuse to see the world in a personal way… and the way of painting is irrelevant.[34]

Four Panes of Glass (1967), a row of four panes of transparent glass in black metallic frames hinged together and supported by floor-to-ceiling black metal rods, offers an 'object lesson' about painting. The glass rectangles swing up and down without changing the viewer's perspective on the surrounding environment. In Richter's words, they allow one to 'see everything and grasp nothing.'[35] *Four Panes of Glass* interjects itself into Richter's production to set forth an essential paradoxical truth pertaining to painted representation. The work's transparent, framed elements are filled by surrounding reality yet remain empty, whereas a non-transparent canvas is never void, no matter what painted reality appears on its surface.

Landscape painting has occupied Richter intermittently since 1968 and his subjects, based on photographs, include mountain ranges, city-, cloud- and seascapes, and, more recently, rural architecture such as churches and barns. The terrain of the distant peaks of *Himalaya* (1968) or the buildings of *Townscape Madrid* (1968), for instance, originally recorded by aerial photographs, dissolve into fluid areas of paint. Evidence of brushwork overrides the crispness of views taken with a telephoto lens to bring the image in line with the proximity of the canvas surface.

In landscapes where the materiality and texture of paint has been suppressed, horizon lines stretch across the canvas to divide land or water from sky. A work such

Gerhard Richter **Townscape Madrid** 1968

Gerhard Richter **Sea Piece (Wave)** 1969

as *Clouds (Window)* (1970) treats the sky as if it were a template of nature to be understood in terms of its representational presence in the culture rather than as an instance of directly studied phenomena. This painting does not involve the attempt to precisely register fleeting effects of nature, as might a nineteenth-century work by Claude Monet (1840–1926), any more than it seeks to reveal nature as an awesome, larger-than-life force, in the manner of German Romantics such as Caspar David

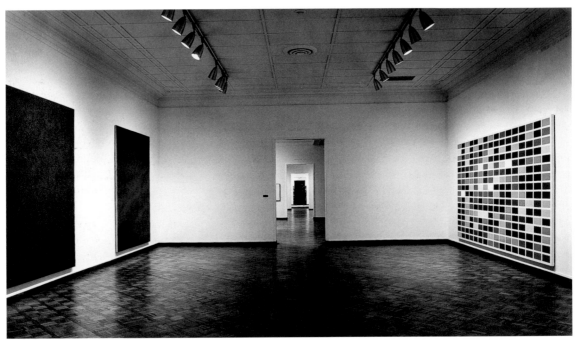

Gerhard Richter **Grey** and **256 Colors** 1973; 1973; 1974 (installation at The Art Institute of Chicago, 1977)

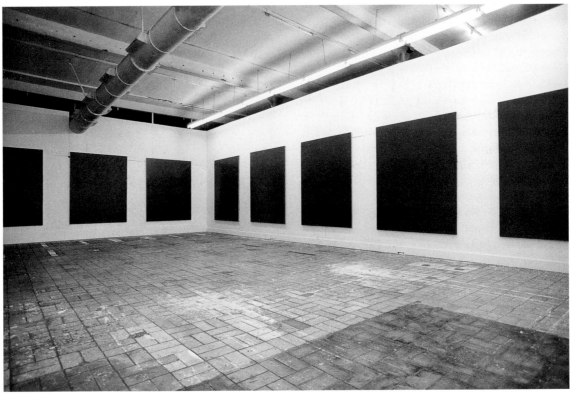

Gerhard Richter **Grey** 1975

Friedrich (1774–1840).[36] The painting's billowing clouds simply provide the information that a section of sky has been allocated to and framed within the context of painted representation.

Since the latter half of the 1960s, Richter has dealt with abstraction in diverse and opposing ways, similarly pursuing methods to bar secondary meaning from the direct apprehension of painting *qua* painting. Whereas his Color Charts of 1966, 1973, and 1974 evince the infinity of chromatic possibility, the Grey Paintings (1967–76) express the uniformity of matte colorlessness. The earliest Color Charts replicate commercial paint chip charts in large scale. Richter's decision to use the color chart in the manner of a found object permitted him, somewhat paradoxically, to step aside from the color selection process as well as from the process of making an image or planning a composition. The rows of colors, proffering themselves for eventual application to an object, remain in the state in which they were found, subject to any possible ordering within a grid yet resistant to descriptive, associative, or symbolic meaning. Like actual swatches, the individual rectangles maintain their independence from one another without being subjected to representational signification. Normally an aid at the beginning of the decision-making process, the color chart in Richter's paintings serves as the work itself.

The later Color Charts consist of large-scale grids of differently colored rectangles selected and positioned according to chance procedures, or mixed according to numbering systems that involved primary colors plus grey.[37] By following such systems to their conclusion, Richter could have generated countless permutations of colors so that it 'would have taken over 400 billion years to finish all the canvases.'[38]

The Grey Paintings, like the Color Charts, block out interference from figuration, composition, line, shape, and gestural paint application. Richter has written in this connection:

> Grey. Grey just has a clear-cut character, it does not unleash emotions or associations, grey is neither visible nor invisible… And it is better than any other colour for clarifying 'nothingness.'[39]

Possessing the same tone of grey throughout, the Grey Paintings exhibit evenly textured surfaces. Like the

Gerhard Richter **Annunciation after Titian** 1973

individually colored rectangles held together in a grid that define the Color Charts, the imageless Grey Paintings can be described only as quintessential grisailles.

Richter began his series of Abstract Paintings in 1976. He had painted non-figurative pictures as early as 1968, including a series of Color Streaks that evolved from smearing paint on canvas without reference to a model, in the manner of children's finger painting. As in the case of the Color Charts and the Grey Paintings, the Color Streaks refer only to their own defining characteristics. The later Abstract Paintings investigate the means and meaning of painting even more extensively. Until 1980, works in this series were based on photographs taken of smaller sketches and enlarged as images for depiction. The intermediary photograph insured the impersonality of paint application, inasmuch as brushwork – which, in this case, is both the work's image and its subject – serves virtually as a reproduction of itself.[40] Copies that are one step removed from the original painted surface and are painted originals simultaneously, the Abstract Paintings represent themselves.

Wiping out the distinction between figuration and abstraction, Richter's paintings do not directly comment on society but by their own example call for unrestricted possibilities for transformation. A series of five paintings, each entitled *Annunciation after Titian* (1973) and based on a postcard of Titian's *Annunciation* (c. 1545) in Venice, are not replicas or copies but originals existing in their own historical time. The angel Gabriel and the Virgin Mary disappear into amorphous swirls of brushwork in all but the first version, where they remain legible. A vision of paint replaces narrative iconography, which in Titian's picture centers on the Virgin's vision of the

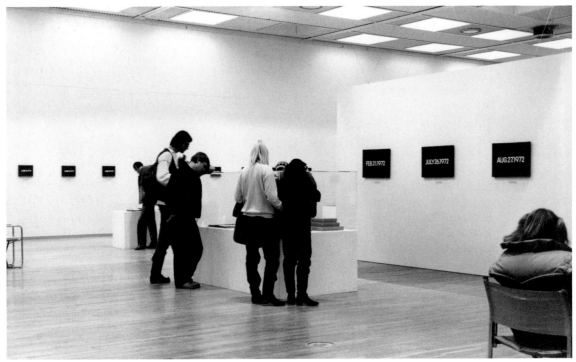

On Kawara **Installation at the Moderna Museet, Stockholm** 1980

messenger sent by God to announce the birth of Christ.
The treatment of the Annunciation by Richter, based on
Titian's sixteenth-century conceptualization of the event
but obliterating his narrative figuration, demonstrates
how painting ultimately is the non-verbal enunciation of
the primacy of the painted image.

In contrast to the other works that form part of On
Kawara's total oeuvre, his *'TODAY'* *Series*, inaugurated
on 4 January 1966, takes the form of traditional painting
by preserving the convention of the rectilinear canvas,
but redefines it with respect to representational imagery.
Whereas paintings by Richter are greatly diversified in
their subject matter but thematically unvarying in their
basic intent to represent painting itself, the individual
date paintings of the *'TODAY'* *Series* are ostensibly,
yet never, the same. Comprised of individual date
paintings, the artist considers the series to be a single,
ongoing work that will be completed at the end of his
lifetime. Sometimes exhibited together around a
particular theme or time span – for example, as one
year's production – the date paintings have entered
public and private collections either singly, in pairs,
or in groups.

Separate paintings belonging to the *'TODAY'* *Series*
represent, in the form of a date, the month, day, and year
each was made. Letters, numerals, and punctuation
marks, scaled to the size of the canvas, are placed
laterally across its center. Although they give the
impression of having been stenciled, the letters of the
month, rendered in capitals and abbreviated when
necessary, along with the numbers for the day and year,
are in fact skillfully drawn by hand in white upon a dark
background. Typeface subtly varies from one painting
to the next and is not determined by an objectively
definable rationale or system. The backgrounds of the
earliest works in the series are cerulean blue or red; later
ones tend to gravitate toward dark grey-browns, grey-
greens, or blues that verge on, but are not, black. Kawara
applies four or five layers of paint to the background of
each canvas and uses an additional six or seven layers of
paint for the date. He obtains a rich matte surface but
effaces all traces of brushwork. Always horizontal in
format, date paintings may be one of eight
predetermined sizes, from the smallest, which measures
8 by 10 inches, to the largest at 61 by 89 inches. Aside
from the fact that a work must be started and completed

on the actual day of its date, the artist has never adopted a systematic procedure of production. When they are small, as many as three paintings may be created in a day; on other days, none may be painted.

The significance of these paintings lies in the fact that they depict not only a date, but also their *own* date. If, historically, paintings have been fixed in time by a date on the front or back of the canvas, the date becomes the subject of the painting and the sole embodiment of the work's figurative imagery. Each painting is unique by virtue of its particular date, since no combination of numbers and letters is ever repeated. Letters and numbers, perceived as independent forms, allow an otherwise immaterial date to assume material form. The date paintings thus succeed in turning abstract, temporal measurement into the concrete reality of painting.

Because of its thematic involvement with temporality, the *'TODAY' Series* shares an affinity with the much earlier, nineteenth-century serial paintings of Claude Monet – to the fifteen Haystacks of 1890–91, for example. By working in series, Monet sought to capture the infinite, fleeting qualities of observed reality engendered by ceaseless but momentary shifts in light – and, by extension, the passage of time – within the static format of multiple canvases. Not concerned with the specific effects of changing light as Monet was, Kawara depicts the notion of time itself.

The paintings of Kawara may also be compared with the Number and Alphabet paintings of the mid- to late 1950s by Jasper Johns, for whom, as for Kawara, the numeral or letter offered an already flat, abstract form as a subject for delineation. In the work of both artists, these symbols are visually self-sufficient, but in John's work, numbers or letters are synthesized with the materiality of paint and brushwork. Having subjected pre-existing symbols of quantification and language to the demands of painterliness, Johns strips them of their communicative necessity. If numbers and letters used as formal images primarily play a painterly role in paintings by Johns, in Kawara's they serve a formal and informational purpose.

Works in the *'TODAY' Series* steer clear of illusion in that the letters and numbers of the day's date replace traditional imagery and composition. The necessary configuration of abstract symbols engenders 'figuration,' while the former conventions of composition yield to the

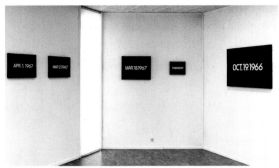

On Kawara | **Installation at the Van Abbemuseum, Eindhoven** | 1981

Claude Monet | **Haystacks** | 1890–1 (installation at The Art Institute of Chicago, 1984–5)

Jasper Johns | **0–9** | 1959

On Kawara | **Oct. 31, 1978, 'TODAY' Series: 'Tuesday'** (detail) | 1978

demands of 'composing' the date. The designating elements of each date serve as the curvilinear and linear parts of a coherent visual whole. In the sense that one can only represent, but not see, a date, Kawara's paintings do not supply information about their relationship to external reality. Within the confines of the painted canvas, however, the written date itself – otherwise a mere abstraction – takes a painted form. The *'TODAY' Series* thus demonstrates how a painting can be self-reflexive and non-illusionistic yet still connected with external points of reference. Each date painting thus asserts that *it* is 'present,' although its date, perforce, refers to a time already past.

The solid background hue of each date painting varies slightly from painting to painting with no claim being made for color in either a positive or negative way. The artist neither attempts to suppress color nor does he espouse a belief in its power to surpass mundane reality as did, say, Yves Klein. The white lettering and colored background of his paintings allude to the contrast between the light of day and the dark of night.[41] Although color lends definition to objects and has the propensity for symbolic or emotional overtone, in Kawara's work it evades any and all equation beyond its own definition in terms of saturation, value or hue. Within its painted context, the color of each work is as unequivocal as its date. Whether a date painting is bright red or dark blue or one of many dark greys makes no thematic difference except for the fact of difference itself.

Kawara establishes an endless potential for nuance by defining color choice in terms only of light and dark. The countless possibilities of background color gradation paradoxically nullify subjectivity since unlimited shades of difference lose explicit meaning. Subjectivity and objectivity of selection cancel each other out insofar as subtle differentiation leads to the appearance of sameness while simultaneously disproving it. Since pigmentation instates itself as a given element of perception that 'colors' whatever is seen in an inexplicable but multifaceted manner, the color of each date painting, like its date, may elicit certain thoughts but remains a quality unto itself without a precise referential or verbal parallel. The degree to which physiological and psychological factors play a part in human vision thus enhances the dual sense of factual immediacy and impenetrable mystery manifested by these works.

Kawara's date paintings, with their numerical and linguistic elements, represent diurnal repetition, change, and continuity. Each work possesses a subtitle and also is accompanied by a hand-made cardboard box that contains a newspaper of that day from the city where the work was painted; in some cases, a portion of a newspaper page is glued to the inside lid of the box. The subtitles range in content from long quotes to short phrases, from a notation of a personal thought to an international event.[42] In more recent years, they merely have stated the day of the week. The box affirms the painting's definition as an object, while the subtitles and newspaper anchor the work of art to, and juxtapose it with, daily reality.

The inclusion of a newspaper or newspaper fragment in the painting's box accentuates the dichotomy between art and everyday actuality and simultaneously links them. The fact that the boxed newspaper may or may not be exhibited with its painting emphasizes the independence and interdependence of the two. Since the early part of the twentieth century when Georges Braque (1882–1963) and Pablo Picasso (1881–1973) introduced newsprint into their *papiers collés*, the daily newspaper has acted as a representative of the non-art, material world, as distinct from the fictional world of a painted canvas or drawing. In *Bottle of Vieux Marc, Glass, Newspaper* (1913) Picasso truncated the word 'Journal' (newspaper) to produce 'Jour' (day), perhaps as a joke within the work since the penciled bottle of marc is 'vieux' (old), while the newsprint pertains to that day. Differently from Cubist collage, which integrates newspaper fragments into an overall pictorial fabric(ation), Kawara's works deliberately keep the newspaper and painting separate. Metaphorically drawing a distinct line between the reality of art and non-art, he nonetheless refers to their incontrovertible, if intangible, connection. Painting and newspaper are thus cross-referenced by Kawara without being literally glued together.

The newspaper accompanying the date paintings grounds them in the world of constant flux and continuing events (as opposed to the supposed 'timeless' context of art). In this regard, one is reminded of Warhol's paintings of the early 1960s that depict front-page headlines from tabloids such as the *New York Mirror*. In Warhol's work, the newspaper provides already existing, mass-produced, gripping, non-art imagery deployed for shock value. In relation to the date

Pablo Picasso **Bottle of Vieux Marc, Glass, Newspaper** 1913

Andy Warhol **129 Die in Jet (Plane Crash)** 1962

paintings, the newspaper serves as a temporal gauge of ongoing, *daily* reality outside of any pictorial translation. Based on real, day-to-day occurrences, it substitutes for the artist's handwritten signature as a kind of 'authoritative' document of authenticity. Content of a sensational or emotional nature is, moreover, kept in check rather than spilling over into painting.

Transitional works by Kawara from the early 1960s prefigure the *'TODAY' Series*. *Nothing, Something, Everything* (1963), in which black Letraset capital letters form the word 'SOMETHING,' is one of hundreds of drawings. A pencil line encloses the letters within a rectangular perimeter that follows the shape of the paper so that 'something' is singled out, isolated, aggrandized. As the subject of pictorial representation, it stands alone and demands consideration as to exactly what it might stand for, whether a quantity or an object. Presented out of context and therefore providing no supporting verbal information, the letters assume a visual form as they do in the date paintings. Set within the outline of the traditional rectangular format, they come to be 'read' as shapes. As both a two-dimensional object and an abstract signifier, the word is both subject and image. As the drawing's title suggests, moreover, 'nothing' and 'everything' are 'something'.

Two paintings from 1965 are the direct antecedents of the date paintings. *Title* (1965), is a large tripartite work. The words on each of three individual canvases respectively read: 'ONE THING – 1965 – VIET-NAM.' Lettered in white on a magenta background, the work refers both to itself as an object (one thing) as well as to where it is located in time (1965), place and history (Vietnam). With minimal means it implies a maximum of external points of reference, the political not excluded, while remaining self-referential. *Location* (1965; ill. p. 6) refers to one of a number of geographical coordinates in oceans and deserts around the globe that Kawara initially had planned to represent in a series of paintings, but turned his attention instead to the date paintings. Two lines of large white letters and numerals on a dark grey background specify a place somewhere in the Sahara Desert by stating: 'LAT. 31°25' N' above and 'LONG. 8°41' E' below. Although the painted canvas pertains to a geographical place rather than to a point in time, *Location* depends, like the date paintings, on language and numbers to extend representational meaning beyond the canvas.

Another key work of the same year, *Code* (1965), achieves the same literal and factual quality as the date paintings. A work on sheets of writing paper, *Code* consists of interconnected, colored markings in horizontal lines that look like a generic, though unknown, script. Only the artist knows the code by which he translated into color and form passages from a manual on how to write love letters. The question as to what constitutes meaning – the verbal, the visual or both – underlies Kawara's *Code*, inasmuch as color symbols, signaling art, have been substituted for linguistic symbols, signaling language. The work implies that the visual and verbal are mutually involved in concealing/revealing one another, while language may be seen as the key to an oeuvre that mediates between abstract signification and the non-illusionistic presence of painting.

Through different categories of work realized between the mid-1960s and mid-1970s, the German artist Blinky Palermo called into question the rectilinear planarity of painting's traditional framed support retained by Richter and Kawara.[43] Works classified as Objects date to 1964; the first Stoffbild, or 'fabric painting,' was made in the latter half of 1966; and at the end of 1968 Palermo began his Wall Drawings and Paintings. He continued to create Stoffbilder until 1972 and Objects until 1974, and exhibited a work that was more installation than painting at the Venice Biennale of 1976.

One of Palermo's earliest Objects, *Totes Schwein* (Dead Pig, 1965) augurs the direction his work would take – a direction away from the intermediary canvas support toward an alliance with architecture. A pig, hanging head down, is pictured on a canvas topped by an irregular piece of wooden board. The outline of the pig stops short of the wood where it merges with a triangular form delineated on the board. The juxtaposition of painted canvas with found object and the conjunction of real and abstract form prefigures the full flowering of Palermo's reassessment of painted form. After 1965, Palermo removed the restrictions of two-dimensionality, in some cases, or of rectilinearity, in others, as conditions for his painting. In this way, form would come to have an existence in and of itself and be freed from dependence on a separately delimited background.

Following the implications of *Totes Schwein*, ensuing Objects overtly circumvent the traditional rectangular

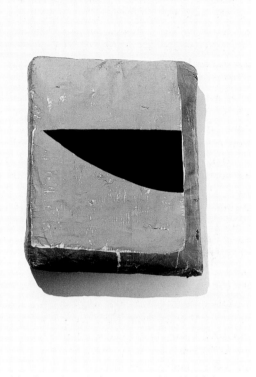

Blinky Palermo **Totes Schwein (Dead Pig)** 1965

Blinky Palermo **Kissen mit schwarzer Form (Cushion with Black Shape)** 1967

picture format, their irregular shapes pointedly ignoring enforced rectilinearity. As its title suggests, *Kissen mit Schwarzer Form* (Cushion with Black Shape, 1967) resembles an upright cushion. Made of foam rubber covered with cloth and attached to the wall, it is painted a red-rust color on its rounded, outer edges and bright orange on its rectangular face. A curvilinear black shape cuts eccentrically through the center. Stuffed like a pillow but richly imbued with brushwork, *Kissen mit Schwarzer Form* is a three-dimensional object whose presence is painterly and tactile. The emphatic black shape on its surface, moreover, assumes an autonomy it would not possess on the surface of a flat picture plane. Thus superimposed on a protruding object, the shape's own flatness 'stands out.'

Exploring the means for presenting painting as an immediate visual reality unimpeded by illusory space, Palermo's Objects not only dispensed with rectilinearity but also reconsidered paint application. *Schmetterling* (Butterfly, 1967) is a long, narrow, vertical painting.

Palermo wrapped canvas around wood and nailed it at the back to give the work slightly rounded edges. Measuring several centimeters in depth, it flares slightly at the bottom. Its dark olive green surface, displaying minor imperfections, extends over its edges onto brightly painted orange sides that dissolve the appearance of definitive edges and give a sense that the work hovers slightly above the plane of the wall.

Palermo constructed a number of Objects in a manner that enhances the autonomy of painted shape. In the case of *Schmetterling II* (1969), a long, thin, irregular, vertical shape almost touches a decidedly irregular polygonal form placed high on the wall to its left. *Tagtraum II* (Daydream II, 1966), also a two-part work, is constructed out of a wooden 'T' and an unspecific rounded shape that, covered with beige and purple silk, is thickly painted in uneven areas of white, violet, black, and orange. Instead of *containing* the form on a two-dimensional surface within a rectangle, Palermo outlined

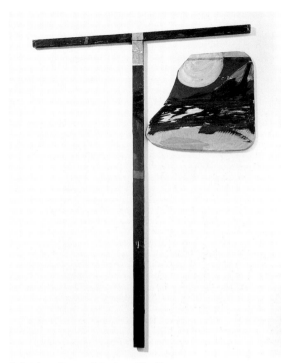

Blinky Palermo **Tagtraum II (Daydream II)** 1966

the entire painting/object so that it would function indiscriminately as both a form and a support.

While he was working on the Objects, Palermo embarked on the Stoffbilder, which he fabricated, quite literally, from bolts of cloth purchased from department stores in the desired colors. Unlike the Objects, the Stoffbilder not only have pristine surfaces, but are rectangular and two-dimensional rather than irregularly shaped. Fabric, attached tautly to a stretcher, creates smooth, rectangular planes of color one above the other. With the exception of early or experimental pieces of satin or silk, and also with the exception of white fabrics such as muslin or linen, the Stoffbilder are made with matte cotton yardage whose surface texture and weave do not distract from the direct perception of the abutted areas of two or three separate color areas that are neatly stitched (almost seamlessly) together. The standard available width of fabric determined the maximum possible dimensions of the colored rectangles, which the artist matched and scaled intuitively.

The broad bands of cotton yardage of the Stoffbilder are perceived as unobstructed fields of solid color. Commercially available fabric stands in for oil or acrylic on canvas so that expanses of dyed cotton fabric, substituting for a painted ground, fuse color, form, and surface support into a single presentational unity. Released from identification with any external referent, color in the Stoffbilder, like form in the Objects, is not subordinate to rectilinearity and announces the reality of its canvas field.

Wall Drawings and Paintings by Palermo, manifesting radical, yet logical, extension of the ideas underlying the Objects and the Stoffbilder, dispensed with the intermediary support of a canvas and allied themselves with their architectural support. They were executed in connection with temporary exhibitions or, occasionally, for a private home. More than twenty projects realized in the years between 1968 and 1973 have been recorded by sketches and photographic documentation compiled by the artist. Affiliated with their place of installation and/or made for temporary exhibitions, wall works are no longer extant.

For an exhibition which opened in December 1968, Palermo used the three rooms of the Heiner Friedrich Gallery, Munich to draw a series of 'open,' 'closed', and 'divided' linear and geometric forms. He drew directly on the gallery's walls with a reddish-brown oil crayon, creating outlined forms by abstracting the linear elements based on the figure '5.' The layout of the three rooms of the gallery determined the location of the linear shapes. Each of these configurations uniformly measured two by one meter high and one meter in width, except for a square measuring a meter on its sides. The forms, spaced one meter apart, continued around the room but allowed for the interruption of a doorway and windows.

The Wall Drawings and Paintings were conceived in several different ways. Drawings made for the Galerie Ernst, Hanover, in 1969; the Lisson Gallery, London, in 1970; the Atelier, Mönchengladbach, in 1970–71; and for the house of Franz Dahlem in Darmstadt in 1971, followed the stipulations set down in Palermo's proposal to the Lisson Gallery:

> A white wall with a door at any place surrounded by a white line of a hand's breadth. The wall must have right angles. The definite form of the line is directed to the form of the wall.

In each instance the formerly blank wall areas acquired independent form.

Blinky Palermo | **Stoffbild, rosa-orange-schwarz (Fabric Painting, pink-orange-black)** | 1968

Blinky Palermo **Treppenhaus I (Staircase I)** 1970

Palermo employed the same principle when he painted the symmetrical interior of the Friedrich Gallery in 1971 by following the outline of its wall elevations. One wall was painted white, outlined by a strip the width of a hand in ochre, while the other, in reverse, was painted ochre and outlined in white. The surface of the wall clearly functioned as the support for the painting since the white/ochre outlines took their shape from – and gave shape to – their architectural setting.

If form coincided with the walls of an existing structure in certain works, in others, Palermo transposed the formal properties of an architectural element existing elsewhere onto the wall of an exhibition space. *Treppenhaus I* (Staircase I, 1970), the projection of a staircase profile, was painted in grey in the Konrad Fischer Gallery, Düsseldorf. The surface of the wall, in this way, became the supporting ground for an abstract shape derived from the actuality of architecture. Using the same strategy, Palermo produced two wall paintings, *Fenster I* (Window I, 1970) and *Fenster II* (1971). For the first, he copied the structural outline of the mullions from the glass entranceway to the Kabinett für Aktuelle Kunst, Bremerhaven and reproduced this shape on the surface of the wall inside. In the second instance, a dark grey abstract form, painted by the artist in the underground passageway of the Munich Maximilian--strasse, similarly duplicated the formal properties of adjacent window mullions.

On other occasions, Palermo created works on the spot. *Treppenhaus II* (1971) demarcated with grey paint the area between the hand railing and the steps of a staircase in the Frankfurter Kunstverein. His painting in/of the space of the first-floor landing of the staircase of the Museum Friedricianum with *Bleimennige*, a deep

orange, rust-preventative undercoating, for the 1972 'Documenta V' exhibition in Kassel, yielded a different visual result. The emphatic orange color set off the towering stair landing and defined it as an over-life-sized rectangle that, when viewed from various vantage points, took the form of an irregular polygon. By covering an existing area of the given architecture with paint, Palermo 'uncovered' a pre-existing form rather than arbitrarily inventing one.

Palermo often took advantage of the full context of a space. In the large exhibition room of the Baden-Baden Kunsthalle in 1970, he painted a thin encircling blue stripe beneath an ornate molding on the wall just below the ceiling. He thereby ringed the entire space of the room by means of a painted band. The same year, at the Edinburgh College of Art, he utilized the space above a perfectly square staircase by painting its four sides respectively red, yellow, blue, and white. Here again, form evolved out of, and in response to, the dictates of architecture.

The dialogue between space and form also took place in three dimensions. At the Galerie Ernst, Hanover in 1969, Palermo stretched two orange-yellow bands of linen on the side of the room between the junction of wall and ceiling, and, diagonally, on the other side, between wall and floor. The two-dimensional cross-section of the three-dimensional interior assumed an irregular polygonal shape and defined the entire room as an object. In 1973, for the realization of one of his last wall paintings, Palermo painted the free-standing wall partitions of the Hamburger Kunstverein with red oxide. The exhibition caused a public outcry and closed after one week, since the idea of treating the wall area as the background for (a) painting was not understood. Nor was the fact that Palermo had succeeded in transforming the interior walls of the space into a full-scale, room-sized work that functioned simultaneously as painting, sculpture, and architectural environment.

In a single instance, in 1970, Palermo inserted blue isosceles triangles, each measuring 9 by 18 inches, into the exhibition space of the Palais des Beaux-Arts, Brussels. He centered the modestly-scaled triangles in a row running around the four walls of the room. Bearing no reference to a previously existing architectural element but placed at regular intervals around the room, they united architectural space and geometric form.

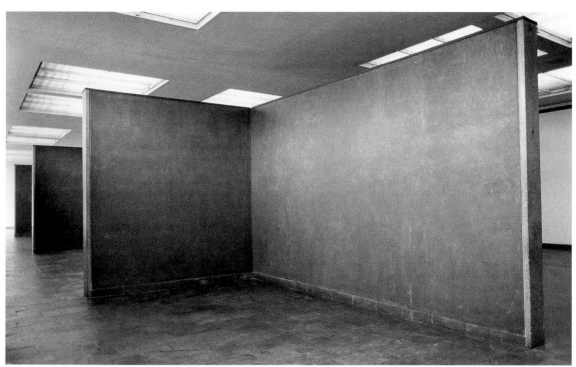

Blinky Palermo **Wall Drawing and Painting, Kunstverein, Hamburg** 1973

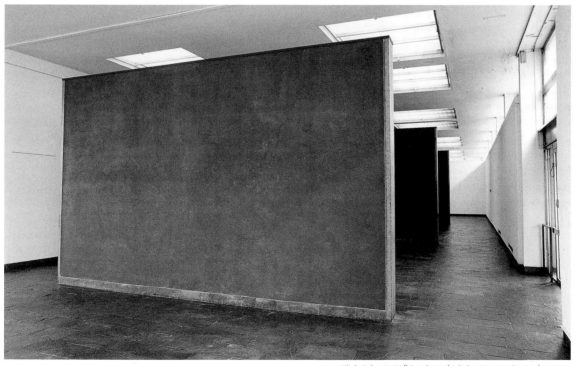

Blinky Palermo **Wall Drawing and Painting, Kunstverein, Hamburg** 1973

Giulio Paolini | **Disegno Geometrico** | 1960

For Giulio Paolini, painting is not about surface as an image of painterly application as for Ryman, nor about the labor indicated by the brushmark as for Toroni, nor about the re-evaluation of form as it is for Palermo. Instead, Paolini's major concern has been to engage painting as a vehicle for the contemplation of its own condition. To this end, he has made the material, authorial, contextual, and historical prerequisites of painting the principal theme of his work. His painting comments on itself as a convention and on the factors that enable it to materialize as art within the parameters of this convention.

Early in the 1960s, Paolini formulated his approach to the fundamental practice of creating an image on the canvas surface. His first paintings exhibit within their own frame the preliminary methods or particular materials that precede the traditional construction of a finished image. *Disegno Geometrico* (1960), a tempera on canvas, turns the initial preparation, associated with the composing of an image, into the image itself. Bisecting diagonal lines,

drawn in ink from the four corners of the picture plane, and bisecting vertical and horizontal lines from all four canvas edges, meet in the center of the rectangle. This work resulted from 'the decision to copy onto canvas, in the correct proportion, the preliminary design of *any* design, that is, the geometric squaring off of the surface.'[44]

Paolini further explained that he 'was trying to free the picture from its function as a vehicle for images' insofar as 'the picture is none other than the very elements which go to make it up.'[45] *Untitled* (1961) displays an actual paint can behind a sheet of transparent plastic stretched on a supporting wooden frame. The can of paint is, therefore, not a representation *on* a canvas surface, but a presentation of an object containing the material – paint – necessary to produce an image. As a substitute for the usually opaque canvas surface, the transparent plastic allows the viewing of something real in lieu of a fiction.

At the Galleria La Salita, Rome in 1964, Paolini took another step toward freeing his painting from being a

receptacle for illusionistic imagery and toward revealing aspects of the work's support. For this exhibition, he hung a group of imageless, plywood panels in the gallery while setting others against its walls. By withholding depiction of imagery, the 'panel paintings' called attention to the walls on which they were hung as well as to the surrounding space on which they depended.

Although it reintroduced an image, *174* (1965, see ill. p. 36) deliberately forfeited overt acknowledgment of original authorial invention. This work enlarges page 174 from a book entitled *Capire l'Arte Moderna* (How to Understand Modern Art). The contents of the page supply the painting with its compositional content and imagery: a chart of twentieth-century art movements and dates in the form of a centralized, linear diagram. Terms for specific movements such as Dada, Surrealism, or Abstract Expressionism accompany parallel lines of varying length that designate time periods between 1900 and 1970. The painting may thus be described as a literal delineation of an outline of historical time frames assigned to developments in art. Because of its direct appropriation of an already existing art-related, yet non-art, image, the work portrays the awareness of its own position within history.

From the mid-1960s on, paintings by Paolini have proposed an aesthetic agenda in which the canvas surface provides a forum for painting to examine itself in terms of its existence as an image-bearing, rectangular object that, having issued from the mind of a creator, takes its place in the historical continuum on the walls of exhibition spaces. Aiming to give credence to the authorial role of the artist while declaring that his work is not about the artist's own subjectivity, Paolini demonstrates how he is a part of the process of implementation – a mere conduit for engendering representation.

In a work such as *Delfo* (1965) the artist 'figures' as an image within the painting. By introducing his image into the work, Paolini paradoxically removes himself as a subjective (and normally unseen) presence from it. He thereby illustrates the distinction between an artist's individual persona and the role the artist plays in the creation of a work. Represented by a life-sized photographic reproduction, Paolini, wearing sunglasses as if to hide his identity, appears behind stretcher bars with his arms folded, feet apart. His visage is covered by the vertical stretcher bar so that portraiture is indicated

Giulio Paolini **Senza Titolo (Untitled)** 1962

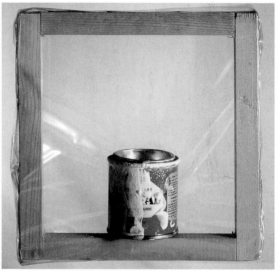

Giulio Paolini **Senza Titolo (Untitled)** 1961

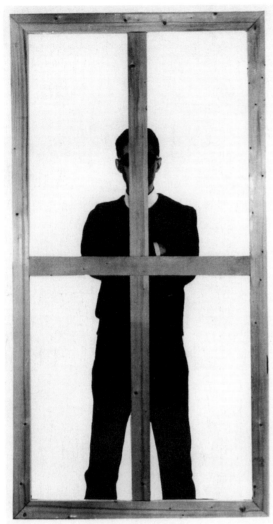

Giulio Paolini | **Delfo** 1965

on the one hand, while being virtually ruled out on the other. The photographic image of the artist indicates the fact of authorship at the same time that the stretcher bar, the basic element of the canvas support, superimposes itself on the artist's features. Specifically, the stretcher bar does not permit a view beyond or behind the pictorial image that here excludes its own author, whose guarded inclusion suggests that the work's creator has been subordinated to his own creation.[46] Or, as Paolini has put it, the author, who is essentially just another spectator, simply 'intervenes to unmask [the work],' and functions as 'someone who raises the curtain on a scene which awaits revelation.'[47]

Subsequent works by Paolini expand upon his search for ways to have painting speak for and about itself and for images to reflect on being images. Through the use of photography as a means of duplication, given the camera's ability to 'take' a picture, he has created a variety of works that embody within his paintings the images of Old Masters. *Giovane che guarda Lorenzo Lotto* (Young Man Looking at Lorenzo Lotto, 1967), turns the act of viewing painting upon itself by reproducing to scale in black and white a portrait of a youth by the sixteenth-century Italian artist Lorenzo Lotto (1480?–1556). Because the frontality of the youth's face, which is a two-dimensional photographic reproduction, merges with the frontality of the canvas, the face-as-portrait casts its glance toward an implied spectator. The painting, in reverse, looks inward to address its own presence as an independent, rectangular object.

The photographic re-creation of historical paintings, or details from them, has enabled Paolini to make a case for his works as already existing images rather than as newly invented ones. Identifying himself with authors belonging to much earlier historical periods, the artist hides his identity in order to suppress evidence of his authorial in(ter)vention and to detach the painted image from associations outside its own history. *L'Ultimo quadro di Velázquez* (The Last Painting of Velázquez, 1968), enlarges a telling detail from *Las Meninas* (The Maids of Honour, 1656), by Diego Velázquez (1599–1660): the faint heads of the observers who are the artist himself and a woman, both of whom are outside the picture being painted (by Velázquez), but whom Velázquez has represented as reflections in the mirror. As the only figures in Paolini's painting, they are no longer painted reflections, since Paolini has wrested

them from the context of the Velázquez. In isolation and fading into the canvas weave, the two personages appear in Paolini's painting like ghosts from earlier modes of painted illusion and as haunting presences that are confined to the physical reality of their flat, painted surface.

In the years following 1968, Paolini broadened his inquiry into painting, continuing to present the painted surface as a forum for self-investigative debate. *2121969* (1968-69), a photographic work on canvas whose title specifies the date as 12 February, 1969 – the opening day of the exhibition of the painting – represents an image of the gallery interior where the painting was shown. The painting's place of exhibition, in this case, supplied the painting's image. A slightly later work, *Quattro Immagini Uguali* (Four Equal Images, 1969), reinforces the idea that the thematic content of Paolini's painting revolves around the desire to exhibit painting as a factual, material entity rather than as an image of something other than itself. Four identical square canvases placed on four separate walls of a rectangular room might, as it appears, have originated one from the other. A small square drawn on canvas occupies the center of each of the four paintings, while half of a square, in line with the central square, is cut off by the canvas edge on either side of all four paintings. Each painting mimics both the one opposite and the one adjacent. If the four separate canvases were abutted so as to produce a row of evenly spaced, small squares across joined surfaces, an open, half square at the left and right edges of the abutted canvases would nonetheless remain. They signal the possibility of an open-ended image that could generate itself indefinitely, as if of its own accord without an author.

Paolini's *Apoteosi di Omero* (Apotheosis of Homer, 1970–71) is an homage to authorship in general as opposed to a paean to any one individual. It is an installation consisting of thirty-three music stands, each presenting a photograph of a living actor except for one with text. Modeled in concept on the nineteenth-century painting *Apotheosis of Homer* (1827) by J. A. D. Ingres (1780–1867), the photographed actors represent historical figures including Socrates and Jesus Christ as well as the French Symbolist poet Arthur Rimbaud and Queen Elizabeth I, for example. A key that identifies actor with personage is shown on one of the music stands. Like the figures in Ingres's painting whose names belong to history, all have had a major impact on

Giulio Paolini **Young Man Looking at Lorenzo Lotto** 1967

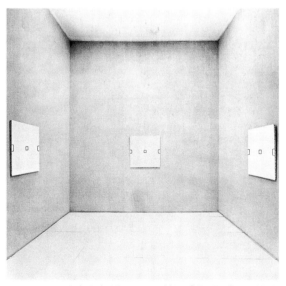

Giulio Paolini **Quattro Immagini Uguali (Four Equal Images)** 1969

Giulio Paolini | **Apoteosi di Omero (Apotheosis of Homer)** | 1970–71

their culture. Paolini's actors pay homage to Homer as an 'emblem of classical inspiration,' according to the artist, who further has noted that the 'spectator can feel himself reflected in each of the actors, and thus in each of the historical characters....'[48] The viewer is given the chance to assume the role of one or many characters through identification with the actors. The artist himself, however, in an act of self-banishment, has vanished from the scene for which he is the impresario. After having set the stage for ushering in a panoply of historical figures, he leaves behind clues concerning the work of art's greater historical context.

Works by Paolini from the mid- and late 1970s reinforce his essential concern with promoting the reality of a painting over its traditional role as a conveyor of illusionistic images, or as a sign of an authorial presence. *Chimera II* (1975), comparable with Roy Lichtenstein's Stretcher Bar series (1968), displays two blank canvases that are set within the surrounds of twin canvas versos. The two canvases are contained within an illusionistic box indicated by perspectival pencil lines drawn on the 'front' of the canvas, which displays its back. The work as a whole turns traditional perspectival illusion around in a literal manner insofar as the two, smaller frontal canvases are foregrounded on the versos of two larger joined canvases. The lines of perspective, in sum, here participate in the subject matter of the painting rather than in fostering illusion.

As a work such as *Oedipus and the Sphinx* (1976) clearly emphasizes, painting in Paolini's oeuvre affords an occasion for representing the process of questioning as part of the process of viewing. On the right-hand panel of a two-part work, Oedipus, as seen in the eponymous painting by Ingres and who has been photographically reproduced in black and white, is attentive to the riddle-asking Sphinx. On the left-hand panel of Paolini's work, a penciled outline of Ingres's painting repeats and mirrors Ingres's original image. Avoiding the creation of his own image, Paolini conveys the idea that painting functions to question itself.

The images to be found in early works by Paolini are those that address their own formation or their exhibition context. Later images take cognizance of painting's existence within an ever-widening framework of historical time. In Paolini's words, 'the image [the artist] must discover is not his own but everyone's.... Despite appearances, destiny imposes on the artist an absence from the world stage.'[49] In self-evident meditation on their place and presence within the open-ended narrative of history, the paintings of Paolini look squarely at themselves as historical objects whose flat frontality is imbued with powers of self-interrogation.

While Toroni, Richter, Kawara, and Palermo have approached their art from different perspectives, they, too, have endeavored to look at painting as a vehicle for self-criticism. Showing painting to be about its own brushwork, Toroni has broadened its background support to include the bare wall. Endowed with wide possibilities for application on any number of planar surfaces, the imprints interact with any and all aspects of an existing architectural situation. As the artist has suggested, the supporting surface is not dominated by the imprints covering it, but shares equal responsibility with them for defining the totality of the work: '*La peinture ne cachait plus le support, ce qu'elle avait toujours fait. Le support ne primait pas non plus*' (Painting does not hide its support as before, nor does the support take over).[50] By means of the evenly spaced series of uniform imprints, which he applies to prime, distinctive, or focal flat areas instead of to a framed or stretched canvas, Toroni engenders a reciprocal interchange between paint, surface, and architecture.

Richter's work delivers its message through the subtraction of narrative or expressive content, which

accentuates (the) painting as an objectified, concrete presence. Because it has the ability to remain silent without forfeiting thematic signification, 'art,' Richter believes, 'is the highest form of hope.'[51] Without questioning or seeking the overthrow of painting, he addresses the idea of ongoing evolution that – dependent on cycles of rebirth and death observed in nature and society – may be incurred by the efforts of the impartial but impassioned artist. Insofar as his oeuvre is concerned, all types of subject matter from the pastoral to the pornographic are subsumed by the painted field, wherein everything is shown to be nothing more than the reality of painted illusion.

The date paintings of Kawara rely on the components of written communication to make their particular visual statement. With their stark and striking presentation of the date on which each was created, they mark the moment of their genesis and thus demarcate their own place within the span of a lifetime and of history. If a date, on one level, is mute as a pictorial image, on another level it stands for the infinite number of events, from the most personal to the most universal, that occur on specific days. Like temporal signposts, the date paintings punctuate their environment whether they are inserted into the midst of other works of art or isolated on a wall. Telling of nothing but themselves, they direct the viewer toward a consideration of the ongoing continuum of past, present, and future.

In Palermo's Wall Drawings and Paintings, form is freed from enclosure within the boundaries of rectilinearity and/or a canvas surface. Form is contiguous instead with selected features of architectural reality, or else takes this reality directly into account. Having liberated form from participation within a greater, contrived compositional whole or from association with representational imagery, Palermo proposed alternative methods for the derivation of form and alternatives to the painted ground of painting in order to redraw the conventional line between real and painted space. The Objects imbue painted form with an independent existence in three-dimensional space. Although flat, the Stoffbilder endow the very form of painting with material actuality. Finally, the forms brought to view in the Wall Drawings and Paintings converge with the forms found in the reality that prescribed how the work 'took shape.'

The methods and goals of Toroni, Richter, Kawara, Palermo, and Paolini along with those of their approximate contemporaries such as Mangold, Baer, Marden, and Ryman, coincide with those of artists who, like Stella and Manzoni, for example, in the late 1950s, had initiated a re-examination of the fundamental principles of painting. Stella or Manzoni's desire to suppress signs of authorship – as displayed by painterly virtuosity, technical skill, or inventiveness – in favor of highlighting the self-reflective aspect of painting carried over to the work of these artists. This slightly later generation similarly rejected subjectivity, compositional invention, and referential illusion. Without forfeiting the gains of self-reflexivity, they further expanded the previous scope of painted content. Richter accomplished this, in large degree, with the aid of photography, and Kawara by his reliance on the representational capacity of language. Through direct affiliation with architecture, the work of Palermo and Toroni extended painting beyond the canvas edge, whereas the work of Paolini has taken a close look at the contextual and historical factors that give rise to a painting while making authorial subservience the main subject of his work. Commonly expressing fundamental aspects of painting's being, works by artists who elected to comply with – while broadening – its terms, set their sights on banishing illusion without losing touch with the world.

im-age (im′āj), *n.* [OF. F. *image,* < L. *imago* (*imagin-*), copy, likeness, image, semblance, apparition, conception, idea, akin to *imitari,* E. *imitate.*] A likeness or similitude of something, esp. a representation in the solid form, as a statue or effigy; also, an optical counterpart of an object as produced by reflection, refraction, etc. (see phrases below); also, form, appearance, or semblance (as, "God created man in his own *image,* in the *image* of God created he him": Gen. i. 27); also, an illusion or apparition (archaic); also, a counterpart or copy (as, the child is the *image* of its mother); also, anything considered as representing something else; a symbol or emblem; also, a type or embodiment (as, "An awful *image* of calm power . . . now thou sittest": Shelley's "Prometheus Unbound," i. 296); also, a mental picture or representation, as formed by the memory or imagination; an idea or conception; also, a description of something in speech or writing; in *rhet.,* a figure of speech, esp. a metaphor or a simile. **—real image.**

Joseph Kosuth **Titled (Art as Idea as Idea): 'image'** 1966

[Two]
Medium as Message/Message as Medium

Representations of language are by no means foreign to the visual arts. Only since the second half of the 1960s, however, has language been defined as a medium for independent use in place of materials such as paint, watercolor, charcoal, clay, stone, or bronze. Predicting developments whose full effect would be felt in the latter half of the 1960s, Clement Greenberg called in the early 1960s for stringent adherence to media compliant with the norms of painting and sculpture. He postulated that, in order to accomplish its main 'task of self-criticism,' and to 'find the guarantee of its standards of quality as well as of its independence,'[1] a work of art should not transgress the defining characteristics of its discipline. Greenberg admonished that 'a modernist work of art must try, in principle, to avoid dependence upon any order of experience not given in the most essentially construed nature of its medium.'[2]

Despite Greenberg's adjurations, language had become fully established as a primary medium of aesthetic production by the onset of the 1970s. The groundbreaking work of Lawrence Weiner (b. 1942), Robert Barry (b. 1936), Ian Wilson (b. 1940), Joseph Kosuth (b. 1945), and Art & Language (founded 1968) proclaim the ascendancy of language as a vehicle of representation at the disposal of visual artists. In their respective oeuvres, linguistic elements function without subordination to an all-encompassing pictorial field or sculptural format and, equally significant, without direct or necessary affiliation with the literary arts. As a pictorial and/or sculptural medium, language serves to replace brush and canvas while supplanting the need for substantive materials.

The introduction earlier in the twentieth century of words or word fragments into the paintings and collages of Cubists and Dadaists and the inclusion of words and poetic texts in Surrealist works, offer a prelude to the later 1960s when language would govern, rather than simply take part in, aesthetic form and content. Fluxus works from the late 1950s and early 1960s anticipated the role language would play in skirting the medium-specific restrictions associated with painting and sculpture after 1965. Whereas Fluxus may be credited with promoting the idea of aesthetic cross-breeding, Conceptual works sought to efface traditional divisions between medium and métier rather than between categorical classifications as such. The inaugural definition of the concept of 'intermedia' – a word coined by Fluxus artist Dick Higgins that condoned the redrawing, and even the complete erasure, of boundary lines between art, music, theatre, dance, and literature – set the stage for the self-sufficiency of language in Conceptual art. Artists associated with Conceptual art, whose practices followed immediately upon Fluxus innovation, altered the characteristics of painting and sculpture from within these categories rather than endeavoring to dissolve them. To this end, Conceptual artists extended, but did not totally obliterate, the physical and conceptual boundaries of the object even though, breaking the former paradigms of painting and sculpture, they rendered them unrecognizable.

Paintings by Ed Ruscha (b. 1937) from the early 1960s provide a noteworthy precedent for the idea that language might take over representational duties conventionally assigned to the established media of painting and sculpture. Ruscha had begun to incorporate formal and semantic elements of language into his painting in 1959. For example, in *E. Ruscha* (1959), the capital letters 'E. HA' are thickly painted over layers of gestural brushwork above the letters 'RUSC,' which occupy the rest of the square canvas. An arrow editorially squeezes the 'H' and the 'A' into the artist's last name. The letters of the artist's name – without being a signature, as in the contemporaneous paintings of Robert Ryman – provide the painting's imagery.

Ed Ruscha | **Actual Size** | 1962

Stuart Davis | **Lucky Strike** | 1924

Sweetwater (1959), now destroyed, was painted the same year. Of particular interest is the way in which the word 'Sweetwater,' the name of a small American town, looks as if it had dropped from broad patches of exuberantly applied paint on the upper portion of the canvas into the otherwise empty area below. Inked in seriffed typeface, it explicitly differentiates itself from the effects of abstract brushwork.

Belonging to the generation of artists linked with Pop art, Ruscha has culled his verbally produced imagery from popular sources, be it from comic books, product labels, or the phraseology of the culture at large. The red, undulating typeface used in *Annie* (1962) reproduces the name found in the title of the comic strip, 'Little

Orphan Annie.' *Actual Size* (1962) allots nearly half of its six-foot area to the word 'Spam,' painted in large yellow letters across the top of the canvas. A relatively tiny image of the product's label, scaled to 'actual size', floats in the remainder of the canvas field. Comparable to paintings by Stuart Davis (1894–1964) from an earlier generation of American artists known for Cubist still lifes built around brand-name items such as cigarettes, *Actual Size* also replicates a labeled product. But in the latter instance, the product is not secondary to an overall composition. Furthermore, the word 'Spam' has been enlarged and separated from the context of its label to serve autonomously as word and image. In works such as *War Surplus* (1962), *Smash* (1964), or *Those of Us Who Have Double Parked* (1976), for example, painted words emblazoned across the center of the canvas add a layer of meaning that could not be expressed pictorially, while they simultaneously serve as formal elements.

Language, form, and materiality go hand in hand in the art of Bruce Nauman, who, from 1967 to the present, has intermittently used neon as a medium for shaping meaning by translating scripted words into sculptural form. Nauman's Neon pieces are based on the phonetic, phonemic, figurative, and referential properties of words. Slight alterations in the positioning/repositioning, or the addition/subtraction of individual letters in works such as *Raw/War* (1970) or *Death/Eat* (1972) engender major changes in semantic content. The Neons alternately illuminate single words with pulsations of light. Semantically, they tread a thin line between sense and non-sense, and touch upon aspects of the human or social condition. Resembling anonymous signs from the world of advertising, but disconnected from any marketable product, they simultaneously confer material form on abstract signification and bestow signification on material form.

Eating My Words and *Waxing Hot*, from Nauman's *Untitled* (1966–67), a set of eleven color photographs, bring about the material objectification of language. This is achieved by the artist acting out idiomatic expressions, as in a game of charades. In the former photograph, the artist sits at a kitchen table spreading jam on bread cut-outs of the five letter shapes of the word 'words.' In the latter, the hands of the artist are shown in the process of applying wax to free-standing, red, wooden block letters that spell 'hot.' In these photographs, sculptural form and linguistic expression are fused as a result of

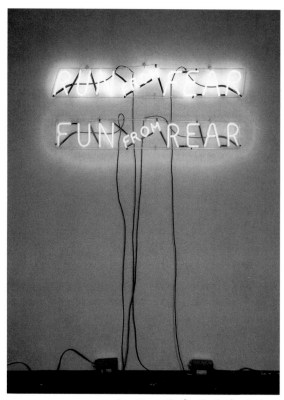

Bruce Nauman | **Run from Fear, Fun from Rear** | 1972

Bruce Nauman | **Waxing Hot** | 1966–67

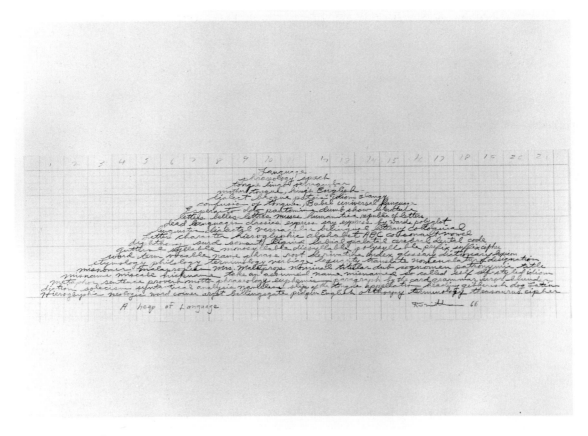

Robert Smithson **A Heap of Language** 1966

play-acting, which involves plays on words carried out in literal fashion. By infusing words with physicality, the artist/producer, furthermore, distances himself from traditional acts of personal expression.

A small-scale pencil drawing by Robert Smithson (1938–73) entitled *A Heap of Language* (1966) predates both his large-scale outdoor earthwork sculptures realized in the early 1970s and his Nonsites of 1968. In Smithson's little drawing, more than a hundred sequentially penciled words, all of which relate to language, such as 'phraseology,' 'speech,' 'tongue,' 'lingo,' 'English,' 'dialect,' 'brogue,' 'hieroglyphic,' 'Mrs. Malaprop,' or 'cipher' are arrayed next to and layered above one another in a mound shape.[3] At the top of the pile is the word 'language.' The individual words that give rise to this work function formally and lexically at the same time. Smithson's anomalous and unique drawing – a kind of miniature 'earthwork' built out of language – is hinged between his work as a sculptor and his work as a writer. Just as words perform as both objects and abstractions in *A Heap of Language*, so in writings by Smithson, words are employed to create analogies between the metaphoric and the material, between the mental and the corporeal and, more generally, between language, art, and the physicality of the earth.

An illustrated essay printed in the magazine *Art Voices* (Fall 1966), 'The Domain of the Great Bear,' researched and written by Smithson in collaboration with Mel Bochner, ignores the firm division between work of art and published article. Taking the American Museum of Natural History and Hayden Planetarium in New York as its starting point, it carries the reader from the cosmic heights of planetary movements to the bathos of institutional settings. Because of its unusual design layout (including a reproduction of a sign with a hand pointing to 'SOLAR SYSTEM & REST ROOM'), it differs from typical expository contributions to art journals but does not forfeit the discursive character of an article detailing a museological investigation.

Clearly separating itself from the texts of critics, art historians, or artist-writers, the article departs from standard expository practices in its deadpan delineation of institutional absurdities. Bochner and Smithson's text makes visible correlations between the sublime and the ridiculous and brings thoughts about the infinity of the universe 'down to earth' in all of society's corporate splendor. The IBM logo above the museum's 'Astronomia Corridor', pictured in one of the article's accompanying photographs, is specifically singled out. Text and illustrations – including a rendering of a dinosaur watching a bolide and a motley group of shivering bears (portrayed as victims of global warming) standing in front of the White House – reinforce one another, while the work's ending summarizes its acerbic tone: 'A chamber of ennui. And fatigue. It is endless, if only the electricity holds out.' Successfully eluding classification, 'The Domain of the Great Bear' at an early date questioned the hard-and-fast separation between writing and sculpture. Itself a kind of hybrid work, the essay augured the ensuing development of a new breed of aesthetic production rooted in language rather than in the physicality of visible form.

Vanguard works by David Lamelas (b. 1946) are symptomatic of the mobilization of language for the purpose of visual representation that, exemplified by a work such as 'The Domain of the Great Bear,' had taken an unprecedented course by the end of the 1960s. Lamelas had already been using photography, video, and film in works dealing with perceptions of time within/without the frame of the work. *'Interview' with Marguerite Duras* (1970) focuses on language as a system of signification that, itself, is predicated on sequence. The eponymous subject is the noted French author, and the work consists of a 16mm film in black and white, plus ten photographic stills of Duras as she is being interviewed. These are paired with wall panels on which her remarks, made at the moment each photograph was taken and excerpted from the interview, are printed. A clicking noise throughout the film marks the junctures at which the artist photographed Duras. By thus breaking in on the usually uninterrupted flow of speech, Lamelas alerts the viewer to time passing within the film in its relation to time passing outside of its temporal framework. In this way, he freezes the passage of filmic time into photographic moments and passages of text.

Language for Lamelas in *'Interview' with Marguerite Duras* is mainly a tool for prying into mechanisms of illusion. In *Publication* (1970), language becomes an area for investigation with relation to the production of other artists and is the subject of a work that developed out of Lamelas's initial idea of organizing a round-table discussion in the Nigel Greenwood Gallery, London to serve as an exhibition.[4] As it turned out,

FORMING
THE
SEVENTY SEVEN WORDS
BEING
KNOWN

IN BEING AT THE EXTREME OF EXPLICITNESS TO THE CULTURE
THIS EXISTENCE THIS EXPLICITNESS AS ART THE CAPACITY
THE STRUCTURAL TO STRUCTURE
POSSIBILITY AS BY A FORMING
AN AS INSTANCE THOROUGHLY
OF ART FORMING THROUGHOUT
THE WORD THE WORD
 REJECTS OBJECTS

 TO THE CULTURE
FROM THE CULTURE BY THE CULTURE THROUGH THE CULTURE
 THIS AS THE CULTURE ANY
 INSTANCE FORMING
BEING ACCEPTED BEING
BEING REJECTED THOUGHT

 IMPLICIT
 IN
 THE WORD
 AS ART
 ENTERING
 ESCAPING
 INDIVIDUAL
 PERCEPTION

MARTIN MALONEY
AMSTERDAM 1970

26

David Lamelas **Publication** 1970 (cover and page by Martin Maloney)

the work took the form of a publication in which thirteen invited artists and art writers – with no distinction being made between the two – discussed the following three points:

1. Use of oral and written language as an Art Form.
2. Language can be considered as an Art Form.
3. Language cannot be considered as an Art Form.

Lamelas takes care in the introduction to point out that his personal attitude is not a part of the assembled material, which in timely manner constituted a work in language about language that took the form of an exhibition inside a publication. The exhibition may thereby be defined as having taken place in the past but exists in the present inasmuch as the book, as the idiom has it, can never be closed on language.

By adopting language as their exclusive medium, Weiner, Barry, Wilson, Kosuth, and Art & Language were able to sweep away the vestiges of authorial presence manifested by formal invention and the handling of materials. In the process, their work broke from the defining framework of painting and mold of sculpture. Because of language's unique capacity to be the very substance of the message it delivers, works by these artists are congruent with that of which they speak, since what they *are* and what they are *of* coincide.

Lawrence Weiner reached the conclusion in 1968 that language could function on its own in lieu of other materials. His work utilizes language as it is; that is, not in predetermined association with a material support or contextual framework. The thematic content of individual works derives solely from the import of the language employed, while presentational means and contextual placement play crucial, yet separate, roles. Embodied in language, Weiner's work is not confined in traditional manner to an existence in one place or time. Taking the form of linguistic construction, it is to be

understood as sculpture. These 'sculptures' are peripatetic and infinitely multivalent in terms of how, when, and where they are shown.

Weiner has recounted that the official turning point in his approach to sculpture occurred when he was in the process of installing a piece for the now historic outdoor exhibition, 'Carl Andre, Robert Barry, Lawrence Weiner.' The exhibition, conceived by Chuck Ginnever and organized by Seth Siegelaub, was held on the grounds of Windham College in Putney, Vermont in the spring of 1968. Having placed his work, entitled A SERIES OF STAKES SET IN THE GROUND AT REGULAR INTERVALS TO FORM A RECTANGLE TWINE STRUNG FROM STAKE TO STAKE TO DEMARK A GRID A RECTANGLE REMOVED FROM THIS RECTANGLE (1968, #001),[5] in a vulnerable location, he later found it had been damaged. Although upset at the time, Weiner came to understand that physical harm need not be a concern.[6] Despite the damage, the work of stakes and twine remained intact as a linguistic construction. Before this moment, proposals for sculptures took the form of phrases penned on graph paper. Descriptive text, merging with the work's title, thereafter came to exist as the work itself.

Following the Windham College experience, Weiner devised the statement that has accompanied presentations of his work since 1969, which reads:

The artist may construct the piece.
The piece may be fabricated.
The piece need not be built.
Each being equal and consistent with the intent of the artist, the decision as to condition rests with the receiver upon the occasion of receivership.

By means of this statement, the artist stipulates that the actual, physical realization of any one of his works, which are formulated in language, is not a requirement but an option left open to any perceiving subject, himself included. THE RESIDUE OF A FLARE IGNITED UPON A BOUNDARY (1968/69, #029) was, in fact, carried out by Weiner under the auspices of the Stedelijk Museum, Amsterdam during the exhibition 'Op Losse Schroeven: Situaties en Cryptostructuren' (Square Pegs in Round Holes: Structures and Cryptostructures) in the spring of 1969. The same year, A SQUARE REMOVAL FROM A RUG IN USE (1969,

#054) was also physically realized, this time in the home of collectors in Germany who had purchased the piece. At the collectors' request, Weiner came to their Cologne residence and cut a square section from one of their rugs. He thereby created a lacuna by subtraction rather than, more typically, importing a new physical object into a space.

With the execution of Cratering Pieces (1960) in Mill Valley, California, Weiner – having abruptly terminated his undergraduate studies in New York – began his reconsideration of the assumptions underlying sculptural practice. Using dynamite to make large gouges in wide open spaces of land instead of creating delineated, portable objects, he attempted to broaden sculpture's ascribed boundaries. As he has suggested, 'the craters came about as a way to make sculpture by the removal of something rather than by the normal intrusion of things.'[7]

Special relevance is assigned by Weiner to an untitled work consisting of a partially carved limestone block placed on a trestle (1960–62; reconstructed 1982). Having chipped away at this stone for long stretches of time without determinate results, Weiner perceived the block as simply being a record of cumulative action upon the material. The block helped him to define the idea that, in the final analysis, 'sculpture [is] about "Put in Place," volume or mass put in place. It's a matter of transportation; you move it from one place to the other….'[8] Although unique, the block signifies the origin of Weiner's later understanding that a work's positioning in any one place at any one time need not be mandatorily 'carved in stone.'

Weiner exhibited Propeller Paintings (1963–65) in his first two solo exhibitions, in 1964 and again in 1965 at the Seth Siegelaub Gallery, New York. With images derived from television test patterns, these early paintings are notable for the emphatically colored, blade-shaped forms that fully acknowledge, but tentatively transgress, their rectilinear surrounds. Some five years later, in a radio symposium, the artist recalled that 'the picture-frame convention was a very real thing. The painting stopped at that edge. When you are dealing with language, there is no edge that the picture drops over or drops off. You are dealing with something completely infinite.'[9]

Weiner referred to untitled drawings on graph paper as 'tick drawings' (1966–68) because of the way he had

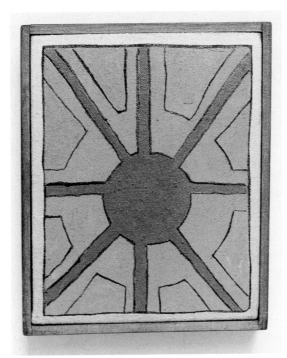

Lawrence Weiner **Propeller Painting** 1964

Lawrence Weiner **Untitled** 1967

filled individual squares of the paper with an m-shaped squiggle.[10] The drawings' interest lies in the way they telescope into one meaning the making of marks and the passing of time. They represent temporal and spatial coordinates of aesthetic activity as well as the energy created when pen/cil is put to paper, and break up the regularity of the paper's grid pattern. Irregular patterns arising from the interplay between marked and unmarked squares within a rectangular border rebel against subordination to rectilinearity.

Upon completion of the Propeller Paintings, and while continuing the drawings on graph paper, Weiner embarked on a series of paintings that would be his last in the traditional sense of paintings as flat, extant objects affixed to the wall. The Removal Paintings (1966–68), from which a rectangular area was removed from the corner of the stretcher frame, blatantly questioned the inviolate rectilinearity of painting. In an effort to minimize the typical painterly signs of authorial presence, Weiner evenly covered each canvas with spray paint and added bands of a slightly different color to the work's top and/or bottom. Additionally, he asked prospective owners to select the size and color of the work themselves. Nonetheless, he was still left with works of art that ultimately could not function as pure 'visual information'[11] in disassociation from the attributes of uniqueness and monetary worth connected with painting.

A solo exhibition in December 1968 organized by Seth Siegelaub definitively marked Weiner's departure from previously accepted methods of making and exhibiting art. The exhibition, comprising twenty-four works, took place only on the pages of a palm-sized gray book entitled *Statements*. Printed one to a page, the works are divided into the 'general' and the 'specific.' In this regard, ONE 14 OZ. AEROSOL CAN ENAMEL SPRAYED TO CONCLUSION DIRECTLY UPON THE FLOOR (1968, #008) is more precise than AN AMOUNT OF PAINT POURED DIRECTLY UPON THE FLOOR AND ALLOWED TO DRY (1968, #036). Some works, such as A 2" WIDE 1" DEEP TRENCH CUT ACROSS A STANDARD ONE CAR DRIVEWAY (1968, #019), had been previously sold and constructed. With retrospective reference to an early Cratering Piece, a FIELD CRATERED BY STRUCTURED SIMULTANEOUS

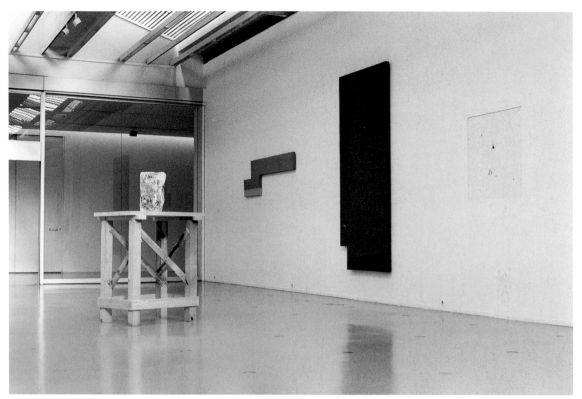

Lawrence Weiner **Early works** Installation at 'L'art conceptuel, une perspective,'
ARC Musée d'Art Moderne de la Ville de Paris, 1989

Lawrence Weiner | ONE QUART EXTERIOR GREEN INDUSTRIAL ENAMEL... | 1968

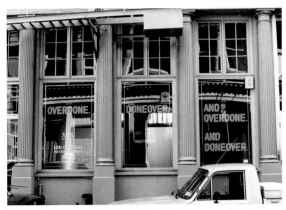

Lawrence Weiner | OVERDONE. DONEOVER. AND OVERDONE. AND DONEOVER. | 1971

Lawrence Weiner | MANY COLORED OBJECTS... | 1979

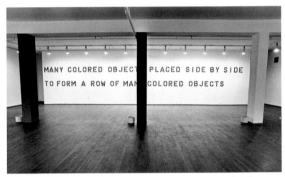

Lawrence Weiner | MANY COLORED OBJECTS... | 1979 (installation Leo Castelli Gallery)

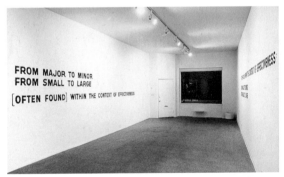

Lawrence Weiner | FROM MAJOR TO MINOR... | 1974 (installation Claire Copley Gallery)

Lawrence Weiner | BROKEN OFF | 1971 (installation Chicago 1987)

TNT EXPLOSIONS (1968, #030) introduces the rest of the works.

For the most part, Weiner's works have remained exclusively in their linguistic state without being constructed.[12] They often take the form of phrases spelled out on the wall using commercially available, black adhesive letters or stenciled, drawn, or painted letters. One presentation, ONE QUART EXTERIOR GREEN INDUSTRIAL ENAMEL THROWN ON A BRICK WALL (1968, #002), was painted in dripping letters on an exterior brick wall. With ironic distance, it alluded to prevalent Abstract Expressionist practices deliberately rejected by Weiner.[13] As well as being lettered, inscribed, or printed on a wall, in a book, or on a poster, a work may be delivered vocally on an audiotape or a record or as part of a film or video. No matter what form it takes, the work becomes objectified upon its materialization as a written or spoken text.

Until early in the 1970s, Weiner typed works on sheets of paper and pinned them to the wall for exhibition purposes. For his exhibition in 1972 at the Leo Castelli Gallery, New York, he simply mounted the exhibition mailer on the wall. Not until the Italian art collector Count Panza di Biumo asked permission to transfer several works directly onto the walls of his living quarters did Weiner introduce his varied methods for lettering the interior walls of exhibition spaces or the exterior of buildings.[14] Without interfering with the work's content, the nature of the lettering influences its visual appearance, as would a frame around a painting or a vitrine protecting a three-dimensional object. Color, scale, style, spacing of letters, and the positioning of the statement – at eye level, close to baseboards, near the ceiling or in outdoor circumstances – vary greatly.

Weiner was among the first artists to present his work anonymously outside of institutional art spaces. His 'major concern has been the use factor of art within a society' in that he believes art 'is an attempt to place material which could be used to enrich the daily lives of other human beings.'[15] He has thus stenciled or chalked works on city pavements or tacked unsigned posters in public places. His installation for a group exhibition in 1974, 'Idea and Image in Recent Art' at the Art Institute of Chicago, predated works by later artists that offered 'give-aways' to viewers. In this instance, a plexiglas box on the museum wall contained posters of the work that were meant to be taken home by exhibition visitors.[16]

Attempting to counteract the idea of art being out of reach, Weiner also has printed works on objects such as emblematic stickers, plaques, plates, matchbooks, pins, and other ephemera.

Whether shown on the walls of conventional exhibition spaces or set within unorthodox visual frameworks, Weiner's work interacts with the culture at large inasmuch as language's chain of verbal signifiers underlies all social discourse. Space for the artist ultimately means the 'entire cultural context' as opposed to 'an aesthetically contracted space.'[17] Weiner's works may thus be continually transplanted from one context to another while still remaining rooted in the culture. Because of their countless unspecified applications and potential for ubiquitous placement, they bond with any context into which they are inserted. 'Art institutionalizes itself,'[18] the artist has affirmed. In the final analysis, however, it is viewers who, informed by the culture as well as by the particulars surrounding a work's placement, ultimately bring their own experience and frame of reference to bear.

The context in which a work is put on display tends to influence how it is read. A two-part work, conceived by Weiner for the Castelli Gallery (1974, #s 393, 394) is worded as follows:

UP ON (IN) THE AIR
DOWN ON [IN] THE GROUND
BEING WITHIN THE CONTEXT OF [A]
REACTION

BEING WITHIN THE CONTEXT OF
REACTION:
UP ON (IN) THE AIR
DOWN ON [IN] THE GROUND

Having set up a dialogue between its wording and its location on the second floor of a building, the Castelli work verbally referred to the idea of 'reaction' on the one hand and 'a reaction' on the other. Standing within the context of a gallery dedicated to the most recent developments in art, visitors might have made a connection between their own viewing of a relatively new kind of art at the top of a flight of stairs and their reaction to it upon their return to the street. The work makes no literal demands on the viewer, but serves only to distinguish between abstract generalization and subtly

differentiated levels of concrete specification. Parentheses and brackets perform within the linguistic spaces of lettering to expand the possibilities of received meaning.

Geographical context in some instances may also determine, without dictating, the way a work is understood. The following work (1978, #451),

LAID OUT FLAT
BENT [NOW] THIS WAY
TURNED [NOW] THAT WAY
(in effect LOOPED OVER)

was created for presentation in 1978 at the Renaissance Society at the University of Chicago, the Chicago river being its source of inspiration. The artist 'was fascinated by the idea that the Chicago river originally was made to swing around to accommodate the city's garbage flow.'[19] The piece could be understood simply on its own terms as a non-specific, endlessly adaptable image, or viewed in reference to countless other real-life manifestations.

MANY COLORED OBJECTS PLACED SIDE BY SIDE TO FORM A ROW OF MANY COLORED OBJECTS (1979, #462) is a prime example of a work that has changed its manner and place of display on a number of occasions. Originally made for exhibition at the Castelli Gallery, it thereafter entered a group exhibition of recent American art at the Art Institute of Chicago. Several years later, it was featured in 'Documenta 7' in Kassel, Germany. Instead of installing this piece in the galleries – along with the hundreds of other works selected for this large international exhibition by a team of organizers – Weiner elected to install it above the entrance of the eighteenth-century building used for the exhibition. Having the appearance of an inscription of universal wisdom that might typically adorn the architecture of the period, the work appeared as if it had always been part of the facade. The same piece was also printed on a removable paper band encircling the exhibition's two-volume catalogue.

Like every work by Weiner, MANY COLORED OBJECTS… functions as a paradigm of its own construction. Because it leaves the number, color, and positioning of the objects undetermined (along with any reference to what the objects might be), it comments on its immediate circumstance while generating the possibility of an inexhaustible number of images. In Kassel, where the piece subtly held sway over the extensive grouping of works, the reference to the eclectic exhibition could not be missed. Now belonging to private collectors in Belgium, it is painted in blue letters on a high brick wall rather than being accommodated indoors with the rest of the objects in the collection.[20]

The semantic inexhaustibility of language endows Weiner's art with its broad thematic scope. Some works may transcend geographical and political boundaries and operate on a global scale, as witnessed by AN OBJECT TOSSED FROM ONE COUNTRY TO ANOTHER (1968, #028) or REMOVALS HALFWAY BETWEEN THE EQUATOR AND THE NORTH POLE (1969, #096). Less tangible or quantifiable are A TRANSLATION FROM ONE LANGUAGE TO ANOTHER (1969, #071), AN ACCUMULATION OF INFORMATION TAKEN FROM HERE TO THERE (1970, #143), and AN AMOUNT OF CURRENCY EXCHANGED FROM ONE COUNTRY TO ANOTHER (1970, #155).

Weiner treats language in a neutral way as the means to objectively impart information regarding aspects of the verifiable external world. All of his works are grounded in the actuality of observable qualities, processes, conditions, actions, substances, or things that produce change in states of being. Early pieces found in the book *Statements* specify their material components as, for example, 6 TEN PENNY COMMON STEEL NAILS DRIVEN INTO FLOOR AT INDICATED TERMINAL POINTS (1968, #003), while a work such as A CITY DRAGGED (1969, #076) involves interaction with the physical environment and was, in fact, performed by the artist in Stockholm. Having rented a boat for the day, he pulled a dragnet all around the city's waterways.[21] Expanding upon previous forms of art production and norms of display, his work expresses the properties, behavior, or functions of materials, objects, or empirical phenomena.

Whereas Weiner's early productions, such as ONE FLUORESCEIN SEA MARKER POURED INTO THE SEA (1968, #004), pertain to specified substances and/or actions, slightly later pieces like AND THEN THERE WERE NONE (1970, #154) or AS IF IT HAD BEEN (1972, #275) are not at all explicit. If the phrase 'and then there were none' is understood to indicate the removal of something, the phrase 'as if it had been' – suggesting something that could have existed in any particular form – speaks in the past and conditional tense

to the multifarious possibilities of what any one viewer might picture, no matter how specific or general a work by Weiner might be.

While works may comprise long phrases in certain instances, in others they are pared down to minimal verbal or adverbial designations, as in TRIED AND TRUE (1970, #156), TO THE SEA (1970, #157), and WITHOUT OR WITHIN (1972, #253). Constituted in language and subject to the rules of grammar, Weiner's works bind nouns (often used in prepositional phrases) together with verbs (usually employed in the past or passive), adjectives, adverbs, or prepositions, as in A WALL STAINED BY WATER (1969, #067) or A CUP OF SEA WATER POURED UPON THE FLOOR (1969, #055). Any or all of these parts of speech often function without accompanying nouns. Dispensing with both subject and object, IGNITED (1969, #081), FERMENTED (1969, #082), and DISPLACED (1969, #083) are pared down to a single past participle.

Occasionally Weiner has permitted the ambiguities of language to enter his work by encouraging the deliberate double meanings found in well known expressions or figures of speech. By presenting these phrases in isolation, the artist allows the literalizing propensity of language to take over in such pieces as AROUND THE BEND (1970, #228), OVER THE HILL (1970, #231), or BESIDE THE POINT (1970, #232). Not so much interested in the vagaries of language for their own sake, Weiner takes full advantage of whatever semantic modes might be applicable to envisaging that which is grounded in, but not bounded by, material reality.

The use of language by Robert Barry also releases the work of art from confinement to visibly demarcated boundaries. Barry's decision to move away from painting in 1968 and, as of 1969, to formulate his work in language has made it possible for him to embrace broadly based ideas about emptiness and infinity.[22] 'There is something about void and emptiness,' he maintained, 'which I am personally very concerned with...*Nothing* seems to me the most potent thing in the world.'[23] Pertaining to the cognitive space of conception wherein objects and images are harbored in thought, Barry's language-based work developed from the concerns of his painting.

Paintings by Barry from 1963 through 1967 (many of which were destroyed in a studio flood) make reference

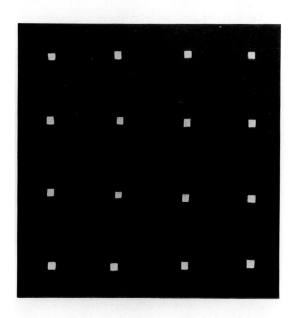

Robert Barry **Untitled** 1964

to the spatial reality beyond the edge of the canvas. Those shown in his first solo exhibition of 1964 at the Westerly Gallery, New York consisted of squares of unpainted canvas that punctuated the surrounding field of color at regular intervals to expose the weave of the canvas. Leaving the outer edge unpainted as well, Barry intimated that the work might be considered part of an overall spatial continuum. As noted in the gallery's press release, 'while each painting may be considered individually, Mr. Barry conceives his exhibit as a total and unified lyrical experience.'

With the production of brightly colored monochrome paintings in 1966, Barry took further steps toward negating the once sacrosanct perimeter of the canvas. Left unframed, these works protruded several inches from the wall and, at their outer edges, narrow vertical strips of bare canvas wrapped around the edge of the stretcher. Devoid of imagery, they disregarded the traditional cut-off point of a painting's predetermined limits to link the work with its surrounding space.

As distinguished from traditional paintings that may be hung anywhere, Barry's small monochrome canvases of 1967 relate to the entire wall of a given space. *Red Square* (1967), a single small canvas, includes the

BASIC FORMAT FOR WIRE OR CORD INSTALLATION BETWEEN THREE OR MORE TREES—ALL DIMENSIONS VARIABLE. R.BARRY '68

Robert Barry **Wire or Cord Installation Between Three or More Trees** 1968

specification that it be installed at the center of a wall. Other monochromes accommodate more than one canvas of the same size: a unique tripartite, triangular monochrome, and quadripartite paintings whose separate elements range from one inch to a side at their smallest to about eight inches to a side. Of critical importance is the fact that Barry specified how far apart the individual canvases should be hung or how many inches they each should be placed from a wall's four corners. The background wall in both these cases is thematically accommodated within the totality of the work.

As a logical next step, works of 1967–68 relinquished the canvas surface altogether. By means of line strung between points, they highlighted their architectural and spatial context.[24] These 'lines' were made of materials of varying tensile strengths such as white cotton string, transparent filament, steel wire, or waxed black thread. Barry stretched them either outdoors between two or more trees, for example, or indoors between floor and ceiling or from wall to wall. For the exhibition 'Carl Andre, Robert Barry, Lawrence Weiner' at Windham College he extended four white, shiny ¼-inch nylon ropes parallel to each other from roof to roof between two identical buildings on the college campus. The work spanned a large construction site, as the school was still in the process of being built. Incorporating the activity of the moment within its visual field, Barry's installation, unlike sculptures by Andre and Weiner on the ground, required viewers to look up. According to the artist, 'the idea of sky, nature, natural phenomena have always been part of my work.'[25]

ROBERT BARRY, New York

5

Inert gas series, 1969; Helium (2 cubic feet)

Description: Sometime during the morning of March 5, 1969, 2 cubic feet of Helium will be released into the atmosphere.

Robert Barry **Page from 'March 1969' catalogue** 1969

By 1968 Barry had also begun to create works from materials invisible to the naked eye, such as carrier waves of different frequencies, ultrasonic sound, microwaves, electromagnetic energy fields, radioactive substances, and inert gases. These works, as he has explained, are 'made of various kinds of energy which exist outside the narrow arbitrary limits of our own senses. I use various devices to produce the energy, detect it, measure it, and define its form.'[26] Viewers are apprized of the work's inclusion in an exhibition by means of a wall label. The Inert Gas piece included in Seth Siegelaub's 'March 1969' exhibition, however, was made known only through publication in the catalogue that, untypically, was in the form of a calendar. In the calendar, each day of March is allocated to a separate page, and each of the thirty-one invited artists presented a work on one page/day of the month rather than in a gallery space. Barry's participation is noted by the statement: 'Sometime during the morning of March 5, 1969, two cubic feet of Helium will be released into the atmosphere.'

A poster for Barry's April 1969 exhibition in Los Angeles, organized by Siegelaub, records the release of

Robert Barry **Inert Gas Series: Helium (2 cubic feet)** 1969

five inert gases: helium, neon, argon, krypton, and xenon. To realize this exhibition, Barry purchased vials of gas from a scientific supply store and broke them open at different locations in and around Los Angeles. He smashed one at the edge of an outdoor swimming pool, another in the desert, and another on the beach. Each work represented the passage of a substance 'from a measured volume to indefinite expansion,' as is printed on the exhibition poster. Each of the gases was thus returned to its place of origin in the atmosphere. Invisible works like those of the Inert Gas Series, which are materially real but known only through documentation, fuse with the environment and at the same time pass into the immense and indefinite cavity of open space.

Works in the Inert Gas Series were the last made from invisible materials and were followed by works that provoked explicit mental involvement with the exhibition space through the medium of language. Verbal statements that initially had served simply as identifying labels for otherwise invisible pieces became, in 1969, an integral part of the work. According to Barry, his intent was to transform the exhibition space by supplying new thoughts about its relationship to artistic activity.[27] The Psychic Series (1969), taking the form of a text in the catalogue for 'July, August, September,' an exhibition conceived once again by Siegelaub to 'take place' in a published context, states:

> Everything in the unconscious perceived by the senses but not noted by the conscious mind during trips to Baltimore during the summer of 1967.

As in the Inert Gas Series, nothing is made visible. In the Psychic Series, however, language takes over completely, insofar as there is no quantifiable physical material; only thought has been presented as an all-pervasive element for its own contemplation.

Barry's *Telepathic Piece* (1969), included in the 1969 'Simon Fraser Exhibition,' organized by Siegelaub for the Simon Fraser University, British Columbia, appears in the catalogue as a statement set off by brackets. Much as they serve in grammar to cordon off one body of information from another, the brackets indicate an intervention into an 'area' or sequence of thought:

> [During the Exhibition I will try to communicate telepathically a work of art, the nature of which is a

series of thoughts that are not applicable to language or image.]

By means of language and its symbols it communicates the idea that thought, not physical materials, is the underlying ingredient of the work. Even if, in the process of articulating conscious ideas, language and/or imagery cannot in and of themselves be voided, *Telepathic Piece* subverts its own realization as an object. The work, which cannot leave the page, engages with the idea that thought is a viable material for the production of art.

A work submitted to David Askevold's (b. 1940) Project Class at the Nova Scotia College of Art and Design (NASCAD), Halifax, Canada in the fall of 1969 further illustrates Barry's method of using a textual statement to set forth the conditions for speaking about abstract quantities and processes – such as knowledge and thinking – within the parameters of a work. The statement reads:

> The students will gather together in a group and decide on a single common idea. The ideas can be of any nature, simple or complex. This idea will be known only to the members of the group. You or I will not know it. The piece will remain in existence as long as the idea remains in the confines of the group. If just one student unknown to anyone else and at any time, informs someone outside the group the piece will cease to exist. It may exist for a few seconds or it may go on indefinitely, depending on the human nature of the participating students. We may never know when or if the piece comes to an end.

Although it incorporates the notion of confines, the NASCAD piece has no determinable spatial or temporal boundaries. Resting on the principle of a shared idea, the work is anchored purely in thought via language.

Other thought pieces by Barry similarly repudiate materiality. His *Interview Piece* (1969) exists only in the exhibition catalogue for 'Prospect 69' held at the Kunsthalle, Düsseldorf. In this work, Barry (who composed both questions and answers himself) responded in his own name to a 'Questioner.' According to the artist, who speaks in, through, and about the work, 'language can be used to indicate the situation in which the art exists.' The interview format addressed the fact

that the work was in an exhibition but was not an object in a gallery space. It assumes form only in the catalogue by means of a hypothetical exchange of ideas.

Barry's famous and infamous *Closed Gallery Piece* (1969) took yet another tack for supplanting the traditional material object with language. Whereas *Interview Piece* takes up space on the page of a catalogue but not in a gallery, *Closed Gallery Piece* occludes the exhibition space altogether. On the mailer announcing the time and place of his exhibition, the artist states that during the period of his exhibition the gallery will be closed. The work has been worded a little differently each time it has been presented. Thus, for example, printed on the invitation card sent by the Eugenia Butler Gallery, Los Angeles in 1969 is Barry's name, the gallery's address and 'MARCH 10 THROUGH MARCH 21/THE GALLERY WILL BE CLOSED.' The card for his exhibition at the Galleria Sperone, Turin announced 'For the exhibition the gallery will be closed – per la mostra la galleria sarà chiusa dal 30.12.1969.' By means of a few words amounting to an assertive proclamation sent by mail, Barry lays claim to the exhibition space as a physical container and organizational structure able to support its own closing. Transported through the postal system to an audience beyond the geographical location of the specific gallery sponsoring the work, *Closed Gallery Piece* transcends all manner of physical limitation or interference, while it defines the idea of emptiness in terms of (a) real space.

Like *Closed Gallery Piece*, *Marcuse Piece* (1970–71) has been realized on a number of occasions. When first shown in December 1970, the artist wrote in pencil directly on the wall of the Galleria Sperone: 'Some places to which we can come, and for a while, "be free to think about what we are going to do." (Marcuse).' Using reverse tactics from the *Closed Gallery Piece*, Barry opened the exhibition for entry. By quoting the last words from Herbert Marcuse's *An Essay on Liberation* published in 1969, he emphasized the contemplative over the commercial aspect of gallery enclosures.

On a number of occasions Barry has worked within a traditional book format. *One Million Dots* (1968) is divided between twenty-five pages, the number allotted to each of the seven artists participating in *Carl Andre, Robert Barry, Douglas Huebler, Joseph Kosuth, Sol LeWitt, Robert Morris, Lawrence Weiner*, which was published by Seth Siegelaub and John Wendler in December 1968 and

ONE MILLION DOTS

Robert Barry | **One Million Dots (detail)** | 1968

Robert Barry | **The Space Between...** | 1969

Robert Barry | **Type Drawings at 'Defining of it...,' Leo Castelli Gallery** | 1971

is known as the Xerox Book. Each page, a xeroxed copy of an original sheet of Ben-Day dots, contains 40,000 easily distinguishable, evenly dispersed, and squared-off dots. Inasmuch as the pages could be multiplied ad infinitum on a copy machine, Barry's Xerox Book project is about unbounded replication. A related enterprise, *One Billion Dots* (1968), required the printing of twenty-five volumes of one thousand pages, each of which also displays 40,000 dots. Predicated on the idea of a potentially endless printing of volumes, *One Billion Dots* contends with the notion of open-ended expansion.

The page for Barry is simultaneously a mentally delineated space and a physical one. This is made clear by two works in issue Number Six (July 1969) of the magazine *0 TO 9* founded by Vito Acconci and Rosemary Mayer. The works are listed in the magazine's table of contents as: *The Space Between Pages 29 & 30* and *The Space Between Pages 74 & 75*. In the first instance, Barry defined the invisible space between two sides of a page. The end of a project by Bernar Venet (b. 1941) is printed on page 29, while Dan Graham's essay 'Eisenhower and the Hippies,' commencing on page 30, is printed on the reverse. Barry's entry in the magazine may be 'read' in terms of material reality and as an abstract idea simultaneously.

In the second instance of Barry's *0 TO 9* contribution, the space located between pages 74 and 75 is a changeable and accessible one. The amount of space filling the gutter between the two pages depends upon whether the magazine is fully or partially opened or whether it is closed. A flexible space, it may be perceived whenever the reader turns to the designated pages. Just as in Barry's Inert Gas, Carrier Wave, or Radiation pieces, apparent emptiness is, in some sense, filled to become the subject of the work.

With the introduction of words into his work, Barry enlisted the page as a site for representing mental activity as an expression of spatial infinity. Type Drawings consisted of statements on either standard 4 by 6-inch index cards or $8\frac{1}{2}$ by 11-inch sheets of paper. Usually beginning with the indefinite word 'it,' the statements, as definitions of a sort, are not definitive since the descriptive specifics of the 'it' are unknown. They are, for this reason, left open to an endless number of readings. Type Drawings on index cards possess such statements as 'It is almost ready to be fulfilled'

(1969); 'It exists because of me, but its nature is unknown to me' (1969); 'It is not actually known, but could be' (1969); or 'Something which can never be any specific thing' (1969). Type Drawings on one or more pages of typing paper elaborate upon the 'it' or 'something' referred to in the index card pieces. The description of qualities extend in a columnar list down the center of the page. *Artwork with 20 Qualities* (1970), one of many possible examples, begins with 'It is allusive,' followed by: 'unique, persistent, harmonious, composed, consistent, limited, orderly, coherent, active, varied, changeable, flexible, durable, intense, divisible, extendable, involved, dependent, influential.'

Having renounced material and pictorial representation, this work casts a linguistic net in an effort to capture the uncapturable nature of infinite possibility.

When a number of Type Drawings were shown together during Barry's spring exhibition entitled 'Defining of it…,' at the Leo Castelli Gallery in 1971, they were displayed in loose-leaf notebooks set out on tables. By 1969, Barry was also engaged in projecting images of typed – and later printed – phrases or single words in a continuously repeated sequence.[28] When projected in a darkened room at equally spaced intervals that alternate with moments of emptiness, each projected word or phrase comes into view as a single entity. Performing outside a grammatical framework or logical ordering, individual words or phrases elude narrative or depictive meaning. The cumulative sum of temporal interstices between verbal cues thereby add up to an overall experience of consecutive voids and spatial interludes.

In Word Drawings begun in 1974, Barry similarly plucked out words from participation in grammatical structure. He ordered them within the physical confines of works that melded linguistic content with formal configuration. For example, words used in a plan for an early Wallpiece (1979) read along the wall's perimeter as follows: 'Of course – Change – Deadly – Too Much – Apparent – I will – Nothing else – Disagree.' Whether printed, drawn, incised, or spoken, such highly generalized words or truncated phrases replace material, shape, color, and form.

As the quintessential vehicle for communication and thought, language replaces traditional representation in

Robert Barry **Untitled** 1976

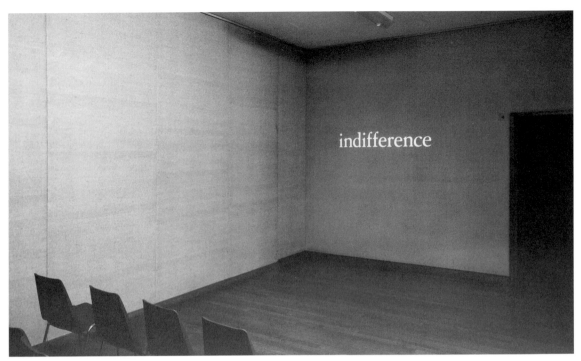

Robert Barry | **Words and Circles (detail)** | 1975

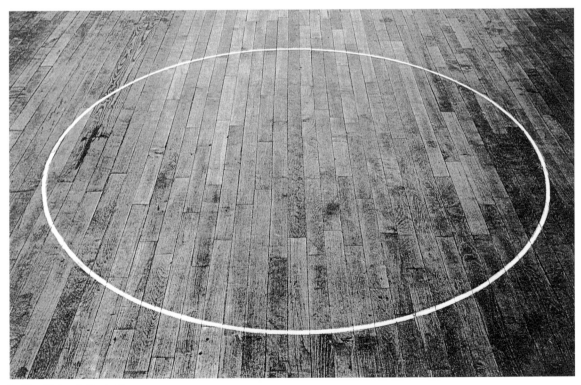

Ian Wilson | **Circle on the Floor** | 1968

[90] Medium as Message/Message as Medium

Ian Wilson's work. Wilson encapsulated his aesthetic goals and way of working when he wrote:

> I present oral communication as an object, …all art is information and communication. I've chosen to speak rather than sculpt. I've freed art from a specific place. It's now possible for everyone. I'm diametrically opposed to the precious object. My art is not visual, but visualized.[29]

Wilson has rigorously shunned the creation of any form of physical object and has sought to resist all forms of objectification. Since 1968 he has operated principally through the channels of speech, turning only in the 1980s to also include the production of sets of books based on the repetition of a single abstract verbal construct such as 'unknowable,' 'absolute knowledge,' or 'perfect.'

Wilson's replacement of the pictorial with linguistic representation grew out of a concern with the principles of abstraction. Before giving up the construction of material objects, he fashioned shallow, bowl-shaped relief sculptures out of white fiberglass. These circular reliefs (1966–67) measured approximately two to three feet in diameter. Protruding almost imperceptibly from the wall, they did not cast a shadow. Instead, they blended with the wall's color and texture and were barely detectible. Unencumbered by excess physicality, Wilson's wall reliefs were thus an attempt to press beyond the world of objects toward an abstract reality not available to sight or senses.

Circle on the Floor (1968), known also as *Chalk Circle*, was drawn directly on the parquet floor when first shown in a group exhibition at the Bykert Gallery, New York. Consisting of a ½-inch thick white line, it circumscribed an area of about six feet in diameter. The importance of *Circle on the Floor* (and also of a nearly identical work of the same size drawn in pencil called *Circle on the Wall*) lay not in its positioning on the floor or its Minimal spareness, but in its abstract intangibility. The work may be redrawn anywhere, at any time, and still remain the same. For Wilson, the act of thinking and speaking about such a form – that is, of pointing to or saying 'this is, or this was, a circle' – came to suggest an even greater degree of abstraction than the reproduction of a circle on the floor or the wall.[30] Once this work was no longer on display,

Wilson realized, it nonetheless could be pictured simply through the use of the term 'circle.' He therefore concluded that the abstract shape of a circle need not be drawn since it could equally well be brought to mind by a signifier.[31]

In pursuit of ways to expunge material form from his work, Wilson arrived in 1968 at the idea of taking the word 'time' as a point of departure. Unlike 'circle,' the word 'time' is not backed up by a concrete, formal entity that may be pictorially rendered, but opens the door to complex and fundamental thoughts and ideas about the perception and experience of reality. Wilson embarked on a self-styled program of inserting the word 'time' into whatever conversation he happened to be engaged in while speaking with friends and acquaintances on the street, at public exhibition previews, or at private get-togethers. When casually asked what he was working on at that moment, Wilson would reply that he was thinking about the question of time. Or, he would look for a way to bring up the word 'time' to mention in passing or for more detailed discussion. He did not address the subject of time simply for its own sake, but allowed a single word/concept to serve as a focal point for whatever verbal communication it might stimulate. As he has elaborated:

> I would be at a gallery opening and someone would ask me: 'so what are you doing these days?' I would reply, 'I am interested in the word time.' Later, someone would ask: 'But how can time be your art?' And I might have replied: 'As it is spoken, "time."' Another day, someone might have asked, having heard I was using 'time' as my art: 'So what are you working with these days' and I would reply: '"time." I am interested in the idea' … I like the word when it is spoken: 'time.'
> And so the word was used over and over again.[32]

The Time work, which lasted for about a year, offered a prelude to his further investigation into methods by which 'to challenge the tradition of the precious object in art.'[33] Conversations into which he interjected 'time' encapsulated the word in all of its abstract universality. Through his use of 'time' conversationally, he threaded a verbal sign through the spaces of social discourse and, in the process, defined the activity of repeating a single word – time and time again – as his art.

The Time work led to *Oral Communication* (1969–72). The artist continued to pursue the methodology of casual dialogue that he had applied to his study of the word 'time.' As in the case of the Time work, *Oral Communication* took place on an informal and unstructured basis in the course of the artist's daily life with its attendant social encounters and art world gatherings. But instead of bringing up 'time' as a subject, as he had done before, Wilson would tell interested persons that he now was involved with 'oral communication.'

The Time work stemmed from his understanding that a word in lieu of a shape might represent a concept, but his descriptive designations of 'oral communication' grew from the further realization that the Time project had depended principally on processes of communication. The phrase 'oral communication,' he determined, more pertinently served to characterize an endeavor whose ultimate subject 'is speech itself,' or 'art spoken.'[34] When asked in an interview in 1969 whether 'there is a difference between the act of oral communication and the object it concerns,' Wilson replied:

Any discussion, any oral communication, is an example of the object of my thought or the object that I am trying to communicate to you…. What I am trying to do is to direct your attention to the idea and activity. Though the carriers are physical, their thought object is not and therefore becomes an easily transported experience.[35]

At the time that Wilson was exploring the possibilities of *Oral Communication* and experimenting with spoken language as an art form, he was invited to participate in a number of the major group exhibitions of the late 1960s and early 1970s. His work often was included within the formal structure of these exhibitions despite the fact that no sign of the work's existence – not even the presence of a wall label – ever appeared within the context of the exhibition space. To acknowledge that his work was in the exhibition, Wilson included his name in the official listing of artists in the catalogue. He thus emphasized that his work was to be perceived through speech and not through a physically manifest object.

Wilson's use of the space allotted to him in the catalogue for an exhibition entitled 'Art Systems' at the Centro de Arte y Communicación, Buenos Aires in June 1971 helps further to clarify his method for participating in exhibitions. In this instance, a handwritten letter from the artist to the organizer specified that Wilson's catalogue submission would be sufficient to represent him:

The following is intended as my entry in your exhibition's catalogue at the Museum of Modern Art in Buenos Aires. Please print my name in the list of participating artists which I presume will be found at the beginning of your exhibition's catalogue.
 This is my entry in your exhibition.

The catalogue for the exhibition '18 PARIS IV 70' explicitly spells out in English, French, and German what Wilson's proposed work was to be and, in accordance with the specified guidelines for catalogue submission, what he actually exhibited:

I. My project will be to visit you in Paris in April 1970 and there make clear the idea of oral communication as artform.
II. Ian Wilson came to Paris in January 1970 and talked about the idea of oral communication as artform.

Wilson's participation in a group exhibition did not necessitate his presence for *Oral Communication* to be operative. As the Paris exhibition catalogue entry suggests, *Oral Communication* nonetheless lent itself to scheduled gatherings for discussion. A specific invitation to participate in an exhibition could provide the impetus for such a preplanned occasion although it was not a prerequisite for *Oral Communication* to be operative.

The free-form nature of *Oral Communication* was superseded by prearranged Discussions, which have continued from 1972 to the present. *Bulletin 59* (September 11, 1972), published by Art & Project, Amsterdam, documents two invitations to discussions. One was held under the title of *Oral Communication* at the Konrad Fischer Gallery, Düsseldorf in November 1970 and the other, a Discussion, was held at the John Weber Gallery, New York on May 25, 1972. The latter reads, 'Can Something be "Made" Clear?' and – noticeably omitting the term Oral Communication – continues

'A discussion to be held… *at 6:00 p.m.*' From the start Wilson considered the element of discussion to be an implicit corollary of his aesthetic endeavor. As he told his interviewer in 1969, 'I find a discussion form preferable. The fact of discussion might be more important than what I have to say.'[36] Ultimately, therefore, he defined his work as an ongoing discussion made up of formalized Discussions – not as staged performances, but as a forum for deliberation between the artist and one or more persons.

Revolving around the question of knowledge, numerous Discussions have been held over the years in museums, galleries, or the homes of private collectors in Europe and North America. At the artist's strict insistence, the Discussions are never recorded or published. A handwritten or typed certificate signed by the artist documents the date and place of the event and may be acquired by an individual or institution as proof of participation. Like the earlier Time and *Oral Communication* works, the Discussions are viewed by Wilson as an extended investigation and work in progress.

At the beginning of the 1980s, Wilson synthesized the general nature of the Discussions in printed texts that encapsulated the epistemological relationship between the known and the unknown. A text printed on the back of an invitation to a Discussion at the Stedelijk Van Abbemuseum, Eindhoven on 3 June 1983, for example, lends insight into the tenor of his inquiry. The text on this particular invitation card reads:

> that which
> is both
> known and
> unknown
> is what
> is known
>
> that which
> is both
> known and
> unknown
> is not
> known
> as both
> known
> and unknown

> whatever
> is known
> is just
> known

Applying the Socratic method, Wilson opens a Discussion with a question about the possibility of knowledge. Participants deliver their own opinions through an informal process of response, debate, argumentation, or interjection. With direction from Wilson they spontaneously speculate about the nature of truth and the human condition while the work itself, juggling verbal paradox, steers clear of conclusive content.

As an examination of the Investigations (1968–75) of Joseph Kosuth suggests, Kosuth's understanding of abstraction differs markedly from that of Wilson. In an interview in the catalogue for 'Prospect 69,' Kosuth articulated his interest in placing his work in 'the sphere of the abstract.' Elaborating upon the questioner's remark, 'Your work seems to have even less resemblance to anything we previously considered art,' he replied, 'My work is a continual kind of investigation' and, therefore, 'my primary concern has been with abstraction.'

The early reductive grey-toned paintings of Kosuth, which were never shown publicly, explore methods for suppressing compositional form and color. His last (*c.* 1964) is a painted rectangle that progressively lightens from a dark grey center to a white outer rim. White paint, of special note, is applied to the wall around the canvas' borders and, in an attempt at self-deprecation as well as self-reflection, aspires to blend into and become one with the wall.

According to Kosuth in a broadcast interview, he first used language in 1965 in conjunction with a sheet of uncolored glass positioned against the wall.[37] An accompanying label serves as both title and statement: *Any Five Foot Sheet of Glass to Lean Against Any Wall.* The use of glass thus shifted representational responsibility from figurative or abstract imagery to language and replaced the opacity of canvas with the transparency of glass, normally used within a window frame or as a protective surface over a painting. Kosuth subsequently introduced greater specificity into his work. *Clear Square Glass Leaning* (1965) not only consists of what its title describes – four square sheets of glass

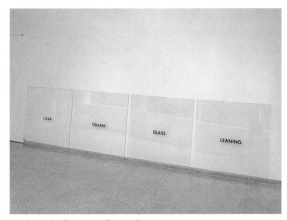

Joseph Kosuth | **Clear Square Glass Leaning** | 1965

Joseph Kosuth | **One and Eight – A Description** | 1965

propped against the wall – but the four words are lettered, one per sheet, directly on the glass. The words 'clear,' 'square,' 'glass,' and 'leaning,' in this way, describe the properties of the sheet of glass.

During this early period, Kosuth conceived sign-like phrases in neon that also announce their own components. The linear phrase 'Five Words in Blue Neon,' spells out to the letter the constituent parts of *Five Words in Blue Neon* (1965), for example. These works substitute the literal aura emanating from neon tubing for the invisible aura surrounding handmade objects, while they illuminate the signifying efficacy of language. Differing from neon pieces by Nauman with their double meanings, those of Kosuth are single-mindedly literal.

In the tripartite works of the *Proto-Investigation* (1965), a utilitarian object such as a chair, broom, lamp, umbrella, hammer, saw, or box is bracketed by a black-and-white photograph of the object reproduced to scale and a photostat of its printed definition enlarged from a dictionary. Such works as *One and Three Chairs* (1965), for example, carry the Readymade of Duchamp to another level of consideration. Combining three equal parts – a concrete thing, a photograph of it, and a text about it – they combine Duchamp's idea that art is a product of authorial selection with the idea propounded by Kosuth that it is also a self-reflexive signifying system. In 'Art After Philosophy,' his noted text of 1969, Kosuth encapsulated, 'Art is the definition of art' and is not 'concerned with questions of empirical fact.'[38] In this regard, works from the *Proto-Investigation* present photography and language – in lieu of other 'forms' of representation – as they may seem to be 'at work' in the production of signification.

The First Investigation (1966–68) comprises a range of individual works that take the form of photostatic blow-ups printed in white on black, each of which, like all ensuing Investigations, is subtitled 'Art as Idea as Idea.' Derived from Ad Reinhardt's 1962 statement that 'art is art-as-art and everything else is everything else,' they eliminate the concrete object and its photographic reproduction found in the *Proto-Investigation* and give full representational responsibility to language. To realize this Investigation, Kosuth extracted definitions of single words from a variety of different dictionaries. Not confined to objects such as 'box' or material bodies such as 'water,' they provide

definitions of adjectival qualities such as 'one,' 'white,' 'grey,' 'empty,' or 'precise,' or of abstract nouns such as 'nothing,' 'idea,' 'meaning,' 'colour,' or 'thought.' Varying typographically and lexically, *The First Investigation* works assert themselves as non-illusionistic bearers of meaning equated with that which is objectively described but not objectified.

By means of textual appropriations from the dictionary, Kosuth substituted linguistic definition for traditional pictorial depiction and erased signs of his own hand or authorial originality in so doing. As he has commented, 'the expression was in the idea, not the form – the forms were only a device in the service of the idea.'[39] The Investigations' subtitle ('Art as Idea as Idea') underscores what the photostats thematically state: that the medium of language may be used within the domain of art independently from compositional or material form to express the idea that, as art, they are about ideas.

Following from his understanding that 'a work of art is a kind of *proposition* presented within the context of art as a comment on art,'[40] Kosuth arrived at *The Second Investigation* (1968-69), which proposed the idea of locating his work in the world. As he later observed, this group of works initiated 'an increased shift of focus from the "unbelievable" object to what was believable and real: the context. Objects or forms employed became more articulations of context than simply and dumbly objects of perception in themselves.'[41]

To realize *The Second Investigation*, Kosuth turned to the 'Synopsis of Categories' from *Roget's International Thesaurus*, first published in 1852 under the title *Thesaurus of English Words and Phrases Classified and Arranged so as to Facilitate the Expression of Ideas and Assist in Literary Composition* and since revised. Its basic organizational structure was conceived by physician Peter Mark Roget, who wrote that

Joseph Kosuth **The Second Investigation (Art as Idea as Idea)** 1968–69 (installation at the Leo Castelli Gallery 1969)

Joseph Kosuth **The Second Investigation (Art as Idea as Idea)** 1968–69 (page from the Daily Mirror, 5 November 1969)

the 'Synopsis of Categories' is the 'system of classification of the ideas which are expressible by language.'[42] Roget established six primary Classes of Categories – Abstract Relations, Space, Matter, Intellect, Volition, and Affections – which later were increased to eight through the addition of Physics and Sensation. Subdivided into sections and subsections, the Synopsis proposes an expansive taxonomy of linguistically classified phenomena.

The Second Investigation advances the idea that art may be interpolated into the public domain by way of unexpected interpellations. Individual works from this Investigation consist of excerpts from Roget's Synopsis that Kosuth either inserted into media publications (often using the advertising sections of newspapers and magazines) or mounted on public signs and large billboards. *The Second Investigation* was carried out internationally in many different languages; examples are numerous and often amusing. A single category excerpt may be short, as in the case of:

> I. Existence
> C. Formal Existence
> 5. Intrinsicality
> 6. Extrinsicality

from Category One, placed by the artist in the January 1969 issue of *Artforum*. Assigned a squared-off section of its own on a page of the magazine, it is juxtaposed with advertisements for forthcoming gallery exhibitions. In some instances, the artist spread the publication of related sections from a lengthy category (such as Communication of Ideas) over half a dozen different newspapers (published on the same day in the same city) in order to accommodate all of its subcategories. Time permitting, the artist would have liked to distribute every one of the categories of the Synopsis. He would thereby have ploughed back its many sections into the unstructured reality from which the categories were culled and on which the Synopsis attempts to bestow form.

Works placed in four Swiss newspapers were exhibited together as a group under the heading 'Spaces (Art as Idea as Idea)' during the 1969 exhibition 'When Attitudes Become Form' in Bern. In his catalogue statement, Kosuth maintained:

The new work is not connected with a precious object – it's accessible to as many people as are interested; it's non-decorative – having nothing to do with architecture; it can be brought into the home or museum, but wasn't made with either in mind; it can be dealt with by being torn out of its publication and inserted into a notebook or stapled to the wall – or not torn out at all – but any such decision is unrelated to the art.[43]

As the artist himself pointed out, the use of spaces in magazines and newspapers made it possible for him to avoid the creation of unique and singular material objects of monetary value. Having inscribed portions of an existing linguistic system of classification – claimed by him as an artist in Duchampian fashion – into the non-art context of media publications around the globe, he proposed a new equation between art and reality. Moreover, he set up a confrontation between language pertaining to ideas and the informational texts of media sites. In this manner, he knit together otherwise separate communicative systems. Although both are based on language, their signifying purposes, abstract and promotional respectively, are alien to one another except within the province of art.

The Third, Fourth, Fifth, and *Sixth Investigations* (1968–71) recontextualize existing forms of textual 'material' within the context of art. *The Third Investigation (Art as Idea as Idea)*, subtitled 'One Introduction and Three Contents,' was designed to be printed on advertising placards of subways and buses during 'Recorded Moments,' an exhibition organized in 1970 around the theme of time by the Moore College of Art, Philadelphia. This Investigation consisted of 'An announcement of the information of the availability (library and private purchase) and public notification of their "Art Condition"' of: the introduction to *The Philosophy of Time* edited by Richard M. Gale and the table of contents to *Man and Time* by J. B. Priestley, *Time in Literature* by Hans Meyerhoff, and the anthology *Time and its Mysteries*, also by Meyerhoff. Timely books on time were, in a manner of speaking, given a chance to sell themselves and their content within the context of advertising. But, operating within the context of art, the bibliographical citations advanced the idea that aesthetic content could be predicated on the textual instead of on material physicality.

The Fourth Investigation, composed of gummed labels on which instructions were crudely typed, addressed the 'four concerns' given on the first label:

A. ART AS CONCEPT (AS IDEA)
B. ART AS INFORMATION (AS IDEA)
C. ART AS VISUAL EXPERIENCE (AS IDEA)
D. INVESTIGATION OF CHANCE FOR NON-COMPOSITIONAL PRESENTATION

The labels were glued to a twenty-foot stretch of wall during the 1969 exhibition 'Number 7,' organized by Lucy Lippard for the Paula Cooper Gallery, New York. Correlated with the period of the exhibition from 18 May through 15 June, each label was given a date. The label texts enjoined viewers to take charge of creating their own experience based on imperative phrases such as the one for 7 June/Saturday:

1. TAKE A JET RIDE TO LOS ANGELES
2. (OR,) VISIT LAS VEGAS
3. READ AT RANDOM THROUGH: "THE McGRAW HILL ENCYCLOPEDIA OF SPACE" McGRAW HILL, N.Y.
4. LOOK AT MANHATTAN FROM THE TOP OF THE EMPIRE STATE BUILDING.

Composed only of language and reminiscent of constructive, game-like directives for children once found in daily newspapers, the work is neither depictive nor compositional. As opposed to instructional Fluxus works, which it superficially resembles, *The Fourth Investigation* does not aim to initiate performative activity per se but to 'illustrate,' via language itself, that language forms the basis of proposals and propositions leading to engagement with the world outside the self.

The Fifth and *The Sixth Investigation* similarly experiment with ways to promulgate the ideational basis of art by linguistic means. As in the prior Investigations, linguistic forms are directly appropriated from previously published sources or modeled upon their usage in the culture. Exhibited in the Whitney Museum's '1969 Annual Exhibition: Painting,' the former consists of riddles found in the branch of philosophy that deals with logic and mathematics. These brain-teasers, like the example below, stress the importance of mental dexterity as a component of art production and reception in place of an artist's dexterity of hand or a viewer's visceral response:

IF TOM IS TWICE AS OLD AS HOWARD WILL BE WHEN JACK IS AS OLD AS TOM IS NOW, WHO IS THE OLDEST, THE NEXT OLDEST, AND THE YOUNGEST?

They also posit the idea that abstract forms of reasoning might be subjects for a work of art for which the act of questioning – free of the onus of giving an answer – is a function of viewing.

Lewis Carroll's 'Sets of Concrete Propositions, proposed as Premises for Soriteses: Conclusions to be found' from Book VIII, Chapter I of his *Symbolic Language* (a textbook on logic published in 1896 by the Reverend Charles Lutwidge Dodgson under the pseudonym he also used for *Alice's Adventures in Wonderland*), supplies the content of *The Sixth Investigation*. In his Introduction, Carroll, speaking to his readers, advises following the rules laid out for approaching a book meant for 'mental recreation,' affirming that the study of symbolic logic 'will give you clearness of thought – the ability to *see your way* through a puzzle – … and, more valuable than this all, the power to detect *fallacies* … in books, in newspapers, in speeches and even in sermons….'[44] Carroll's examples of soriteses begin as follows, as does *The Sixth Investigation*:

1.
(1) Babies are illogical
(2) Nobody is despised who can manage a crocodile;
(3) Illogical persons are despised.
Univ. "persons"; A – able to manage a crocodile; B – babies; C – xxxxxxx; D – logical

and continue:

2.
(1) My saucepans are the only things I have that are made of tin;
(2) I find all YOUR presents very useful;
(3) None of my saucepans are the slightest use.
Univ. "things of mine"; A – made of tin; B – my saucepans; C – xxxxxx; D – your presents.

Answers to these linguistic puzzles, which explore the underpinnings of sensible versus nonsensical discourse may be found elsewhere in Carroll's book but not in Kosuth's work. Once again, existing formulations in language replace compositional form. Models of analysis and problem-solving, in this case, invest the work with subject matter derived from linguistic tools for sharpening deductive methods of reasoning. Omission of solutions to Carroll's examples (or any reference to their source) makes *The Sixth Investigation* purposely puzzling rather than didactic or definitive.

Like *The Second Investigation*, 'Proposition One' of *The Seventh Investigation* appeared in four different public contexts in 1969 and 1970: in Italian on a large banner strung across a thoroughfare in Turin, Italy; in English and Chinese on a billboard in New York City above a sign advertising J&B Scotch whisky; as a wall text in 'Information' at the Museum of Modern Art, New York; and at the bottom of page 11 as an advertisement in the *Daily World* (Saturday, 5 September, 1970), a Communist newspaper published in New York. Within these varied contexts, Kosuth inserted a text about mental functions taken from a book on psychology that reads:

1. TO ASSUME A MENTAL SET VOLUNTARILY. 2. TO SHIFT VOLUNTARILY FROM ONE ASPECT OF THE SITUATION TO ANOTHER. 3. TO KEEP IN MIND SIMULTANEOUSLY VARIOUS ASPECTS. 4. TO GRASP THE ESSENTIAL OF A GIVEN WHOLE; TO BREAK UP A GIVEN WHOLE INTO PARTS AND TO ISOLATE THEM VOLUNTARILY. 5. TO GENERALIZE; TO ABSTRACT COMMON PROPERTIES; TO PLAN AHEAD IDEATIONALLY, TO ASSUME AN ATTITUDE TOWARD THE 'MERE POSSIBLE,' AND THINK OR PERFORM SYMBOLICALLY. 6. TO DETACH OUR EGO FROM THE OUTER WORLD.

By slotting phrases from one contextual situation into a second, unfamiliar one, Kosuth spliced otherwise unrelated text and context together. *The Seventh Investigation* exhibits how the former depends on the latter, since it demonstrates that meaning arises as much from how language is positioned as it does from what it states. While such a text may be out of context

Joseph Kosuth **The Seventh Investigation (Art as Idea as Idea)** 1969

Joseph Kosuth **Information Room** 1970 (Kunstbiblioteket Lyngby, Denmark)

Joseph Kosuth **The Eighth Investigation, Proposition 3** 1971 (Leo Castelli Gallery)

on a banner, billboard, or in a newspaper advertisement, it is unavoidably contextualized within the construct of art. More than that, however, the idea that a text with an agenda for thoughtful action is able to enter, under the aegis of art, into a non-art context in the public domain, lies at the heart of the work.

The *Information Room* (1970), from which the *Eighth* (1971), *Ninth* (1972–73), and *Tenth Investigation* (1975) evolved, was instituted by Kosuth as a way to treat the exhibition space as a venue for knowledge rather than as a container for objects. Realized more than once, one *Information Room* was installed in 'Conceptual Art and Conceptual Aspects' at the New York Cultural Center and another in an actual library in Denmark. A work comprising multidisciplinary texts set on reading tables, it turned the traditional art-viewing context into an environment for intellectual consumption. Of major significance, *Information Room* collapses reading material into the material of a work that is physically contained within its own walls while it thematically extends beyond them. Providing a point of intersection between reader/viewer and informational sources, the work offers itself as a catalytic model for cultural enlightenment and change.

By the late 1960s Kosuth had become acquainted with the founders of Art & Language, a collaborative group continuing to this day whose number of members, often in flux, reached its peak in the mid-1970s.[45] Art & Language (A&L) was founded in Coventry, Britain in 1968 when Terry Atkinson (b. 1939), David Bainbridge (b. 1941), Michael Baldwin (b. 1945), and Harold Hurrell (b. 1940) joined forces. Atkinson and Baldwin had already been collaborating on a number of significant pre-A&L projects, as had Bainbridge and Hurrell with whom they were in communication by the time of the latter's 1967 'Hardware Show' in London at the Architectural Association.[46] In the following years, A&L extended its base of operation to include participants living in New York. By the mid-1970s, this shifting body of co-workers, residing on both sides of the Atlantic, numbered some thirty to forty individuals.

The earliest activities of A&L centered around establishing the Art & Language Press and the publication of the journal *Art-Language*. The first issue, edited by the founding four, appeared in May 1969 bearing the subtitle (on this issue only) *The Journal of Conceptual Art*. On the masthead of the next two issues,

published in February and June 1970, the name of
Kosuth, invited to serve as American editor, was added
to those of the founding members. The following year,
art historian Charles Harrison (b. 1942), who has
chronicled the A&L project and is a participant in it,
assumed responsibility for the journal as general editor
after having left his post at *Studio International*. Nineteen
issues of *Art-Language* (ending with Volume 5, Number
3 in March 1985) were published and, after more than a
decade-and-a-half hiatus, is being published again.
Unprepossessing in scale and design, *Art-Language*
documents the protean nature of A&L concerns.

The merging in 1971 of A&L with the New York-
based Society for Theoretical Art and Analyses (as well
as its journal *Art Press*), formed in 1969 by Ian Burn
(1939–93), Mel Ramsden (b. 1944), and Roger Cutforth
(b. 1944), marked an important step in the evolution of
what would come to be a highly charged collaborative
effort. Burn and Ramsden had met in Australia as
students. Both moved to London in 1965 and to New
York in 1967. Prior to their contact with *Art-Language*,
where they published texts at the end of the 1960s, they
had enjoyed a close working relationship and jointly
created a number of works.

Works by Burn and Ramsden share common ground
with those of Atkinson and Baldwin regarding 'matters
of linguistic/pictorial referentiality.'[47] Their respective
early works, in each case, anticipate the full-blown,
textual production of A&L. Conceived, although never
exhibited, for a gallery exhibition in Australia, Burn and
Ramsden's *Soft-Tape* (1966–67) gives voice, in all
actuality, to the idea of representing a viewer-dependent
cognitive space existing in place of the illusionistic space
of painting or the displaced space of sculpture. Meant to
be played on a tape recorder set in a gallery, the work is
an audio text that in part asserts:

> It seems to us that light, space, time, materials,
> motion, all exist as a tremendous fabric. Nothing of
> this fabric should be twisted or cut; the world
> should be left just as it is. The determination of
> such elements is, of course, still in question. We
> suggest that one can use a spectator to determine
> a work.[48]

A printed text explains that a particular positioning near
the recording equipment and a degree of concentration

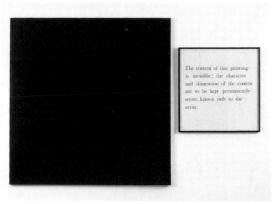

Art & Language **Secret Painting** 1968

is required if the tape's words are to be grasped. Of note
is the text's final statement: 'ANY determining decisions
a spectator makes while confronting the mechanism
are to be considered a part of the intent of the work.'[49]
The placement of the spectator, by means of language,
at the 'center' of the work to serve as an active agent
rather than as a passive onlooker, forms the core of the
A&L project.

By inclusion of the written word, Ramsden's paintings
'approach' the spectator through language at the same
time that they seek to disqualify pictorial attributes such
as texture, form, and color as the sole prerequisites for
aesthetic meaning. By way of example, *Secret Painting*
(1967–68) parodies the black Abstract Paintings of
Ad Reinhardt or reductive, abstract works in which
'nothing' (in the way of a scene or composition) seems
to be there but which nonetheless remain encoded
according to their surface qualities, however pared down.
In this particular work by Ramsden, a modestly scaled,
square, black acrylic on canvas hangs to the left of a
smaller, framed photostat, which reads:

> The content of this painting is invisible; the
> character and dimension of the content are to be
> kept permanently secret, known only to the artist.

The Minimal idea of a self-reflective, painted surface
(which presents what it is, and nothing more, as its
content) is carried linguistically by Ramsden to another
level of consideration. In *Secret Painting*, what is clearly
a painting and what is equally clearly a text are
inextricably tied together; the former, the viewer is told,

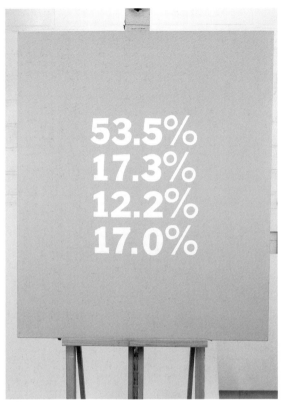

Art & Language **100% Abstract** 1968

is without visible content inasmuch as the latter 'illustrates' this verbally. The work's verbal component thus controls meaning, paradoxically, by means of its assertive negation, which parodies while seeming to remedy the seeming vacancy of wordless Minimal canvases.

Content in Ramsden's 100% Abstract paintings (1968) is derived from the splicing together of painted and ideographic representation. Centered on the canvases of this series is a large-scale pair of numbers, decimal points, and percentage signs placed one above the other. For instance, '72.5%' above and '27.5%' directly below, are painted in white acrylic and surrounded by a field of grey. Comparable in approach to On Kawara's date paintings, Ramsden's paintings are similarly self-descriptive, but numbers, symbols, and punctuation marks refer to the proportions of chemicals, printed on the can, that make up the paint on the canvas instead of to the work's date of execution. His 100% Abstract paintings, in double-edged fashion, cut to the quick of ideas regarding modes of depiction based on the signifying propensity of paint. By means of fact-bearing ciphers, they suppress illusion and metaphor by representing only the physical constituents of their paint.[50]

Paintings by Burn from the same period in which he used automobile lacquer, present shiny, reflective monochromatic surfaces. With regard to works such as *Blue Reflex* (1966–67) or *Grey Reflex* (1966–67), the artist wrote that 'surface is not important' and furthermore that 'the work retains no fixed appearance,'[51] being constantly altered by external factors including ambient light intensity, viewing angle, and visual incident incurred by the presence of one or more viewers. The six framed mirrors of *1–6 Glass/Mirror Piece* (1967) dispense altogether with the use of paint, retaining their ties with painting only because of their rectilinearity and the fact that they hang on the wall. By virtue of their mimetic reflectivity they offer simulations of reality. As objects of daily use, they are employed by Burn to prompt consideration of aesthetic purpose within an art context.

Burn's *Mirror Piece* (1967) and *Undeclared Glasses* (1967) introduced printed texts written by the artist. Text in the former is contained behind thirteen separate pieces of glass along with one framed mirror. In the latter, a single framed text on the wall is accompanied

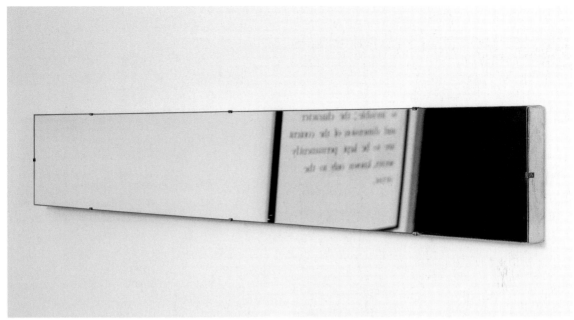

by two sheets of glass on the floor that lean against the wall. With their inclusion of unembellished, analytic language, these pieces draw attention to the fact that they are made up of a conceptual component, here combined with, but distinguished from, the perceptual and functional aspect of mirror and glass. As such, they furthered Burn's interest in questioning accepted determinants of art.[52]

The title of Burn and Ramsden's *Six Negatives* (1968–69) refers to the physical and mental processes by which the artists arrived at this work and to the nature of its subject matter as well as to its photographic reversal of text and background to white-on-black in one of its versions. Derived, like Kosuth's *The Second Investigation*, from Roget's 'Synopsis of Categories,' *Six Negatives*, however, is built upon modes of subtracting rather than of extracting text for contextual relocation. In early versions of the thesaurus, positive terms belonging to Roget's six Classes of Categories are arranged in a left-hand column and juxtaposed with a right-hand column of negative terms. The positive terms are crossed out by the artists with the heavy lines of a black ink marker. Burn remarked subsequently that 'this work has no meaning or value as an aesthetic object and… is only representing the art condition; that is, it is a record rather than a picture of the art process.'

Ian Burn | **Undeclared Glasses** | 1967

Art & Language **Six Negatives (detail)** 1968–69

Art & Language **Six Negatives** 1968–69

He concludes that physical experience of this work does not add to it in any way, 'possibly due to the work being about something which is incapable of being pictured.'[53] The work proposes the idea that, to be 'art,' an object need not be a pictorial and/or material statement. It accomplishes this by turning the act of obliteration into one of assertion, that is, the idea of negation is registered as a concrete visual process of mark-making. As Burn further pointed out, 'one must recognise the systems for dealing with language before one can "see" the work.'[54] Ramsden, for his part, maintains that the work was an attempt to 'damage' language in order to 'make art out of what was left over.'[55] In other words, *Six Negatives* may be understood in terms of measures taken by Burn and Ramsden for destroying worn out aesthetic structures in order to rebuild them from the ground up using the ruins of language.

Works by Atkinson and Baldwin predating the official formation of A&L share common ground with those of

We need objects?

One may argue that an extensional object is merely designated, i.e. it is directly referred to in a Fregean context, it is distinct from 'idea' and the set of properties which make it up. The 'mode of presentation' of that object may be said to subsist somewhere between the concept, if you like, or idea (of it) and its simple designation - its simple picking out, distinguishing from others. It is that which is designated. The mode of presentation, or object constituted in terms of mode of present-ation is not the object itself in this extensional sense, nor is it anything entirely 'subjective' or, if you like, accountable only in a private experiential or ideational domain. In the Fregean system one can effectively compare the 'object', the 'mode of presentation'. I associate object and the ideational one with the table, the cube - the cube as a relational entity presented sensorily in a certain way, and the retinal image of each individual spectator.

Intention as 'the object in a certain mode of presentation'. For reasons of antipsychologism, Frege wanted to make sure that the object, in the extensional sense should neither be confused with its mode of presentation nor the idea of it.

Art & Language **38 Paintings: No. 11** 1966

Burn and Ramsden. Not unlike Burn, Baldwin had made 'paintings' of an ambiguous nature in 1965 by mounting mirror on canvas. These precede the photostated panels he made with Atkinson a year later, which present printed excerpts from writings by them or by others. As in the case of a mirror Painting, a photostated text-panel Painting possesses an 'intrinsically unpictorial surface [that] is inevitably pictorial.'[56] Although remaining blank insofar as painted representation is concerned, a mirror functions as a site of visual information. Photostated Paintings are 'filled' with the language of instruction, discussion, analysis, speculation, and of debates applicable to aesthetic practice, but, like a mirror, are devoid of formal, compositional content. Comparable with the reflective surface of a mirrored painting, which does not depict anything yet has content nonetheless, the photostated works embody ancillary areas of thought that linguistically support or surround works of art. A paragraph from the longer text

of *38 Paintings: (Painting No. 5)* (1966), for example, analyzes (with an ironic aside to the essential forms of Minimalism) the visual properties of a cube:

> The cube is taken and placed in position so that one face only can be seen. If the cube is now rotated on a vertical axis the second face will gradually come into view and, if rotation is continued, the first face will disappear and the second face only will be visible.[57]

During the period of their collaboration prior to 1968, Atkinson and Baldwin created works thematically involving the revocation of established canons of representational content. *A Map to not Indicate…* (1967), a letterpress print in an edition of 50, sums up its own subject matter in its title, which includes half a dozen lines of capitalized text commencing with CANADA, JAMES BAY, ONTARIO, QUEBEC, ST. LAWRENCE

Map to not indicate: CANADA, JAMES BAY, ONTARIO, QUEBEC, ST. LAWRENCE RIVER, NEW BRUNSWICK, MANITOBA, AKIMISKI ISLAND, LAKE WINNIPEG, LAKE OF THE WOODS, LAKE NIPIGON, LAKE SUPERIOR, LAKE HURON, LAKE MICHIGAN, LAKE ONTARIO, LAKE ERIE, MAINE, NEW HAMPSHIRE, MASSACHUSETTS, VERMONT, CONNECTICUT, RHODE ISLAND, NEW YORK, NEW JERSEY, PENNSYLVANIA, DELAWARE, MARYLAND, WEST VIRGINIA, VIRGINIA, OHIO, MICHIGAN, WISCONSIN, MINNESOTA, EASTERN BORDERS OF NORTH DAKOTA, SOUTH DAKOTA, NEBRASKA, KANSAS, OKLAHOMA, TEXAS, MISSOURI, ILLINOIS, INDIANA, TENNESSEE, ARKANSAS, LOUISIANA, MISSISSIPPI, ALABAMA, GEORGIA, NORTH CAROLINA, SOUTH CAROLINA, FLORIDA, CUBA, BAHAMAS, ATLANTIC OCEAN, ANDROS ISLANDS, GULF OF MEXICO, STRAITS OF FLORIDA.

Art & Language **Map to not Indicate:** CANADA, JAMES BAY... STRAITS OF FLORIDA 1967

SEAWAY, NEW BRUNSWICK, MANITOBA, AKIMISKI ISLAND, LAKE WINNIPEG on the first line and ending with ⌈SOUTH CAROL⌉INA, FLORIDA, CUBA, BAHAMAS, ATLANTIC OCEAN, ANDROS ISLANDS, GULF OF MEXICO, STRAITS OF FLORIDA on the last. Serving as both a caption to and content of the work, the titular list is printed below a rectangle in which the outlined shapes of Iowa and Kentucky, respectively labeled, float toward the upper left corner of an otherwise vacant field. What is missing – premised on the work's a priori definition as a map – are the typical configurations that designate the outline and positioning of geographical areas. Denuded of graphic elements pertaining to land masses, *Map to not Indicate…* indicates the takeover by language of the territory once administered almost exclusively by shape and form.

A project such as *Air Show* (1966) by Atkinson and Baldwin takes form as an essay within *Frameworks* (1966–67), published by Art & Language Press in 1968 in a numbered edition of 200. *Air Show* is accompanied in *Frameworks* by other 'shows': 'The Air-Conditioning as Device' and 'Some Thoughts on Air-Conditioning as a Technical Vehicle.' Baldwin's related 'Remarks on Air-Conditioning' was submitted by Robert Smithson to *Arts Magazine* and published in its November 1967 issue. 'Air Show' substantiates the two artists' understanding of the exhibition 'space' as a linguistically understood premise that transcends a gallery's existence as the physically defined premises for art. Taken together, these shows are to be thought of as 'a challenge to the million years habit of identifying things.'[58] The outcome of experimentation and desire for conversation and dialogue as a necessary component of such works occasioned different formats for presentation as the artists recycled them from one textual/cultural venue to another. For example, *The Air-Conditioning Show* included an actual air-conditioner when displayed in Coventry in 1967. When this exhibition was restaged at the School of Visual Arts, New York in 1972 as an exhibition organized by Kosuth, a cooling unit was similarly put on view. A flyer, including 'Remarks on Air-Conditioning' from *Arts Magazine* and other reprinted texts, was pinned to the wall and was also available as a handout.

So as not 'to get casuistically stuck with "picturing," or with the pure or the alloy of visualization,'[59] the artists verbally canvass possibilities for specifying the existence

Art & Language **Study for the Air-Conditioning Show** 1967

of a column of air in *Air Show*.[60] Such a mass is defined as a matter for inquiry rather than simply as physical matter. Inquiry regarding the air's physical definition centers on the proposal for a thermodynamic study of the air and the justification for such a procedure. *Air Show* – which includes, in addition to the text in *Frameworks*, separate tabulations on paper such as *Three Vocabularies for The Air Show* (1966) – is not about materiality in its greatest degree of incorporeality nor about the idea of infinite space, but is about the process of examining a possible, if invisible, condition. Atkinson and Baldwin's column of air, a theoretical appropriation from reality resting on a one square-mile base, undergoes a rigorous analysis that includes study of the possible effects of temperature on air mass. A tour de force of argumentation in language adopted from science and philosophy, *Air Show* lays out all the 'necessary

conditions for an occurrence' with the intended result of squeezing the remnants of extraneous 'juiciness' from a work described as 'visually "non-juicy."'[61]

By the time A&L was invited to participate in the 1972 'Documenta V' exhibition in Kassel, Germany, its membership had increased to include students of Atkinson and Baldwin at Coventry College of Art, among them Graham Howard (b. 1948), Lynn Lemaster (b. 1949), Philip Pilkington (b. 1949), and David Rushton (b. 1950).[62] The first of the Indexes produced by A&L during the next couple of years, *Index (01)*, carried earlier A&L initiatives to a level of public visibility not previously enjoyed (or necessarily sought after). This ambitious project dramatically synthesized the goals of a collaborative driven by the quest to liberate art from material(istic) autonomy and subservience to the notion of the signature artist. With the emergence of A&L as an enterprise grounded in language rather than in paint or the traditional materials of sculpture, 'it became gradually if unevenly possible,' as Harrison cogently has expressed it, 'to conceive a breaking down of those hierarchies which had served absolutely to distinguish the critical from the aesthetic and art from language.'[63] Sensational in its foreclosure of all sensuous qualities that attempt to reach out to the bystander by dazzling the eye or by being entertaining or 'attractive,' the Documenta Index invites viewers to share responsibility for the production of meaning by perusing the material – textual through and through – made available to them.

Installed in a room of its own, *Index (01)* is a compilation of printed and typed texts housed within four pairs of grey metal files set on blocks at eye level. Forty-eight different drawers – six per cabinet – contain xeroxed copies of the articles published in *Art-Language* (and in Rushton and Pilkington's two issues of *Analytic Art*, a student publication) as well as unpublished manuscripts by A&L members. Arranged in alphabetical and sub-alphabetical sequence in the order of their completion or degree of completeness, separate pages of text are hinged together inside flip file drawers. A coded alphabetical listing, or index, is placed at the beginning of each pair of file cabinets. Correlated to each of the published and unpublished inclusions, the index runs not just from A to Z, but also from A(i)a to Z(i); A(ii)a to Z(ii); and A(iii)a to I(iii), since subcategories were necessitated by the number of texts. Entries A through G in the first cabinet, for example, comprise articles from

the first volume of *Art-Language*, including key pieces by non-members Sol LeWitt, Dan Graham, and Lawrence Weiner, in addition to the two texts by Bainbridge and one by Baldwin in the same issue.[64]

The nearly one hundred texts of *Index (01)* evidence the wide-ranging nature of the burgeoning A&L project, which, not limited to questions exclusively related to art and aesthetics, encompass topics pertaining to language, photography, philosophy, science, society, ethics, morality, education, etc. Serving as a documentary record of several years of discussion, dialogue, and debate among A&L participants, *Index (01)* is not merely an impressive compendium of writings. On a more profound level, it conveys the spirit of analysis behind the large body of writings that are conceptually colligated as an aesthetic enterprise in storage units typically found in offices.

A key at the top right of each bank of files explains the cross-referencing system used by A&L to index the interlocutory process revolving around texts in relation to other texts. The symbols '+,' '–,' and 'T,' respectively, indicate compatibility, incompatibility, or lack of relational value determined by scrutiny of a single text in the Index in relation to others within it. As stated in the first lines of the lengthy preamble of the work's accompanying poster, *Documenta Memorandum (Indexing)*, 'Indexing problems are quite interesting. They are coincident with the difficulties encountered in mapping the space in which our conversation takes place.'

The printed, codified results of indexing are papered to the wall from floor to ceiling when the work is put on view. While some sections present substantial degrees of comparative activity, others are relatively short:

B (iii) c
(+) A (iii) b1 P(i) Z(ii)1 D(ii)126 D(iii) a*
(–) B (ii) a*
(T) F (iii) A(ii)cf B(iii)b H(iii)abc

Presentation of the outcome of such analyses affords viewers (who have chosen to enter the work as reading subjects) the possibility of participating in the cross-referencing process. Rather than being asked to address the material in the filing cabinets sequentially from start to finish, spectators may engage with the texts by referring to the wall codifications, yet remain at liberty to deal with the material in their own ways.

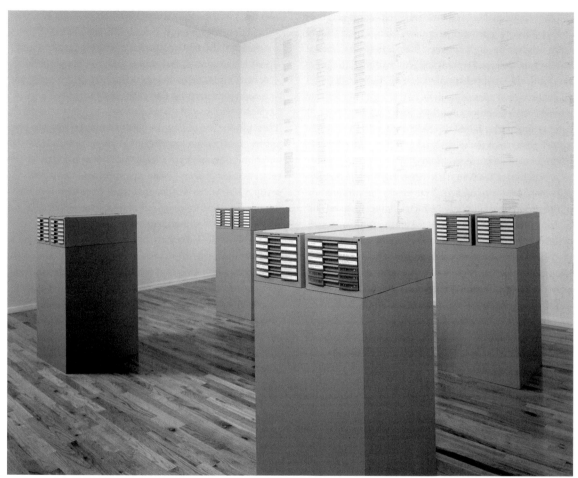

Art & Language **Index (01)** 1972

AN ARTIST IS NOT MERELY THE SLAVISH
ANNOUNCER OF A SERIES OF FACTS.
WHICH IN THIS CASE THE CAMERA HAS
HAD TO ACCEPT AND MECHANICALLY
RECORD.

John Baldessari **An Artist is Not Merely the Slavish Announcer...** 1966–68

Photography: Restructuring the Pictorial

Photography, the light-sensitive medium developed in the nineteenth century, is now taken for granted as a visual system of communication second only to language. Much as the way the spoken or written word relates to literature, photographs operate both inside and outside the framework of aesthetic practice. With its ability to imprint on film what is set before a camera lens, photography runs the gamut of art genres from portraiture to landscape while functioning in a multiplicity of non-art circumstances from news reportage to advertising. Its short history as a Fine Art is enriched and complicated by its positioning in relation to painting, whose descriptive methods it once threatened to replace and with whose pictorial effects it often competed, as well as by questions of original intent versus eventual reception. With the introduction, furthermore, of easily portable cameras and equipment, photography became a commonplace medium available to the amateur as well as to the professional.

The artists who turned from painting and sculpture to photography in the late 1960s found the means to reassess pictorial and sculptural concerns without redress to authorial signs of the hand, compositional arrangement, painted illusionism or three-dimensional materiality. The oeuvres of Bernd and Hilla Becher (b. 1931 and 1934), Jan Dibbets (b. 1941), John Baldessari (b. 1931), Douglas Huebler (1924–97), Gilbert and George (b. 1943 and 1942), and Victor Burgin (b. 1941) bear witness to the ways in which the medium of photography was set free from its former subordination to painted or sculptural form. In contradistinction to the classification of photography as a category of fine art with its own set of rules and criteria (comparable to the respective art versus non-art history and use of film and video), this medium was discovered by artists to be a means for addressing issues of representation that, until the 1960s, had remained in the purview of painting and sculpture.

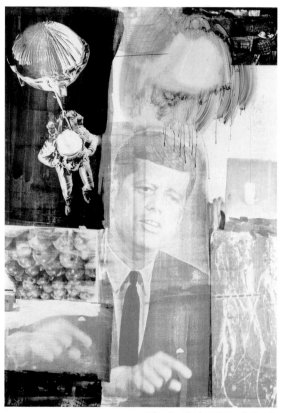

Robert Rauschenberg | **Retroactive I** | 1964

The full-fledged entry of photography into the domain of painting and sculpture in the second half of the century was inaugurated by Robert Rauschenberg's inclusion of photographs (along with news clippings and reproductions from the media) in his Combine Paintings dating from 1954 and his Silkscreened Paintings begun in 1962. The Combines have their roots in the earlier twentieth-century tradition of collage, but Rauschenberg's gestural application of oil on canvas sets the Combines firmly within the discourse of painting.

Ed Ruscha **Thirtyfour Parking Lots in Los Angeles** 1967 (cover)

Ed Ruscha **Thirtyfour Parking Lots in Los Angeles** 1967 (page detail)

A student of photography at the interdisciplinary Black Mountain College in North Carolina in the late 1940s, Rauschenberg abandoned the youthfully considered idea 'to walk across the United States and photograph it inch by inch in actual size.'[1] Such a goal nonetheless speaks to his desire to take possession of the visible world in an all-encompassing, non-judgmental manner.

With the insertion of his own or found photographs into the overall format of painting, Rauschenberg brings the panoptic aspect of life into a kaleidoscopic view on the canvas. Photographic elements in the Combines join with lowly, non-art objects to present a comprehensive view of everyday reality and materials that vie with the material reality of paint. Rauschenberg's introduction of commercial silkscreening techniques allowed him to transfer a photographic image to another flat surface as well as to enlarge it. The silkscreen paintings tap even more insistently into the real world from within the context of painting. They succeed in suggesting – without seeking to spell out – the myriad formal, verbal, and thematic points of cross-reference and correspondence that typify his art. Photography in the work of Rauschenberg as, for example, in the work of Gerhard Richter, notably performs its representational task in alliance with painting. Rather than providing an alternative to the canvas surface, photographs reinforce painting's reach toward existing reality without proposing a take-over of painting.

Works by Ed Ruscha from the early 1960s foreshadowed the definitive liberation of photography from its subordination to painting and sculpture. Ruscha's photographs are contained within small, self-published, once modestly priced books that complement his works on canvas (discussed in the preceding chapter) whose imagery derives from popular culture and the media. The earliest of more than a dozen such publications include *Twentysix Gasoline Stations* (1963), followed by *Various Small Fires and Milk* (1964), *Some Los Angeles Apartments* (1965), *Every Building on the Sunset Strip* (1966), *Royal Road Test* (1967), and *Thirtyfour Parking Lots in Los Angeles* (1967).

Ruscha's books are noteworthy for the banality of their subject matter – the filling stations, buildings by unknown architects, and parking lots endemic to the American urban landscape. The stations, relegated one to a page in *Twentysix Gasoline Stations*, are in no apparent order but exist as a factual presentational

sequence to be followed from page to page as one travels through the little book. By not glamorizing his subject matter, Ruscha has treated each image in a straightforward, deliberately artless manner and ignored the usually sought-after artful effects of lighting, cropping, composition, or print quality. What Ruscha proposes in place of an aestheticized documentary is truth to his subject matter. His withdrawal of overt authorial comment and interpretation legitimizes compilations that, in a factual manner, focus on highlighting specific manifestations of vernacular culture.

Along with language, photography has provided an alternative to the descriptive and depictive nature of painting. Since the late 1960s it has been employed, as by Ruscha, to record an object or event. In works by Bruce Nauman or Joseph Kosuth, for example, the photograph assumes a representational function outside the parameters of a painting, sculpture, or book. Individual photographs assuming documentary status, moreover, commonly participate in composite works. They incorporate more than one singularly framed image or involve other modes of representation such as maps or language.

Photographic pieces by artists such as Richard Long (b. 1945), Dennis Oppenheim (b. 1938), and Eleanor Antin (b. 1935) exemplify how the documentary dimension of a work may be enmeshed with its formal, material, and ideational realization. By virtue of the camera's ability to record any scene or scenario that appears in front of it, the performative and photographic act fuse in works pertaining to the landscape and/or the body. Although photographs often may simply serve as a record of an ephemeral or performed event, in the work of Long, Oppenheim, and Antin, photographic medium and subject matter taken by the camera, to varying and lesser degrees, go hand-in-hand to determine the resulting work.

'I am an artist who sometimes chooses to use photographs, although I am not a photographer,'[2] Richard Long maintains. Prior to attending St. Martin's School of Art, London from 1966 through 1968, Long had begun to work outside of the studio in direct contact with nature. His first outdoor work, *Snowball Track* (1964), was 'a snowball drawing.'[3] By steadily rolling a snowball, the artist inscribed a line on the ground as the ball picked up more and more snow along its route.

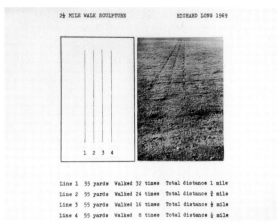

Richard Long **A 2½ Mile Walk Sculpture** 1969

Having thenceforth gone outside the studio to collect his materials, Long is known for indoor floor sculptures consisting of large stones or chunks of rock or of desiccated driftwood as well as for his photographic works. The floor sculptures cut linear paths through the exhibition space or are arranged in the shape of a circle. In lieu of physically realizing a sculpture in a museum or gallery situation, Long also draws his journeys on maps. His itinerary may form a geometric or linear pattern, or else the shape of a walk may be determined by given features of the land. The work's title, such as *A Six Day Walk Over All Roads, Lanes and Double Tracks Inside a Six Mile Wide Circle Centered on the Giant of Cerne Abbas, England* (1975), details the program and route the artist followed.[4]

Many works by Long, which likewise draw both from and upon nature, are photographs. One of his earliest, *A Line Made by Walking, England 1967* (1967), enframes a line of trampled grass that stretches from the bottom of the image toward a clump of distant trees at the top. *England 1968* (1968) represents an X-shape created by treading through a field of daisies. *A 2½ Mile Walk Sculpture* (1969) documents the creation of four parallel lines of equal length in the ground. The number of miles covered by the artist are charted by four black lines. Accompanied by a descriptive caption, which enumerates back and forth distance covered, the lines are shown in association with a photograph of the indentations Long pounded into the earth by walking.

Although the photographic work is 'different from the place and the stones and whatever,' as Long has

suggested, it is 'the appropriate way for that place to become art in the public knowledge'[5] and be seen by an audience. Single, captioned photographs, accounting for much of Long's production over the years, provide 'a factual record'[6] of either linear paths traced in the ground during a particular walk – usually in remote areas – or sculptures made with materials found along the way. Long always takes his photographs with the same Nikkormat camera and lens in order to 'keep everything simple and straightforward.'[7] Together, the photographic print and caption evince the activity invested in the work and encapsulate the experience of a walk in the nearby English countryside or in a desolate area of the globe. The photograph, moreover, betokens the artist's direct interaction with nature in places that remain untarnished by urbanization.

For Dennis Oppenheim, photographs initially served to document a fait accompli although, retrospectively, they have had to stand in for the large-scale works of the late 1960s he incised in the earth as well as for works after 1970 that use his body in connection with the land.[8] Like Long, Oppenheim found it necessary 'to go outside the bounds of a loft area into the use of the earth,' which from above appears like a pictorial surface and from below is 'more volumetric… like walking through a sculpture.'[9] Schooled in California, Oppenheim moved to New York in 1966 and soon thereafter realized his earthwork pieces. *Annual Rings* (1968) was constructed on the border of the United States and Canada and *Directed Seeding* (1969) in Holland. Based on the pattern of a tree's growth rings, but immensely enlarged, the former work was laboriously cut into winter ice to form concentric, circular paths on either side of a river.[10] The latter work also existed on a magnified scale. An entire field provided the surface upon which a tractor etched parallel, undulating lines into the ground for the planting of wheat. *Cancelled Crop* (1969) provided a sequel when the full-grown wheat was harvested in the shape of an X. Dissimilar from the X-shape in Long's *England 1968* produced by walking, Oppenheim's X-shape was produced on a scale necessitating mechanized harvesting equipment. Furthermore, at a symposium at Cornell University, New York during the exhibition 'Earth Art' at the Andrew Dickson White Museum of Art in 1969, Oppenheim remarked that 'there is no need for me to photograph my work.'[11] If Long's daisy field was never intended for viewing except in a photograph,

Oppenheim's earthworks, to the contrary, were, ideally, to be directly observed at the site.

Photographs in Oppenheim's Gallery Transplants of 1969 and ensuing pieces involving the body convey what transpired in transpositions using land or skin surfaces as grounds for formal transference. *Gallery Transplant* (1969), for instance, comprises a map of Jersey City, a floor plan of the Stedelijk Museum, Amsterdam, and a photograph of the actual, full-scale drawing of the museum's plan, which the artist etched in the dirt on a plot of land in New Jersey. The photograph in this particular work provides visible evidence of what took place in the transaction without claiming to replace the once extant physical work.

Crossing the thin line between strict, two-dimensional documentation of an existing three-dimensional work, *Reading Position for Second Degree Burn* (1970) literally embodies the photographic process. It primarily concerns the creation of a white rectangle on red skin through the artist's exposure to the sun while he was lying on the sand with a copy of a red book on military tactics covering his chest.[12] Without the before-and-after photographs, the work could not have been brought to view since it was performed only in front of a camera and not for an audience.

Eleanor Antin has enacted or staged works specifically for the purpose of photographing them. *Carving: A Traditional Sculpture* (1972) operates, like Oppenheim's witty use of the sun, with a strong element of humor. The artist, having been photographed successively in front of the same door, portrays her progressive weight loss over a thirty-six day period in a series of small black-and-white shots taken in the nude from the front, back, and side. Weaving the concept of feminine beauty into a demonstration of seriality, she gives the work a feminist twist. Antin ironically 'carves' a sculpture based on the traditional assumption that a woman is an object, while the finished work rejects definition as a volumetric material object.

From the time *100 Boots* (1971–73) was begun to its exhibition as a group of more than fifty post cards at the Museum of Modern Art, New York in 1973, Antin mailed individual cards to about one thousand addresses. *100 Boots*, a mail art performance work, is fully reliant on photographic documentation for its existence. The cards picture the travels of one hundred rubber boots as they wend their way through the suburban and urban

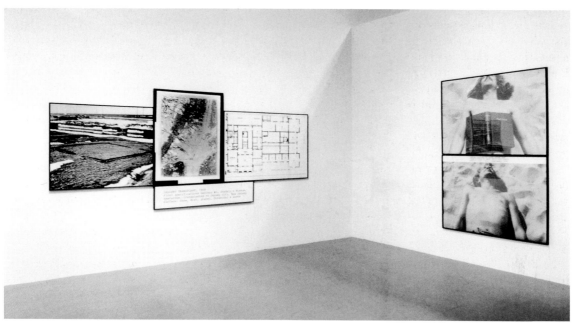

Dennis Oppenheim | **Gallery Transplant** (left); **Reading Position for Second Degree Burn** (right) | 1969; 1970

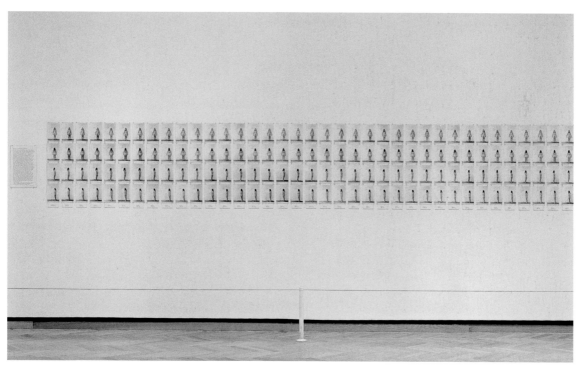

Eleanor Antin | **Carving: A Traditional Sculpture** | 1972

Eleanor Antin 100 Boots Doing Their Best: Del Mar, California, June 24, 1972, 11:30 am 1971–73

Eleanor Antin 100 Boots Move On: Sorrento Valley, California, June 24, 1972, 8:50 am 1971–73

contexts in which they find themselves. The boots perform like characters in a narrative drama with the camera invisibly following their peregrinations.[13] Antin has written that 'documentation is not a neutral list of facts. It is a conceptual creation of events after they are over.'[14] *100 Boots* spins a socially and psychologically loaded tale that, in all of its staged whimsy, is made real by photography.

Given that the content produced by photographic documentation issues only from an artist's directive, mechanical reproduction by itself is necessarily neutral. As such, it serves to record all manner of subjects with due appreciation granted to its static limits as a 'still.' Dependent on how the camera is positioned, on what it is trained, and for what reason, the still image may be combined with other shots or representational information to structure the totality of a work. A belief in the neutrality of the photographic process initially allowed the medium a kind of freedom that has since been challenged. For artists including Nauman, Long, Oppenheim, or Antin in the 1960s and 1970s, photography offered a means to bring a performed activity – or a pre-formed, but unavailable or ephemeral, work – to light as a pictorial or sculptural entity. Photography in such cases does not function as just a visual souvenir, but is part and parcel of what it delivers to view.

The treatment of the photograph as a document is similarly operative in the oeuvres of the Bechers, Dibbets, Baldessari, Huebler, Gilbert and George, and Burgin. Beyond its role, however, in recording and conveying subject matter of a performative nature that would otherwise not be seen or which is specifically staged or enacted for purposes of the final work, the individual photograph in the oeuvres of these artists is intrinsic to and inseparable from the overall conception of the work. The individual photograph serves not only as a visual record of some aspect of reality, but also participates within the totality of a representational construction made up of single, but co-dependent, elements.

Because of its explicitly documentary character and its focus on the built environment, the work of Bernd and Hilla Becher has much in common with that of Ruscha. For over four decades, the Bechers have been photographing imperiled building structures that form part of the European and American industrial landscape.

By means of the document, they likewise isolate and reassemble segments of a chosen portion of observable reality without overt commentary. However, if Ruscha is mainly interested in presenting a cross-section of the contemporary urban environment, the Bechers endeavor to gather together the pieces of a vast imaginary puzzle of existing shapes that, when put together to structure any one work, have equal compositional value.

When they met in the late 1950s, Bernd Becher was studying graphic design and typography at the Academy of Art, Düsseldorf, having previously studied with the illustrator Karl Rössing at the Academy of Art in Stuttgart. Hilla Wobeser was working as a photographer in an advertising agency. She had come to Düsseldorf from East Germany to further her studies at the Academy, although it only offered classes in painting, sculpture, and architecture.[15] Married in 1961, the Bechers began their collaboration in 1959.

Prior to his collaboration with Hilla, Bernd Becher's specific interest in photography had developed from his attempt to copy with precision the factories, mines, and plants that had intrigued him since his youth in an iron-ore mining town. Having come to the realization that he 'was really more interested in the building itself than in any kind of interpretation,'[16] he turned in 1957 from drawing detailed and realistic portraits of buildings to photographing them. As he recollects:

Many of [the buildings] were delicate steel structures which lost their delicacy in the paintings. At the same time, almost by chance, I started collecting photographs of mine buildings, which were left in the offices when the mines were closed down. Then at one point I was making drawings of a closed mine, and suddenly the buildings began to be demolished. So I took photographs because I realized painting was too slow. Also, the old photographs and my own gave a more accurate representation of those buildings than did the paintings.[17]

Hilla Becher was a photographer's apprentice in Potsdam where she received first-hand training in carrying out commissions from portraiture to architecture under the guidance of a highly respected photographer who was steeped in the craft of a profession handed down to him from an earlier

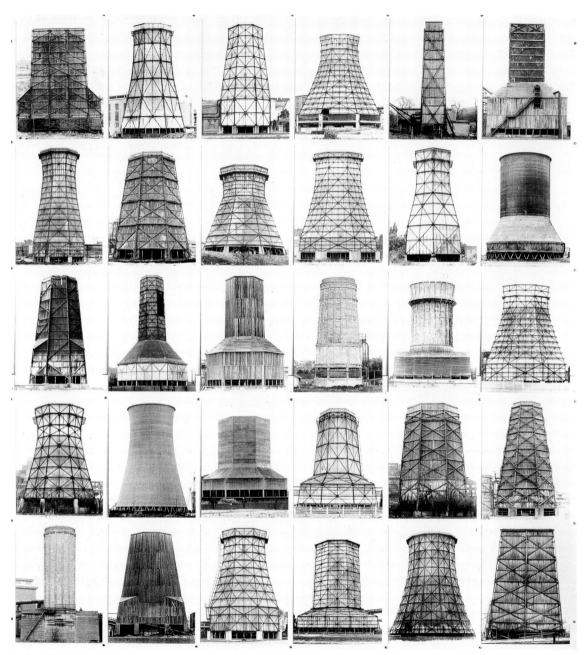

Bernd and Hilla Becher **Anonymous Sculpture** 1970

generation of photographers. Her apprenticeship proved to be invaluable for learning fundamental procedures and standards of photographic documentation and for gaining expertise in the use of a large-format camera. Memorable projects with which she assisted included the photography of the grounds, buildings, and interior spaces of the eighteenth-century Sanssouci Palace, Potsdam, summer residence of Frederick the Great of Prussia. A commission from the railroad requiring documentation of ironwork structures and intricate mechanical parts captured her imagination as well.[18]

By 1963, the year of the Bechers' first solo exhibition at the Ruth Nohl Gallery in Siegen,[19] the couple had laid the groundwork for what would become a lifelong undertaking. This has resulted in an ever-increasing body of work that demonstrates a total commitment to the idea of objectivity – a commitment that is inseparable from the desire to record structures that belong to a rich taxonomy of industrial building types. With the goal to 'produce a more or less perfect chain of different forms and shapes,'[20] the Bechers have labored assiduously over the years to present the manifold visual similarities and differences inherent in structures built by unnamed industrial engineers. Each link in their envisioned chain participates in the underlying assumption that a seemingly inexhaustible supply of visual forms and shapes may be revealed through a photographic study of these industrial structures. Their aim has not been simply to make complete inventories of the different building types, but to gather as much relevant visual material as possible before specific and typical examples are destroyed.[21]

The Bechers have enumerated some of the distinct types of industrial structures that they were already in the process of documenting by the end of the 1960s: pitheads; water towers; gas-holders; blast furnaces; silos; lime-kilns; oil pumps; high tension pylons; washing and screening plants; and refineries.[22] Their first publication, *Anonyme Skulpturen: Eine Typologie technischer Bauten* (Anonymous Sculpture: A Typology of Technical Constructions) of 1970 further includes cooling towers. Coal mines, winding towers, steel mills, distribution plants, coal bunkers, grain elevators, preparation plants, maintenance buildings, and framework houses may be added to the list of structures that the Bechers have photographed since the late 1950s and early 1960s in Belgium, France, Germany, Luxembourg, the Netherlands, and Great Britain and, since 1974, in the United States.

The way in which the Bechers present fully framed, centered, and equally scaled images of individual industrial structures as part of a series gives their work its meaning. Their photographs consist of head-on or perspective views of the front, back, or sides of a structure. Separately framed images devoted to single views function as part of a larger ensemble and usually are grouped together within the context of an overall grid.[23] In an early text about the Bechers, Carl Andre

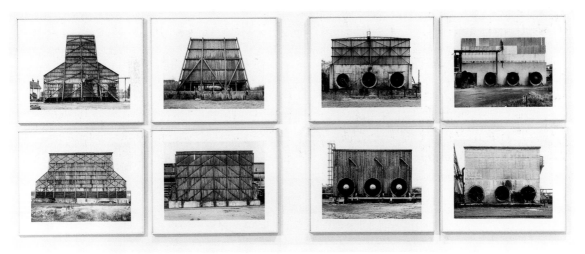

Bernd and Hilla Becher **Cooling Towers** 1966–75

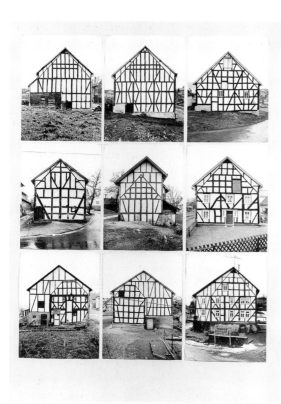

Bernd and Hilla Becher | **Typology of Framework Houses** (detail) 1959–74

identified the organizational principles guiding their arrangement of individual prints – made from the negatives of photographs taken on many different expeditions over the years – to form the final work. Together, groups of photographs portray:

> structures with the same function (all water towers); structures with the same function but with different shapes (spherical, cylindrical, and conical water towers); structures with the same function and shape but built with different materials (steel, cement, wood, brick, or some combination such as wood and steel); structures with the same function, shape, and materials.[24]

Additionally, according to Andre, a work by the Bechers sometimes consists of building types possessing different functions;[25] or, it might present comparative views of the same building taken from different vantage points or different building types from the same vantage point. In sum, the Bechers follow logical organizational schemes

that shield them from the creation of hierarchical compositional arrangements of shapes and curtail authorial subjectivity. Looking for ways to 'photograph without having to alter anything,' they have definitively noted that they 'didn't want to compose.'[26]

The Bechers act to suppress normally sought-after photographic effects that carry the potential for symbolic, anecdotal, or expressive interpretation. In an effort to minimize distractions from the image of the building or structure, they endeavor to exclude extraneous information such as clouds, foliage, or human figures. And, to diffuse the dramatic implications occasioned by angled light, they ensure that each of their photographs is taken in even light under a hazy sky.[27] With the desire to let the 'forms speak for themselves and become readable,' they refrain from an attempt to 'hide or exaggerate or depict anything in an untrue fashion.'[28]

While emphasizing their concern for the legibility of a building, the Bechers also stress their interest in capturing the individual aspects of different kinds of structures.

> Each building has certain qualities. If the subject is circular you need only one point of view to represent the whole thing. But the winding towers, for instance, show a shaft and a stress to one side which is caused by the transmission located at the top.... If you really want a true representation of this it should be photographed from a frontal viewpoint.... Also, it is interesting to show the structure from several angles.... The photographs should always show all the details and the textures of the materials.[29]

Of major significance to the Bechers is the fact that structures built in the nineteenth and twentieth centuries to meet the diverse requirements of industry came into being for reasons of functional necessity. The shape of each building type has, therefore, been determined by its industrial purpose. 'Gasometers,' for example,

> work on two different principles. For one the volume of the structure must reduce with the volume of the gas inside. The other system has an internal method of separating the gas from air. They both observe the same rule but in different ways.

With a structure like water towers, there is never a real change because they rely upon the law of gravity....[30]

Ornamental or decorative elements as well tend to be intrinsic to need and use. 'The iron work details even on the gasometer are not just decorative: each one has either a strengthening or a protective function.'[31] In fact, 'the more imperative the function, the more variety can be found in the structure. If there is a lot of leeway for design, the structures become very similar, and vice versa.'[32]

Because photo-documentation allows for the compilation of dispersed information, the Bechers are able to 'mine' the richness and abundance of visual variables to be found in utilitarian-based designs. 'You only see the differences between the objects when they are close together, because they are sometimes very subtle.... And [their] individuality can only be shown if they are comparable,' Bernd Becher has remarked.[33] As a student in the late 1950s, he had considered the idea of making a photomontage, in one case, by placing the image of an iron ore mine within the context of an image of workers' housing. Although he abandoned this plan upon learning of the earlier history of photomontage, he has, since that time, continued with Hilla to use photography as a means to circumscribe and recontextualize his subject matter.

Precedents for the Bechers' industrial subject matter may be found in the work of a number of German photographers from the first part of this century, including Max Burchartz (1887–1961), Werner Mantz (1901–83), Albert Renger-Patzsch (1897–1966), and Hermann Oskar Rückwardt (1845–1919) as well as in the work of Americans such as Alvin Langdon Coburn (1882–1966) or Edward Weston (1886–1958).[34] The photographic rendering of anonymous industrial architecture by the Bechers differs significantly from that of their predecessors, who were interested in close-up, cropped, and angled details of factories and power plants or in wide-angled landscape views. Cylindrical towers in Burchartz's *Benzol and Ammonia Processing Tank* (c. 1928), for example, reach dramatically toward the sky.[35] They veer from the lower right to the upper left of the photograph, which – antithetical to the approach of the Bechers – cuts the building off from full view. Alternatively, the power station in Rückwardt's

Putlitz Bridge with the Moabit power station (1912) is seen from above against a backdrop of smokestacks rising up in the distance.

In marked contrast to landscapes of the Ruhr district from the late 1920s and early 1930s by Renger-Patzsch, the photographs of the Bechers admit no far-off vistas with smokestacks, nor juxtapositions of urban, industrial scenes, or structures with agrarian vestiges.[36] The work of the fine art photographers who predate the Bechers, it should further be noted, is not confined to industrial subjects, as is the Bechers' practice. On the contrary, Coburn's *Pittsburgh Smoke Stacks* (1910) or Weston's *Armco Steel, Ohio* (1922) are part of a range of the varied landscape subjects taken up by photographers such as themselves earlier in the century.

The photographs of August Sander (1876–1964) and of Karl Blossfeldt (1865–1932), along with those of Renger-Patzsch, are often mentioned in connection with and as precedents for the Bechers' documentary quest and systematic approach to their subject matter.[37] Sander sought to 'take a true cross-section of the present age ... beginning with the farmer and ending with representatives of the intellectual elite.'[38] His attempt to survey the nature of the times through portraits of individuals from all social strata and professions parallels the Bechers' interest in classification. Blossfeldt made an extensive study of individual plant forms, which he photographed in close-up against a neutral background so as to reveal their architectural aspect.

Although similarities may be drawn between the procedures of these earlier photographers and the methods of the Bechers, the Bechers' work is not wholly allied with the tradition of fine art photography. As opposed to the American artist Charles Sheeler (1883–1965), for whom the painting and photographing of factories were separate facets of his vision, the Bechers chose to disregard the previously accepted distinctions between fine art and fine art photography as well as between fine art photography and documentation. ' The question if this is a work of art or not is not very interesting for us,'[39] Hilla Becher has written. By refuting such a question from within the parameters of their production, the Bechers have played a major role in decompartmentalizing aesthetic practice.

The Bechers' treatment of buildings as if they were specimens sharing aspects in common with scientifically based fact-finding studies, disavows any sort of

overarching or totalizing analysis. The accumulation of comparative views and details ultimately suggests that completeness for its own sake is not only unachievable but irrelevant to a mission connected with issues of aesthetic production. In a scientific manner – without a scientific goal – the Bechers strive to feature the properties of each pictured structure in and of themselves. With anthropomorphic reference to portraiture in some instances, they single out buildings according to family type.[40] This makes it possible for them to bring visual models of individuality and diversity into a contrapuntal relationship with similarity and uniformity. Not purporting to pass judgment or deliver conclusive truths, the Bechers' photographs purposefully drain picturesque content and social commentary from images of industrial monuments that do not deliver information beyond the intricacies and eccentricities of their formal and functional qualities. But in its demand for the meeting of the objective and the aesthetic, the work of the Bechers implicitly takes a political stance.

The photographs of the Bechers do not directly illustrate the circumstances of industrialism that gave rise to the buildings whose features they record. They have stated:

We don't agree with the depiction of buildings in the 20s and 30s. Things were seen either from above or below which tended to monumentalize the object. This was exploited in terms of a socialistic view – a fresh view of the world, a new man, a new beginning. Later the Nazis gave this style their own interpretation and incorporated it into their ideology.[41]

Through its resistance to personal prioritization of one shape or object over another, their work speaks on behalf of authorial rationality over authoritarian subjectivity.

Whereas the primary goal of the Bechers is to promote formal fact over personal fabrication, Jan Dibbets is dedicated to the development of images that proclaim the flatness of the two-dimensional picture plane and refer to the real world at the same time. A native of Holland, Dibbets takes his art-historical point of departure from Pieter Saenredam (1597–1665) insofar as several centuries later he, too, has wanted 'to say something about abstraction and about the fact that abstraction can be present in a figurative image – and that this doesn't have to look like a Mondrian.'[42]

The months from March to October spent by Dibbets at St. Martin's School of Art, London on a grant from the British Council in 1967 brought him into contact with students such as Richard Long whose involvement with the land and direct use of materials culled from nature specifically impressed him. In the spring of that year Dibbets had stacked stretched canvases on top of one another and entitled the resulting pile *My Last Painting* (1967). By the fall he had turned from painting on canvas to working directly with materials from nature. For a small, but seminal, one-day exhibition of ephemeral works at the Galerie Loehr in Frankfurt,[43] he exhibited a water piece on the floor inside the gallery and a sawdust ellipse on the courtyard cobblestones outside. From the entryway to the courtyard, the ellipse appeared to be a tipped up circle rather than an oval lying parallel to the ground. Dibbets photographed the piece at ten- to fifteen-minute intervals as it was gradually destroyed by throngs of visitors entering without heed to, or angry about, the work underfoot.[44] The exhibition, whose

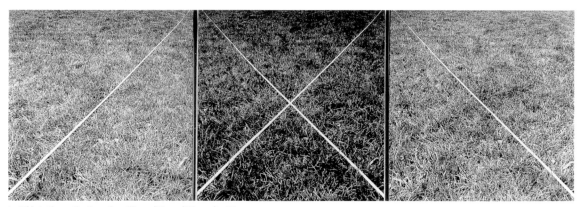

Jan Dibbets **Perspective Correction – Diagonal/Crossed/Diagonal** 1968

subtitle was '19:45–21:55,' lasted for little more than two hours on September 9th, 1967 and was organized around the idea of ephemerality. As the artist has pointed out, however, he came to be more interested in the documented image than in material disintegration for its own sake. 'I make most of these works with ephemeral materials: sand, growing grass, etc. These are demonstrations. I do not make them to keep, but to photograph. The work of art is the photo,' he maintained at the time.[45]

Works by Dibbets from the latter part of 1967 were made from the grassy sod of lawns and similarly dealt with perspectival distortion. As Rini Dippel observed not long thereafter, Dibbets's grass pieces carried over the concerns of his painting from the ground of the canvas to the real ground. In a sod piece of 1967, *Grasruiten* (Grass Diamonds), the artist cut out two diagonal quadrants from a square marked in the grass and thereby displayed the fact that a square on the ground, when it is perceived from a distance, looks like a rhombus. *Twee ruiten* (Two Diamonds) (1966), a painting consisting of a purple square floating above a pink square, also dealt with the nature of perspectival distortion. The lower quadrant of the pink square was hidden from view and, in reality, was non-existent. In *Grasruiten*, to the contrary, the hidden quadrant made from sod did exist although it was covered up by the cut-out grassy square set on top of it. Having thus moved away from painting abstract geometric shapes that played with discrepancies between reality and illusion, Dibbets transferred his examination of the optics of perspectival distortion from the canvas to the natural world.

With the Perspective Corrections, realized between the fall of 1967 and the end of 1969, Dibbets began a full exploration of relationships between abstraction and reality. To achieve the shape of a square in his photographs, the artist drew or constructed trapezoidal forms against indoor and outdoor backgrounds. According to Bruce Boice, the Perspective Corrections 'are a defiance of normal illusionistic perspective and a reversal of the usual situation of the illusion of perspective.'[46] Black-and-white photographs of rope strung between stakes driven into a lawn provide the imagery of *Perspective Correction – Diagonal/Crossed/Diagonal* (1968), a photographic image in three parts. The diagonal lines of the photographs at

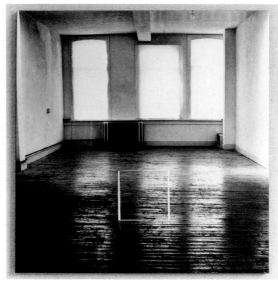

Jan Dibbets | **Perspective Correction – My Studio II** | 1968

either end and the crossed lines of the center photograph visually parallel their pictorial surface by having cancelled out the false representation of three dimensional space. According to the catalogue, *A Trace in the Wood in the Form of an Angle of 30 Degrees Crossing the Path* would have marked a V-shape through the woods made by overturned turf that met at the crossing of an existing path. The work would have created sightlines that actually could be followed in the context of trees and falling snow. A different work was realized instead: *A Trace in the Woods in the Form of a Line of Trees Painted White.* The trunks of a row of trees in the forest were painted at a height that increased incrementally. From a particular point in the woods, however, the trees gave the impression of having all been painted at the same height as they visually receded into the distance.

Perspective Correction, My Studio I, 1: Square on Wall (1969), in a similar manner, features the outline of a square on a wall of an interior with a window. Although taken at an angle, the square appears to be aligned with the plane of the photograph as well as with the background surface of the wall. But whereas the wall recedes illusionistically toward an imaginary vanishing point to give a pictorial semblance of architectural depth, the outlined square remains true to the flatness of the photograph.

The camera, for Dibbets, has served in accordance with its ability to imprint an image onto a light-sensitive

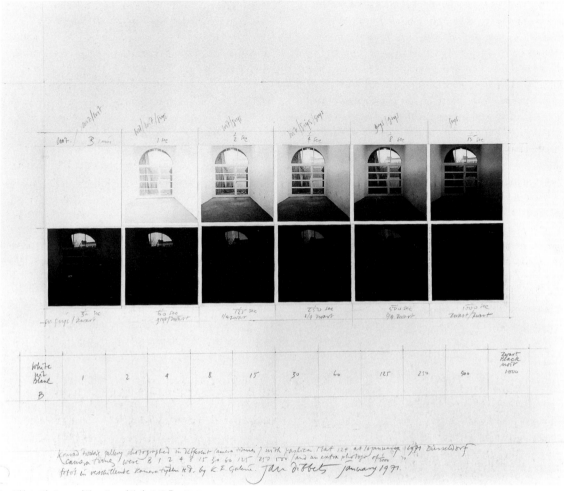

Jan Dibbets **Shutterspeed Piece, Konrad Fischer's Gallery I** 1971

surface. Not dissimilar from Oppenheim's use of the sun to make a shape on his body, *Shadows Taped off on a Wall, Museum Haus Lange, Krefeld* (1969) engaged the operational principle behind photography. Using masking tape, Dibbets demarcated the striations of light from a window as they fell successively onto different areas of the exhibition wall throughout the day. The sum of shadows thus recorded on the wall functioned to meld abstract patterning and architecture. The compositional arrangement of the work, moreover, resulted from the casting of shadows by the sun instead of at the behest of the artist.

At an early date Dibbets maintained that 'most of [his] work deals with light, what light is, how you see, what is real, how things are.' This light is 'just natural light,' not requiring intervention by the artist since it 'has its own processes.'[47] *The Shadows in My Studio as They Were at 27-7-69 from 8:40–4:10 Photographed Every 10 Minutes* (1969) photographically documents thirty-four sequential moments. Aimed at an open doorway and window overlooking a balcony, the camera remained in one place from morning until afternoon. As natural light throughout the day came through the door and window at different degrees of intensity, it created rectangular shapes in various positions on the floor and generated the form of the work, which moves compositionally from left to right and frame to frame.

Natural light emitted by the rays of the sun and light mechanically regulated by the photographic process together define Dibbets's work of the early

1970s. *The Shortest Day at the Van Abbemuseum* (1970), a large, square color photograph, visually captures the increase and decrease in light from dawn to dusk of the winter solstice. Eighty separate shots, mounted ten across and eight down, repeatedly present the view through the museum's window to the street and form an overall grid. Modulated by sequential gradations in color starting and ending with black, the work as a whole treats light as both medium and subject matter and integrates the view of city buildings through the window with the planarity of the pictorial surface.

Two works of the following year focus self-reflexively on the mechanistic regulation of light by the camera. *Shutterspeed Piece, Konrad Fischer's Gallery I* (1971) presents two rows of six photographs of the entryway to an exhibition space and is accompanied by penciled notations regarding the artist's procedure. For the work's realization, the camera remained fixed on the view of the gallery's door while the amount of light allowed through its lens was progressively lessened. The first photograph, taken with a slow shutter speed, is overexposed and white, whereas the last one is black. Between these two extremes, the scene at hand emerges from whiteness and then, as the shutter speed accelerates, recedes into darkness.

Shutterspeed Piece, Horizontal (1971) engages photographic means to observe the visual results of controlled light. Neither an interior nor exterior scene is shown since Dibbets aimed the camera at partially closed Venetian blinds. Notations accompanying the twelve photographs of the blinds indicate the shutter speeds from 1/4 to 1/500, which cause the twelve images to darken progressively. Blocking out the light and the view by virtue of their function, the blinds are experienced as abstract striations. In related manner, light falling on

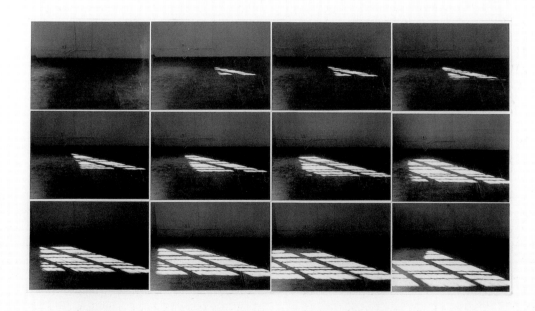

Jan Dibbets **Shadows on the Floor of the Sperone Gallery** 1971

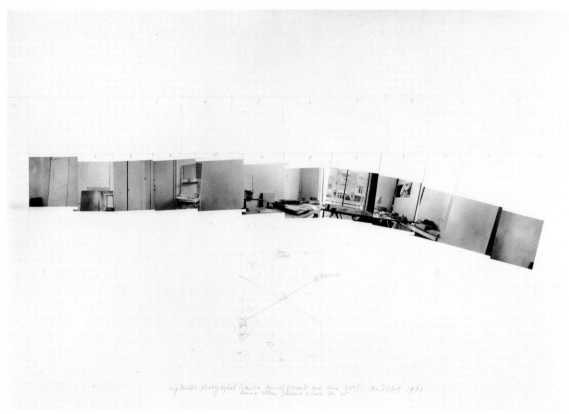

Jan Dibbets | **Panorama – My Studio** | 1971

film coincides with the resulting sequence of twelve expanding light patterns that fall on the gallery floor in *Shadows on the Floor of the Sperone Gallery* (1971). A grid of three rows of four rectangles delivers an abstract narrative of shapes whose expansion in size resulted from sunlight that poured in through an unseen, mullioned window and became increasingly intense throughout the day.

Photographic reality takes command over optical illusion in all of Dibbets's production, although the former is dependent on the latter. *Panorama Dutch Mountain, 12 x 15° Sea II A* (1971) depicts an 180-degree sweep of seashore against the horizon line. Dibbets took twelve separate shots in color at an unpopulated beach, turning the camera on its tripod fifteen degrees from left to right with each successive rotation.[48] The line of surf dividing beach and sky, splayed out in an upward curve within the photograph, unites the contiguous images mounted edge to edge in a row. The work's title wittily expresses the idea that the notorious flatness of the Dutch landscape has ironically been superseded by the flatness of the picture plane.

Later works by Dibbets further enlist the camera as a fixed recording eye that can be set on an angle and can travel from one segment of reality to another. In the panoply of works in his oeuvre, single images have been combined to form, for example, panoramas, as in *Big Panorama, Amsterdamse Bos* (1971), or serial configurations of upended landscape horizons, as in *Land Horizon 0° – 135°* (1972). Abstract constructions of a slightly later date are based on close-up views of a variety of flat, textured surfaces, including those of fallen leaves as in *Structure Piece* (1974), rippled water as in *Waterstructure* (1975), car doors as in *Colour Study* (1976), or city pavements as in *Structure Panorama 360°* (1977). Use of the camera enabled Dibbets to turn traditional pictorial illusionism inside out. The optical illusion that attends the reproduction of three-dimensionality is, in all cases, translated by the photographic process into two-dimensional abstraction. With the desire to express, rather than hide, the fact of pictorial planarity without forfeiting reference to external reality, Dibbets manipulates the camera to cancel out the falsification produced by linear perspective. Different from photographs by Richard Long, for example, concerned with documenting the artist's formal intervention into the landscape, photographic constructions by Dibbets

wipe out the usual distinction between foreground and background found in views of nature. Representations of grass, leaves, water, or a pavement, normally represented below the horizon line as if underfoot, as much as of a distant horizon line itself, in Dibbets's work appear to be flush with the actual surface of the flat, upright image rather than to recede into artificial space.

Mechanical reproduction enabled Dibbets to seamlessly piece together abstract images that simultaneously reflect nature and respect planarity just as it has served the Bechers in their collection of extant, if disappearing, architectural forms that they reassemble within a two-dimensional narrative of shapes without hierarchical ordering. Similarly, John Baldessari treats the camera as a fact-finding device and, aided by it, has challenged traditional methodologies for arriving at subject matter and compositional arrangements. By late 1965, Baldessari wrote, he had become 'weary of doing relational painting and began wondering if straight information would serve.'[49] Pursuant to *Cremation Project* (1970), which entailed ceremoniously destroying his earliest paintings at a crematorium, Baldessari had embarked on a search for methods of representation that might preclude reliance on the tried-and-true, hard-and-fast 'art signals'[50] associated with painting. Works from the brief period when he was living in his home town of National City, California (1966–70) betoken his later rationale for terminating an involvement with painting in favor of photographic representation.

During the second half of the 1960s, language, used both on its own and also in connection with snapshots, provided Baldessari with the means to extricate himself from aesthetic convention. For works on canvas begun in 1966 he hired a sign painter, choosing not to hand-letter them himself. The painted texts include written extracts either from the artist's personal notebooks or from art textbooks or passages from the writings of well-known contemporary critics of the time such as Clement Greenberg, Max Kozloff, or Barbara Rose. Art-related texts, which vary in length from a single statement to lengthier explanatory ones, resulted from the artist's interest in using 'language not as a visual element but as something to read.'[51]

Language, employed independently from images, comprises the entirety of compositional and representational components in Baldessari's National City works. With underlying wit and irony, paintings

'composed' purely of text turn the tables on the very tradition of which they speak. They reproduce the formulaic procedures and attitudes surrounding aesthetic production as part and parcel of their own pictorial imagery and, in this way, both reject and parody them. For example, the subject matter of *Subject Matter* (1967–68) is 'Subject Matter.' The painting reads:

> Look at the subject as if you had never seen it before. Examine it from every side. Draw its outline with your eyes or in the air with your hands. And saturate yourself with it.

In lieu of practicing what is preached by the painted text, Baldessari transforms banality into originality in his presentation of text as image. *Tips for Artists Who Want to Sell* (1967–68) proclaims what colors, genres, and subjects are most attractive to buyers, having divested itself of such considerations. *Terms Most Useful in Describing Creative Works of Art* (1967–68) presents a three-column list of over fifty words such as 'blend,' 'delight,' 'develop,' 'create,' or 'impart' found in writings about art. Taken together with hackneyed words such as 'a new slant,' 'invigorate' or 'exalt,' they assume fresh meaning within the context of (the) painting.

In the three-year period during which he was working on the Text Paintings, Baldessari also realized his Phototext Paintings consisting of acrylic and photo emulsion applied to canvas. If the former had partially grown out of his fascination with the 'how-to-teach-art' manuals he had collected,[52] the latter address the existence of preordained do's and don'ts in matters of photographic composition and blatantly disregard commonly held rules. Carrying his early interest in photography as a hobby and means of visual note-taking to another level, Baldessari's Phototext Paintings break these rules of the trade and, in all cases, avoid a classically artful outcome. The artist standing in front of his house in *Wrong* (1967–68), for example, appears to have a palm tree growing out of his head. The caption, 'wrong,' stresses the fact that incorrect judgment in placing the subject and aiming the camera has caused results normally considered unfortunate. Phototext Paintings taken in the artist's home town, moreover, do not interpret the locale in light of established principles regarding noteworthy subjects or accepted compositional procedures. Instead, a work such as

18th and Highland, National City (1966–67) offers an unspectacular view of a drive-thru hamburger restaurant while another, *Econ-o-Wash, 14th and Highland, National City Calif.* (1967–68), depicts a roadside car wash.

The text of *An Artist is Not Merely the Slavish Announcer...* (1966–68) encapsulates Baldessari's main mission in these and future works: to be, in fact, the forbidden 'slavish announcer.' Below a photograph of a parking lot with a tree trunk inartistically appearing smack in the foreground of the picture, a text emphatically declares: 'An artist is not merely the slavish announcer of a series of facts, which in this case the camera has had to accept and mechanically record.' By defying proper practises of the medium, Baldessari specifically emphasizes how photographs record what is in front of the camera's lens and – airbrushing or digital technology aside – are not selective in what is picked up by the lens for portrayal. As the work therefore suggests, a photograph can show 'things pretty much as they are' if one does not 'wait for the right light or the best angle' before shooting.[53]

Upon his completion of the Text and Phototext Paintings, Baldessari produced a series of fourteen works, the Commissioned Paintings of 1969. Of special relevance is the fact that the artist did not paint them himself nor did he directly choose their subjects. In each of the fourteen paintings a different object is shown in conjunction with a pointing finger. A caption below states 'A Painting by [the person's name].' In the painting by Jane Moore, for example, the finger points to a stove top. In Helene Morris's, it points to rope and wires coiled up in a cardboard box. Sam Jacoby painted a finger pointing to the leaf of a plant.

Both the act and the idea of pointing is displayed in the Commissioned Paintings. For their realization, the artist as their creator concertedly exempted himself from being their fabricator and, furthermore, excluded himself from the process of choosing the objects represented. Baldessari had acquainted himself with the artists who painted his paintings at the various art fairs he frequented in southern California. To each artist he gave a dozen different color slides resulting from a project based on pointing.

As he has described it:

> ...I was having a friend of mine, George Nicolaidis, walk around and point out the things in a visual

field that jumped out at him. Again, I was exploring the impetus to do art – first you have to choose and select. As he pointed, I would photograph him in the act of documenting that, rather than writing it down. So I had all these slides with a sort of documentary nature to them. They weren't about beautiful composition; I was just recording the fact of something being selected.[54]

Baldessari told each of the commissioned artists that their choice of slide was not important, saying 'The only proviso is not to try to make art out of it, just copy it as faithfully as you can and the art will emerge.'[55] Insofar as they are based on slides and were supposed to be duplicated as precisely as possibly, works by the commissioned artists function in a photographic manner. Equally significant, Baldessari did not choose the subjects to be copied, but allocated their selection to others.

Baldessari first employed photographs independently from a canvas in *California Map Project/Part 1: California* (1969). Ten color photographs, a photograph of a map of California, and an explanatory text comprise the work. The work is structured upon the word 'California,' as this has been printed on the map. At each of the sites where the individual letters happen to be located, he created the appropriate letter's shape in the landscape. The 'C' was made of logs and the first 'A' was painted on a large rock, etc. As a group, the photographed sites spell out 'California.' Photographs in Baldessari's map piece, which is linguistically pegged on the found letters of a place name, serve to bring geographically disparate segments of observed reality together in one place.

An exhibition at the Nova Scotia College of Art and Design in April 1971 might be considered a turning point in Baldessari's development. He had the students at the school repeatedly write 'I will not make any more boring art' on the gallery walls, which they covered with the phrase. The artist also made a half-hour videotape showing himself writing these words, and a lithograph exists in an edition of fifty. Like a remedial punishment, the work offers the promise to reform past behavior, which the artist would henceforth seek to do by means of photography rather than through works on canvas.

Fully embarked by 1971 on a career filled with ever-changing schemes for discovering alternative compositional criteria, Baldessari continued to maintain his self-proclaimed role as 'the strategist.'[56] As strategist,

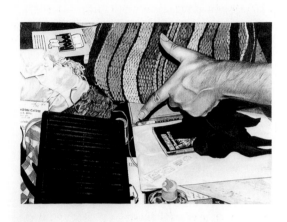

A PAINTING BY NANCY CONGER

John Baldessari **A Painting by Nancy Conger** from the Commissioned Paintings 1969

he has engaged photography both as a reinforcement of his linguistic and literary forays and as a mechanical aid to make visible a wide range of aesthetic tactics. These varied tactics consistently have allowed him to step aside in the final determination of a work's composition.

'There's a very strong theme that seems to occur in my work and it was in some early work called "choosing,"' Baldessari has stated, observing that '"choice"…seems to be a fundamental issue of art.'[57] *Choosing (A Game for Two Players): Rhubarb* (1972) photographically documents the process of choosing and, with its overt theme of selection, carries over from the Commissioned Paintings wherein the choice of depicted objects was delegated by the artist. In each of seven photographs, three horizontally placed red rhubarb sticks are set against a green background. A finger points to one of the three sticks in each of the seven photographs, which visually record the moment a particular stalk was chosen by the artist or the person with whom he was playing the game. The work's imagery – linear permutations of stalk shapes, some of which are longer, or thicker, or more bowed, or with

John Baldessari **Cigar Smoke to Match Clouds That Are Different (By Sight – Side View)** 1972–73

more protuberances – derives from Baldessari's documentation of a selection process. This process is recorded as it was occurring instead of being an image that presents a finished product. Works in this series were also made using green beans, garlic, scallions, asparagus, mushrooms, and turnips.

Subsequently, Baldessari devised a number of different methods for arriving at unorthodox pictorial solutions that are connected to the real world by photography. *Cigar Smoke to Match Clouds That Are Different (By Sight – Side View)* (1972–73) and *Throwing Balls in the Air to Get a Straight Line (Best of 36 Tries)* (1972–73) demonstrate how the camera frees the artist from hand-drawn, formal invention and its accompanying decision-making processes by mechanically providing him with given shapes. In the first work, puffs of smoke from the artist's mouth are paired with rectangular reproductions of clouds in a group of prints and, in the second, rubber balls assume different configurations against the background of the sky in each of four prints.

The visual components of works by Baldessari are governed by the predetermined conditions he sets up in advance so as to detour conventions of compositional arrangement. *Alignment Series: Things in My Studio (By Height)* (1975) exemplifies yet another of his many anti-compositional tactics in the 'attempt to get away from "this looks good by that thing."'[58] For example, eleven black-and-white photographs mounted vertically on a board were assembled according to each object's height from the artist's studio floor. Alternatively, the color 'scheme' of *Car Color Series: All Cars Parked on the West Side of Main Street, Between Bay and Bicknell Streets, Santa Monica at 1:15 P.M., September 1, 1976* (1976), a series of seven photographs, was informed, as its title explains, by the positioning of cars at a designated moment rather than by subjectively chosen hues.

Photography in Baldessari's oeuvre binds serial images together and, in a work such as *Concerning Diachronic/Synchronic Time: Above, On, Under (with Mermaid)* (1976), ties otherwise unrelated objects or scenes together. This three-tiered work of six black-and-white photographs whimsically pairs the following elements from top to bottom: an airplane and a seagull, centered within their frames; a speedboat, like a speck on a lake at the far lower left of the first picture and the speedboat leaving the right-hand side of its pair; and a submarine with two figures, and a mermaid, of which both images are full-framed and slightly cropped. In the artist's words:

> I wanted the work to be so layered and rich that you would have trouble synthesizing it. I wanted all the intellectual things gone, and at the same time I am asking you to believe the airplane has turned into a seagull and the sub into a mermaid during the time the motorboat is crossing. I am constantly playing the game of changing this or that, visually or verbally.[59]

In this work, Baldessari plays with notions of time in order to make tangential analogies and to tease the viewer away from habituated expectations regarding hierarchical arrangements of form and narrative connections between images.

Images taken from the television screen 'provided the raw material for bypassing aesthetic judgments'[60] in a

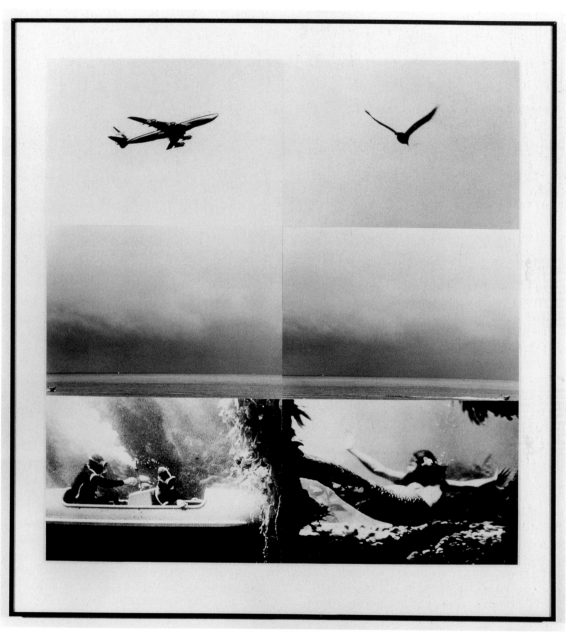

John Baldessari **Concerning Diachronic/Synchronic Time: Above, On, Under (with Mermaid)** 1976

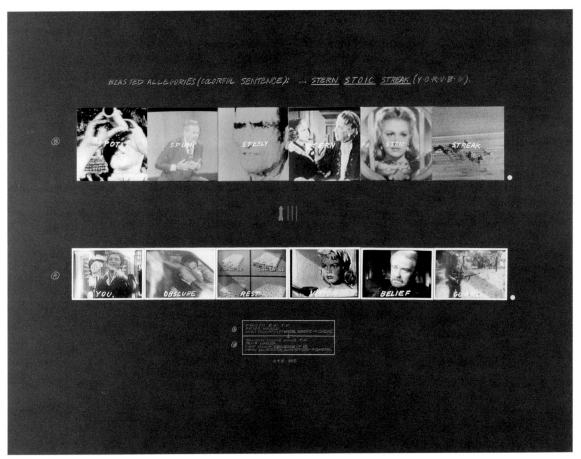

John Baldessari | **Blasted Allegories** | 1978

group of separate works conceived under the heading of Blasted Allegories, completed in 1978. Television offered Baldessari 'a window into the world…much like the window/door one steps through in Renaissance painting/space.'[61] Scenes culled from the television at temporally regulated intervals also provided 'a dictionary of images' with which to construct a series of works according to complicated rules involving shuffled words and color-wheel codes, all of which were found and matched more or less by chance. The artist's main intent was to make 'visual order by word order, and word order by visual order; to avoid my own good taste by letting the order of language, color, and other systems take over.'[62] The viewer is at liberty to read any number of meanings into narratively non-sequential sequences of verbal/visual suppositions and juxtapositions. For example, in *Blasted Allegories (Colorful Sentence [Yellow*

Journalism]): Obstacle Winning (1978), the words 'you-enter-late-lane-obstacle-winning' are respectively printed over a band of six disparate stills from stories aired on television. Baldessari, in this way, achieves the sought-after idea that meaning in these works be left to the interpretation of its viewers, who may read whatever *they* choose into the layered combinations of images, colors, and words.

Having endeavored to keep aesthetic dogma and personal preference at arm's length, Baldessari offers the open-ended option of finding in these pictures 'all the meaning a person would need to give life value.'[63] Photography, often in combination with language, permits Baldessari to refrain from imposing definitive meaning on his work and to remove some responsibility from his authorial shoulders to those of the viewer. In his later work, Baldessari has continued to use photography

to complicate straightforward narrative. Believing that photography in and of itself has a direct connection with reality, he enlists it to communicate the complexity, fluidity, and indeterminacy of meaning. Although Baldessari can point at the real world and shoot it with a camera, the artist cannot ultimately, his oeuvre suggests, control or dictate meaning. Baldessari therefore arranges for meaning to reveal itself as a visual 'arrangement' within a pictorial context whose specific declarative message is that essential meaning is ineluctable. The work thus taps into and demonstrates how an endless number of choices for ordering and reordering are possible.

The camera as it was used by Douglas Huebler is also an instrument to carry out directives pre-established by the artist. Whatever method the artist applies to derail traditional approaches to creating a picture, the camera follows suit. Huebler's many Duration, Location, and Variable Pieces, realized over the period of a decade, integrate the complementary systems of photographic representation and linguistic explanation. Multiple photographs, with or in lieu of other forms of documentation, accompany the signed, typewritten statements that account for the structure of each work.

The major turning point in Huebler's career occurred during preparations for a solo exhibition organized by Seth Siegelaub in November 1968. Unlike the works he had shown in the major exhibition of Minimal sculpture, 'Primary Structures,' held at the Jewish Museum, New York two years earlier, those in Siegelaub's exhibition did not assume three-dimensional form. 'The world is full of objects, more or less interesting; I do not wish to add any more. I prefer, simply, to state the existence of things in terms of time and/or place,'[64] Huebler famously wrote not long thereafter. During the exhibition, nine 'sculptures' and four drawings were kept in Siegelaub's New York apartment at 1100 Madison Avenue rather than being put on display in a public gallery. The catalogue, distributed by mail, was considered to be an extension of an exhibition consisting of 'sculptures' that took form on paper only. Intrepid viewers wishing to see the works in the apartment were welcome to do so.[65]

Shortly before Siegelaub had invited him to make an exhibition, Huebler had begun to re-evaluate the direction in which his sculptural concerns were leading. In 1962, he had given up painting to construct solid-colored wall reliefs. Their repeated elements expressed

the shape of their surrounding edge and were predicated on the interplay between material form and real space. By 1967 Huebler had created six or seven large-scale geometrical sculptures made of plywood covered with light-colored Formica. Sitting directly on the floor or the ground, the Formica-covered plywood sculptures were composed of interlocking modular units and, from any one angle, offered a view of their surrounding environment. As he stated in the catalogue for 'Primary Structures,' Huebler wanted 'to make an image that has no privileged position in space, and neither an "inside" nor an "outside".'[66] Not long thereafter he came to recognize the inherent paradox of these multifaceted and, theoretically, infinitely expandable sculptures. Any undue multiplication of the same-sized, interlocking units would, paradoxically, have defeated his purpose of integrating work and surroundings. Were modular units indefinitely added to one another, the sculptures would have increased in size to the point of absurdity. *Bradford Series #14* (1967), shown in a group exhibition of outdoor sculpture in 1968 at Tufts University in Boston, Massachusetts, was the last of its kind.

By turning away from the creation of three-dimensional objects to the use of two-dimensional documentation including maps, drawings, descriptive language, and photographs, Huebler effectively was able to cover thematic ground not possible by means of traditional sculpture. Works in Siegelaub's November exhibition overcame the literal obstacles of spatio-temporal physicality that any such indefinitely expandable sculptures would necessarily have encountered. Most pertinently, these works, referred to as Site Sculpture Projects, demonstrate the abundance of ideas underlying Huebler's search for a satisfactory 'methodology for deconstructing – dismantling – whatever, the rules of formalism, of aesthetics, etc.,' which nonetheless might preserve the 'sense of infinite expansion' imparted by the free-standing sculptures.[67]

The earliest work in the November exhibition, a drawing entitled *Snow Piece Proposal* (March 1967), is specifically about defining the site of a sculpture as the sculpture itself. It accomplishes this by inferring that 'X' marks its own spot. Wafer-thin X-shapes, constructed out of aluminum affixed to electrical heating tape, lie on top of four areas of fallen snow. When the snow melts, the X's are revealed as negative imprints that arise simultaneously from both sculpture and site. In contrast

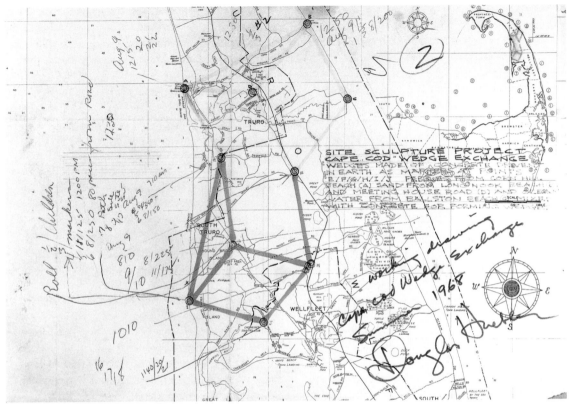

Douglas Huebler **Working drawing for Cape Cod Wedge Exchange** 1968

with Long's *Snowball Track*, which is about the process of leaving a mark on the land rather than on a canvas or sheet of paper, *Snow Piece Proposal* equates a sculpture with its site.

Huebler's ensuing use of ordinary road or city maps led further toward his reformulation of the traditional relationship between work and site. His map pieces collapsed specifically delineated journeys and geographical expanses into one representational totality. Itineraries (of trips not actually taken) charted by the artist with highlighter pens through particular towns and cities give these works their formal and spatial definition. Shapes result from lines drawn between one existing geographical point and another. Maps thus supplied the artist with real points of departure for the creation of imagery from which he, as author, could distance himself. In Huebler's work, maps do not have a documentary function with respect to place, as they do in Robert Smithson's Nonsites, nor do they represent an actual or proposed journey 'made' by the artist as in the

work of Long, but provide the route by which to arrive at a method for the creation of form.

Cape Cod Wedge Exchange (July 1968) is one of the first works in which Huebler included photographic documentation along with a map.[68] In addition to an aerial photograph of Cape Cod, the Massachusetts land mass that curves out into the Atlantic, the work presents two contingent wedge shapes drawn on a map of the area. The artist's procedure is outlined within the work:

Small wedges were made of concrete mixed with pebbles from Corn Hill Beach (A), sand from Long Nook Beach (B) and Ryder Beach (I), and ocean water from Ballston Beach (C). The wedges were then taken to the locations which had been previously drawn on a map in the configuration of two wedges, more or less 'twisting' from two shared locations (E and F); the wedges were simply left on the ground, or sand, one at each site thereby

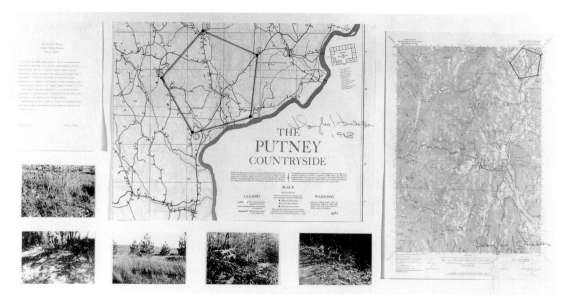

Douglas Huebler Site Sculpture Project, Windham College Pentagon, Putney, Vermont 1968

connecting all locations with markers composed of substances common to Cape Cod.[69]

Photographs of the sites, where the wedges originated and then were relocated, mediate between the flat diagrammatic wedge shapes depicted on the map and the actual beach locations where the concrete wedges were deposited as markers. In short, by means of photography, Huebler fused representational planarity with the material reality of the inlets along the Cape coastline.

For a related work involving urban centers, *New York–Boston Exchange Shape* (September 1968), Huebler plotted six points, respectively, on maps of the two cities and connected them to form a hexagon on each one. The artist subsequently traveled to the locations pinpointed on the maps for the purpose of taking photographs. Unstudied views of pavements, curbsides, or street corners substantiate the existence of the places on the map. A list of street names where the photos were snapped is also included. Consisting of maps, photographs, and text, the work presents a framework for pairing and comparing otherwise disconnected points in the real world. Comparable with *California Map Project / Part 1: California* by Baldessari, *New York–Boston Exchange Shape* similarly juxtaposes cartographic and photographic representation. Whereas linguistic elements printed on the map guide the formation of

Baldessari's work, geometric form and geographical location are merged in Huebler's work.

According to Huebler, his Site Sculpture Project *42 Degree Parallel Piece* (August/September 1968) was an attempt to make the largest but least intrusive or impositional sculpture imaginable.[70] Fourteen locations at 42 degrees longitude were identified on a map of the US. The line starts from Truro, Massachusetts and extends across the country to a small town in California. To anchor and give weight to the work as a set of points existing in reality, Huebler secured receipts from post offices in each of the fourteen towns he had marked on the map. He procured them by writing to request area maps from each town's chamber of commerce. Taking advantage of the 'return receipt requested' option offered by the United States postal service, he sent his letters by certified mail. As stated in the text of the work, 'the piece was brought into existence when all of the documents were returned and rejoined with the sender's receipts.' In lieu of concrete place markers and photographs, pink postal receipts imbue the work with its form and give it a transcontinental footing.

Composed of photographic and linguistic representation, the Duration, Location, and Variable Pieces ultimately took precedence over works involving maps. Incorporating photographs in nearly all cases, they are contingent upon the many different schemes

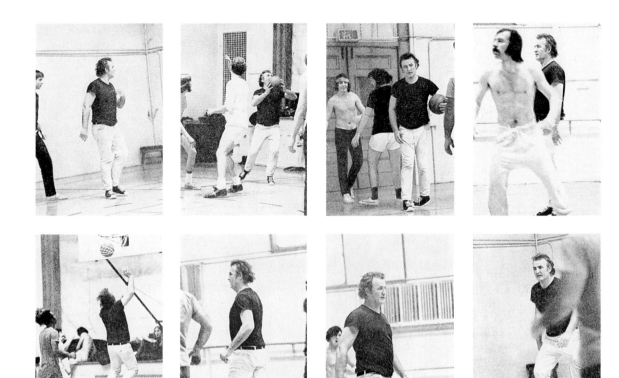

Douglas Huebler **Variable Piece No. 20** (detail) 1971

VARIABLE PIECE No. 20
Bradford, Massachusetts

On January 23, 1971, for eleven minutes, the specific physical location of the artist was photographically documented at exact 30 second intervals as, at each of those instants, he relocated himself within an extremely fluid spatial environment. 23 photographs join with this statement to constitute the form of this piece.

January, 1971 Douglas Huebler

Douglas Huebler **Variable Piece No. 20** (detail) 1971

articulated in the typewritten statements for mapping the parameters of the work. Functioning as co-dependent representational systems, language and photography avert subjectively determined compositional arrangements and markings. As used together by Huebler, they eradicate the distinction between a consolidated object and the space that surrounds it – an achievement not possible through traditional approaches to sculpture.

The typed and signed statement in Huebler's *Duration Piece No. 4, Bradford, Massachusetts* (September 1968) exemplifies how language explains the basis – in this case, a temporal one – on which the accompanying unposed snapshots were taken. The statement reads:

Photographs of two children playing 'jump-rope' were made in the following order:
I. Three photographs were made at 10 second intervals.
II. Three photographs were made at 20 second intervals.
III. Three photographs were made at 30 second intervals.
The nine photographs have been scrambled out of sequence and join with this statement to constitute the form of this piece.

By virtue of his having scrambled the sequence of individual images secured by the click of the shutter, the artist confirmed the suppression of personal aesthetic choice, which he had also held in check by deferring to the second-hand of his watch.

Photographic documentation in the Duration, Location, or Variable Pieces, carried out in accordance with the artist's specified verbal stipulations, gives each work its temporal, spatial, and conditional parameters. *Variable Piece No. 20, Bradford, Massachusetts* (January 1971) is another of many equally illustrative examples:

On January 23, 1971, for eleven minutes, the specific physical location of the artist was photographically documented at exact 30 second intervals as, at each of those instants, he relocated himself within an extremely fluid spatial environment.
23 photographs join with this statement to constitute the form of this piece.

The series of photographs captures their subject playing basketball in a gym. Individually they represent one of an infinite number of incidental moments, which only a camera could have isolated and frozen.

Language binds together the photographic data obtained by the artist to give coherency to otherwise separate and meaningless images. It furthermore demands the reconsideration 'of the experience of any phenomenon after it has been processed by language.'[71] *Variable Piece 1A (the netherlands, united states, italy, france, and germany)* (January 1971) demonstrates how ordinary, descriptive language operates in Huebler's work to bestow meaning on otherwise isolated instances of visual fact. It also displays how language tends to dominate phenomena and foster stereotypical thought. The statement reads:

eight people were photographed in the instant exactly after each had been told: 'you have a beautiful face,' or 'you have a very special face,' or 'you have a remarkable face', or in one instance, nothing at all. the artist knew only one person among the eight; it is not likely that he will ever again have a personal contact with any of the others.
the eight photographs join with this statement to constitute the form of this piece.[72]

The photographs in this respect bear witness to the idea that all kinds of people – male and female, young and old – are not only flattered by the prospect of being photographed but are taken in by the verbal suggestion that they have a beautiful or interesting face. The photographic cliché of the smiling face is here reinforced by linguistic cliché. 'I'm speaking against the irresponsibility of language,' Huebler maintained with regard to his interest in 'freeing nature from the imposition of language, mythology and literature.'[73]

Location Piece No. 6 – National (June 4, 1970) offers yet another instance of the great variety of conditions that Huebler devised for consolidating otherwise unseen aspects of reality within an indivisible whole. Conceived for the 'Information' exhibition at the Museum of Modern Art, New York, this piece concerns the breadth and diversity of information processed by the news media. For the work's realization, Huebler requested that one randomly selected newspaper from each of the

Douglas Huebler **Location Piece No. 6 – National** (detail) 1970

United States send him a press photo. The photographs, Huebler's letter, a list of the invited newspapers, and the artist's typed and signed statement are shown together. Each of the media events, captured in a single shot, are thus united in a work that ties together temporally connected, but visibly unconnected, events.

Huebler's verbal stipulations, which prearrange for – without predicting – the visual results of a work make thematically possible the concept of all-inclusivity. *Variable Piece No. 70 (in process) – Global* (November 1971), is worded as follows:

> Throughout the remainder of the artist's lifetime he will photographically document, to the extent of his capacity, the existence of everyone alive in order to produce the most authentic and inclusive representation of the human species that may be assembled in that manner.
> Editions of this work will be periodically issued in a variety of topical modes: '100,000 people,' '1,000,000 people,' '10,000,000 people,' 'people personally known by the artist,' 'look-alikes,' 'overlaps,' etc.[74]

Works belonging to his Everyone Alive series emphasize Huebler's underlying aesthetic goal: to allow reality as the sum of infinite visual phenomena to speak, via the camera, for itself.

More concerned with ways to 'get an angle' on reality than with attempts to artificially cut out static segments

from it, Huebler articulated in 1969 that 'the act of perceiving is what concerns me rather than what is perceived, because it is more interesting to find out what it is we do when we do perceive.'[75] Photographs serve, in this respect, as empirical data for situations instigated or explored – but never controlled – by the artist. Employed as a means for direct empirical notation, they afford the possibility of producing visual relationships that could not otherwise be observed. Triggered by verbal scenarios set forth by the artist, photographs bring together instances from the unstructured and ongoing continuum of people, places, and events that constitute visible reality.

The desire to embrace the whole of life motivates the work of Gilbert and George. While all-inclusiveness is an abstract idea that theoretically girds Huebler's practice, it serves as the major principle underlying the work of Gilbert and George. They arrived at their photographic method in an effort, shared with other contemporaries, to downplay formal invention and skillful manipulation of materials associated with the painted or sculpted masterpiece. With their foremost goal being to present life as fully as possible to a wide audience, they maintain: 'We believe the camera is the best modern brush today – because the artist wants to speak to the world. That is what he has to do, so that is the best form.'[76]

Early in their careers together, Gilbert and George dropped their surnames in order to emphasize the fact

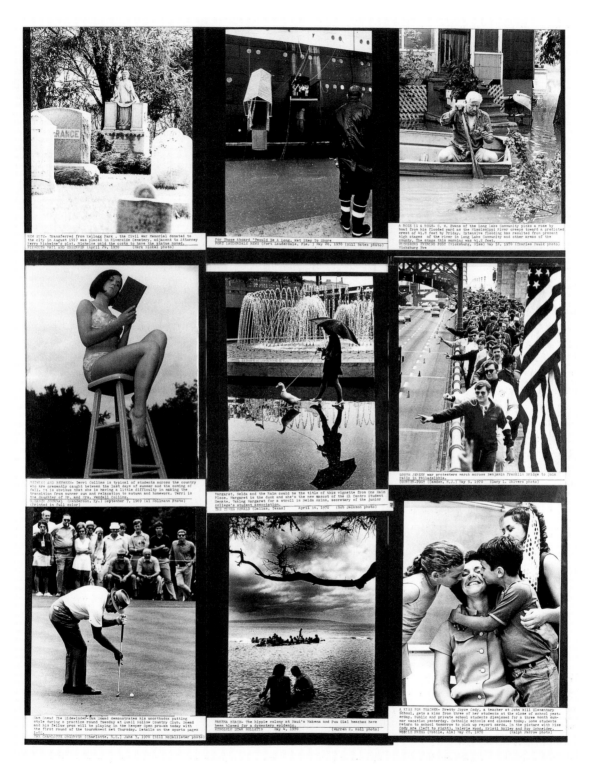

Douglas Huebler | **Location Piece No. 6 – National (detail)** 1970

that they are an indivisible authorial unit. Under the heading of sculpture (in the 1970s they variously called themselves Sculptors, Human Sculptors, or Living Sculptures) they have published artists' books, created pieces they refer to as either Postal or Magazine Sculptures and have also made films and videos. Photography, a word they themselves do not use, has however been their principal medium since 1971 when they created their first 'photo-pieces.' The artists' collaboration began when they were students at St. Martin's School of Art in the late 1960s. The photo-pieces, which they have continued to create in the 1990s, were preceded by their renowned Living Sculpture Presentations (1969–77) and briefly overlapped with their production of The Charcoal on Paper Sculptures (1970–74), and *'The Paintings' (with Us in the Nature)* (1971).

Works accomplished while they were still at St. Martin's suggest the way in which the artists were endeavoring to link sculpture to the broader scheme of life. These works give clues to the route the two would later take in works that depend on photography's direct connection with the world. *Three Works/Three Works* (1968) veered from traditional sculpture by virtue of its presentational conditions – a reception at Frank's Sandwich Bar on May 23 from 2.30 to 4.30 in the afternoon. The artists identified themselves on the mailed invitation by their respective – and coincidentally identical – initials, 'G.P.,' which appear on the upper right and upper left of the card. They each displayed three multi-colored molded or cast objects on two separate tables, but did not indicate which of one of them was responsible for which three works. The six 'Object-Sculptures' – a long rectangular shape, a cylindrical shape, a longer and a shorter rod, a disembodied mask, and a truncated pedestal – consisted of basic, non-functional forms. These otherwise intrinsically inessential objects took on meaning inasmuch as they became the raison d'être for a social gathering. Emblematic of sculpture but dispossessed of authorial validation, the object-sculptures, lying on tables in a restaurant rather than installed in a gallery, metaphorically came to life within the context of a real event.

The *Snow Show* (June 1968), a joint work created at the end of the school year, similarly sought to connect sculptural form with real-life surroundings rather than give credence to form for its own sake. 'What we did,' as Gilbert describes it, 'was put plaster on the floor to make it all white like snow, then we put the objects in. Then we closed off the door with plexiglas so you could see all these objects in a snowscape, and you could see this whole landscape of London through the window in front of you as well.'[77] The resulting effect was that of a still image, according to George. Serving as backdrop and frame, the window overlooking the city united the scattered objects inside with the view outside.

By the time they had introduced *Our New Sculpture* (1969), their first of many ensuing Living Sculpture Presentations, Gilbert and George had ceased their creation of objects in order to accentuate life as lived over motionless materiality. *Our New Sculpture*, which subsequently became *Underneath the Arches* (1969), was shown on January 23rd at St. Martin's. On this occasion, the two artists, standing on a table dressed in suits with glove and stick in hand, pantomimed the lyrics of the English music-hall ballad, 'Underneath the Arches,' about two happy-go-lucky tramps. Prefaced by brief remarks about sculpture, the presentation lasted about five minutes.

While the gramophone emitted the bittersweet words and sounds of the song, Gilbert and George mouthed the words of the tramps. Soon after this debut presentation, they omitted their preliminary words and alternatively titled the work *The Singing Sculpture* (1969). Soon thereafter they appeared with metallic makeup on their hands and faces to make themselves 'feel more like sculpture'[78] and sang the words of the song along with the recording. The now legendary public appearances by Gilbert and George as singing personifications of sculpture were realized on many different occasions in Europe in 1970, often for hours on end, and in New York at the Sonnabend Gallery in 1971.

Seeking to weld art to life by donning the guise of sculpture, Gilbert and George produced a number of other works under the heading of Living Sculpture Presentations. Not only did they sing the song of carefree vagabonds but they also installed themselves in public as if they were stony-faced statues. Although not officially invited to participate in 'When Attitudes Become Form' when it travelled to London in the fall of 1969, for example, they realized *A Living Sculpture* (1969) at the Institute of Contemporary Arts by standing in a central area of the exhibition space during

the private view. With their faces covered with multi-colored, metallic makeup, they remained immobile for the entire evening. Not long thereafter, with permission from the museum's director, they presented a five-hour-long version of *Posing Piece* (1969) on the staircase of the Stedelijk Museum, Amsterdam, wearing their trademark suits and wearing makeup. By setting themselves up to personify sculpture rather than to produce three-dimensional forms, they exhibited themselves as paradigms for artist and model simultaneously.

In 1969, Gilbert and George had embarked on totally shared lives and were looking for further ways to represent the idea that a work of art might embody the multifaceted aspects of life and, equally, be all-inclusive with regard to its audience. When they moved that year to 12 Fournier Street in London's East End, they labeled their establishment and enterprise: 'Art for All.' Like a name given to a notable residence or the title of a business, 'Art for All' appears on publications by Gilbert and George as well as on mailed works including invitations and the mailings they call Postal Sculptures. Additionally, they declared 'all the world an art gallery' as part of a Magazine sculpture entitled 'We met in London last year.' The entire text reads:

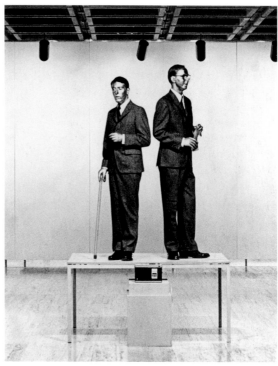

Gilbert and George | **Underneath the Arches** 1969

> We began to dream of a world of beauty and happiness of great riches and pleasures new of joy and laughter of children and sweets of the music of colour and the sweetness of shape, a world of feeling and meaning a newer better world, a world of delicious disasters of heart-rending sorrow, of loathing and dread a world complete, all the world an art gallery.[79]

The particular use of language by Gilbert and George replaces high art rhetoric with sentimental tropes that have the old-fashioned ring of what one imagines a bard resurrected from another century might sing in more recent times. Their texts borrow from or hark back to traditional, popular literary modes such as the limerick, ballad, or ode, yet are their own melange. 'We had to devise a vocabulary, a language that did not exist in the past…that reflects this age,' they have explained while adding that this language 'is not intended exclusively for a particular elite but for the man in the street.'[80]

Through the agency of the printed word – in books, magazine pieces, and mailings – Gilbert and George

assume the role of modern-day troubadours to sing of art and life and themselves as living sculptures. In *A Message from the Sculptors Gilbert & George* (1970), a Postal Sculpture, the following text was mailed as a formal announcement card. Photographs of the artists are framed within the embossed motif of a Classical temple that properly acknowledges, with refined ostentation, a momentous occasion:

> Gilbert and George, the sculptors,
> are walking along a new road.
> They left their little studio with
> all the tools and brushes, taking
> with them only some music,
> gentle smiles on their faces and
> the most serious intentions in the
> world.[81]

In the varied texts composed by Gilbert and George, often accompanied by sketches or photographs, the artists present themselves as their own subject matter. Given their self-designated personae as Living Sculpture

Gilbert and George **To Be With Art Is All We Ask (detail)** 1970

Sculptures 'speak' to their audience while they portray the authors who – visibly embedded in and nearly overwhelmed by leafy nature – are immersed in daily existence and communing with art. Gilbert and George consider the Charcoal on Paper Sculptures to be 'primitive photo-pieces.'[83] They wanted them to appear aged and crudely rendered, as if drawn on parchment in another era, and to be imbued with the feeling of 'a letter, not an art work.'[84] The hand-drawn illustrations, constructed out of separate squares of paper, are based on photographs taken by the artists. Glued side by side in a grid, the smaller squares of paper make possible large-scale, environmental works that in some instances fill an entire room.

Their use of photography opened up a wealth of subject matter and an entire world of images to the artists, who were searching for methods to bring all aspects of life into an aesthetic structure. 'We can take an image of *anything*,'[85] they came to realize. The first photo-pieces offer an alternative means to the photo-based Charcoal works as well as to the six triptychs belonging to '*The Paintings' (with Us in the Nature)* of 1971. As in the Charcoals, the artists are figured within the lushness of the English countryside, where they seem to be rapt in reverential contemplation of nature and greenery. '*The Paintings…*', which essentially are colored versions of the Charcoals, also underscore the artists' desire to communicate without the distraction of technical virtuosity.

Once they had learned that photography might be used in lieu of drawings that approximate the traditional *modello* (by which a drawing in earlier centuries was squared for transfer to a cartoon for a fresco or painting), Gilbert and George determined this medium to be the most appropriate for their art-for-all and art-about-all message. The Nature photo-pieces, bypassing signs of the artists' hands-on involvement, look squarely at their subject matter, which combines and interweaves portrait and landscape modalities. The subject matter of the Nature photo-pieces parallels that of the Charcoals and '*The Paintings…*' insofar as the sculptors have placed themselves within natural surroundings. By their use of the photographic medium, however, these works shed all vestiges of hand production to delineate a fresh path leading in the direction of representational truthfulness.

Without altogether eliminating nature from photo-pieces after 1971, Gilbert and George supplanted it with

they endeavor to promote their concept of a broadly based, democratic art through different media categories. Whether taking the form of a live performance, a publication, or a postal work, their works verbally and visually allude to the tradition of sculpture at the same time that they negate the dead weight of three-dimensionality.

The Charcoal on Paper Sculptures, begun a year before the photo-pieces, 'were not drawings,' according to the artists who 'thought of them as… documents' and, more particularly, as a 'means of communicating with the world around us.'[82] These 'sculptures' are comparable with the Living Sculpture Presentations as well as with the Magazine and Postal Sculptures. Similarly incorporating language, the Charcoal on Paper

contextual situations that give their ensuing work a social edge. Commencing in 1972, with pieces constructed around drinking and drunkenness, they began to contend with their relationship to life as participants in society. Lending their own presence to the formation of each work, they embody life forces that issue, as they see it, from 'the head, the soul, and the sex.' They have written that 'In our life these forces are shaking and moving themselves into everchanging different arrangements. Each one of our pictures is a frozen representation of one of these "arrangements."'[86]

Photography provides Gilbert and George with the opportunity to choose, for representational purposes, from any and all possible visible moments. The first photo-pieces comprise individually framed, rectangular vignettes that hang together in variously arranged groups in accordance with a particular theme. Representations over a several-year period of inebriation lay the groundwork for further forays into areas of experience that have been addressed photographically. Ten separately framed black-and-white photographs constitute the entirety of *Falling* (1972), the first in the group. The same basic image, subjected to slightly different degrees of cropping and exposure to light in the darkroom, is placed on the wall at differing angles to

the floor and to each other. The ten images appear to be in the process of tumbling down, taking the pictured sculptors, hands in pockets standing in a bar, with them.

The drinking pieces assume different forms and shapes on the wall and incorporate separate photographs of varied sizes. *BALLS: The Evening Before the Morning After* (1972) is constructed from approximately one hundred smaller and larger frames, whereas *A Drinking Piece* (1973) is made up of only seven. These works connote the loosening of social constraints and strictures at the same time as they inject the movement of actual scenarios caught by the camera into their pictorial content.

Almost always dressed in coat and tie in accordance with conventional social standards of presentability, Gilbert and George perform a prominent, yet depersonalized and emblematic, role in each picture. During the 1970s, their works evolved from attention to literal interiors and internal states to illustrations of the state of society. In 1977, they introduced images of youths, vagrants, and other members of society observed on the street. In *The Alcoholic* (1978), for example, the artists' heads in large-scale profile, bowed as if in thought, are juxtaposed with the image of a figure at the base of the picture lying on the sidewalk. Like Endymion

Gilbert and George **Dead Boards No. 5** 1976

in nineteenth-century iconography, the figure lies sleeping but, unlike the mythical character, he has passed out from alcohol, as the work's title makes evident. Without judgmental commentary, *The Alcoholic* alludes to the social discrepancies and inequities of modern life.

It is the instability of meaning contained within a photographic image that is Victor Burgin's main area of investigation. Concerned with thematic issues removed from those of Gilbert and George, Burgin sheds doubt on the unquestioned truth value of photographic messages. Just like the sculptors Gilbert and George, however, he considers photography to be the most appropriate medium for art today. 'It has a current social coinage, in a way that painting hasn't,' he has pointed out, because 'photographs are encountered in almost every aspect of daily life.'[87] In Burgin's production, photography is not intended to offer a one-on-one relationship to what is picked up on film through a camera lens. On the contrary, the artist proposes that the visible content of a mechanically reproduced image be subjected to discriminating readings since 'manipulation is of the essence of photography.'[88]

During graduate work at the School of Art and Architecture, Yale University, from 1965 to 1967, Burgin

continued studies in philosophy begun in London at the Royal College of Art with Iris Murdoch. At Yale, he came directly into contact with a number of prominent artists, such as Ad Reinhardt, Helen Frankenthaler, Frank Stella, Donald Judd, and Robert Morris, who were visiting instructors. But it was the then relatively new field of semiology that provided him with a crucial foothold to reach his own aesthetic conclusions. His early thinking benefitted in large degree from the theoretical writing of the French structuralist Roland Barthes, who in the early 1960s mapped principles derived from linguistics onto the study of other systems of communication based on signs.

The belief articulated by Robert Morris that a sculpture should be consonant with its architectural surroundings struck Burgin as particularly significant. Burgin himself had created spare, grey paintings and other objects drained of illusionistic content, which leaned against the wall or lay on the floor.[89] In 1967, with the intent of carrying Morris's injunction to strip the object of all secondary associations and content extraneous to the fact of its own existence, Burgin turned to making works that took the form of written instructions. About fifteen were set down in writing on index cards and kept together in a file box.

Some five or six of the instructions written by Burgin were later physically constructed by the artist. For instance, two equilateral rope triangles, both measuring three feet to a side, constituted *Memory Piece* (fabricated 1969), which Burgin installed in Greenwich Park in London to meet his stated conditions for two spatially separated but identical units.[90] Although the respective triangles co-existed, having been placed at opposite ends of an existing path, they could not be seen at the same time. Burgin has observed the importance of 'the perceiver's role in the formation of the specific nature of any such "object."'[91] *Memory Piece*, in this regard, came together only by virtue of the faculty of memory, which made it possible for a viewer to keep the first of the triangles in mind.

If *Memory Piece* drew attention to the subjectivity of viewing by defining the work in terms of the mental act of recollection that binds its parts together, *Photopath* (fabricated 1969) accentuated strictly informational content in order to de-emphasize materiality. First shown at the London venue of 'When Attitudes Become Form,' it followed the written instructions for a work in which

Gilbert and George **The Alcoholic** 1978

Victor Burgin **All Criteria...** 1970

'images are perfectly congruent with their objects.'[92] Twenty-one photographs taken of twenty-one continuous sections of the floor boards of the exhibition space were printed to size and stapled directly on top of the boards so that the grain of the wood and the photographic image were exactly matched. Congruent with its physical circumstance, *Photopath* avoided three- dimensionality.

Burgin noted in his important early article, 'Situational Aesthetics,' that 'it may no longer be assumed that art, in some mysterious way, resides in materials.'[93] The instructional pieces filed on index cards were superseded by works such as *This Position* (1969), *Any Moment* (1970), and *All Criteria* (1970). These works exist as a series of linguistic statements that abstractly address spatio-temporal situations in relation to a viewing self. Presented simply as pages in a book or as printed sheets papered to the wall, they further shun traditional object status.[94] The first of these pieces invites the reader to consider eleven possible states of time and self in a manner reminiscent of philosophical propositions. Each commences with the words 'This position signifies,' and states a possibility of 'self' somewhere on a time line between 'X and X' – for example, 'THIS POSITION SIGNIFIES ALL

SENSORIMOTOR REFLEXES OF SELF SUBSEQUENT TO X AND PREVIOUS TO X'. Each proposition pinpoints a fleeting temporal interval during which an action or experience relating to a self/person takes place. The resulting 'object' is a purely mental one with temporal rather than spatial dimensions.

All Criteria – following from *Any Moment*, which deals with time and recollection with respect to a perceiver – was designed to be valid wherever it might be encountered, whether on a page or in an exhibition space. The criteria, left general and all-encompassing, involve the interaction between individuals, events, and things. For example, number 5 of the fourteen elements of the work states: ALL CRITERIA BY WHICH YOU MIGHT ASCRIBE INDIVIDUALITY TO THINGS OTHER THAN OBJECTS. The generalized nature of the statements entrusts spectators with the responsibility for filling in specifics, having been given a verbal template with which to self-consciously reflect upon their position in the world in terms of their subjectivity.

In *Performative/Narrative* (1971) Burgin addressed the nature of the photographic image, which he has pointed out 'can carry a large number of different meanings. It is "polysemic." Generally, the polysemy of the image is controlled by its juxtaposition with a verbal text.'[95] Drawing heavily upon his knowledge of structuralism and semiotics, and upon his understanding of the British philosopher A. J. Austin's definition of the 'performative' in language,[96] Burgin sought to illustrate the way in which photography, an all-pervasive but not all-telling visual presence in the social landscape, 'performs' in association with a text.

Performative/Narrative exists in book form in Burgin's *Work and Commentary*, published in 1973, as well as being a wall piece. It is made up of a series of sixteen separate photographs, each of them showing the same chair in front of the same desk with the same lamp and file folder on it. A partial view of a book case and file cabinet in the background signifies an office context. The sixteen images, at first glance appearing to be the same, present permutations of binary states of the objects shown: the chair (under the desk or away from it); the desk (drawer open or closed); the reading lamp (on or off); and the file folder (open or closed). An exhaustive series of the sixteen permutations of binary digits (1111, 0111, 1011, 0011, 1011, 1101, 0101, 1001, etc.) correlates with the

Victor Burgin **Performative/Narrative** (detail) 1971

permutational states of the objects photographed. These binary digits are connected with fragments of a narrative pertaining to events not shown that might have occurred in the office setting, emptied of people, represented in the photographs. For example, the first of these narrative fragments, reads: 'Taking a tissue from a drawer in the desk the girl wiped some spilled coffee from the surface of the desk, then she closed the drawer.' In the photograph associated with this text, file folder and drawer are open as they are in the second. In the third photograph, the file folder is closed. The accompanying text reads: 'Much of the time at that desk he would pass in thinking of his secretary, in a succession of near simultaneous images culled from all parts of the globe.'

An introductory statement to *Performative/Narrative* sets forth the range of possible connections in close temporal or spatial proximity between events or between participants in the narrative as well as between participants and inanimate objects in the photographs. Additionally, a group of sixteen texts, each consisting of four sets of conditions, is threaded through the work. These conditions obey the same binary logic as the photographs, beginning with all positive statements and ending with all negative statements. Whether or not

they are preceded by 'Not,' they assert for one, 'your knowledge of the preceding narrative,' and, two, of the preceding photograph. The third states 'Not/The criteria by which you might decide that aspects of 1 are analogous to, correlate with, or may be placed in some common context with, aspects of 2.' Finally, the fourth states 'Not/Your inferences from 1 and 2 on the basis of 3.' In essence, they ask viewers to consider all the criteria upon which their knowledge about the image is based. Taken together, texts and photographs in *Performative/Narrative* forge a view of the multiplicity of meanings any one photograph – unavoidably a detail from a larger set of unknown conditions – might have in conjunction with information supplied by the narrative associated with it.

A work of 1973, *VI*, furnishes another variant of text and image combinations. Here, the same photograph is repeated in tandem with a changing narrative and, in this case, includes socially pointed subject matter. Appropriated from a British mail order catalogue, the photograph presents the image of a happy, nuclear British family. Large-type captions, composed by the artist, deal directly with dominant social values and beliefs in order to suggest links between photographic and verbal content. The first, for example, maintains

Within the image:

A complex of phenomena so integrated as to be seen as a unit with properties not derivable from the parts of that unit in summation; a sector of a given perceptual field identified, at a given moment, as a whole and as having attributes more extensive than the sum of the attributes of its constituent elements; a gestalt.

Any physical object is to be positively valued only if it may be instrumental in the achievement of a goal.

Victor Burgin **VI** (detail) 1973

'Any physical object is to be positively valued only if it may be instrumental in the achievement of a goal' and the last, 'Precipitance in the achievement of goals is to be positively valued.' Likewise, the remaining captions comment abstractly on the positive value of goals. They are interpretatively linked to the photograph by expectations incurred in relation to their proximate positioning beneath the image. Another, separate group of texts written by Burgin in the theoretical language of structuralism, runs concurrently through the work in counterbalance to the consumerist values embedded in and evoked by text and image. The work, in this way, lays bare the methods employed in its construction rather than cloaking them in the manipulative terms of advertising. At the same time, it proffers such methods to decode the proselytizing texts and images rampant in modern society.

By the mid-1970s, Burgin had begun to make use of feminist and psychoanalytic criticism in his examination of how photographs, in complicity with language, are used in Western culture. To form the tripartite work *Sensation/ContraDiction/Logic* (1975), images were extracted from advertisements and combined with texts written by the artist in the style of advertising copy. Three large, square photographs of equal size are headed, respectively, by the words in the work's title and captioned by statements written in the second person. The images – close-ups of a woman's hands on her naked torso, fingers of a woman's hand above her lips, and a full-faced view of a man putting his finger to his lips to signify a secret – have indeterminate meaning. The texts omit contextual points of reference and ironically apply phrases pertaining to sensation, possession, or property. Their misty, mystifying

rhetoric rings hollow while it echoes the emptiness of the alluring promotional images.

A series of eleven black-and-white photographs entitled *UK76* (1976) further investigates how images function when they are allied with promotional texts.[97] The eleven separate photographs, taken by Burgin himself, carry a different text that is printed over a portion of each image. Each text, mimicking styles of language found in advertising, has specific bearing on its assigned photograph. For example, in 'Today is the Tomorrow You Were Promised Yesterday,' the text, placed in the upper left-hand corner of the image, reads partially as follows: 'The early-morning mist dissolves. And the sun shines on the Pacific… Wander down a winding path. Onto gentle sands. Ocean crystal clear. Sea anemones. Turquoise waters. Total immersion. Ecstasy.' The message of the text, perhaps an inducement to take an expensive vacation, conflicts with the photographic representation of a low-income housing complex. The

photograph, furthermore, which includes a pregnant woman on the far left pushing a stroller, belies the textual injunction for a promised tomorrow in a place where 'pelicans splash lazily in the surf.' By connecting obviously 'slanted' writing with seemingly neutral black-and-white images, the artist makes an ironic spectacle of the contradiction between the imaginary world created by advertisers and the world most people in the UK recognize more readily.

Like a text, Burgin suggests, an image must be interpreted as a 'complex of signs used to communicate a message'[98] so that attention may be given to what its concealed assumptions might be. The artist has articulated the theoretical premises of his work in extensive writings that complement an art motivated by the desire to declare the *mis*representation that 'lies' beneath the surface of representation, particularly in images of the advertising media with their commercial objectives. On account of the authority of their supposed

Sensation

Create a little sensation
Feel the difference that everyone can see
Something you can touch
Property
There's nothing to touch it

ContraDiction

You've got it
You want to keep it
Naturally. That's conservation
It conserves those who can't have it
They don't want to be conserved
Logically, that's contradiction

Logic

Everything you buy says something about you
Some things you buy say more than you realise
One thing you buy says everything
Property
Either you have it or you don't

Victor Burgin | **Sensation** | 1975

Victor Burgin 'St Laurent Demands...,' from UK76 1976

St. LAURENT DEMANDS
A WHOLE NEW LIFESTYLE

Hips matter a lot. By day
each dirndl skirt is stitched
firmly down over the hips
or else there is a suede
hip yoke.
By night black velvet
camisole bodices extend down
over the hipline then
the bright taffeta skirt
springs out free.
Yves' day-time clothes,
like his ready-to-wear
three months ago,
are a ramble through
Eastern Europe.

factual presence, photographs – whose 'point of view' and 'frame of reference' are not actually seen within their circumscribed, two-dimensional format – have the ability to cover up 'the actual material condition of the world *in the service of specific vested interests.*'[99]

With the intent of disclosing how the dominant ideology operates through representation, Burgin believes that a 'job for the artist which no one else does is to dismantle existing communication codes and to recombine some of their elements into structures which can be used to generate new pictures of the world.'[100] He sees photographs as conduits that enable a clearer view of the present social reality, but only if and when they are properly decoded. Otherwise, Burgin has articulated, 'we remain susceptible to the picture of the world'[101] that widespread photographic representation imposes.

The work of Burgin, along with that of the Bechers, Dibbets, Baldessari, Huebler, and Gilbert and George, suggests the range of aesthetic aims which photography has pursued in the name of reality, on the one hand, and in the interest of pictorial construction on the other. Like others of their generation, the Bechers promote surface fact over personal fabrication and deal with already existing shapes rather than with invented subjects. Photography has provided them with a method for straightforward duplication by which to reveal a nearly endless permutational variety of forms that have come to light through an extensive comparative study of a wide cross-section of industrial building designs. Each photographic view supplies yet one more visual instance of an architectural structure for accommodation within the structure of the work.

Photography functions in Dibbets's oeuvre to cancel the pictorial illusion of spatial depth in the creation of abstract works that do not obliterate reference to observable reality. He marshals the sun in lieu of paint to compose works that are informed by reality rather than directly formed by the artist. Specifically, his works wipe out the traditional vanishing point in pictorial constructions that honor the legitimacy of the flat surface over the claims to truth made by linear perspective.

In contrast to Dibbets's involvement with relationships between abstract picture-making and real-life picture-taking, Baldessari is involved with discovering ever new methods by which to minimize authorial dictates in the creation of compositional form and pictorial meaning. Whereas variously colored, shiny car doors in Dibbets's *Colour Study* of 1976 provide a referent for the purposes of abstraction, Baldessari's *Car Color Series: All Cars Parked on the West Side of Main Street, Between Bay and Bicknell Streets, Santa Monica at 1:15 P.M., September 1, 1976* is compositionally driven by chance rather than by direct aesthetic choice. Standing behind the camera, which duplicates whatever is set in front of it, the artist is able to back away from demonstrations of manual skill or technical prowess so as to make manifest the results of whatever provisos he may have conceived to produce pictorial meaning.

Also eschewing straightforward invention for its own sake, Huebler defined 'art as an activity that extends human consciousness through constructs that transpose natural phenomena from that qualitatively undifferentiated condition that we call "life" into objectively and internally focused concepts.'[102] His Duration, Location, and Variable Pieces depend on the camera to arrest motion and frame objects within its field of vision according to the artist's directives. Through his reliance on the camera 'as a duplicating device whose operator makes no "aesthetic" decisions,'[103] Huebler offers a glimpse of the infinite, multifaceted, and fleeting nature of perceivable phenomena instead of a simple slice of life. His works redefine the nature and scope of the traditional pictorial field in order to enframe otherwise unframable aspects of spatio-temporal reality.

With the broad sweep of their metaphoric brush, Gilbert and George seek to depict the whole of life as lived and experienced by them. Photography, in whose veracity they trust, is not beholden to a single viewpoint or held back by norms of 'uprightness' set by the horizon line. By dividing each work into separate but related pictorial panes, the artists disregard straight-forward picture-window illusionism. They are thereby free to investigate the many corners of the reality in which they, as living sculptures, find themselves. At liberty through photography to explore a wide range of themes and subjects from whatever angle they choose, they reflect upon the human condition. Hoping to break free from the social mold that defines them without utterly shattering it, Gilbert and George wield the camera in lieu of the chisel in an attempt to lessen the repressive load of conformity that weighs upon art and society.

During the 1970s, photography served multiple purposes and, with the exception of Burgin's work, functioned denotatively. If Burgin's work lays the groundwork for the skeptical awareness needed for seeing through the two-faced potential of photographic images, in the oeuvres of the Bechers, Dibbets, Baldessari, Huebler, and Gilbert and George, photographs provide an unimpeded entrée to external reality. Although Burgin has presciently demonstrated how a photographic image is subservient to language in the information it supplies and is thus open to ideological bias, he nonetheless may be grouped with those who, in the second half of the 1960s, severed ties with the traditional categories of painting and sculpture in order to reorganize earlier pictorial concepts along new lines.

Sol LeWitt **Objectivity** 1962

Systems, Seriality, Sequence

The independent use of linguistic and/or photographic means in place of paint or conventional art materials characterizes the work of many of the artists who, in the latter half of the 1960s, rejected the representational methods of the past. Seriality in the work of these artists rests on the application of organizational schemes, or systems, that engender a number of possible visual sequences. Often used in conjunction with numerical or other permutational sequences, serial systems have served a range of purposes. The oeuvres of Hanne Darboven (b. 1941), On Kawara, Stanley Brouwn (b. 1935), Mel Bochner (b. 1940), and Christine Kozlov (b. 1945) expressly exemplify how artists utilizing representational means such as maps or numbers – as well as, or in conjunction with, language – have been able to divest their aesthetic production of illusionistic planarity or volumetric materiality. Intent on steering away from the presentation of painted imagery on canvas or the creation of objects in three-dimensional space, they renewed the pursuit of their Minimal predecessors for self-evident visual immediacy.

The serially based work of Sol LeWitt demonstrates a pivotal shift from the guiding principles of Minimalism to those of Conceptualism. LeWitt is given credit for having launched the term 'Conceptual' in his famous 'Paragraphs on Conceptual Art' of 1967 and 'Sentences on Conceptual Art' of 1969, which synthesize the rationale behind both his own practice and that of a number of his contemporaries. A key passage from the Paragraphs puts forth the main premise of LeWitt's methodology:

> To work with a plan that is pre-set is one way of avoiding subjectivity. It also obviates the necessity for designing each work in turn. The plan would design the work. Some plans would require millions of variations, and some

Donald Judd **Untitled** 1973–75

a limited number, but both are finite. Other plans imply infinity. In each case however, the artist would select the basic form and rules that would govern the solution of the problem. After that the fewer decisions made in the course of completing the work, the better. This eliminates the arbitrary, the capricious, and the subjective as much as possible. That is the reason for using this method.[1]

From his early wall reliefs of 1962 to the Wall Drawings that would encompass entire rooms, LeWitt's work evinces the artist's desire to avoid personal, and provisionally capricious, methods of decision-making. Use of a predetermined plan, as he stipulates, guarantees the objective honesty of a work based on its own set of internal conditions rather than on arbitrary manipulations of color, line, or form.

LeWitt considers his works from the early 1960s to be 'neither paintings nor sculptures, but both,'[2] and refers to them as 'structures.' These pieces jut out from the wall and, comparable with works by Donald Judd, bear the message of their own gestalt, or formal presence. Pictorial reliefs, incorporating single

Sol LeWitt **Wall Structure** 1963

words like 'look' or 'run,' preceded his highly accentuated, projecting wall pieces. In *Objectivity* (1962), for example, the five phonemes of this word perform in a sequence of five rows from the top of a painted wood square to the bottom in the following manner: they project from the surface as small individual squares; they lie flat on the surface; they recede from the surface; and, finally, they are replaced by solidly painted squares. The word 'Ob-je-ct-iv-ity' not only contributes to the work's flat imagery, but also participates within the equalizing grid of the object. It thus belongs inseparably to a picture plane that advances and recedes in actuality, while spelling out and echoing the objective reality of its state as an object.

To 'continue the idea of working with the picture plane in three dimensions by piercing or building out from it,'[3] LeWitt began to experiment with serial form in his wall reliefs of 1963. In *Wall Structure* (1963), which was his 'first serial attempt,'[4] rectangular volumes, enclosed one within another, progressively widen and shorten outward from the work's center to its rim and jut out from the wall into the viewer's space. This offered an alternative to the incorporation of linguistic elements placed in topographic relation to the picture plane as they are in *Objectivity*.

With the realization of *Muybridge I* (1964) the following year LeWitt furthered his investigation of pictorial planarity and spatial reality with relation to duration. Familiarity with the studies of the Anglo-American photographer Eadweard Muybridge (1830–1904), who is known for hundreds of photographs of animal and human locomotion, aided LeWitt in his concerted search for ways to counteract the static nature of singular objects. *Muybridge I* is built upon the nineteenth-century photographer's procedure for presenting an object in motion as a series of individually recorded moments to be read from left to right. As opposed to *Wall Structure*, this work, to be read in a left-to-right sequence, is experienced in real time. Photographs are contained within a long, compartmentalized black box with ten equally spaced occuli. Spectators may peer successively through each of the ten holes to view the image of a walking female nude. Inasmuch as the first image shows the woman's entire body in the distant background and the last is a close-up of her navel, the figure, who walks in the direction of the

Sol LeWitt Serial Project #1 (ABCD) 1966

camera's lens, appears to come progressively closer to the viewer and to the surface of the picture plane.

Muybridge II (1964) operates on a similar principle. In this work, the nude is sitting and, instead of striding toward the camera, remains stationary as the camera gradually moves in her direction until only her navel is visible. Wittily treading the tenuous line between objective observation and subjective voyeurism, *Muybridge I* and *Muybridge II* playfully refer, without succumbing, to the pictorial notion of foreground and background (while also alluding to traditional depictions of the female nude in earlier art). By creating the effect that the nudes are coming ever closer to viewers in tandem with their own sequential movement, LeWitt's Muybridge-inspired pieces activate the static nature of traditional figuration at the same time that they eliminate the vanishing point of perspectival illusion.

LeWitt's understanding of the implications inherent in Muybridge's photographic progressions was reinforced by his recognition of the importance of Dan Flavin's *Nominal Three* (1964) in relation to his own nascent ideas regarding seriality.[5] These ideas were fully developed in *Serial Project #1 (ABCD)* (1966), a work that takes permutational progression – which, in Flavin's piece, from left to right across the wall in spatial intervals, accommodates one, two, and three fluorescent tubes – to a much greater degree of complexity.

In *Serial Project #1 (ABCD)*, exhibited at the Dwan Gallery, New York in 1967, LeWitt's utilization of a serial modality became fully apparent. The artist described his approach to this work in *Aspen Magazine*, introducing his presentation with the explanation that 'serial compositions are multipart pieces with regulated changes.' They are to 'be read by the viewer in a linear or narrative manner (12345; ABBCCC; 123, 312, 231, 132,

213, 321) even though in their final form many of these sets would be operating simultaneously, making comprehension difficult.' Serial compositions, he further maintains, preclude subjectivity since 'chance, taste, or unconsciously remembered forms would play no part in the outcome.' The work in this instance was composed of 'a finite series using the square and the cube as its syntax.'[6]

'There is no need to invent new forms,'[7] LeWitt emphatically notes in *Aspen Magazine*. On the Dwan Gallery exhibition announcement, which reproduces a diagram of 'One Set of Nine Pieces' and contains numerous specifications, he further observes: 'The individual pieces are composed of a form set equally within another and centered. Using this premise as a guide no further design is necessary.' Moreover, he points out that 'these pieces should be made without regard for their appearance but to complete the narrations that are pre-set.'

Shortly after his adoption of preset 'narrations' for the realization of three-dimensional structures, LeWitt expanded his production to include drawing. In response to the invitation to participate as one of seven artists in the Xerox Book (1968), LeWitt filled twenty-four of his allotted twenty-five pages with permutations based on a quadripartite linear system within four squares that, in turn, are subdivided into four more squares. Each of any of the elemental squares alone presents evenly and tightly drawn parallel straight lines that run either vertically, horizontally, or diagonally to the right or left. The artist presented twenty-four combinations of sixteen-square sets 'by rotating the numbers in four sections of four'[8] as shown in the numerical scheme on the last page of his piece.

Simple visual points of departure that adhere to a clear and rational advance plan have engendered visually rich and complex permutational sequences in LeWitt's two-dimensional production, just as they have in the cubical works that evolved from *Serial Project #1 (ABCD)*. Projects based on linear elements reveal how a serial method in drawing led to the broad scope of visual ideas and effects found in LeWitt's books, prints, and Wall Drawings. A work directly related to the Xerox Book project, *Four Basic Kinds of Straight Lines and All Their Combinations in Fifteen Parts* (1969), according to LeWitt, 'provided the vocabulary for further series' in black and white and in color. This work consists of fifteen permutational variations obtained by the presentation of vertical, horizontal, and diagonal straight lines within the confines of fifteen separate squares. Each of the fifteen squares subtly displays a slightly different surface texture and – with two, three, and four different directional lines having been superimposed one upon another – become progressively denser.

By developing a systematic method for engendering his drawings, LeWitt divorced personalized draughtsmanship from the handling of line. Lines, including straight or not-straight lines, broken lines, short lines, touching or not-touching lines, etc., have been employed in diverse ways toward a wide range of visual ends. Having shed its former representational function as a container of shape, line in works by LeWitt is not descriptive or expressive nor is it employed to delineate an object that is subsumed within a larger pictorial scheme.[9] Instead, lines promote themselves as self-fulfilling entities detached from secondary duties such as outlining a figure or representing shading by means of cross-hatching. Thus controlled by preplanned permutational systems, LeWitt's works supply concrete evidence for the overarching premise voiced in the 'Paragraphs' and 'Sentences on Conceptual Art' that concept supersedes craft in the realization of an aesthetic idea.

Permutational sequences in LeWitt's work are comparable to the mathematical progressions employed by Donald Judd to obviate signs of personal decision-making processes associated with compositional arrangements. Emphasizing in an interview that the elements of his work are given, not invented, Judd commented on the importance of his use of regular or uneven progressions based on different kinds of mathematical series such as the Fibonacci sequence, or inverse natural number series.

No one other than a mathematician is going to know what that series really is. You don't walk up to [the work] and understand how it is working, but I think you do understand that there is a scheme there, and that it doesn't look as if it is just done part by part visually. So it's not conceived part by part, it's done in one shot. The progressions made it possible to use an asymmetrical arrangement, yet to have some sort of order not

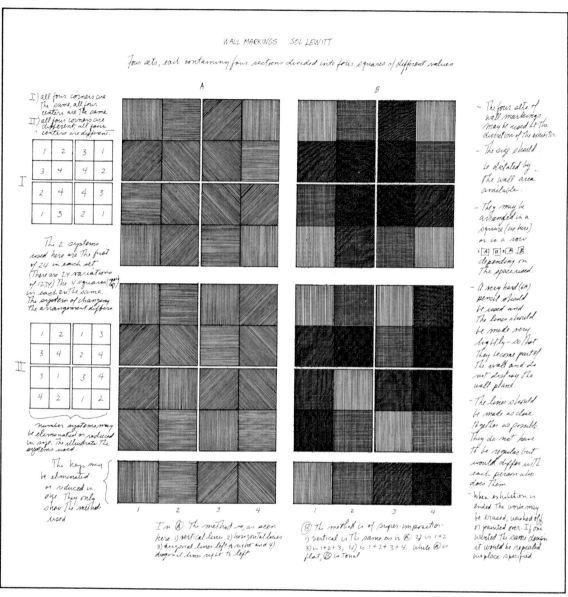

Sol LeWitt **Wall Markings** 1968

involved in composition. The point is that the series doesn't have anything to do with mathematics, nor does it have anything to do with the nature of the world.[10]

In works by LeWitt, in contrast to those by Judd, the underlying program given in descriptive and instructional titles for two-dimensional and three-dimensional works – such as *47 Three-Part Variations on*

Three Different Kinds of Cubes (1967) or *Ten Thousand Lines, One Inch Long, Evenly Spaced on Six Walls Each of a Differing Area* (1972) – is brought to the surface as an integral part of their content. Serial methods, which remain behind the scenes in Judd's oeuvre, are openly and thematically declared in the work of LeWitt and others working in a related vein.

Lines in LeWitt's drawings perform in response to prearranged sequences that provide each work with its

```
1.  Rectangles are located according to coordinate position on
    following page.
2.  In listing of rectangles, horizontal coordinates precede vertical
    coordinates.
3.  Listing system (below) is based on exhaustion of horizontal
    coordinates.

(1,1)   (2,1)   (3,1)   (4,1)   (5,1)   (6,1)   (7,1)   (8,1)
(1,2)   (2,2)   (3,2)   (4,2)   (5,2)   (6,2)   (7,2)   (8,2)
(1,3)   (2,3)   (3,3)   (4,3)   (5,3)   (6,3)   (7,3)   (8,3)
(1,4)   (2,4)   (3,4)   (4,4)   (5,4)   (6,4)   (7,4)   (8,4)
(1,5)   (2,5)   (3,5)   (4,5)   (5,5)   (6,5)   (7,5)   (8,5)
(1,6)   (2,6)   (3,6)   (4,6)   (5,6)   (6,6)   (7,6)   (8,6)
(1,7)   (2,7)   (3,7)   (4,7)   (5,7)   (6,7)   (7,7)   (8,7)
(1,8)   (2,8)   (3,8)   (4,8)   (5,8)   (6,8)   (7,8)   (8,8)
(1,9)   (2,9)   (3,9)   (4,9)   (5,9)   (6,9)   (7,9)   (8,9)
(1,10)  (2,10)  (3,10)  (4,10)  (5,10)  (6,10)  (7,10)  (8,10)
(1,11)  (2,11)  (3,11)  (4,11)  (5,11)  (6,11)  (7,11)  (8,11)
(1,12)  (2,12)  (3,12)  (4,12)  (5,12)  (6,12)  (7,12)  (8,12)
(1,13)  (2,13)  (3,13)  (4,13)  (5,13)  (6,13)  (7,13)  (8,13)
(1,14)  (2,14)  (3,14)  (4,14)  (5,14)  (6,14)  (7,14)  (8,14)
(1,15)  (2,15)  (3,15)  (4,15)  (5,15)  (6,15)  (7,15)  (8,15)
(1,16)  (2,16)  (3,16)  (4,16)  (5,16)  (6,16)  (7,16)  (8,16)
(1,17)  (2,17)  (3,17)  (4,17)  (5,17)  (6,17)  (7,17)  (8,17)
(1,18)  (2,18)  (3,18)  (4,18)  (5,18)  (6,18)  (7,18)  (8,18)
(1,19)  (2,19)  (3,19)  (4,19)  (5,19)  (6,19)  (7,19)  (8,19)
(1,20)  (2,20)  (3,20)  (4,20)  (5,20)  (6,20)  (7,20)  (8,20)
(1,21)  (2,21)  (3,21)  (4,21)  (5,21)  (6,21)  (7,21)  (8,21)
(1,22)  (2,22)  (3,22)  (4,22)  (5,22)  (6,22)  (7,22)  (8,22)
(1,23)  (2,23)  (3,23)  (4,23)  (5,23)  (6,23)  (7,23)  (8,23)
(1,24)  (2,24)  (3,24)  (4,24)  (5,24)  (6,24)  (7,24)  (8,24)
(1,25)  (2,25)  (3,25)  (4,25)  (5,25)  (6,25)  (7,25)  (8,25)
(1,26)  (2,26)  (3,26)  (4,26)  (5,26)  (6,26)  (7,26)  (8,26)
(1,27)  (2,27)  (3,27)  (4,27)  (5,27)  (6,27)  (7,27)  (8,27)
(1,28)  (2,28)  (3,28)  (4,28)  (5,28)  (6,28)  (7,28)  (8,28)
(1,29)  (2,29)  (3,29)  (4,29)  (5,29)  (6,29)  (7,29)  (8,29)
(1,30)  (2,30)  (3,30)  (4,30)  (5,30)  (6,30)  (7,30)  (8,30)
(1,31)  (2,31)  (3,31)  (4,31)  (5,31)  (6,31)  (7,31)  (8,31)

                                                (over)
                                                        79
```

```
(9,1)   (10,1)   (11,1)   (12,1)
(9,2)   (10,2)   (11,2)   (12,2)
(9,3)   (10,3)   (11,3)   (12,3)
(9,4)   (10,4)   (11,4)   (12,4)
(9,5)   (10,5)   (11,5)   (12,5)
(9,6)   (10,6)   (11,6)   (12,6)
(9,7)   (10,7)   (11,7)   (12,7)
(9,8)   (10,8)   (11,8)   (12,8)
(9,9)   (10,9)   (11,9)   (12,9)
(9,10)  (10,10)  (11,10)  (12,10)
(9,11)  (10,11)  (11,11)  (12,11)
(9,12)  (10,12)  (11,12)  (12,12)
(9,13)  (10,13)  (11,13)  (12,13)
(9,14)  (10,14)  (11,14)  (12,14)
(9,15)  (10,15)  (11,15)  (12,15)
(9,16)  (10,16)  (11,16)  (12,16)
(9,17)  (10,17)  (11,17)  (12,17)
(9,18)  (10,18)  (11,18)  (12,18)
(9,19)  (10,19)  (11,19)  (12,19)
(9,20)  (10,20)  (11,20)  (12,20)
(9,21)  (10,21)  (11,21)  (12,21)
(9,22)  (10,22)  (11,22)  (12,22)
(9,23)  (10,23)  (11,23)  (12,23)
(9,24)  (10,24)  (11,24)  (12,24)
(9,25)  (10,25)  (11,25)  (12,25)
(9,26)  (10,26)  (11,26)  (12,26)
(9,27)  (10,27)  (11,27)  (12,27)
(9,28)  (10,28)  (11,28)  (12,28)
(9,29)  (10,29)  (11,29)  (12,29)
(9,30)  (10,30)  (11,30)  (12,30)
(9,31)  (10,31)  (11,31)  (12,31)

    80
```

Adrian Piper **Untitled page work for o TO 9** (pp. 79–81) 1969

particular self-propelling mechanism, which not only serves as a structuring device but also as an integral part of the resulting – yet not visually predictable – piece. In a parallel manner, writing about his music in 1968, the American composer Steve Reich (b. 1936) maintained:

> I am interested in perceptible processes. I want to be able to hear the process happening throughout the sounding music. ... Though I may have the pleasure of discovering musical processes and composing the musical material to run through them, once the process is set up and loaded it runs by itself.[11]

Not unlike LeWitt, Reich articulated the idea that a preplanned modus operandi would, in fact, play itself out as part of the finished piece. The written outline for *Pendulum Music* (1968), for example, describes how a number of performers first take hold of their respective microphones, which are suspended from the ceiling by cables at equal distances to speakers and plugged into amplifiers. The players then pull back their microphones and, releasing them in unison, allow them to swing freely as the performers turn up the amplifiers. The piece ends once all of the microphones have come to a standstill and the audience hears the sound of amplifiers being unplugged. When activated, Reich's sound system functions autonomously, just as permutations of linear elements, planned in advance, determine the visual outcome of a drawing by LeWitt.[12]

The more recent work of Adrian Piper (b. 1948), which deals with racial stereotyping and xenophobia, issued from her earlier consideration of the principles enunciated and demonstrated by LeWitt in 1967.[13] In 1968 Piper noted her ever-increasing 'sympathy with the position on art taken by Sol LeWitt,' and the fact that she was 'interested in the construction of finite systems…that serve to contain an idea within certain formal limits and to exhaust the possibilities of the idea set by those limits.'[14]

Untitled (1969), published in *0 TO 9* Number Six, deals with the extant magazine page. Piper's page is not an

idea like Barry's *The Space Between Pages 29 & 30* and *The Space Between Pages 74 & 75* in the same issue but is taken for granted as an existing site. It possesses a grid drawn and numbered from one to twelve across its top and from one to thirty-one from the top to the bottom of its left-hand margin. On two accompanying pages, all of the grid's possible coordinates are listed. 'In the listing of rectangles, horizontal coordinates precede vertical coordinates,' she specifies from within the work. In addition to the grid, the work consists of two other pages that present numbers typed in twelve columns: '(1,1)' through '(1,31)' in the first column to '(12,1)' through '(12,31)' in the last. As further noted, the 'listing system (below) is based on exhaustion of horizontal co-ordinates.' The page in this instance is covered from top to bottom and left to right by numerical figures that follow a strict 'pattern' of logic and also serve, in effect, to 'fill' the page systematically and self-referentially.

Another work from the early period of Piper's development carried her aesthetic interests a major step beyond the pure self-referentiality of the *0 TO 9*

piece. Piper clearly spells out her desire at this time to attend to the fact of her own self-consciousness and to explicitly foreground herself as both the subject of, and an object in, her work. In this regard, she realized the *Hypothesis* series (1968–70), a group of nineteen diagrammatic works on graph paper with photographs. Piper later reflected on her motivation and method:

> This series was the crucial link between the earlier conceptual work and the later, more political work I did having to do with race and gender objectification, otherness, identity, and xenophobia. In the *Hypothesis* series I was investigating myself as an object that moves through space and time just like any other object, but unlike other specific three-dimensional objects, this one has a peculiar capacity; namely, the capacity to register self-consciously the space and time I am moving through, to actually represent that consciousness symbolically – in photographs – and abstractly – in a coordinate grid, and communicate it.[15]

For the *Hypothesis* series Piper took photographs that would document her consciousness at a certain moment and define her in relation to inanimate objects. Some photographs were taken randomly and others were taken at predetermined time intervals while she was watching television or walking down the street with her camera. 'The photos were symbolic representations of the contents of my consciousness at a particular space-time location and moment.'[16] Each 'Hypothesis Situation' documents a particular interval of her consciousness by relating the photograph to the space-time coordinates she plotted on the graph paper. By virtue of its studied seriality, this work of Piper's pertains to the fact that orientation in the world is necessarily a (con)sequence of different spatio-temporal conditions that coincide with consciousness of self.

During the early 1970s, Piper further pursued ideas involving the integration into her art of her conscious self. In the Catalysis series she began to examine 'the difference between human objects, that is, objects who have subjectivity, and other kinds of objects that do not, other kinds of nonsentient objects.'[17] In *Untitled Catalysis for Max's Kansas City* (1970), a performance done for one of art critic John Perrault's 'Streetworks'

Adrian Piper **Catalysis III** 1970

Adrian Piper **Catalysis IV** 1970–71

exhibitions, she 'attempted to approximate objecthood… by closing off [her] modes of sensory input.'[18] In other pieces in this series, Piper carried out actions in public situations, as in *Catalysis I* (1970) when she rode the New York City subway at rush hour wearing clothes with a terrible stench. In *Catalysis III* (1970), she walked down a crowded street and through a department store with a large 'wet paint' sign across her chest. In *Catalysis IV* (1970), she appeared in public with a hand towel stuffed into her mouth. Although unobtrusive in her demeanor, she staged an unspoken confrontation between herself and an unsuspecting anonymous public accustomed to the status quo. She thus proposed her essentially non-disruptive, yet clearly different, self as warranting inclusion within a functioning social framework.

Piper's extensive oeuvre is widely recognized for explicit socio-political content that seeks 'to be a provocation, a kind of shock therapy that jolts individual viewers into an examination of their own values and behaviors.'[19] As she herself emphasizes, her later endeavors stem from her initial attraction to the rationalism promulgated by LeWitt. According to Piper, LeWitt 'created the context in which the cognitive content of a work could have priority over its perceptual form.'[20] The foregrounding of a permutational system as its own reflexive subject matter by LeWitt manifested itself in her work insofar as it evolved from her consideration of her 'body as a conceptually and spatiotemporally immediate art object' and from there to an involvement with her 'person as a gendered and ethnically stereotyped art commodity.'[21]

If Piper's work addresses issues of self in relation to social stereotyping, that of Roman Opalka (b. 1931), who commenced his ongoing *Opalka 1965/1 – ∞ Detail* series in 1965, is involved with the self in relation to individual existence. For almost four decades, Opalka, who came to France from Poland, has been painting works on canvas that represent straightforward numerical sequences that increase by one integer at a time. The first painting that marks the beginning of this series and will ultimately define his life's work, begins with the number '1' at its upper left-hand corner and proceeds sequentially. The painted numbers, which end with 35327, progress across and down the canvas from upper left to its lower right to fill it entirely.

Roman Opalka · **Opalka 1965/1–∞ Detail 1896176–1916613** · 1965–

Roman Opalka | **Opalka 1965/1–∞ Detail 1896176–1916613** (detail) 1965–

The evenly and closely spaced lines of relatively small white numerals are depicted against a grey background. All of Opalka's canvases measure 196 by 135 cm and represent consecutive numbers, which continue from one completed canvas to the next. The title of each painting is dated and given as *Opalka 1965/1 – ∞ Detail* followed by the first number painted on the upper left and the last number at the bottom right. Thus, more than a dozen years later at an exhibition at the John Weber Gallery, New York, *Opalka 1965/1 – ∞ Detail – 1750249–1771723* designated the first of a group of sixteen separate canvases and *Opalka 1965/1 – ∞ Detail – 2173184–2194426* was the last.

Starting each painting from the beginning with a loaded no. 0 paintbrush, Opalka reloads his brush when it is practically emptied of paint. What has changed over the years, in addition to the specific numerical sequences, is the amount of white paint added to the background. The first Detail was made on a black background. In 1972 the artist decided to add white to the background paint and to thereby increase the amount in each successive painting by one percent. As the numbers rise, painting by painting, they eventually will disappear into the whiteness of paint to bring about a total fusion of figure and ground. This results in a merging of the artist's life project with the attempt to count to infinity. Strict adherence to numerical progression, therefore, is here associated with ideas about eternity in relation to the toll taken by time on the artist as human subject. Opalka records himself counting out loud while he paints and, upon the completion of each canvas, takes photographs of his face. As each work moves toward a representation of infinity, the artist, who is audibly present in the recordings accompanying the paintings, visibly ages. Through its presentation of the artist's own

image as an emblem of aging, the work of Opalka pits the idea of infinite numerical sequence against the brevity of a single lifetime.

Numerical sequences and/or linguistic, cartographic, or photographic serial systems have permitted Darboven, Kawara, Brouwn, Bochner, and Kozlov along with LeWitt, Reich (in the field of music), Piper, and Opalka to defer to the driving force of a work's internal logic. Exempt from the necessity of material embodiment, the integers forming part of numerical progressions and permutations participate as the primary visual elements of a work rather than in preparatory studies or drawings. They serve on their own as units of quantity or of temporal and spatial measurement within a total representational conception. The letters involved in the creation of linguistic meaning or the flat representational aspect of maps or photographs similarly may also be used within serial schemes to counter illusion and signs of authorial expression.

Toward the development of the means to embody a tangible, yet non-material, transcription of temporal and spatial relationships, Hanne Darboven began in the late 1960s to investigate the myriad permutations provided by the four to six digits needed to notate the day, month, and year of a standard Gregorian calendar date. Her numerical sequences, differently conceived for each work, are based on the dates that exist within the span of an entire century – without, however, including the first two numbers of the year (i.e., the 1 and the 9 of the twentieth century). While Opalka bases his work on strict sequentiality, Darboven bases hers on intricate arithmetic procedures and permutations akin to the serial systems of LeWitt.

Darboven's oeuvre yields visual and thematic testimony to the idea that making art entails total immersion in and steadfast attention to this pursuit. It represents, in and of itself, a lifetime commitment to the mental and physical demands of aesthetic activity and the understanding that such a commitment must be carried out within the framework of ongoing and passing time. In 1968, having completed her formal art studies in Hamburg, Germany and living in New York since 1966, Darboven devised the principle that underlies the majority of her works.[22]

Darboven's catalogue pages for the exhibition 'Konzeption/Conception,' held at the Städtisches

Hanne Darboven **Untitled** 1966–67

Hanne Darboven **Untitled** 1968

$1.2.69 = 1 + 2 + 6 + 9 = 18\}$

The digits 6 and 9 are calculated separately. All other double-digit numbers are calculated as a unit. All notations are recorded in numbers. Each number is repeated as many times as the face value indicates.[23]

Sample:

$1.1.69 = 1 \times 1 \, / \, 1 \times 1 \, / \, 6 \times 6 \, / \, 9 \times 9 \, /$

$31.12.69 = 31 \times 31 \, / \, 12 \times 12 \, / \, 6 \times 6 \, / \, 9 \times 9 \, /$

The ensuing four pages of the catalogue present columnar sequences of handwritten numbers pertaining to the artist's specified system. This work begins with No. 1 and ends with No. 42, proceeding from the artist's so-called 'construction' sum (in German, 'Konstruktion') of 17K to conclude with that of 58K. The columnar sequences of sums are derived from the numbers of the days belonging to each of the twelve months of the year. Individual dates are indicated by their precise numerical content. New Year's Day at the beginning of the year is indicated as 1-1-69 (=17), for example, and New Year's Eve at year's end as 31-12-69 (=58). The laws of addition determine what figures lead from one to the next. In the Leverkusen work, numbers designating dates add up to 17, at their lowest sum, and accumulate through 58 at their highest and serve to define each successive tally over the space of these four catalogue pages.

The realization by Darboven that calendar dates might supply endless computational possibilities resulting from addition and multiplication provided her with a guiding structure on the one hand and an open-ended, unconfined freedom for action on the other. They have guaranteed her an unending source of numbers that have served in countless combinations. At first, during the early part of her New York sojourn in 1966/67, Darboven had used the tiny squares of graph paper as a supporting structure for exploring spatial and numerical relationships expressed by parallel, perpendicular, and diagonal lines and by lines drawn within or across individually demarcated sections. Letters written home at this stage suggest her interests and thought processes. On 4 September 1966 she wrote:

I have worked intensely now on two items: Axial symmetry and diagonal symmetry, the two opposites. The former standing for static, the latter for movement, rotation …. The diagonal symmetry

Museum, Leverkusen in 1969, outline how her computational method operates. On the first of her allotted five pages, she pointed out in a handwritten statement:

What I have written down stems from the dates of the year: (19)69

$69 = 17K \rightarrow 58K = No\ 1 \rightarrow No\ 42$

(K = Konstruktion)

All in all the digits of the numbers forming the date add up to 42

The calculated total of the digits of the numbers will be progressively greater (from $17 \rightarrow 58$) and increase in the frequency (from 1 to 12) and return to 1 again.

Calculation Example:

$1.1.69 = 1 + 1 + 6 + 9 = 17 \rightarrow 1x = No\ 1 = 17K$

$2.1.69 = 2 + 1 + 6 + 9 = 18\} \rightarrow 2x = No\ 2 = 18K$

Hanne Darboven **24 Gesänge – B Form (24 Songs – B Form)** 1974

is built into the axial symmetry, meaning axial
symmetry is the first order being destroyed by
the second order, the diagonal symmetry. Two
complexes, when brought together, form a third
complex – the third order…and for this order
I have created a new base order.

And nearly a year later, on 9 June 1967, she told
her family:

> everything is based on: Numbers, the small
> multiplication table. Numbers in permutations,
> in progressive, symmetrical, and mathematical
> sequences; shifted angles, numbers, and
> multiplications of numbers and angles, all in
> mathematical permutations. I find this fascinating,
> being rather ignorant of mathematics.[24]

Numbers in Darboven's work, permitting all manner
of permutations and progressions, give rise to formal
delineations that, since 1968, have been grounded in
calendar time. Whereas the gridded graph paper of
the early drawings holds the artist's linear and spatial
inquiries in place, numerical formulations based on dates

harness the work to elements that suggest the passage
of time. Darboven, in essence, replaced the spatial mesh
of the grid with an invisible supporting scaffold of
numerical formulations associated with the calendar
day. The artist was able, therefore, to directly construct
works that, anchored within the flow of time, escape the
grid's fixed nature. 'A system became necessary,' she
has maintained, for 'how else could I in a concentrated
way find something of interest which lends itself
to continuation?'[25]

Room-sized pieces by Darboven, analogous to literary
or musical cycles, participate cumulatively in the artist's
extensive overall production. The sheer volume of work
achieved in the last decades significantly contributes, on
one level, to the meaning of her oeuvre. *Ein Jahrhundert
in einem Jahr* (One Century in One Year, also titled
Bücherei: Ein Jahrhundert, or Books: a Century, 1970) is
one of a number of major projects from the early 1970s,
which also include large-scale pieces such as *Four Seasons*
(1973), which extends more than thirty-nine feet across
a wall; *24 Gesänge – A Form* (24 Songs, 1974), consisting
of 596 pages; or *24 Gesänge – B Form* (1974), whose 120
panels together measure approximately fifty feet in
length. Such works bear witness to the overwhelming

Hanne Darboven | **Index: 1 x 100 → 00 → 99 → 2 → 61** | 1978

aesthetic largesse represented by the amount of time Darboven has given to the creation of her work.

Ein Jahrhundert in einem Jahr was first shown in 1971 at the Konrad Fischer Gallery, Düsseldorf, where four years earlier Darboven had her first solo exhibition with the display of more than one hundred graph paper *Konstruktionen* (Constructions).[26] Initially presented as a year-long exhibition, from January through December, it consists of four hundred and two black ring-binder notebooks as well as sixty-eight framed drawings that comprise the accompanying Index. Three hundred and sixty-five of the binders contain one hundred pages – one page per year of the entire century. All of the 1 January days of the twentieth century are to be found in the first binder, and so forth to the last, which holds 31 December.[27] Therefore, each month is accounted for by twenty-eight, thirty, or thirty-one separate binders. Of the remaining thirty-seven notebooks, twenty-five (with 168 pages) pertain to 29 February; ten (holding 111 pages) pertain to the century's decades; and two (with 190 pages) each pertain to half a century. Carved

out from the temporal span represented by the calendar, a century is delivered to view as a clear and quantitative 'block of time.' Resistant to subjective murkiness, *Ein Jahrhundert* is not about fleeting time that slips through ones fingers, but about time as a reality that may be given objective form through numerical sequences based on calendar dates.

Whether intimate in scale, filling an entire exhibition space, or taking the form of a book, Darboven's works are striking in view of the numerous calculations whose intricacies are plotted in advance and laid out in what the artist refers to as the Index. The numerical formulas from which a particular work is spawned may leave the viewer 'spellbound by the magic'[28] inasmuch as the underlying scheme of each work, however inherently straightforward and basic, manifests a high degree of complexity. Darboven herself maintained in 1968 that 'I could not restructure any of my systems by starting them methodically from their respective beginnings. For these depend on work previously done.'[29] She has stated furthermore that 'the plan can only provide an impulse,'[30] which originates at its most fundamental level with 2 = 1, 2; 1 + 1 = 1, 2, etc. (which she uses on her personal ink stamp almost like a logo to signify the principle of her system).

Much preliminary thought precedes the writing out of each of Darboven's works from start to finish, and the artist thus emphasizes the importance of the plan as a starting point more than as an end in itself. 'I investigate my formulas which I build myself, almost to the point of supersaturation with knowledge – and then I do them.'[31] By means of her temporally based formulas Darboven liberates numbers from their quantifying function to imbue them with a graphic function instead. 'I only use numbers because it is a way of writing without describing [*Schreiben nicht beschreiben*],'[32] she has stressed and further insists that her work 'has nothing to do with mathematics. Nothing! ... A number of something (two chairs, or whatever) is something else. It's not pure number and has other meanings.'[33]

Numbers in any one work by Darboven may be typed and/or handwritten either as Arabic or Roman numerals or may be expressed as verbal symbols in either German or English. Her numerical systems, unwinding on paper, ensure an endless variety of permutations. 'Many variations exist in my work,' she states. 'There is constant flexibility and changeability, evidencing the

relentless flux of events.'[34] The resulting 'figurative' imagery of her computations attests to the almost ceaseless stream of mental energy that accounts for the great range of visual diversity originating with the artist's tabulations and delineations, notations and underscorings, diagrams, charts, and cross-outs.

The sum of Darboven's procedures takes over from traditional compositional elements of shape and form to represent the passage of time through passages of written numbers and words that do not refer to anything but themselves. As Coosje van Bruggen has articulated it, 'the changing dates are a record and a reminder of time passing. Irrevocably, tomorrow will turn into today or [in German] "heute," which Darboven will write as a word on the page only to cross it out, signifying time spent.'[35] The crossed-out 'heute' further suggests, as on a list of things to do, that yet another day of work has been accomplished. The meaning of such passages lies in their self-reflective, denotative nature. The artist has sought to remove any possible shade of meaning from her notations so that numbers and words might occupy the space of the paper or the page of a book as self-evident visual constructions.

Early publications by Darboven illustrate the way in which she has treated numbers and words as representational building blocks in lieu of traditionally outlining shapes or writing with narrative intent. The bound version of *00–99 Ein Jahrhundert I–XII*, begun in 1970, was published in 1976. Its 401 typed pages are followed by an Index page.[36] This page summarizes the book's contents, which are divided into one chapter for each month of the year. The book throughout contains typed sequences of numbers in German from 'eins zwei' (one two) on its first line to '[a]chtundfünfzig neunundfünfzig sechzig einundsechzig'(fifty-eight, fifty-nine, sixty, sixty-one) on its last. The sequences are logical and consistent in that they spell out the specific numbers of each date belonging to their respective month, with the first chapter containing all of the days in January and the last chapter all of the days in December. The dates and their 'Construction' sums from 2K to 61K are handwritten sequentially down both margins and identify the respective paragraphs of typed numbers occupying every page. The typed numbers form chunks of densely arrayed lines of text that vary slightly in length. The blocks of text, in turn, are punctuated by small asterisks that separate decades within chapters,

Hanne Darboven **Page from 'ATTA TROLL' nach Heinrich Heine…** 1972

while the typed text conforms to the squared-off margins of each page that visibly hold the words in check. The artist's formula for the numerical sequences gives the outpouring of numbers a reason for being and, stemming what would otherwise be random, allows for the conflation of the temporal, the spatial, and the lexical.

"Atta Troll" nach Heinrich Heine in: Zahlenworte [abgezählte Worte] wieder aufgeschrieben … ("Atta Troll" after Heinrich Heine in: Number Words [counted words] written down again) was published in connection with the exhibition of this work at the Kunstmuseum Luzern, Switzerland in 1972. The text of the book takes the physical, printed form of the words of Heinrich Heine's famous mock-heroic epic begun in 1841. Darboven, however, has rewritten Heine's tale in terms of the number of words, line by line, of each and every stanza of all of the poem's twenty-seven chapters. Each line of verse commences with a numeral – 3, 4, 5, 6, or 7, depending upon the number of words in Heine's text – and is followed by the artist's handwritten linguistic enumeration of these integers in sequential order.

O D Y S S E E **3**

H O M E R

ERSTER GESANG

Ratschluß der Götter daß Odysseus, welchen Posidon verfolgt, von Kalypsos
Insel Ogygia heimkehre. Athene, in Mentes Gestalt, der Telemachos be-
suchet, rät ihm, in Pylos und Sparta nach dem Vater sich zu erkundigen
und die schwelgenden Freier aus dem Hause zu schaffen. Er redet das erste-
mal mit Entschlossenheit zur Matter und zu den Freien, Nacht.

Sage mir, Muse, die Taten des vielgewanderten Mannes,
Welcher so weit geirrt nach der heiligen Troja Zerstörung,
Vieler Menschen Städte gesehn und Sitte gelernet hat
Und auf dem Meere so viel' unnennbare Leiden erduldet,
Seine Seele zu retten und seiner Freunde Zurückkunft. **5**
Aber die Freunde rettet' er nicht, wie eifrig er strebte;
Denn sie bereiteten selbst durch Missetat ihr Verderben,
Toren! welche die Rinder des hohen Sonnen beherrschers
Schlachteten; siehe, der Gott nahm ihnen den Tag der Zurückkunft.
Sage hievon auch uns ein weniges, Tochter Kronions. **10**
Alle die andern, soviel dem Verderben entflohn,
Waren jetzo daheim, dem Krieg entflohn und dem Meere.
Ihn allein, der so herzlich zur Heimat und Gattin sich sehnte,
Hielt die unsterbliche Nymphe, die hehre Göttin Kalypso,
In der geräumigen Grotte und wünschte sich ihn zum Gemahle. **15**
Selbst da das Jahr nun kam im kreisenden Laufe der Zeiten,
Da ihm die Götter bestimmt, gen Ithaka wiederzukehren,
Hatte er Heil noch nicht vollendet die mühende Laufbahn,
Auch bei den Seinigen nicht. So jammerte seiner die Götter,
Nur Posidon zürnte dem göttlichen Odysseus **20**
Unablässig, bevor er sein Vaterland wieder erreichte.
Dieser war jetzo ferne zu den Äthiopen gegangen,
Äthiopen, die zwiefach geteilt sind, die äußersten Menschen,
Gegen den Untergang der Sonnen und gegen den Aufgang,
Welche die Hekatombe der Stier und Widder ihm brachten. **25**
Allda saß er, des Mahles sich freuend. Die übrigen Götter

Hanne Darboven **Homers Odyssee** (detail) 1971

The quantification of the poem's words, line by line, with the words 'eins zwei drei' or 'eins zwei drei vier,' etc., drains the story line (about a dancing bear) from Heine's heroic tale, since its recounting is transformed into counting. What Darboven accomplishes in this manner, is to infuse the actual lines of the well known literary text with a palpable sense of the time and creative energy that are invisibly invested in its words. Through her conversion of Heine's poetry from narrative to numerical sequences, she draws the 'writing' of another author into her own enterprise. At the same time, she draws out and disposes of any remnants of representational subject matter. In its stead, she presents the very process of writing – and, by implication, aesthetic activity – as its own non-referential reality.

Darboven's earlier *Homers Odyssee* (1971) also clarifies how an existing text is incorporated into her work. Fourteen panels of five pages each contain the artist's handwritten transcription of the first five 'Gesänge' (songs), or chapters, of J. H. Voss's German translation of *The Odyssey*. The artist's handwritten script merges with and is submerged by the poetic resonance of Homer's

words. These words visually participate in the work as handwriting, which Darboven has substituted for an image penned by hand or created by brushwork. Moreover, given that the transcribed text is about the voyage of Odysseus, *Homers Odyssee* specifically and metaphorically concerns the idea of travel, whether this be with reference to lines or words that move across a page or to the journey of the artist whose work day by day unfolds over time.

Whereas words and numbers are clearly delineated in *Homers Odyssee*, undulating lines associated with handwriting are a dominant feature in much of Darboven's work. Disassociated from semantic meaning, these pulsating and undulating lines course across the page. Through the confluence of line and writing, they speak on behalf of their existence as graphological and visual indicators of the mental activity that is conducted from mind to hand.

Persistence in the realization of a task and temporal flux intertwine in works that literally and figuratively mark the passage of time.[37] 'I use no forms of expression,'[38] Darboven has emphasized. In *Age of Bismarck* (1978), she expanded her subject matter to embrace historical figures and moments in historical time through the inclusion of photographs. However, at the core of her oeuvre is the premise that the time put into a work is its own overarching message. Darboven's art is founded on her dedication to the magnitude of her endeavor and the 'realization' that art results from the time bestowed on its production. '"Art" is work… not every work is art but art is work and vice versa,' the artist has written.[39] Time, in conjunction with the mental and physical energy given to a project, and the demarcation of time as it proceeds from one day to the next – leaving an accumulation of personal and historical events behind it – are fused within Darboven's work as a unified representational totality.

Predicated on the richness of her early formulas and schemes, Darboven's oeuvre has continued to underscore the reality that unveils itself once the artist has set a work in motion. Her later work is impressively exemplified by *Kulturgeschichte 1880–1983* (1980–83), a monumental assembly of mechanically reproduced images and found objects of both high and low art (including postcards, magazine covers, textile pattern books, as well as toys, folk art objects, and lifesize

Hanne Darboven | **Homers Odyssee** 1971

figures), documents from her life and work, and illustrations from the media. Collected by the artist over a ten-year period, they are brought together in an installation that requires several large-scale exhibition rooms for its display. *Kulturgeschichte 1880–1983* casts a wide net over the personal and the historical without expressionistic or interpretive comment. Despite its multilayered visual and referential complexity, the work as a whole permits representation to serve only for its own sake.

Whereas time, for Darboven, represented by numerical calendrical divisions, is an inescapable and abstract driving force that structures both life and (the) work, for On Kawara it is an open-ended, diurnal continuum demarcating (his) existence as per denotation of month, day, and year. As well as the *'TODAY'* Series discussed in Chapter One, the art of Kawara includes: *I Read* (begun 1966); *I Went* (1968–79); *I Met* (1968–79); *I Got Up At* (1968–79); *I am Still Alive* (begun 1970); and *One Million Years – Past* (begun 1969) and *One Million*

On Kawara **I Read** (detail) 1966/68

Years – Future (begun 1980). All of these works relate to the cumulative cycles of day and night that, when added together, equal a lifetime. Each is positioned in relation to the artist's ultimately finite lifeline, invisibly inscribed against the background of spatial and temporal infinity. These serial works seek to anchor the notion of time – the major organizational force behind human experience and consciousness – within a representational framework.

The *I Read* series was begun by Kawara at the same time as the *'TODAY' Series*. On the days he made one or more date paintings, the artist cut news items from daily papers and inserted them into loose-leaf notebooks organized by year. The number of clippings he chooses on any one day depends only on what he might have found of interest in the local press. The clippings are glued on standard sheets of plain graph paper, each of which is stamped with the appropriate month, day, and year. The headlines or excerpts from news bulletins in the early clippings for *I Read* initially provided Kawara with a source of subtitles for his paintings. By January 1973 he had abandoned the use of subtitles appropriated from the news, but maintained the *I Read* notebooks as an independent work.

To read *I Read* is to be reminded of the tide of events that once were current and to observe the raw material of history before time has put them into perspective or treated them as inconsequential. As a daily record of a vast range of events and situations involving the weather as much as the political climate, the work functions as a temporally experienced collage that binds together the historically important and unimportant. All events reported in the clippings exist here on the same plane of importance since they are integrated into Kawara's work, not into an historical archive. Their significance lies not just in their subject matter but also in their date. Without comment or cohesion, the pages of *I Read* permit a momentary glance into the shifting sands of time before they have been sifted by history. Providing a journalistic journey where the relevant and irrelevant, memorable and unmemorable, global and local, catastrophic and trivial are indiscriminately and inextricably combined, *I Read* must be viewed in retrospect and from the standpoint of the past and present simultaneously. The role of time in the shaping of history is thus the subject of this work, which chronicles itself as it 'moves' through time.

On Kawara **I Went** (detail) 1968/69

Line, as employed in the traditional manifestation of representational form, gives way in this work to the headline and to the variety and vagaries of different typographies and tongues that constitute the printed news. Although a news item from a later vantage point may seem remote in time or as recent as yesterday, the headlines and snippets from yesterday's news retain their sense of immediacy no matter what their subject may be.

From 1968 to 1979 Kawara maintained a similar series of loose-leaf notebooks whose separate transparent sheaths hold the work *I Went*. During the same years, he built up the journal series *I Met*, which exists in notebook format as well. Notebooks for *I Went* contain a record of the artist's daily itineraries marked in red ink on a xeroxed map of whatever city he was visiting or living in at the time. *I Met* consists of individual pages listing the names of people – family, friends, acquaintances, and strangers – whom he encountered that day. The date is stamped on every page of both of these works and, in both, a separate preceding

On Kawara · **I Met (detail)** 1968

page identifies any change in the artist's geographical location. Whereas *I Read* addresses time with respect to its historical sweep and brings commonly shared occurrences into high relief, *I Went* and *I Met* are derived directly from the artist's own life. The visual form of *I Went* is controlled by wherever Kawara's errands, appointments, or sightseeing may have taken him. *I Met* lists in basic order of appearance the individuals whose paths he crossed or with whom he spent his time.

Through the documentation of his daily course along city streets for the realization of *I Went*, begun while he was a tourist in Mexico, Kawara translated his route from one destination to another into the planar linearity of drawing. The trajectory of any one day, marked in red ballpoint, combines with the flat representational features of maps from many cities in many different visual combinations. The maps present configurations of streets, land areas, rivers, and place names without reference to scale and imbue *I Went* with its variety of formal permutations. By systematically tracing his path

on a map every day for a period of years, Kawara indicated his movement from place to place with reference to the passage of time. Without fabrication, he merged the linearity and planarity of drawing with the actuality of documentation culled from his daily perambulations and pursuits. Interested in the idea of his own perpendicularity in relation to the horizontality of the ground/map, Kawara cut indications of scale off the maps so as to better picture himself as if from above. The map was a means for him 'to see his location from the sky – to see [himself] from outside.'[40]

In *I Met*, language, not line, reveals those points of interpersonal contact that connect over time to form the social fabric of existence. A single column of names typed in capital letters on successive notebook pages is centered above the date stamped at the bottom of each page. The number of names on each list varies from one or two to over twenty. Certain names weave in and out of the lists, while others appear just once or twice in the work as a whole.

A comparison of lists of names from different cities on different days suggests the way *I Met* represents the temporal and geographical intersection of the artist's life with the lives of others. For example, on New Year's Day, 1973 in Stockholm Kawara met: PONTUS HULTEN, GÖSTA WIBOM, DISA HÄSTAD, ANNA LENA WIBOM, ELIZABETH LIND, ELSA HÄSTAD, SIW ERIKSSON, KLARA HULTEN. The next day he met: TAGE WESTERLUND, MILLA TRÄGÅRDH, PONTUS HULTEN, ZENATI ATTALLAH, KARIN BERGQUIST LINDEGREN, BJÖRN SPRINGFELDT, HASNI HAMIDI, AHMED YAMANI. Later that year in New York on 27 September he met: HIROKO HIRAOKA, JACK PLUNKETT, MARIA BERRIOS, HUGH SHIROO, CHIE MATSURA, YUICHIRO SHIBATA, KENJI KIRITANI, MARTIN SEGAL, PEDRO GONZALEZ. The listed names provide an unlimited source of linguistic diversity and, in the manner of poetry, sketch verbal portraits.[41] Neither invented nor changed, but belonging to actual and not fictional persons, the names establish real points of contact in a complex social network through which individuals thread their respective ways. Kept together in notebooks divided by year, the works *I Read*, *I Went*, and *I Met* bring abstract time into view vis-à-vis the concrete reality of events, places, and people by utilizing common systems of representation – the news media, maps,

On Kawara | **I Got Up At 9:56** | 1968/73

On Kawara | **I Am Still Alive** | 1970/78

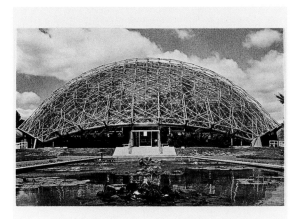

On Kawara | **I Got Up At 9:56** | 1968/73

On Kawara | **I Am Still Alive** | 1970

and proper names – to convey their formal content.

Kawara has also taken advantage of available modes of communication to deliver, quite literally, his aesthetic message. From 1968 until 1979 when his briefcase, in which he was carrying his rubber stamp, was stolen in Stockholm,[42] he mailed color postcards every day to two different people for periods of time that, being variable, were not based on any preset system. The cards presented a typical, horizontal scene from, or overview of, the place where Kawara was living or staying at the time. The recipient of a card would be informed about the artist's geographical whereabouts by means of an image reproducing a salient aspect of the city or culture. On the other side of the card Kawara stamped the time, to the exact minute, at which he started the day, prefaced by 'I GOT UP AT.' The custom of sending postcards provided him with a method with which to question the idea of 'timelessness' and to emphasize art's potential as a vehicle for communication and representation over its value as a permanent, precious handmade object.

Whether an aerial view, skyline, street scene, or architectural interior, the face of each card presents an excerpt from life. Each scene, no matter how stereotypical, isolates a different view from an unviewable totality. Surveying the different aspects of visual and cultural diversity, the horizontal postcards present the varied topography of the world as a frontal pictorial image. The words 'I GOT UP AT' on the reverse of the cards reaffirm the artist's return to a waking state and resumption of a vertical position in readiness for getting 'through the day.'

Since 1970 Kawara has intermittently sent telegrams, now numbering in the hundreds, to selected recipients.[43] The message from the artist reads 'I AM STILL

On Kawara | **One Million Years – Past** | 1969

ALIVE,' urgently reminding the receiver – who may receive more than one telegram – of the brevity of individual existence. Variations in the visual appearance of each cable arise from the telegraphic properties of the wireless versus the graphic properties of a drawing or handwritten communiqué. Dispensed and dispersed internationally, Kawara's telegrams detour the immediate channels of buying and selling by arriving directly at the recipient's door.

The ten-volume sets of notebooks of *One Million Years – Past* and *One Million Years – Future* convey the vast, yet measurable, expanse of time from 998031 BC through AD 1969 and from AD 1981 through AD 1001980.[44] Ten rows of sequentially typed columns of individual years, separated by decade, cover standard $8\frac{1}{2}$ by 11-inch pages. Each page, front and back, accommodates a listing of five hundred years. By representing one million years from the date the work is started, going backwards and forwards in time respectively, Kawara gives concrete representational form to a vast temporal span that, relative to human evolution and civilization, is enormous although, geologically speaking, it is brief.

The period of a day represented by its date provides Kawara with a structure for engendering works pertaining to existence, as this is simultaneously understood both as an abstract idea and in relation to everyday experience. Since 1971, Stanley Brouwn has used his own stride as a representational unit. His works are structured in terms of the measurement of distance rather than of time. The majority of Brouwn's works take the form of books, works on paper, or index cards accommodated in file boxes. Subtle and spare in their visual effect, they stretch the imagination by means of representation, yet remain down to earth in their concern with the many facets of spatial reality that, with reference to both urban and outer space, ranges from the infinitesimal to the infinite.

Throughout the 1960s Brouwn pursued methods to extricate his art from the ruts of tradition. Coming in contact with artists similarly engaged in overtly protestational forms of aesthetic activity and the repudiation of convention, he participated in Fluxus performances and events in Germany and Holland during the first half of the 1960s. Although never officially part of Fluxus, his inclusion in a number of its events reinforced his efforts to question established procedures and behavior affecting both art and society. Fluxus provided him with an informal aegis under which

to develop strategies – based on the performative and the belief in the elision of art and life – for an oeuvre aligned with Conceptualism's engagement with issues of representation. It set the stage for Brouwn's future involvement with fusing authorial agency and anonymity, as a description of his 'anonymous' performance in the display window of an antiquarian shop, Amstel 47, Gallery Amstel, Amsterdam, suggests: 'Dressed in a raincoat and with a bag over his head, Brouwn stands on top of a table. With his head and chest covered with newspapers, he holds wads of paper against the display window. He removes his shoe and puts it on the table. He picks up an ax and makes cutting movements in the direction of his shoe. With newspapers clutched under his arm, he holds the shoe against his left ear.'[45]

As early as 1960, Brouwn mailed an invitation for recipients to visit all of the shoe stores in Amsterdam during a specified time period. Rather than attend a customary viewing of framed or freestanding objects in a gallery, viewers were encouraged to make forays into the city. Acting as a catalyst for mobilizing spectators into active engagement with their urban surroundings, Brouwn gave them the opportunity to create their own itineraries and locate themselves within the architectural and social context of modern city spaces.

Around the time that Brouwn realized his shoe store piece, he began his *This way Brouwn* drawings. These works were drawn on plain pads of paper in response to the artist's request for directions from strangers in the street. When approached by Brouwn for an explanation of how to get from where he was standing to another place in the city, anonymous pedestrians either sketched the route for him, listed the street names, or occasionally left the paper blank. In lieu of a handwritten signature, Brouwn stamped the sketch with 'this way brouwn.'

According to a feature article in a daily Dutch newspaper, Brouwn maintained in 1969 that 'art must come down from its ivory tower. It should just be a craft, just like the making of shoes,' and added his belief that 'art must participate in the social process.'[46] Brouwn was further quoted in the article as saying that tourists he observed worriedly studying a map of Amsterdam were 'calling out for a This way Brouwn'[47] and thus for the direction that art could offer.

The *This way Brouwns* challenged traditional practices of aesthetic production and representation. Instead of

Stanley Brouwn **This way Brouwn** 1960

sketching street scenes on an easel with his own hand, Brouwn invited the person in the street to conceptualize a particular route. Sketched in hasty fashion with no aesthetic intent by unnamed pedestrians, a *This way Brouwn* illustrates the endless possibility of individual markings produced in response to being asked, outside of a structured art situation, to show the way.

Early in his career, therefore, Brouwn had discovered a method for sharing his authorial responsibility with fellow travelers in the street and, by extension, had managed to dismiss himself from direct involvement in the composition of the work. As he pointed out in a volume of drawings from 1961 assembled for reproduction ten years later, 'A *This way Brouwn* is produced in the time it takes for the pedestrian to give his explanation. No second thoughts, no polishing and touching up the result.'[48] Brouwn's drawings were made anonymously by others, not by a supposed master, and munificently evince the nature of originality that traditionally is credited – in more ways than one – to a 'recognized' artist who has signed the work. ('There are no good *This way Brouwns*. There are no bad *This way Brouwns*.')[49] Moreover, Brouwn averred, 'I have become direction,'[50] meaning that he had allowed his ego to meld with the representation of the space between one place and another by having obliterated signs of his persona.

Brouwn also created works by collecting footprints left by those who unknowingly stepped on blank sheets of paper that he dropped on the street and subsequently retrieved.[51] The smudged footprints, ironically, are reminiscent of the deliberately amorphous aspect of

a nineteenth-century monotype. A proof of human contact with the ground, a Brouwn foot 'print' is created by the artist without an etching plate and without the need for his direct involvement or presence in the process. Having rejected hand drawn and invented compositional form, Brouwn combined earlier twentieth-century chance operations with the concept of the found object and Duchampian Readymade to achieve his results.

A *This way Brouwn* is included in the 1964 catalogue for the Aachen Festival der neuen Kunst (Festival of new art), edited by Tomas Schmit and Wolf Vostell. Brouwn, for his part, left a blank page with the caption 'THIS WAY BROUWN' for use by the reader. On the previous page, he asked that a drawing 'from memory' of the route from the train station to the person's residence be sent to him at his address in Amsterdam. Whether or not any drawings were sent, Brouwn reversed the usual conditions for the production of representational meaning by having placed responsibility on the receiver. When he suggested that catalogue readers make their own sketches and turn them over to him, he inverted the conventional author/viewer relationship.

For a 1969 invitation mailed on the stationery of the gallery Art & Project, Brouwn asked for 'a *this way brouwn per telegram* of the trajectory that you followed on Friday evening July 11 from your home address (or another address) to art & project/richard wagnerstraat 8/amsterdam.' He further instructed:

It is sufficient to cable:
a) A summation of the most important streets
b) a summation of the striking points passed
a combination of a) and b) is also possible[52]

Here again, Brouwn orchestrated a work that was centered on the influx of individual marks and remarks from disparate quarters rather than on objects he might have executed or found himself. As before, he delegated completion of the work to viewers through correspondence intended to elicit a response.

Brouwn's later use of his step as an elemental unit of measurement evolved from his *This way Brouwns* as well as from works explicitly involved with the idea of walking in a line from here to there. A work of 1962 on a rectangular card depicts a straight horizontal line marked by 'a' and 'b' at its beginning and end. Above the line Brouwn has written by hand 'a walk from a to b; b to a; a to b etc (100x).' In another work, *a walk during one week*, a straight line has been divided into seven equal sections and marked by the letters 'a' through 'h.' Below it, Brouwn has written on seven successive lines 'first day: from a to b; second day from b to c… seventh day: from g to h.'[53] Repetition plays a major role in works to be performed mentally and/or physically by artist or receiver. Without materially impinging on space, they address the notion of spatial delineation and distance with reference to human ambulation.

The step has offered Brouwn a gauge for surveying spatial reality within an urban, global, and cosmic context. Brouwn's entry in the catalogue for 'Konzeption/Conception' in 1969 consists of five photographs 'shot exactly at the moment a passer-by told me the name of the street on my request.' The resulting photographic views represent details of the city based on the intersection of the artist and arbitrarily chosen pedestrians who were asked to communicate the name of the street on which they were walking. At this juncture in Brouwn's development, the footstep was merely implied and his stride not yet fully articulated as a unit for determining length and distance.

'It is not inconceivable,' Brouwn has been quoted as saying, 'and indeed quite likely that I shall be able to sum up all the projects I shall make in my life under a single title, namely: Man walks on the planet Earth.'[54] A letter from Brouwn of 12 May 1969 to officials in the Department of Public Works, Amsterdam proposes a 'this way brouwn path' in the small park bordered by the streets Admiraal de Ruyterweg, Willem de Zwijgerlaan, and Geuzenstraat. Brouwn that year had created a narrow footpath in the garden of Art & Project for visitors to walk along.[55] As his 12 May proposal suggests, he hoped to create a more ambitious work in the center of the city for participation by a wider audience. Brouwn stipulated in his letter:

All decorative plants, shrubbery, etc. will have to be removed from the park in its present state. The paving stones of the path that currently crosses the park, as well as the paving stones between the park and the street curb, will have to be removed too. In this way a stretch of sandy soil will be created from sidewalk to sidewalk. This patch of ground will be seeded with grass. The park is now ready for the

'this way brouwn' path. For this purpose text-signs will be installed on the bridge and on the corner of the Willem de Zwijgerlaan/Adm. de Ruyterweg inviting people to create their own paths. Single-person paths may also be created.

He concluded that, with this accomplished, 'the "this way brouwn" paths through the park will be a reality soon.'[56] If realized, Brouwn's proposal would have epitomized a public work completely given over to functional use and, simultaneously, to representational meaning in the form of lines etched onto a grassy surface by Amsterdam residents and foreign visitors alike. The 'this way brouwn' walkway would have delineated the passage of the many pedestrians from one point in the city to another who had left the imprint of their footsteps.

'This way Brouwn' proposals tend to be mind-expanding and/or futuristic in their tenor. They sometimes deal with ideas about the imperceptible and/or push beyond the limits of 'sensible' reality to proffer an expanded idea of temporal, spatial, and social existence. Works by Brouwn of 1969–70 define the entire earth – whether literally marked underfoot or abstractly represented as a composite of geopolitical divisions – as his base of operation. In the catalogue (consisting of index cards held together in a plastic slipcover) for the group exhibition, '2.972.453,' held in Buenos Aires in 1970 at the Centro de Arte y Comunicación (CAYC), Brouwn announced on his index cards that he had bought square-meter plots of land throughout the world. He gives his address in Amsterdam and states: 'Till now I've got land in the following countries: holland, germany, belgium, italy, switzerland, england, sweden, danemark, u.s.a., japan and turkey.'[57] Engaging with viewers in the process of 'speculation' without being present, the artist lays claim to similarly sized plots of land around the globe whose uniform measurement links them together as a representational structure. The work remains geographically dispersed, yet notionally grounded in physical actuality.

Other works of 1969–70 further convey Brouwn's method for representing abstract concepts in concrete terms without the production of a consolidated, material object. A simple directive constituted his participation in 'Prospect 69,' for example. On a small piece of plywood that hung from a string in the middle of an otherwise empty space of about nine square meters, as described by one observer, Brouwn attached a typed text: 'Walk during a few moments very consciously in a certain direction; simultaneously an infinite number of living creatures in the universe are moving in an infinite number of directions.'[58] In lieu of confronting an object or performance set before them, visitors to the exhibition were invited to follow the artist's bidding to contemplate their place within the cosmos through the self-conscious act of walking in one direction.

The vast, uncircumscribed purview of Brouwn's interest in directional movement and in walking was clearly articulated in his exhibition of 1970 at the Städtisches Museum Mönchengladbach with the title 'durch kosmische Strahlen gehen' (Walk through cosmic rays). The exhibition rooms were bare in one sense, but full in another, given that cosmic rays cannot be seen as they hit the earth from beyond the atmosphere. As the director of the museum, Johannes Cladders, pointed out in his introduction to the catalogue, the empty space of the rooms meant that viewers had to orient themselves not only with respect to their immediate surroundings but also with respect to the entire universe.[59] Of special note, a closed-circuit video camera and monitor in the museum's stairway made it possible for visitors to watch passers-by in the street likewise being invisibly bombarded by rays.

In three publications of 1970, quantifiable distance is joined with direction as a principal representational component of the work. The first of these books, *100 this-way-brouwn problems for computer IBM 360 model 95*, places the reader in relationship to the infinitesimal. The opening page states: 'show brouwn the way in all cities, villages, etc. on earth from point x to all other points in that [sic] cities, villages etc.' Page two follows with: 'show brouwn the way from each point on a circle with x as centre and a radius of 1 angström to all other points.' The fact that '1 angström = 0,000 00001 cm' is noted on the page as well. On each successive page of the book the length of radius is increased by one to yield a total of one hundred angströms by the time page 101 is reached. This number gives pause for thought insofar as Brouwn's request would accrue in a mind-boggling density of submicroscopic interconnecting lines and points. Presumably, not even the IBM computer would be equal to the task. Whether one or one hundred angströms are involved is immaterial apropos the

confines of human perception. The one hundred 'this way brouwn problems' therefore infer, but attempt to supersede, the limits of what might ultimately be conceivable above and beyond the boundaries of sight.

La paz, a small book published as the catalogue for Brouwn's exhibition at the Stedelijk Museum, Schiedam in the early part of 1970, stipulates the number of meters that one is meant to walk in the direction of twenty-one different cities, La Paz, Bolivia being the first. The first four pages, for example, read sequentially as follows:

Walk 95 m in the direction of la paz
Walk 11 m in the direction of rangoon
Walk 776 m in the direction of havana
Walk 180 m in the direction of helsinki

The book ends with: 'Walk 5 m in the direction of guatemala.' In the process of turning the pages, readers may make a series of mental leaps from one spot on the globe to another. During the exhibition, visitors could follow lines on the floor pointing in the direction of those cities towards which they were told on a label to walk a certain distance. The representation of different distances and directions engenders multiple possibilities for spatial experience with direct reference to the globe and the global, no matter how many meters one is meant to walk toward a given geographical destination.

Tatvan is a thin, stapled booklet that was published to coincide with Brouwn's exhibition at the Aktionsraum, Munich in 1970. In this book, Brouwn designated the number of kilometers from 'x' to the Turkish city of Tatvan. The first page reads 'x – Tatvan 1 km.' The next page reads 'x – Tatvan 1000 km.' The third reads 'x – Tatvan 1 000 000 km.' By the end of the book's twenty-five pages, the number of kilometers has reached a figure consisting of sixty-six zeros. By cumulatively increasing the number of kilometers by three zeros on each successive page, the artist conveys a sense of such distances that cannot be covered by foot, car, plane, or spaceship and thereby represents the immensity of space beyond the solar system.[60]

For the exhibition itself, Brouwn took a train trip from Munich to Tatvan on the Turkish border. A couple of kilometers before arriving he shot a Super 8 film from the train. This film was displayed on a screen attached to the back of a truck driven through Munich. Passers-by in the street caught fragmentary glimpses of a geographical landscape outside their line of sight, but not beyond the boundaries of knowledge.

Although personal and imprecise, a step represents a comprehensible distance alluding to human existence on the planet. For his contribution to the 1970 video exhibition, 'Identifications,' organized by Gerry Schum, Brouwn introduced the step as a device for determining distance in relation to the reality of the scene at hand. While aiming his camera in one direction, he shot the moment during which he took a single step. The catalogue describes the two-minute work: 'After a static view of the Dam in Amsterdam for about 30 seconds, the image is disturbed and then becomes static again. The title "One Step" describes what has happened.'[61] The artist, in this manner, featured the single step as the most important element in the construction of his work. Although the change in the image on the screen is barely perceptible, an action has taken place and an adjustment to reality has been made.

Brouwn's exhibition at the Stedelijk Museum Amsterdam in the spring of 1971 marked the first official manifestation of his ensuing focus on producing works involving his footsteps. While the exhibition was in progress, the artist telephoned the museum on a daily basis to report the number of steps he had taken over the course of the day. The number was publicly displayed on index cards.[62] During the period of the exhibition he remained on home turf in the Netherlands for part of the time and also traveled to Belgium, France, Spain, Algeria, and Morocco. His travels are documented in *steps*, a small book designed by the artist and published by the Stedelijk Museum in connection with the exhibition. As Brouwn notes:

from march 18 until april 18, 1971, i defined my total number of footsteps each day by means of a handcounter. during this period i visited a number of countries where i had never been before. consequently, my footsteps there were my first footsteps in those countries.

The date, total number of steps taken, and the names of the country or countries are printed in a small sans serif typeface at the lower right of each of the book's thirty-two pages. The number of steps on any one day ranges from the smallest, 2917, on the second day of the project

while the artist was still in Holland, to a total of 41,885 on 8 April when he was in Spain. Despite the minimal appearance of what is printed on the pages, the reader/viewer is offered a sizeable amount of information insofar as one may glean where on the globe the artist spent his time on a specific date and how much he walked in a particular geographical location on one or another of those days. Narrative incident in the artist's life and travels, consciously suppressed in the work, is replaced by tiny numerical signs that portray broadly based ideas concerning time on earth as this may be experienced on whatever day, in whatever place, by whatever person in whatever 'walk of life.'

For a group exhibition at the Addison Gallery of American Art, Andover, Massachusetts in 1971 entitled 'Formulation,' Brouwn wrote and signed the following statement on one of his two catalogue pages:

> During the last weeks I counted my steps every day during the whole day.
> During a walk through Amsterdam I will send a letter to Andover everytime I meet a mail-box. In this letter I will enclose a card with the number of steps till the moment I stopped in front of the mail-box.
> I will send 10 letters to Andover.

On the other page of the catalogue, the number of steps between mailings is printed in two columns of five numbers each. Numerical quantities such as '938,' '5916,' or '9585,' amply spaced one from another, stand out as self-sufficient figures on the page. Typed numbers, representing distance covered in terms of the number of steps taken by the artist, appear as independent and otherwise unrelated ciphers. Paradoxically, through the information communicated about the number of his footsteps, Brouwn, as artist, succeeded in forging a direct and personal link with an audience without revealing himself within the content of the work and, significantly, without creating an autonomous physical object.

Brouwn realized a number of other pieces in 1971 that, like the Stedelijk and Andover exhibitions, pertained to the counting of his steps. 'My steps in Milan' is printed on the announcement for the March/May exhibition of that year at the Françoise Lambert Gallery, Milan and 'My steps in Brussels' on the invitation card for Galerie MTL, Brussels in

November/December. For Brouwn, the process of accumulating and registering the number of his steps makes it possible to create a work anywhere in the world and at any time. Leading his daily life while counting his steps, the artist, in some sense, becomes the work of which he is the invisible producer.

The book *afganistan – zambia*, published on the occasion of Brouwn's exhibition in May 1971 at the Gegenverkehr e. V. Zentrum für aktuelle Kunst, Aachen enlarges on the geographical aspect of the 'step' works. The work consists of twenty-five pages, each of which lists ten geographical locations per page in alphabetical order. The words 'the total number of my steps in' precedes the name of each place from Afghanistan at the start to Zambia at the finish. The locations in between include the remote or exotic such as Ascension Island, Dahomey, or Sabah, as well as the more generally familiar Australia, Brazil, or Nepal. In this way, Brouwn represents the earth as a whole in terms of its geography – in terms, that is, of how its surface is divided into many different nominally designated components. By suggesting that he has set foot in all of these places, the artist lends concrete form to the abstract idea of geographical representation insofar as he leads readers from page to page and from place to place in a sequence of alphabetical appellations.

For works on paper of 1971, Brouwn drew one or more thin, straight vertical pencil lines to equal the length of his stride(s). Each stride varies slightly in length – just short of a meter – and each line represents the distance of a particular step from one point on the ground to another in terms of the linear actuality of a pencil mark.[63] Brouwn thus translated length and distance into visible linearity and, more importantly, paired the changing size of his own personal footstep with the idea of an immutable standard of measurement, the meter.

Brouwn first exhibited index cards in file cabinets in 1972 at Art & Project and, soon thereafter, at the 'Documenta V' exhibition in Kassel, Germany. Commercially available file containers, often made of grey metal and sometimes exhibited by Brouwn on trestles, serve singly or in stacked rows to hold varying numbers of index cards together in one place. The use of these containers presented the artist with the flexibility to realize a range of different works. All of the works are based on the quantity of steps he has taken or on the

length of any one of his strides measured in millimeters. 'Counting steps is equivalent to measuring distances'[64] for Brouwn and vice versa.

The file containers function only as storage units for the cards amassed by Brouwn. The accumulation of index cards comprising any one work, without demonstrable mass or body, expresses spatial expanse in terms of distance covered by numbers of footsteps or with reference to the length of any one step. The length of Brouwn's stride, from step to step, ranges from 840 mm to 890 mm.[65] Information, placed discretely at the center of each card, may consist of a fine, horizontal hair's breadth line of 1 millimeter, or represent a step as a numerical designation in millimeters, depending on how the specific work has been structured.

The number of file containers defining an individual work varies in relation to what has been measured.[66] The catalogue checklist for Brouwn's 1982 exhibition in the Dutch pavilion at the Venice Biennale suggests the different possibilities presented by the use of the file containers. For example, entry 20 in the catalogue presents a 'constructed walk' (1972) comprising a wooden index-card file box. The box contains one card for each of one thousand steps. The total walk measures 865500 mm, while the distance of a single step, shown in millimeters and slightly different in each case, is indicated respectively on every card. Thus, within the 840–890 mm range, one card may possess the figure of 863 mm, another 875 mm, or another 879 mm, etc. Based on the same principle, entry 22, a 'constructed distance' (1972), is comprised of three thousand cards in three separate metal file containers. Together the cards add up to a walk of 2589272 mm, with each card representing the length of a single step. Alternatively, entry 24, 'step = 851 mm' (1973), represents one step as a group of 851 cards. Each of the 851 cards is marked by a drawn millimeter-long line followed by '1 mm'. The representation of distance, and by implication the imposition of form on the amorphous, undefined expanse of open-ended space, reaches a pinnacle of specificity in Brouwn's varied file container works. In short, a single step may be understood as a millimeter-length dash mark shown on one of many separate cards, or else a distance may be represented as the numerical sum of strides taken and counted by Brouwn.

The numerical and linguistic systems central to Mel Bochner's practice from 1966 through 1973, different from their function in works by Darboven, Kawara, and Brouwn, serve principally to explore alternatives to traditional sculpture rather than specifically to give form and shape to the existential experience of time and/or space. Bochner has specifically sought to extend the prevailing boundaries of the art object, both literally and theoretically, and make manifest the cognitive aspect of aesthetic procedure. His works thus underscore the mental processes necessary for the visual materialization of any work of art as these are based on relationships between knowledge and experience of physical reality.

Bochner's interests revolved around his 'desire for an art that did not add anything to the furniture of the world,'[67] and resulted in an analysis of how something is to be perceived and understood rather than in the construction of an object with a decidedly spatial presence. Between 1965 and 1967, he had experimented with numerical combinations derived from simple serial systems that emphasize construction based on programmatic thought over creation stemming from random, unsubstantiated forms. But, as he expressed it, he was motivated by the further realization 'that ways existed for moving out of an exclusively mental domain without making "things."'[68]

Bochner's early project entitled *Working Drawings and Other Visible Things Not Meant to be Viewed as Art* (1966) may be seen in retrospect as a harbinger of the analytical approach that would lead him further in his reappraisal of two- and three-dimensional shape and form. It functioned as a curated exhibition, which he organized at the School of Visual Arts, New York while an instructor there. *Working Drawings* is considered by Bochner to be an independent work, and it has been so treated when reshown within the context of later exhibitions.

The contents of Bochner's early work-cum-exhibition, which are 'not necessarily meant to be viewed as art,' were procured from other artists or taken from books on subjects besides art. They present a range of art and non-art items – from sketches and studies to scientific or mathematical data to a sales receipt for supplies from a hardware store. For the final realization of this exhibition/work Bochner xeroxed and compiled the individual sheets of paper in loose-leaf notebooks, as opposed to matting and framing them separately. Having thus brought together a variety of documents pertaining to processes of thought or to art activity, he installed the notebooks on pedestals as if they were sculpture. Given

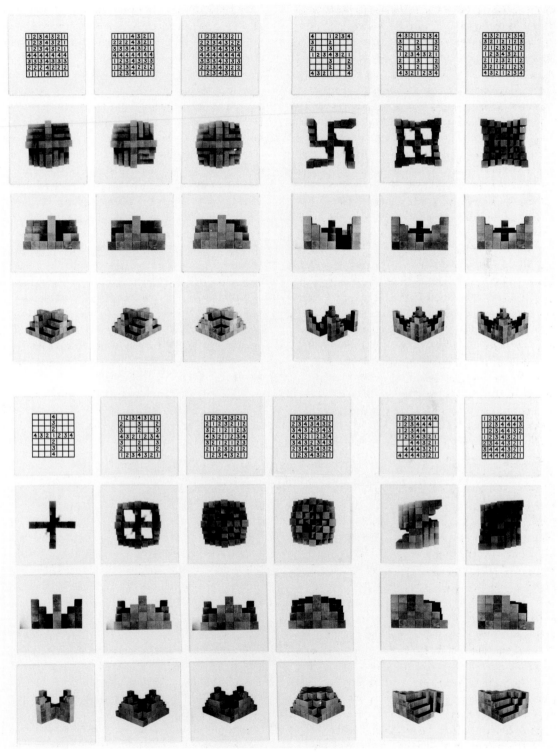

Mel Bochner **36 Photographs and 12 Diagrams** 1966

that the 'working drawings' in *Working Drawings* were
not by the artist himself and, as xeroxed copies were
reproductions and not 'the real thing,' Bochner, on one
level, effectually expressed concerns of the period
regarding issues of authorship. Not only was he not the
work's sole creator, but he also negated the traditional
materiality of sculpture and left only 'volumes,' whose
didactic assembly of pages bear witness to the actuality
of ideas in progress. Taken from their respective
contexts as procedural notations or documents made or
drawn up by artists and non-artists alike, the individual
pages in their separate sheaths were absorbed into the
context of *Working Drawings* by virtue of the artist's
prerogative to make decisions and choices in the
evolution of a completed idea, whether or not this results
in a 'finished' object.

If *Working Drawings* was essentially a self-reflexive
study of aesthetic and intellectual production, Bochner's
first Photo Piece, *36 Photographs and 12 Diagrams* (1966),
followed another course. The artist has explained that he
was 'not trying to make sculpture but to show sculpture
as a method.'[69] Thirty-six photographs record three
viewpoints (plan, elevation, and corner perspective)
of twelve sets of small building blocks, which he had
arranged and then rearranged on his studio table in
different configurations. Each set corresponds to the
numbers on its respective accompanying grid. Not
unlike a sculpture by Donald Judd, for example, the work
bestows visual form on numbering schemes determined
by the artist in advance but, contrarily, eschews
traditional materiality and mass. By means of
photography, Bochner initially succeeded in highlighting
the temporal component of sculptural experience.
From within a two-dimensional format he referred
to sculpture's three-dimensionality in that the work
represents a variety of angles and viewpoints, but, being
flat, has no protrusions.

Bochner's slightly later Photo Pieces examine the
nature of the photographic medium with respect to the
duality of its simultaneously factual and fictional nature.
If, on the one hand, photographic film picks up whatever
is before it, the camera lens, on the other, shuts out the
entire surrounding context. A work such as *H-2*
(1966–67) is a cut-out, relief-like shape consisting of
an arrangement of stepped and receding square blocks.
It appears to jut out from the wall but is flat in reality.
Bochner's photographic 'paintings,' of which this is a

prime example, challenge assumptions about the
representational transparency of photography at the
same time that they carry Frank Stella's slightly earlier
promulgation of the idea of painting's literalism to
another level of consideration. 'Real' because it has
been interpreted within the intellectual framework of
painting, *H-2*, as a photograph, is an illusion as well.
It embodies the photographic qualities of its own means
within the pictorial meaning of an image that appears
hermetic and impenetrable. Instead of utilizing
photography as a window onto nature, with its ability
to duplicate recognizable objects and scenes, Bochner
turned photographic verisimilitude around. By aiming
the camera lens at an arrangement of blocks, he pointed
to the opacity paradoxically attendant upon
photographic veracity.

Bochner's investigation of the photographic medium
with respect to aspects of its own reality led him to a
consideration of the issue of scale and thereafter to the
question of measurement vis-à-vis the real world.
Photographs entitled *Actual Size (Face)* (1968) and *Actual
Size (Hand)* (1968) specify the scale of the artist's face
or hand from within their photographic parameters by
means of a vertical line on the wall demarcated by the
designation '12"'. A twelve-inch line in a photograph
does not physically match the length of twelve inches on
a ruler unless the photograph has been printed, as it was
in this instance, to correspond exactly to the size of the
face or hand outside of the picture.

Having called the bluff of photographic
representation by way of photographic representation
itself, Bochner subsequently turned his back on
photography and proceeded to create works that
dealt with the measurement of real objects, materials,
and spaces. Black adhesive tape, ½-inch wide, affixed
to the wall served to designate whatever specific
heights or widths the artist chose to isolate. These
were labeled accordingly with letter stickers. As he
has observed:

Measurement is one of our means of believing that
the world can be reduced to a function of human
understanding. Yet, when forced to surrender its
transparency, measurement reveals an essential
nothing-ness. The yardstick does not say that
the thing we are measuring is one yard long.
Something must be added to the yardstick in

order that it assert anything about the length of the object. This something is a purely mental act…an 'assumption'.

… In all these pieces nothing has been made…I have only arranged a situation which will momentarily be reabsorbed into its own ordinariness.[70]

For *Measurement: Plant* (1969), conceived for 'Art in Process IV,' organized by the small, forward-looking Finch College Museum of Art in New York, Bochner placed a large potted plant against a squared-off backdrop of parallel, evenly spaced horizontal demarcations numbered from '1' to '9'. The numbers proceeded from bottom to top on the left-hand side of the square and from left to right across its top. The definitive, visual rigidity of the taped black lines offered a notable contrast to the leafy branches of greenery placed in front of them. Again, using the ½-inch wide black tape for *Measurement: Shadow* (1969), Bochner indicated that a shadow cast on the wall by a seven-rung standing ladder was 9 feet 5 inches high. A variety of works involving similar approaches to measuring objects or aspects of the concrete visual world also included the artist's measurement of standard rectangular sheets of brown wrapping paper adhered to the wall.

Bochner's intervention directly into everyday, unmediated reality culminated in the Measurement Rooms first realized for an exhibition in 1969 at the Heiner Friedrich Gallery, Munich. With the same black tape that he had used for measuring objects, the artist indicated the length of all the different wall areas, from point to point, of the rooms of the Friedrich Gallery. Instead of dividing the space into segments based on a pre-measured standard (such as the thirty-six inches derived from the width of brown wrapping paper used previously), Bochner stipulated exactly what length in feet and inches he found each individual wall section to be.

The Measurement Rooms fuse the numerical fact of measurement with the actuality of the bare walls of a given space. Although Bochner divided the existing empty space into spatial intervals on an abstract, mental plane, he nonetheless left the room undivided and whole to be seen as an 'object' of perception and experience. The Measurement Rooms thus discard the conventional notion that art necessarily takes the form of an object placed within the space of a room to embrace that space

Mel Bochner / **Measurement Room** / 1969

instead. Once the artist has measured and delineated wall areas of a room with thin, black lines of tape, the exhibition space as a whole becomes the work of art rather than the container for it. A kind of three-dimensional blueprint of the room is presented to viewers who, in turn, assume a central position within the physical and theoretical boundaries of a work.

Following the Measurement Rooms, *Language Is Not Transparent* (1970) speaks self-referentially about the representational relationship of language to observable reality and expresses the skepticism of the period regarding language's assumed transparency. The work originally was shown at the Dwan Gallery, New York as part of the group exhibition 'Language IV' in June 1970. Bochner wrote the statement 'LANGUAGE IS NOT TRANSPARENT' in white chalk over black, dripping paint directly on the gallery wall. Language, the work suggests, cannot offer a window onto reality any more than can pictorial representation, given that it possesses an independent reality. This reality is contingent on the conditions of the context of its specific use and is open to solicitation with regard to its stated propositions or 'truths.' Participating within the framework of art, Bochner's piece splices together the representational means of language and its painted 'statement' so that they mutually and inseparably serve as both the foreground and background of the total image.

Works by Bochner from the early 1970s rely upon language in certain instances and numbers in others for the derivation of their form. In either case, they highlight their representational elements and procedures in accordance with material reality.

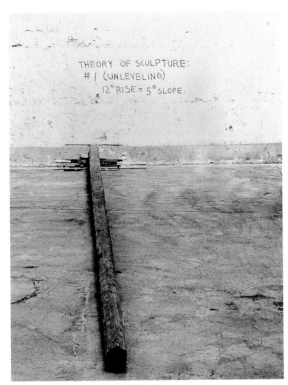

Mel Bochner | **Theory of Sculpture #1 (Unleveling)** 1970

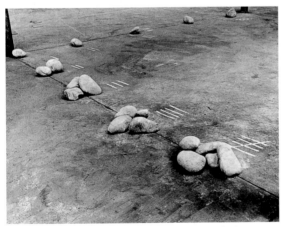

Mel Bochner | **Theory of Sculpture #2 (Counting): Cardinal versus Ordinal 5** 1970

Theory of Sculpture # 1 (Unleveling) (1970), using language, and *Theory of Sculpture #2 (Counting): Cardinal Versus Ordinal 5* (1970), using representations of quantity, both engage non-material representational systems. In the former work, one end of a sixteen-foot wooden pole is propped up on the baseboards of a wall. Its title is inscribed on the wall along with information stating '12" RISE = 5° SLOPE.'

The latter work consists of two sets of stones laid out on the ground in linear configurations that meet at a right angle. Sharing a stone at their point of convergence, one line comprises single, equally spaced stones. The other line is made up of piles with one, two, three, four, and five stones, respectively. Roman numerals from one through five are drawn sequentially in chalk on the floor beside the single stones as well as beside the grouped stones. The representational markings correspond in one line with quantity (cardinal numbers) and, in the other, with sequential order (ordinal numbers). The artist, in this way, combined statistical notations, both linguistic and numerical, with empirically presented objects. Comparable to ensuing works similarly realized on the ground, these pieces take part in the process of probing consistencies and inconsistencies between representation and direct experience. Ultimately, they pose alternatives to earlier conceptions of sculptural form and materiality.

Despite the fact that it is comprised solely of a grid of masking tape adhered to the floor, *Axiom of Exhaustion* (1971) belongs in the province of sculpture. Within the exhibition space, the work is oriented to the directional indications of a compass and sequences of numbers are written in ink on the tape. Eight tapes run east-west and eight run north-south. Permutations based on the first four letters of the alphabet are centered inside each of the resulting forty-nine enclosed squares on crossed pieces of tape. Alphabetical permutations are also located on small lengths of tape that intersect with the outer extremities of sixteen of the sixty-four lines of the overall grid.

In describing the work, which was first installed at the Sonnabend Gallery, New York in 1972, art historian Richard Field recounts that 'each of the sixty-four tapes bore a single series of consecutive numbers, each of which could *run* and *face* in one of the four cardinal directions. For instance, on one tape the numbers progressed from north to south while facing east; on

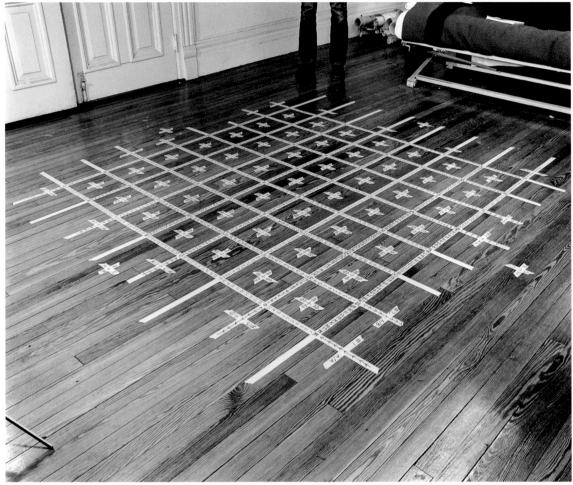

Mel Bochner **Axiom of Exhaustion** 1971

another tape the numbers progressed from south to north while facing south, and so forth.'[71] This results in sixteen possible directional permutations, which are detailed on the crossed tapes as forty-nine different fractional sets from AA to DD. To experience *Axiom of Exhaustion* in the attempt to grasp its numerical progressions, spectators must encircle it many times. The work propels viewers to circumnavigate its non-material borders and plays out 'the complete set of permutations of direction and orientation.'[72] With the elimination of material three-dimensionality, the work cannot be encompassed from one single viewpoint and is accessible from all possible directions.

A slightly later masking tape piece of the same year, *Continuous/Dis/Continuous* (1971), illustrates how

numbers may operate within a progression to generate expectation with relation to coherency and meaning while they remain independent of a referential function. The artist has described how the work is to be installed within an exhibition space:

First a line of masking tape is adhered to the wall, at my eye level, around the entire circumference of the space. Blue carpenter's chalk is rubbed along the top and bottom edges of the tape, overlapping the tape and the wall. This creates a 'halation' which records the original, unbroken continuity of the tape line. The black numbers are written first, running clockwise along the entire length of tape. Next, random lengths of tape, at random places

along the line, are torn off and discarded. The 'empty' spaces of wall, where the tape has been removed, are left framed by the rubbed blue chalk. Beginning at the opposite end of the line the sequence of red numbers is written, but only in the 'empty' spaces. The red number sequence jumps across the remaining stretch of tape, to resume in the next available space, until all the gaps have been filled.[73]

Bochner, in this manner, relied on numerical progression to generate representational form. However, he gave an added 'edge' to the work by allowing it to draw attention to – rather than to take for granted – the components of its own making. He accomplished this through the disruption of the continuity associated with and expected from numerical sequence.

As its title suggests, *Axiom of Indifference* (1972–73) proves the indifference of language to observable facts and epitomizes Bochner's investigation into discrepancies between stating and showing. While this work supplies evidence of the interior/exterior condition of a sculpture, it negates the need for material mass. Pennies are placed both inside and out of four pairs of squares defined by masking tape on the floor.[74] Statements written on sections of the masking tape boundaries of the squares respectively maintain: 'Some are in,' 'Some are not in;' 'All are in,' 'All are not in;' 'Some are out,' 'Some are not out;' 'All are out,' 'All are not out.' The work demonstrates the simultaneous coincidence *and* non-coincidence of a linguistic assertion and its visible proof or non-proof. The artist considers this work to be a summation of many of his ideas with its main issue being 'the problematization of the naively accepted relationship between language and experience.'[75] In his words, *Axiom of Indifference*

revolves around references and how we define them. To what do these statements refer? What is their level of specificity or generality? Is it only the relationship of pennies to tape? Or is it pennies to tape to wall? Or to the whole gallery space? Or to the world outside? Where does one draw the boundaries? Each viewer must construct his/her own set of references, or frames with which to think about the complex overlapping levels of [this work]. But each viewer's 'frame of reference' must

be different. And it is this realization which reveals the central subject of the piece: It is axiomatic that the facts themselves will always remain indifferent to any interpretation.[76]

Just as sculpture is re-evaluated by Bochner, representational practice is questioned by Christine Kozlov. The body of work created by Kozlov from the mid-1960s to mid-1970s is comparable to that of Darboven, Kawara, Brouwn, and Bochner in its employment of numerical, linguistic, and serial systems and sequences. With the desire to free her art from the material and symbolic weight of Minimal sculpture, she had already turned her aesthetic investigation away from traditional painting and sculpture while still in the process of obtaining her Fine Arts degree from the School of Visual Arts.[77] The thematic content of her work is based on its own attempt to cancel out past idioms of representation and materiality. Stringent in its denial of illusion and traditional sculptural mass, it is about the idea of representational annulment.

Among Kozlov's earliest mature works, *Sound Structures* (1965) present a visual analysis of overlapping sound patterns. Also referred to as Audio Structures, they do not lend themselves to being played or heard as would a musical score. Instead, they proffer constructions that employ numerical and temporally based, spatial elements. About fifteen of them were exhibited in February 1967 at the Lannis Gallery, New York founded by Joseph Kosuth. She described her method at some length in the catalogue:

The numbers on the left indicate the different sounds. The horizontals corresponding to each number indicate both placement (in relation to other sounds) and duration in counts of sound (the numbers on top of the horizontals). In structure number 1, for instance, number 1's first duration is 12 counts of sound, stopping for one count, continuing for 11, stopping for 2, continuing for 10, and so on.
The sounds sounding together are realized by reading downward until the sound-indicating numbers repeat; so that again in structure number 1, the first 6 counts of sound, sound 1, 3 and 5 (the constant) are sounding; at the end of count 6 sound 4 enters lasting for 12 1/2 counts, or until the

middle of sound 1 and 3's second duration; after sound 1 and 3's first stop and until sound 1 and 3 start again sound 2 is sounding.
The structures are concerned with symmetry, assymmetry, progression, or with their own intrinsic logic.
The structure's development in sound would incorporate either constant sounds, or sounds with equal beat durations or both.[78]

Possessing their 'own intrinsic logic,' Kozlov's structures pertain to aural experience although they are visual. The interconnections between measured lines and numbers foster the imagery of each work and vary from page to page in their construction. Xeroxed in negative, the Sound Structures are imbued with an unmodulated, evenly toned, deep black background, which is animated by the white numerical and linear notations. One step removed from the handmade, they are divorced from any ulterior representational purpose.

The attempt to eliminate straightforward referential content characterizes Kozlov's ensuing works in all of the diversity of their means. *No Title (Black Film #1)* (1965) and *No Title (Transparent Film #2)* (1967) are presented as one-hundred-foot reels of 8 mm and 16 mm film respectively. Coiled up in small metal canisters, they are not meant to be screened. To produce the black color of the former, the artist filmed a series of black objects to darken the light-sensitive celluloid without producing an image. The latter consists of white leader in an unfilmed state and was exhibited at the Lannis Museum of Normal Art, formerly the Lannis Gallery, in its November exhibition of 'Normal Art.' Like the Sound Structures wherein there is nothing to hear, the No Title pieces are predicated on the deliberate suppression of representational information.

A work exhibited in the Dwan Gallery's 'Language II' exhibition of 1968, serves as a prelude to Kozlov's later methodology. *Practice Project* (1966), also titled *Learning to Type*, consists of typing practice sheets secured in a notebook. Its meaning rests in its lack of any organized textual coherency. With its display of the residue of letters, words, and sentences that contributed to the artist's attempt to master the skill of typing, *Practice Project* repudiates the transparency of language, given that the typed text does not lend itself to signification beyond its own presence on the page.

Christine Kozlov : **Sound Structure** : 1965

Works by Kozlov from the late 1960s similarly reconsider traditional concepts of representation. For the realization of *Information Drift* (1968), the artist happened to be taping from the radio when the news of the shooting of Andy Warhol was broadcast. This report, in turn, was interrupted by news of the shooting of Senator Robert Kennedy. Two coincidental pieces of information related to both art and politics exist indelibly on the tape. Since the tape, however, is displayed without equipment for activating its sound, the work allows only the potential for representation. Having intervened to capture moments in history at the time of their announcement over the air, Kozlov subsequently vacuum-packed this information for exhibition without it being audible or its contents necessarily known.

Retreat from representational content is achieved in *271 Blank Sheets of Paper Corresponding to 271 Days of Concepts Rejected* (1968). The top title page stipulates the subject matter of the work, but otherwise there is nothing to be seen outside of the one-inch stack of sheets of standard typing paper. Representation of any kind has

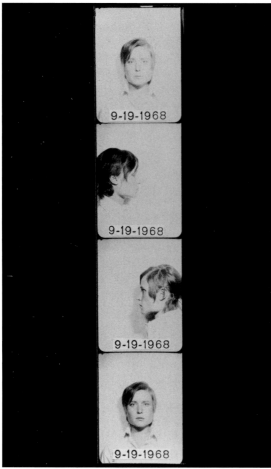

Christine Kozlov | **Self Portraits** | 1968–69

painted each of the successive layers in the attempt to paint out signification. By overloading the canvas with paint she buried all vestiges of representational content under painting's own physical and historical weight.

Two slightly later small works on canvas addressed representational signification through language. *Untitled After Goya* (1968) and *A Mostly Painting (Red)* (1969) measure hardly nine inches in height and twelve inches in width. The earlier painting combines Goya's famous companion paintings of *c.* 1797–98, *La Maja Desnuda* (The Naked Maja) and *La Maja Vestida* (The Clothed Maja), into a single verbal reference: 'Las Majas,' which she hand-lettered in white on a grey background. In Kozlov's work, Goya's two paintings have been titled in the plural to achieve an abstract layering and fusion in the viewer's mind of the two well known images. Goya's paintings are wrapped in mystery with respect to the identity of the sitters and whether, clothed or unclothed, they are the same or different persons. *Untitled After Goya* conflates these disparate and disputed images by means of its two short words on canvas.

Quite differently from the statement under the image of a pipe, 'Ceci n'est pas une pipe,' in René Magritte's renowned *La Trahison des Images* (1929), Kozlov's *A Mostly Painting (Red)*, also hand-lettered in white on a grey background, does not involve the contrast of an image. Rather, its wording, 'A MOSTLY RED PAINTING,' is its image. Locked in combat between what is observed and what is asserted, the work reinforces the fact that representation need not imitate, duplicate, or be beholden to anything but itself. Contradiction between the verbal and the visual serves here to bring out the work's true colors as representation and reality in one.[81]

During the late 1960s, Kozlov also explored alternatives to the historical genre of self-portraiture. For *Self-Portraits* (1968–69), she utilized the photo booth on a regular basis for over a year to record her face in mug shot fashion – head-on and in profile. The strips of photographs in individual sequences of four are mounted in a ring binder in plastic sleeves. Kozlov participated as her own sitter in a work given over to the totally mechanized process of photobooth photography. Points of reference to the artist's inner life have been replaced by multiple examples of her virtually expressionless visage while formal elements vary according to external

been kept off of the clean white pages in order to make the process of rejecting ideas, which necessarily contributes to a final aesthetic solution, the subject of the work.[79]

In her last year of art school Kozlov made her first painting – a five-foot square canvas covered with numerous layers of pale grey housepaint. The painting was built up over the period of the school year as she added more and more layers of paint, sanding them down in between. By the end of the term the painting was so heavy she could not lift it.[80] The use of regular, inexpensive housepaint in lieu of oil or acrylic resulted in a smooth, soft, powdery surface. Consciously referring to the established history of the monochrome, Kozlov did not activate the painted surface nor draw attention to the flat impenetrability of the canvas. On the contrary, she

details of hair style or slight changes in the exact positioning of her head. The harsh outlines of shadows from the flashes of light that accompanied the snapping of each photo indirectly and ironically allude to the effects of chiaroscuro modeling found in Old Master drawings. Unlike earlier self-portraits, however, *Self-Portraits* efface interpretive material from the artist's countenance to render her look as blankly as possible. Although the sequential shots are not signed, having been made by a machine, each one has been given a date. The dates on the photographs do not so much express the passing of time as they serve to distinguish one set of facial views from another. As a numerical system for record-keeping, the dates identify the respective photograph without commenting on any aspect of the subject's personal identity.

Continuing her interest in the idea of the self-portrait, Kozlov further studied methods for representing herself in terms other than those of her visage. In *Eating Piece (Figurative # 1)* (1969) she sought to represent herself through the documentation of her food consumption from February 20 through June 12. One may follow the list of foods eaten by the artist over a period of months, reading across the page, for example, 'orange juice, eggs, bacon, toast with butter and jam / coffee / tea / cheeseburger, etc.' The colloquial expression 'you are what you eat' comes to mind as one surveys the list of comestibles. Unlike the traditional self-portrait, *Eating Piece* does not depict the artist's physiognomy or person. Instead, Kozlov recorded a fixed and daily activity central not only to her 'self,' but also to everyone, in order to take leave of figuration conventionally associated with self-portraiture.

An ambitious work exhibited in 1970 at the Centro de Arte y Comunicación, Buenos Aires, *Neurological Compilation: The Physical Mind Since 1945 (Project 1: The Bibliography)* (1969), has the subtitle *Major Research on the Physical Mind, Including Neurophysiology Neurochemistry Neuropathology Neurosurgery Neuropsychiatry*. Nine notebooks hold a total of over 550 pages of references to articles published on the subject of the brain. Each volume is devoted to a single year of publication titles, which Kozlov typed on standard sheets of paper. Although she initially intended to create a compendium of articles in the field of neurology published as far back as the year of her birth in 1945, Kozlov ended her research with the year 1961.

Christine Kozlov **Neurological Compilation** (detail) 1969

Every page of the nine-volume *Neurological Compilation* is filled with a running list of titles in capital letters such as 'Functional synaptic organization of primary visual cortex neurones in the cat' or 'Effects of light deprivation on the rat estrous cycle.' The compilation functions as an accumulation of dense and technical terminology. It presents a comprehensive view of the state of knowledge about the brain while it simultaneously exhibits the mental energy necessitated by its own conception and reception as art. It entails detailed reference to a broad area of scientific study and, in self-reflexive manner, privileges the mental over the physical in terms of its own realization.

Through her systematic documentation, Kozlov replaced representational content of a traditional visual nature with a comprehensive outline of the existing literature on the subject of the brain. She thereby infused the work with the linguistic properties of its specialized scientific terminology rather than with those of shape, color, or composition. Through her self-appointed task

of amassing a coherent and logical body of written material, she avoided the creation of a work with sculptural mass or pictorial content. Operating within a linguistic framework, the work draws parallels between aesthetic production and neurological research insofar as the latter ultimately sheds light on the human facility for perception and comprehension.

In 1969 Kozlov used a rubber stamp to imprint the words 'This is Not Art' on different surfaces in different geographical locations and contexts. Small framed works on paper are neither preliminary sketches nor finished drawings, but after-the-fact documentation. The statement 'This is Not Art' is stamped in the center of the paper, and on each of the *This is Not Art* drawings, which are signed and dated, the location of the stamp is detailed. For example, one work states at its lower left 'As seen on the train from Paris to Cologne.' The phrase was also stamped on 'Sol LeWitt's shoe,' 'Konrad Fischer's gallery door,' 'Alan Power's table,' and 'Dicky Landry's shirt.' With her rubber stamp, Kozlov encompassed a wide range of objects within a work that linguistically inverted the Duchampian Readymade by negation. Instead of signing a non-art object so as to declare it to be art, she declared her work of art to be 'not art.' The rubber stamp, furthermore, nullified the use of the authenticating authorial signature.

The negation of representational information as its own source of representation is clearly manifest in cables sent by the artist to institutions in response to requests for works. To Kynaston McShine, curator of 'Information,' Kozlov sent a signed telegram in 1970 with the message:

PARTICULARS RELATED TO THE
INFORMATION NOT CONTAINED HEREIN
CONSTITUTE THE FORM OF THIS ACTION

Like the 'This is Not Art' stamp, the text of the telegram hinges on use of the word 'not' to assert the nature of its form and meaning. Because of its format as a telegram, the work was not handled in the routine museological manner. Instead of having to be crated and shipped, it arrived from the artist by telegraphic means, ready for immediate installation.

By the outset of the 1970s, therefore, when *Information: No Theory* (1970) was displayed in 'Conceptual Art and Conceptual Aspects' at The New York Cultural Center, Kozlov already had explored ways to reject representational meaning on one level in order to attend to it on another. *Information: No Theory* ingeniously involves simultaneous processes of recording and erasure that are mutually dependent upon one another. The work is activated when a tape recorder is installed within an exhibition space, as detailed by the artist:

1. The recorder is equipped with a continuous loop tape.
2. The recorder will be set at 'record.' All the sounds audible in the room will be recorded.
3. The nature of the loop tape necessitates that new information erases old information, that is, the time it takes for the information to go from 'new' to 'old' is the time it takes the tape to make one complete cycle.
4. Proof of the existence of the information does in fact not exist in actuality, but is based on probability.[82]

This work does not emit sound but continuously records ambient noise and conversation. By means of erasure and obliteration, it constantly renews its unseen/unheard content in concert with what is heard in reality.

Kozlov's work, with its aim to wipe the slate clean with respect to earlier art production, may be considered in contrast to Robert Rauschenberg's well known *Erased De Kooning* (1953). As a one-time gesture, Rauschenberg rubbed out most of a penciled drawing by his august and more senior contemporary with a rubber eraser. Kozlov, more generally, made it a point to discard all forms of traditional pictorial signification. Without blotting out an existing work of art, she incisively endeavored to create a literal and symbolic tabula rasa in relation to previous concepts of representation.

Serial systems adopted in conjunction with non-traditional representational modes including language and/or numbers has enabled Kozlov, as it has Darboven, Kawara, Brouwn, and Bochner, to give visual form to abstract ideas thus grounded in concrete actuality. The renunciation of representation, in Kozlov's case, is the subject of representation. In the work of Darboven, Kawara, and Brouwn, non-traditional representational systems bring the non-visible into view in the mapping of temporal and spatial reality.

With the primary goal of refraining from the creation of illusion – perspectival, personal, or political – Darboven has expunged static compositional arrangements from her art. Her imagery is therefore indicative of aesthetic invention in the process of its renewal rather than, in Kozlov's work, actively rejected. This process is revealed in her earlier works through the divination of numerical systems and sequences and her recourse to well known texts wherein the act of writing allows representation to present itself as the combined functions of repetition and progression. Each of her aesthetic constructions, in this way, proposes the idea of constant regeneration resulting from written passages attesting to the input of time and labor.

When used by Kawara either on a canvas as a date or in conjunction with his other presentational methods, numbers and letters fuse their symbolic, representational purpose with their function as shapes. As a coherent but multifarious whole, Kawara's oeuvre illustrates the human capacity for consciousness – of both self and surroundings – as this is coupled with the ability to grasp time and space in abstract, visible terms. In contrast to Darboven, whose numerical passages spin tales without plots to propound the activity of aesthetic endeavor within the 'limits' of time, Kawara muses on the stream of life as this coincides, through human consciousness, with the unending flow of time.

Defining the entire planet as a ground and base, Brouwn requires viewers of his work to give measured thought to the nature of spatial distance, both subatomic and astronomic, rather than to temporality. By counting or measuring his steps, he eliminates the need for drawing as a process dependent on invention or the hand. Instead of creating sculpture in the usual manner, Brouwn has sought to make a cognitive inroad into ungraspable space in order to pinpoint a place for himself within the unknowable universe. As opposed to Piper, for example, whose performative methods and concerns are 'self'-specific, the methods of Brouwn – like those of Kawara – are removed from his persona. Although his work necessitates his active participation in its construction, Brouwn presents himself in the third person. The artist as individual ego and as author remains anonymous in order to eliminate the distinction between performer and (per)formed, and between authorial creator and authored creation.

The role of measurement and counting in the work of Bochner may be differentiated from its role in relation to human scale and ambulation in Brouwn's. In Bochner's oeuvre, numbers function independently as part of autonomous systems and to designate spatial intervals. Looking back at his early career, Bochner succinctly summarized the crux of his innovation when he told Richard Field that 'it was my realization that sculpture exists in the space where the mental and the physical overlap.'[83] Field, in turn, has written of 'the play between counting and order, concept and demonstration, mental and visual apprehension, that is at the center of his work.'[84] Through the simultaneous confrontation and integration of verbal/numerical and empirical information, Bochner has focused on the general project of proposing alternatives to volumetric form.

In the interest of setting representation on a plane with reality, Darboven, Kawara, Brouwn, Bochner, and Kozlov have made use of serial systems and/or numerical sequences. This has meant the dissolution of former modes of painting with its unavoidable illusionism and of sculpture with its necessary differentiation from the space that contains it. In the work of Kozlov and Bochner, the conventions of painting and sculpture are overtly challenged within the thematic content of their production. In the work of Darboven, Kawara, and Brouwn, these conventions are replaced by alternative forms of representation to enable issues of time, space, and existence to be directly and fully addressed.

Dan Graham | **Public Space/Two Audiences** 1976

Subject as Object

With the aim of involving the spectator in the dynamics of looking at art, El Lissitzky (1890–1941), one of the principle figures of the Russian avant-garde in the 1920s, set a major precedent for ideas that would be further developed in the second half of the century. Lissitzky is known for lithographs and paintings that he called 'Prouns' (an acronym for 'Project for the Affirmation of the New'), which explore the interaction between abstract planar and volumetric shapes in relation to illusionistic space. Lissitzky considered the Prouns to be a 'changing-trains between painting and architecture.'[1] His radical *Prounenraum* (Proun Room, 1923), conceived for the Great Berlin Art Exhibition of 1923, translated the two-dimensionality of earlier Prouns into the three-dimensionality of the artist's allotted exhibition cubicle. In lieu of installing existing works in the cubicle, he chose to use the surfaces of its four walls, floor, and ceiling to create a work that spectators were supposed to walk into. Reconstructed in 1965, *Proun Room* consists of black, white, and grey layered rectangles that are painted directly on the wall or constructed in relief. Space between rectangles is visually punctuated by spheres and connected by elongated, wooden slats that serve to propel the eye in different directions. Expressing painted form in association with architecture, Lissitzky gave conscious consideration to the fact that viewing subjects would be encircled by the art object.

Three years after the realization of *Proun Room*, Lissitzky was invited to design an installation of modern works at the 'Internationale Kunstausstellung' (International Art Exhibition) of 1926 in Dresden. With its intention to actively engage the spectator, his far-sighted installation design allowed members of the public to select the works they wished to see by means of a system of window vitrines with sliding screens.[2] Lissitzky's rationale, as he described it, may be applied to *Proun Room* as well.

El Lissitzky **Prounenraum (Proun Room)** 1923 (reconstruction 1965)

The great international picture reviews resemble a zoo, where the visitors are roared at by a thousand different beasts at the same time… If, on previous occasions in his march-past in front of the picture walls, he was lulled by the painting into a certain *passivity*, now our design should make the man *active*.[3]

In *Proun Room*, Lissitzky set out to captivate viewers not only by compositionally leading the eye from plane to plane and sphere to sphere but also by surrounding the observer with the work.

Although different one from another, the oeuvres of Dan Graham (b. 1942), Vito Acconci (b. 1940), James Coleman (b. 1941), and Maria Nordman (b. 1943) hark back to Lissitzky's understanding that consideration of the onlooker's presence and the activity of looking are a part of the process of aesthetic production and reception. In their re-evaluation of the autonomous object, these otherwise disparate artists bodily and/or thematically incorporate the viewing subject and integrate the subject

Allan Kaprow | **An Apple Shrine** | 1960

of viewing into the subject matter of their work. Imbuing their work with psychological and/or social content, they obliterate the literal and conceptual border separating the spectator from the object of spectatorship.

The conceptual border between an object and its viewer was initially broached some three to four decades after Lissitzky's *Proun Room* by Allan Kaprow from the vantage point of his Environments and by Robert Morris in his writings and sculpture. Kaprow's Environments of the late 1950s overtly promoted the idea of viewer participation insofar as they were conceived for the very purpose of circumnavigation by viewers, who in some cases had to wend their way through massive accumulations of junk and debris. 'Now I just simply filled the whole gallery up,' he maintained, 'starting from one wall and ending with the other. When you opened the door, you found yourself in the midst of an entire Environment' fabricated out of all sorts of materials from 'sheets of plastic, crumpled-up cellophane, tangles of Scotch tape' to 'bells, tinkles, rattles, grinders, marbles in tin cans that turned over, and so on.'[4] An excerpt from Kaprow's 'Notes on the Creation of a Total Art,' written in connection with his 1958 exhibition at the Hansa Gallery, clarifies his position with regard to the viewer's place in an Environment:

> In the present exhibition we do not come to look *at* things. We simply enter, are surrounded, and become part of what surrounds us, passively or actively according to our talents for 'engagement' …. We ourselves are shapes (though we are not often conscious of that fact). We have different colored clothing; can move, feel, speak, and observe others variously; and will constantly change the 'meaning' of the work by so doing….What has been worked out…is a form that is as open and fluid as the shapes of our everyday experience but does not simply imitate them. I believe that this form places a much greater responsibility on visitors than they have had before.[5]

Motivated primarily by the wish to eliminate the distinction between art and everyday life, or at least to bring the two into close proximity, Kaprow not only surrounded his viewers *with* but also enveloped them *within* the material components of the Environment.

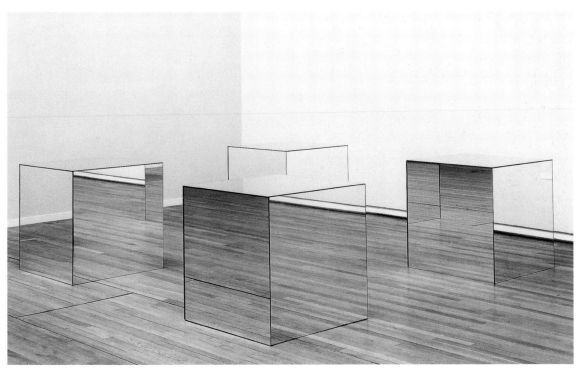

Speaking on behalf of Minimalism, Morris drew attention to the idea that the vacant space between otherwise separate sculptures belongs to the viewer. In Part II of his 1966 'Notes on Sculpture' published in *Artforum*, he wrote that Minimal works give viewers a greater degree of self-awareness in the presence of elemental forms since they have been shorn of distracting compositional or figurative incident. 'The better new work,' as he described it at the time, 'takes relationships out of the work and makes them a function of space, light, and the viewer's field of vision.' He continues:

> The object is but one of the terms in the newer aesthetic. It is in some way more reflexive because one's awareness of oneself existing in the same space as the work is stronger than in previous work, with its many internal relationships. One is more aware than before that he himself is establishing relationships as he apprehends the object from various positions and under varying conditions of light and spatial context.[6]

For a solo exhibition at the Green Gallery, New York, Morris realized *Untitled* (1965), consisting of four mirrored cubes measuring three feet on each side, which he placed six feet apart to form a square on the floor. The cubes' reflective surfaces explicated the otherwise implicit fact that a sculptural form exists in the same surrounding space as its spectators as well as the other way around.[7] Visitors to the Green Gallery simultaneously saw themselves within the context of the room and as figuration on the surface of the mirrored cubes. Although they were a part of the objects of their gaze, viewers nonetheless remained physically apart from the cubes. Morris's cubes, however, presaged developments to follow insofar as they emblazoned their surroundings on their shiny surfaces and caught the eye of anyone observing them at close range.

Several years later, with the development of his corridor pieces and room installations of the late 1960s and early 1970s, Bruce Nauman definitively eliminated the distinction between the physical space of the work and that of the viewer. These works by Nauman cancel the observer's status as a bystander who is traditionally thought to be 'rapt in contemplation' before or in front

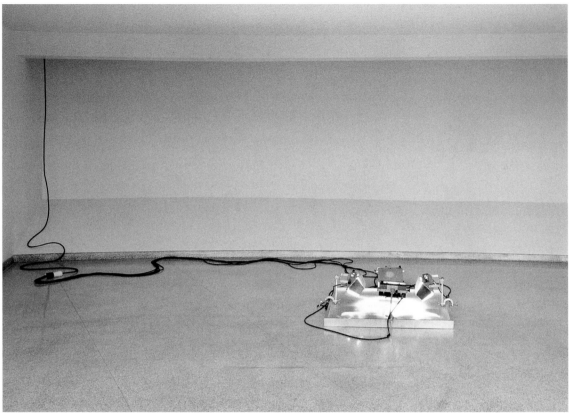

Bruce Nauman | **Lighted Centerpiece** | 1968

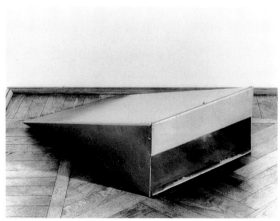

Bruce Nauman | **Device to Stand In** | 1966

of an object, and represent yet another facet of his prodigious investigation and redefinition of sculpture.

Early in his career Nauman had playfully thumbed his nose at the idea of a sculpture being a revered, if not a particularly useful, object. The viewer of *Device to Stand In (Brass Floor Piece with Foot Slot)* (1966), for example, is invited to insert a foot into an open wedged-shape object on the floor. The nature of this form suggests that a spectator be held by, and in, the same place as the normally distanced object. Furthermore, the object itself, to be put on like a shoe or slipper, takes on a performative aspect in association with its viewer.[8]

Two slightly later works further the performative character of *Device to Stand In*. Free-standing sculptures in a room, they incorporate their own lighting fixtures and, in this way, self-reflexively stage themselves. *Lighted Centerpiece* paradoxically and ironically removes itself from the art object's traditional center-stage position by way of its four blinding, 1,000-watt halogen lamps.

These are affixed to the sides of a three-foot aluminum square and are aimed at its slightly recessed center. One may compare *Lighted Performance Box* (1969), a rectangular, aluminum column six-and-a-half feet tall. Housing a 1,000-watt spotlight that hangs inside at its uppermost corner, the aluminum column casts a square of light on the ceiling to reverse the typical method of lighting an object from above.

Nauman extended the idea of the self-staged work in his corridor and room installations. *Performance Corridor* (1969) was exhibited at the Whitney Museum in 'Anti-Illusion: Procedures/Materials.' Of special note is the fact that this work initially had served as the set for *Walk with Contrapposto* (1968), a 60-minute black-and-white video. In this tape, the artist walks up and down the length of the corridor in a contrapposto pose reminiscent of traditional figurative sculpture. At the Whitney exhibition, where only the empty walkway was on view, Nauman substituted the visitors' bodies for his own. Initially, he had used the constraining walls of the narrow corridor to enact sculptural form, but he subsequently refilled the vacated and vacant space with spectators. Spectators walk into, rather than around, *Performance Corridor* so that the void between viewer and object is negated. Empty space, enveloped by the work instead of surrounding it in the usual manner, is kinaesthetically experienced as viewers proceed through it.

By embodying its viewers as participants, *Live-Taped Video Corridor* (1970) also emphatically inverts the usual object-viewer relationship. As opposed to being viewers *of* the work, once again they are viewers *in* it. Two video monitors are installed one on top of the other on the floor at the end of a narrow corridor. A video camera with a wide-angle lens is mounted ten feet above the floor at the corridor entrance. The work functions as follows:

> The top [monitor] displays a live image from the closed-circuit video camera; the bottom one continuously plays a prerecorded videotape of the empty corridor from the same perspective. As the visitor walks deeper into the corridor, his or her image on the monitor (seen from above and behind) appears to move farther away and diminish in size, reflecting the viewer's actual movement away from the camera.[9]

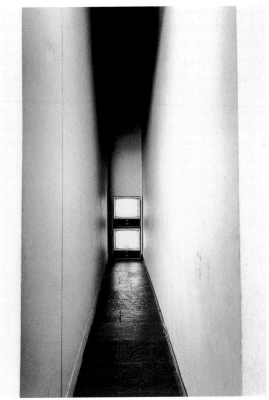

Bruce Nauman | **Live-Taped Video Corridor** | 1970

Incorporating its viewers at the same time that *it* observes *them* by means of its surveillance system, *Performance Corridor* turns the activity of viewing around. Observers are unavoidably enmeshed in the work, which watches them as they watch their own figures recede into the space they are in the process of entering.

For an early room installation, *Touch and Sound Walls* (1969), Nauman employed sound rather than video as the means to bring viewer and work together. Microphones are installed behind one of two walls built forty feet apart in an open space; speakers are hidden behind the other. When the first wall is touched, sound resonates from the second wall shortly thereafter. Sound fills the visibly empty space of the room and aurally binds the visitor to the work with which he or she has made literal contact. The year before, Nauman had animated a room acoustically with speakers built into the walls. The words of *Get Out of My Mind, Get Out of This Room* (1968) emanate from the walls of an empty room. They are yelled, growled, and grunted. 'When you entered this small room – 10 feet square or something – you could hear the sound, but there was no one there. You couldn't see where the sound was coming from…. It was a very powerful piece,'[10] according to the artist. The work assaults its viewers verbally to create immediate acoustical and linguistic impact.

A somewhat later work, conceived for a private home in Vancouver, *Indoor/Outdoor* (1972) takes the form of a closed-circuit video installation with ambient sound. A camera is aimed at the picture window of the living room from outside the house. A view of the living room, along with reflections of the outdoors on the window glass, appear together on the monitor installed in the house. Outdoor noises are picked up by a microphone and conveyed indoors by an amplifier. Those who walk in front of the camera appear on the monitor as well. The viewer, therefore, is included within the indoors and the outdoors, both of which are pictorially sandwiched together on the video screen by virtue of the transparent and reflective properties of the house's picture window.

A work by Nauman may be regarded as being performative and, in this sense, 'more of an activity and less of a product,' to use his words.[11] This activity may be generated by the artist's use of his own body, or, as in the corridor pieces and room installations, by the viewer. Or, a room installation may communicate by means of

closed-circuit video, sound and/or language with the receiving subject, who activates the work by virtue of his or her presence. What ultimately differentiates a work by Nauman from an Environment by Kaprow or the mirrored cubes by Morris is the absence of any intermediary object(s) of focus. With the aid of technology, Nauman dispenses with the material 'product' in the interest of an aesthetic production that prompts the spectator to engage with it directly.

Works by Graham, Acconci, Coleman, and Nordman all have performative aspects, as do those by Nauman, and likewise tend to be room-based. As well, they often depend on audio/visual media and in many cases rely on language to fully accommodate processes of spectatorship within the perceptual and conceptual boundaries of their work. With particular foresight in relation to his own production, Graham wrote perspicaciously about Nauman's use of his own body as an object. Such 'work of Nauman is in the present in the presence of the spectator,' he significantly observed in 1969. 'Just as Nauman has inverted his relation to the sculptural material he works upon, he now becomes the "object" and the "subject" simultaneously: he is both perceiver… and perceived, and both interior and exterior surface.'[12] These comments reveal a great deal about Graham's own aesthetic preoccupation, given that later, in his work, he would transpose to the viewer the subject/object equivalency that, in Nauman's work, pertains to the artist.

Resolute in its retraction of the material object's self-sufficiency, Graham's wide-ranging transformation of sculptural practice resulted in the complete dissolution of the boundary between viewing subject and observed object. Graham began his career in New York as a writer, and from 1964 to 1965 briefly ran the John Daniels Gallery where Sol LeWitt had his first exhibition. During the period from 1965 to 1969, Graham conceived his Works for the Pages of Magazines. The magazine pieces do not deal directly with issues of spectatorship but established the printed page as an alternative exhibition site and thereby short-circuited art's necessary manifestation as a materially autonomous object.

Eliminating the line between a work of art and mandatory physicality, Graham's magazine pieces represent a major step towards his subsequent erasure of the traditional division between work and spectator.

Schema for a set of poems whose component pages are specifically published as individual poems in various magazines and collections. Each poem-page is intended to be set in its final form by the editor of the publication where it is to appear, the exact data used to correspond in each particular instance to the fact(s) of its published appearance. The following schema is entirely arbitrary; any might have been used, and deletions, additions or modifications for space or appearance on the part of the editor are possible.

Schema:

(Number of)	adjectives
(Number of)	adverbs
(Percentage of)	area not occupied by type
(Percentage of)	area occupied by type
(Number of)	columns
(Number of)	conjunctions
(Depth of)	depression of type into surface of page
(Number of)	gerunds
(Number of)	infinitives
(Number of)	letters of alphabets
(Number of)	lines
(Number of)	mathematical symbols
(Number of)	nouns
(Number of)	numbers
(Number of)	participles
(Perimeter of)	page
(Weight of)	paper sheet
(Type)	paper stock
(Thinness of)	paper stock
(Number of)	prepositions
(Number of)	pronouns
(Number of point)	size type
(Name of)	typeface
(Number of)	words
(Number of)	words capitalized
(Number of)	words italicized
(Number of)	words not capitalized
(Number of)	words not italicized

This schema was conceived in March, 1966.

Using this or any arbitrary schema produces a large, finite permutation of specific, discrete poems.

1	adjectives
3	adverbs
1192½ sq. ems	area not occupied by type
337½ sq. ems	area occupied by type
1	columns
0	conjunctions
nil	depression of type into surface of page
0	gerunds
0	infinitives
363	letters of alphabet
27	lines
2	mathematical symbols
38	nouns
52	numbers
0	participles
8½ x 5	page
17½ x 22½	paper sheet
offset cartridge	paper stock
5	prepositions
0	pronouns
10 pt.	size type
Press Roman	typeface
59	words
2	words capitalized
0	words italicized
57	words not capitalized
59	words not italicized

129

Dan Graham **Schema (March 1966)** 1966

In 1969, during a symposium broadcast on the radio, Graham articulated the rationale for their creation:

> I think I'm interested in fusing something in the present without documentation. I was never interested in words or syntax in poetry, but more in information. I wanted the things I did to occupy a particular place and be read in a particular present time. The context is very important. I wanted my pieces to be about place as information which is present.[13]

Well aware that works of art depend on a means of economic support just as much as they do on the walls of physical enclosures, Graham explicitly questioned the concept of the saleable commodity. Works for the Pages of Magazines take part in the timeliness of magazines rather than being positioned as unique, and purportedly timeless, objects within the delimited confines of a museum or gallery.

The earliest magazine pieces, *Scheme* (1965) and *Schema* (1966), derive their formal content from their context on a page. As the meaning of 'scheme' suggests – from the Greek word for 'form' as well as for 'plan' – *Scheme*'s scheme is inseparable from the given area of its pages, on which numbers from zero through thirteen give rise to a pyramidal shape and, from fourteen through thirty, to a parallelogram. The shapes conform to the given page in that they are formed by double rows of repeated and sequential numbers. These progress quantitatively from page top to bottom in a logical sequence to yield formal constructions based on numerical necessity rather than on intuitive choice.

Dan Graham | **Figurative** | 1965

With greater complexity, *Schema* describes the conditions that determine its existence both in language and in print. Consisting of a columnar list of data, it linguistically inventories its own formal properties and published format. The work – or poem, as it is referred to – adapts to the publication in which it appears by enumerating its grammatical elements (number of adjectives, adverbs, gerunds, etc.) and by supplying the specifications for its materialization as a printed text (size of page, weight of paper sheet, name of typeface, etc.). *Schema* simultaneously informs and is informed by its place of publication, where it functions both *on* and *as* a particular page. The content of the work and its contextual placement, in this way, function paragenetically.

Figurative (1965) appeared on page 90 in the March 1968 issue of *Harper's Bazaar* between two advertisements, one for Tampax and the other for a Warner's bra. A list of numbers, printed vertically down the center of a page and representing dollars and cents

paid for thirty or so inexpensive items, is cut off at top and bottom to conform to the height of the page. Since the numbers are not totalled, they represent only themselves and not a final sum. Graham had submitted this portion of a lengthy cash-register receipt to the magazine with the idea that, coming at the end of the buying process, it would function not only as a poem, but in reverse of an advertisement. The receipt was placed and titled by the editorial staff and not by Graham. The shopping receipt, which signifies the result of a commercial exchange, contrasts with the ads, which signify the potential for such an exchange. Irrespective of its placement on the page, *Figurative* is anchored within the volume that contains it and, as a kind of 'anti-ad,'[14] resists being merchandised as a precious and purchasable or saleable object.[15]

Similarly drawing their representational content from their presentational context, other Works for the Pages of Magazines clearly evince a social dimension. *Common Drug/Side Effect* (1966) charts information researched

by Graham that, conveyed by dots in a grid, details the reactions caused by certain drugs. The information imbues the work with a visual aspect clearly reminiscent of the period's infatuation with Op Art, which plays with the eye on a purely retinal level. In contrast to an optical pattern or formal composition, Graham's chart has actual applicability.

Homes for America (1966–67), taking the form(at) of a picture essay in the December/January issue of *Arts Magazine*, is a work that, in its use of linguistic, photographic, and contextual modalities, may be considered emblematic of the period.[16] It consists of Graham's verbal and photographic presentation of variations in basically uniform tract housing typically found on the outskirts of American cities. Without overt comment, the article documents eight choices – designated by musical names such as 'The Sonata' or 'The Nocturne' – of home models offered to prospective buyers. Eight color choices include 'Seafoam Green' and 'Colonial Red.' Although the houses are virtually identical, Graham demonstrates how language attempts to disguise the underlying uniformity of settings that are commonly given names such as 'Fairhaven,' 'Pleasant Grove,' or 'Sunset Hill Garden.' Graham lists all of the permutational possibilities pertaining to a block of eight houses based on four model types and, further, adds a sardonic twist: a list of the proffered colors organized by male and female preferences.

In an important text, Benjamin Buchloh recognized that *Homes for America* 'reflects in an obviously ironic and ambiguous manner the formal and stylistic principles of minimal sculpture.'[17] Graham's work, in marked contrast to its Minimal predecessors, derives its form from the masked social realities that characterize the environs of the contemporary urban landscape. Penetrating beneath the verbal veneer applied to the sale of homes, the work reveals how the presumably objective qualities of form and hue acquire subjective undertones in conjunction with associative phraseology that 'colors' a manipulative, hidden agenda motivated by economic greed rather than by models of social enlightenment.

Graham's magazine pieces succeeded in making the socio-economic basis of art an intrinsic part of works that withstand their own commodification as material, self-sufficient objects. One of his last works of this kind, *Income Piece* (1969) is based on the idea of art as investment. Treating the spectator as a speculator,

COMMON DRUG \ SIDE EFFECT	Anorexia (appetite loss)	Blood clots	Blurring of vision	Constipation	Convulsion	Decreased libido	Depression	Depression, torpor	Headache	Hepatic disfunction	Hypertension	Insomnia	Nasal congestion	Nausea, vomiting	Pallor
STIMULANT also APPETITE DEPRESSANT															
Dextroamphetamine (Dexedrine)	•			•	•				•		•	•		•	
Methamphetamine chloride (Desoxyn)	•			•	•				•		•	•		•	
ANTI-DEPRESSANT															
Iproniazid				•					•	•	•				
Trofanil			•				•		•						
TRANQUILIZER															
Chlorpromazine			•		•	•	•								•
Hydroxyzine			•			•	•	•					•	•	
Meprobamate				•			•			•					
Promazine			•			•	•	•							
Reserpine	•			•	•	•					•	•			
Thiopropazate		•	•	•	•	•	•	•		•					
SEDATIVE															
Barbital			•				•				•				
Phenobarbital			•				•				•				
ANTI-MOTION SICKNESS															
Dimenhydrinate (Dramamine)						•	•				•				
Marezine						•	•								
Meclizine						•	•				•				
CONTRACEPTIVE															
Norethynodrel (Enovid)		•	•				•	•			•	•			

Dan Graham **Common Drug/Side Effect** 1966

Dan Graham | **Homes for America** | 1966–67

Dan Graham | **Income Piece** | 1969

Graham issued shares in 'Dan Graham Inc.' at ten dollars apiece to be advertised in various publications. He saw this work as a method for 'examining (or subverting)… the art world as part of the real economic/social world' as he 'wished to open [himself]… to the entire social-economic system of which art and the artist's "self" had been considered closed-off sectors.'[18] The artist was to receive a salary from the income of the stock and investors were to share in the extra profits. *Income Piece* demonstrated the interconnection between art, society, and economics by featuring its own socio-economic condition as a condition of the work. At the same time, it invited the viewer to be a participant/recipient.

After he discontinued the magazine pieces in 1969, Graham turned to performance, film, and video to further his inquiry into alternatives to traditional sculpture. Early performances, *Lax/Relax* (1969) and *Like* (1971), for example, demonstrated his desire to

redraw the line between actor, action, and audience. First performed at New York University's Loeb Student Center in May 1969, *Lax/Relax* was presented in front of a live audience. The artist mutters the word 'relax' to himself through a microphone while breathing decisively. On a recording, a woman speaks the word 'lax' and then breathes. At the beginning of the performance the recorded speaking and breathing are distinct from the voice and breathing of the live performer, but after thirty minutes the two become indistinguishable. Eventually the sound of breathing alternates with the lax/relax syllables. Graham described the resulting effect:

> The audience may become involved in its own breathing responses and thus locate the surface of its involvement; its attention is somewhere between 'inside' my breathing, its relation to the [woman's] or its own breathing. It may become hypnotically affected.[19]

Graham's performances were governed by the attempt to overcome psychological and social distance between individuals. Instructions for *Like*, first performed at the Nova Scotia College of Art and Design, read as follows:

> The performers have both been instructed to convince the other (the ways in which) he is like him (or her). This performance is continued with a continual coming closer together, until (perhaps as boundaries of self are reached) this is reversed.[20]

Any form of verbal communication or visual gesture may be used by the two performers toward the realization of their task. Graham structured certain other performances around himself, but never was he the exclusive focal point. Rather, by means of performance, he organized methods for himself or others to enact paradigms of identification and interaction.

Films produced by Graham between 1969 and 1974 merge performers and performance, a possibility allowed by the use of a movie camera. For example, *Body Press* (1970–72) represents the viewing process through its equation of the activity of filming with the act of seeing. To produce this work, consisting of two 16 mm color films, Graham utilized two cameras. Two performers – one male, the other female – stand unclothed inside a mirrored cylinder. Each presses a camera flush against his/her body and rotates it around him/herself. The performers spiral the cameras slightly upward at the same speed until their respective cameras reach eye level, at which point they reverse the procedure. When they are standing back-to-back with their cameras behind them, the performers exchange cameras. The procedure is repeated over a twenty-minute period to complete the work, which depends on the interaction between optical mechanisms of vision and observed kinaesthetic movement. As the artist has pointed out, 'kinaesthetically, the handling of the camera can be "felt," by the spectator, as surface tension – as the hidden side of the camera presses and slides against the skin it covers at a particular moment.'[21] When the two films are projected full-scale on opposite walls of a darkened room, spectators have the sense that they themselves are participants in the filming process.

Graham noted that in his films 'the process of physiological orientation – attention – of the performer(s) is correlated to the spectator's process of attention.'[22] Video, on the contrary, 'is a present-time medium.'[23] First employed by him in conjunction with *TV Camera/Monitor Performance* (1970), video allowed Graham to encompass the audience within the totality of the performance. For this video/performance at the Nova Scotia College of Art & Design, he rolled on a stage, feet first, while he aimed a handheld video camera at an audience sitting with their backs to a centralized monitor. The 'monitor image represents a "subjective" view from inside my "mind's eye,"'[24] he asserted. When members of the audience turned around to look at Graham (looking at them) on the screen, they saw the backs of their heads as well as the faces of those who were watching the proceedings on stage.

Graham's room-environments of 1974 rely on the ability of video – meaning 'I see' in Latin – to conduct images back and forth between the reality of one place and another. The first of these works, *Present Continuous Past(s)* (1974), must be entered for the work to be seen. Without occupancy by viewers it does not, in effect, exist. Two adjacent walls of its interior are covered with mirrors. A video camera with a monitor set into a third wall records viewers and their reflections in the opposite mirror as they move about the space. The image of the viewers' gestures and facial expressions appear on the monitor after an eight-second delay. Viewers thus see

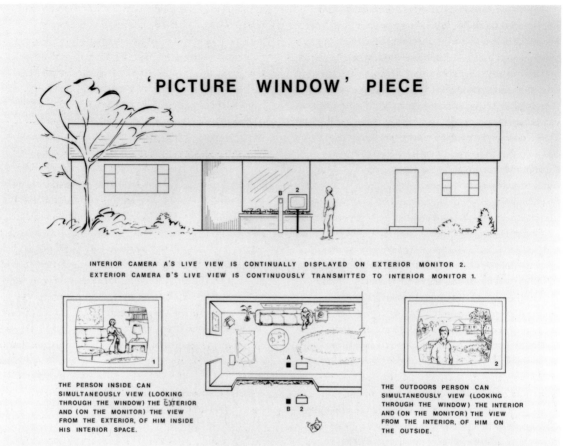

‘PICTURE WINDOW’ PIECE

INTERIOR CAMERA A'S LIVE VIEW IS CONTINUALLY DISPLAYED ON EXTERIOR MONITOR 2.
EXTERIOR CAMERA B'S LIVE VIEW IS CONTINUOUSLY TRANSMITTED TO INTERIOR MONITOR 1.

THE PERSON INSIDE CAN
SIMULTANEOUSLY VIEW (LOOKING
THROUGH THE WINDOW) THE EXTERIOR
AND (ON THE MONITOR) THE VIEW
FROM THE EXTERIOR, OF HIM INSIDE
HIS INTERIOR SPACE.

THE OUTDOORS PERSON CAN
SIMULTANEOUSLY VIEW (LOOKING
THROUGH THE WINDOW) THE INTERIOR
AND (ON THE MONITOR) THE VIEW
FROM THE INTERIOR, OF HIM ON
THE OUTSIDE.

Dan Graham | **Picture Window Piece (proposal)** 1974

themselves and others at the moment of looking in the mirrors and as part of 'an infinite regress of time continuums within time continuums'[25] on the monitor screen. The spectators reflected in the mirrors and shown on the video monitor are simultaneously perceiving subjects and perceived objects within a work that has cast off the outer shell of traditional sculpture. Variance in viewers' actions/reactions keeps the work in constant flux and imbues it with a socio-psychological content that distinguishes it, for example, from Nauman's related *Live-Taped Video Corridor*.

By way of strategically placed cameras and monitors, Graham was able to confront viewers with their own and others' viewing simultaneously. Installations of the cameras and monitors also made possible the immediate

transference of contrasting or related phenomena within the social apparatus from one set of circumstances to another. Graham has written that when connected with architecture, video serves 'semiotically speaking as window and as mirror simultaneously, but [will] subvert the effects and functions of both.'[26] *'Picture Window' Piece* (1974) encapsulates important aspects of later video installations that reveal aspects of the social order in conjunction with specific kinds of architectural settings such as shopping malls and glass office towers. In this and later works, video acts as a conduit between spectators and their social environment as this is signaled by architecture.

'Picture Window' Piece links the interior and exterior of a typical suburban house. For the work to be realized,

two video cameras and monitors are set up in a line with each other on either side of a large picture window.[27] A feature of many postwar American homes and symbol of domestic well-being, the picture window is a transparent boundary between indoors and outdoors that draws a line between private and public life. The indoor camera is trained on the person sitting inside and the outdoor camera is trained on the spectator outside the window. Upon looking out of the window, the indoor spectator has a view of him/herself on the outdoor monitor. Conversely, an outdoor viewer sees him/herself in the outdoor environment while he/she is looking directly into the living room of the house. The indoor viewer becomes self-conscious within the protective barrier of his/her own home at the same time that the outdoor viewer sees him/herself peering through the glass to catch a glimpse of reality behind the picture window.

While it keeps the actual, transparent glass that frames the landscape intact, *'Picture Window' Piece* shatters the picture window's illusory nature as a social divider. The work as a whole embraces its viewers as they both view themselves and are viewed within the social sphere they inhabit. Unlike Nauman's quite similar and comparable *Indoor/Outdoor*, Graham's work creates a dialectic between interior and exterior. If *Indoor/Outdoor* ingeniously takes advantage of the window's transparency and reflectivity, *'Picture Window' Piece* considers the social dualities occasioned by the picture window convention.

Another video installation, *Yesterday/Today* (1975), connects the public portion of an art gallery with an area used for daily activities such as its administrative offices or its cafeteria. Ongoing routine activities occurring in the latter are displayed on a monitor installed in the former. Furthermore, a recording of sounds and conversations, taped the day before in the facility and shown on the monitor, provides the accompanying sound-track for the activities taking place in real time observed on the video screen. The work, as Graham suggests, succeeds in 'documenting what is normally not expressed (because of the conventional meditative silence) in front of the artwork,'[28] which is 'the functional, social and economic realities of the art gallery'[29] normally hidden from view. Although separated by a twenty-four hour interval, the visual and aural modes of delivering information yield nearly parallel scenarios when the work is in operation. Once

again, by means of video transmission between one place and another, Graham constructed a work whose content is derived from behind-the-scenes interpersonal relationships as they are played out in actuality.

An enclosed space that functions without a video camera/monitor, *Public Space/Two Audiences* (1976) represents the transition from the video room-environments of 1974 to the free-standing, transparent and mirrored glass Pavilion/Sculptures Graham began in 1978 and continues to develop in many different forms.[30] *Public Space/Two Audiences* was made for the 'Ambiente Arte' (Environmental Art) exhibition at the 1976 Venice Biennale. Like *Present Continuous Past(s)*, it is a rectangular, closed-off room. Divided in half by a clear, sound-insulating glass barrier, it is enterable through one of two doors and has a mirror at one end. Similar to the video room-environments, it depends on occupancy by viewers in order to function. Looking through the accoustapane divider, one group of viewers sees the other group standing against the backdrop of a solid wall. Looking back through the divider, these spectators see not only the first group but also themselves reflected in the far mirror. Each group may follow the other's communicative gestures without being able to hear what is being said. As Graham has explained:

Public Space/Two Audiences effects an inversion: the spectators, instead of contemplating an art production (products produced for the art market) encased within the room-environment (the architectural enclosure), are themselves placed on display by the container's structure and materials; similarly, the social and psychological effects of the pavilion's material construction, in contradiction to its assumed 'neutrality,' becomes apparent.[31]

In other words, the work's material construction, its exhibition premises, and its viewers become part of an undivided totality. Dispensing with the object's external boundary, *Public Space/Two Audiences* eliminates the interval between a viewer's spatio-temporal presence and the work at hand. Additionally, it presents itself as a microcosm of the dynamics of interpersonal relations and self-referentially bears witness to the ever-changing patterns of social division and cohesion occasioned by the transparent divider.

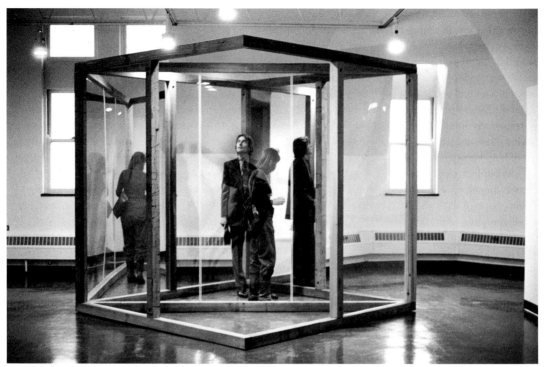

Dan Graham | **Model for Pavilion/Sculpture for Argonne** | 1978–81

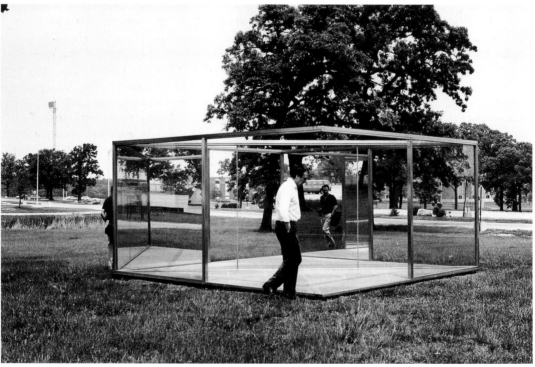

Dan Graham | **Pavilion/Sculpture for Argonne** | 1978–81

With his first two Pavilion/Sculptures, *Pavilion/Sculpture for Argonne* (1978–81) and *Two Adjacent Pavilions* (1978), Graham took yet another major step in his re-evaluation of the sculptural object. Whereas his earlier works had forfeited the creation of free-standing material objects, the Pavilion/Sculptures stand in open space. They are differentiated from traditional sculpture by virtue of their formal liaison with architectural structures ranging from simple glass shelters to skyscrapers. Most notably, neither exterior nor interior takes precedence in works that may be considered reversible. Made with two-way glass and mirror, they may be seen from the outside looking in and/or from the inside looking out. Constantly changing conditions of illumination affect their transparency, translucency, opacity, and reflectivity at any one time, from any and all directions.

The Pavilion/Sculptures similarly invert established relationships between a work's content and its container as well as between an art object and its viewing subjects. Although in its spareness it superficially resembles a Minimal art structure, a work such as *Pavilion/Sculpture for Argonne* is indiscriminate with respect to its internal/external boundaries and, on account of its transparent and reflective properties, is unavoidably site-specific. Mirroring its surrounds, a Pavilion/Sculpture is also cast in a social light. It reflects upon the social body as the open-ended sum of its participant viewers. These viewers – who simultaneously observe as subjects and are observed as objects – give substance to works within which they are integral components.

In a series of scale models realized in the late 1970s and early 1980s, Graham made explicit the relationships between architectural form and function. *Alteration to a Suburban House* (1978) and *Clinic for a Suburban Site* (1978), for example, are generic designs for buildings that, if actually constructed, would blend in with existing modern and vernacular architectural constructions. Spectators may peer into these models, which, exhibited at eye level, have mirrors inside them. The sign of middle-class stability – the picture window – is removed from *Alteration to a Suburban House* to expose the bare walls of the interior dwelling. A glass partition between waiting and consulting rooms in *Clinic for a Suburban Site* alludes to the alienation caused by conventions of architecture. The models question accepted architectural codes and, in theory, are meant to be rendered outside of the physically defined enclave of an art-viewing space and to function within the very social setting they probe. They belong firmly within the overall framework of Graham's aesthetic investigations commencing with Works for the Pages of Magazines and also including a series of early photographs, which examine the 'larger, predetermined synthetic order'[32] as this is expressed through exterior and interior views of urban/suburban buildings and dwellings.

Unlike the work of Graham, the work of Vito Acconci from 1969 to 1979 centers on the artist himself as a visible or audible presence. Having made use of photography, film, video, and sound recording in connection with his installations, Acconci calls attention to the idea that looking at art results from an unspoken pact between an author and an audience. By featuring his body or self in his aesthetic production – which in his case may be considered the 'act' as well as the 'activity' of producing – he crossed the line between the creation of an object and a temporal event and bridged the usual divisions between artist, audience, and exhibition space.

Acconci began his career as a poet in the mid-1960s. A broad range of poems from this early period in his life are published in the magazine *0 TO 9*, which he and the poet Bernadette Mayer founded and edited.[33] Acconci's poetry offers a backdrop for considering his subsequent work as a visual artist inasmuch as language would prove to be his main base of operation throughout the 1970s. His poetry, moreover, demonstrates his predisposition to press beyond the strictures of his chosen medium.

The poems in *0 TO 9* take a variety of different forms and are about the process of laying out words on a page in lieu of inventing linguistic images or supplying coherent referential meanings. In these poems, the page is acknowledged as a surface to be physically dealt with from within its rectangular borders. It is not treated as the unobserved ground that is normally taken for granted in the linguistically meaningful placement of metaphors, similes, or poetic turns of phrase. Instead, a poem by Acconci perambulates its designated page so as to imbue it with a visible, yet verbal, spatial structure. Words, letters, and punctuation function as abstract units of construction that, held together on the page, resist semantic cohesion. As such, they participate in the various systems devised for getting them on, across, and down the page.[34]

Vito Acconci | **Service Area** | 1970

Acconci came 'face to face… with the viewer, who [was] entwined in my field of action.'[47] During the period of the exhibition, he diverted his daily mail delivery from his New York City post office box to his assigned, box-like space in the museum, where he collected his letters and packages every day during museum hours. Keeping his distance from individual members of the public, he remained absorbed and preoccupied with the demands of daily life. By thus weaving his personal routine into the framework of a public art exhibition, Acconci averted the need to import unique or stationary objects into the museum. In their place, he 'performed' real duties as part of an art exhibition and, without resorting to spectacle, subjected himself as a private citizen to the public's gaze.

In two subsequent works, Acconci installed himself in locations outside an institutional space but similarly placed himself in a decided relationship to his viewers. The first, *Untitled Project for Pier 17* (March/April 1971),

was exhibited for a month. An announcement on the wall of the John Gibson Gallery, New York stated that the artist would be at an abandoned pier each night. 'I will be alone, and will wait at the far end of the pier for one hour,' he informed them. Additionally:

> To anyone coming to meet me, I will attempt to reveal something I would normally keep concealed: censurable occurrences and habits, fears, jealousies – something that has not been exposed before and that would be disturbing for me to make public.[48]

The second work, *Claim* (September 10, 1971), consisted of a three-hour performance at the foot of basement stairs of a New York loft building, where the artist sat holding metal pipes and a crowbar. Spectators were able to watch him on a video while he ranted and raved: 'I'm alone down here;' 'I won't let anyone down here

with me;' 'I'll keep you away... get rid of you... I'll do anything to stop you.' Whether assuming a confessional or confrontational pose in relation to real or hypothetical spectators, he forcefully acknowledged the substantive place of the viewer in the formation and realization of these works. Just as Graham established a bond between performers and audience in a work such as *Like* through verbal interchange, Acconci set up scenarios that encompass the viewer within the work by means of his own person and personally directed language.

These two works led to Acconci's first constructed room installation, *Seedbed* (January 1972), at the Sonnabend Gallery, New York. In *Seedbed*, Acconci was audibly present but hidden from view underneath a wooden ramp built over the floor, where he was ostensibly masturbating. At appointed times during the course of the exhibition, the artist's words penetrated the exhibition space as he verbally engaged the visitor in order 'to make [his] space and viewer space come together' so as to be 'more coincident with each other...'[49] His words floated up from under visitors' feet as they heard phrases like 'I'm doing this with you now... you're in front of me... you're turning around... I'm moving toward you... leaning toward you...' In this way, Acconci sought, metaphorically, to embrace viewers within both his and the gallery's space.

Acconci had pondered how he 'could be more a part of the space a viewer was in' and to this end developed ways for viewers to 'enter [his] mental space.'[50] By employing shock tactics, he aimed to bring viewers to their senses, in a manner of speaking, and thus into his arena. During subsequent performances, he enacted his own self-interrogation. As Kate Linker has written in her monograph, 'the performances of 1973 map a trajectory through various states of indecision, guilt, accusation, and recrimination, among others...'[51] Having shifted his emphasis from body to psyche, Acconci sought to build a mental bridge between himself and the spectator in order to further lessen the gap between a viewing subject and the object viewed.

As of 1974, Acconci had removed his own person from his performance installations and substituted audiotapes with recordings of his voice. The installation, *Round Trip (A Space to Fall Back On)* (1975), demarcates the physical gallery as a space for interaction between artist and viewer. The work occupies a corner of a room and is open to entry. Stools and boxes – several with audio

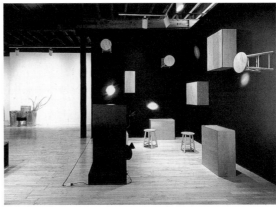

Vito Acconci **Round Trip (A Place to Fall Back On)** 1975

speakers inside them – are stained and varnished like ordinary furniture. They sit on the floor of the enclosure and also protrude from the walls. This furniture, according to Acconci, 'sets up stopping points, resting places, in an open field.'[52] A wooden construction, or 'control-point,' the height of a person houses a speaker and supports three spotlights. The artist's voice urges viewers to interact with him while entertaining their own thoughts. Words and phrases spoken declaratively, murmured, or whispered in hushed tones are interjected between constant knocking sounds. One hears, for example, 'wait,' or 'here,' or 'You must hear something, you've got to feel something...' issuing from different audio speakers at different moments. The artist's rich, deep-throated and resounding voice, anchored at the control point but continuously changing location, travels around the space from speaker to speaker and infiltrates the entire room. The work thus engulfs viewers in language that questions, commands, describes, pronounces, and confides in them through the intermittent use of the word 'you'.

By the second half of the 1970s, Acconci had realized that his work 'could use gallery space as a kind of model for an overall cultural space.'[53] A sound installation of the following year, *Under-History Lessons* (1976), has a distinctly political tone.[54] Acconci first showed the work in the boiler room of PS1 in Queens, New York, an exhibition space that once was a school. Planks and stools overhung with light bulbs on wires evoke a school-like atmosphere. On one of two speakers the theme of a supposed class is announced in Acconci's voice: 'Let's pretend we're in this together...

Let's claim we care enough… Let's be suckers…' From the other speaker he rejoins: 'Ready – let's be suckers…' Then, from the two speakers, he recites parts of the lesson. In the manner of a refrain one hears: 'All right: we-are-suck-ers… Repeat: we-are-suck-ers… Again: mm-mm-mm-mm… Remember: mm-mm-mm-mm-…' Because of its oppressive atmosphere and allusion to the repressive nature of learning by rote, the work prompts viewers to take note of the social situation overall.

The artist continued to play the devil's advocate in audio works from the latter 1970s that, on a political plane, seek to provoke the viewer by name-calling and blasphemous outbursts that infiltrate the exhibition space. *The Peoplemobile* (1979), a flat-bed truck draped with a hooded face mask, transported its own remountable exhibition panels, which could be used for seating and for shelter, from city to city throughout Holland. From two speakers attached to the roof of the vehicle, the work spoke to its public: 'Ladies and gentlemen…is there a terrorist in the crowd…ladies and gentlemen…I have come for your terrorists…watch me: I can look your terrorists straight in the eye…' etc.[55] *The Peoplemobile* implicated its audience by means of its confrontational language while it vocally addressed the phenomenon of terrorism. One of the last of Acconci's audioworks, it marked the moment in his career when he altogether withdrew his visible and/or audible presence from the work.

Like Vito Acconci, James Coleman utilizes media that reflect the passage of actual time. By means of film, video, slide projections, and recorded sound, Coleman has endeavored to avoid the creation of static images. Concomitantly, he has examined relationships between reality and fiction as these are filtered through the mind. Whereas his production from the first half of the 1970s has principally to do with perception, works from the second half of the decade focus on psychological, social, historical, and cultural subject matter. Because of Coleman's use of audiovisual technology in conjunction with language, spectators are able to participate as witnesses to dramatizations that unfold in front of their eyes, so to speak, in their own time.

Works from the early part of Coleman's career deal with subjective factors that determine how and what is observed. *Flash Piece* (1970) set the stage for later works by demonstrating how time and memory contribute to the process of seeing. First shown at the Studio Marconi

gallery in Milan, where the artist had come from Dublin to pursue his studies, it consists of electronic flashes of colored light that are directed at the gallery wall in different temporal sequences within a series of repeated cycles. During each cycle, the time between flashes differs, although such variations are not usually detected since time as measured and time as experienced do not necessarily coincide. In this way, Coleman introduced a subjective aspect of viewing into the subject matter of the work.

Just as *Flash Piece* illustrates the subjective nature of perception, *Memory Piece* (1971) highlights the vagaries of recall. Although the original tape no longer exists, the work may be reconstructed at any time. This work is activated by the participation of individuals who, one at a time, listen to a three-to-five minute text on one of two tape recorders. On the other recorder, they recite or summarize the content of this text to approximate it as closely as possible. This activity may be repeated indefinitely inasmuch as a single tape provides the basis for unlimited texts to be laid over the one preceding it. Previously recorded summaries are not available to participants of a work that, documenting memory functions without giving access to the past, remains eternally and thematically in the present.

As *Memory Piece* makes clear, only memory allows the mind to retain the past, however imperfectly, with reference to the reality of the present. This work evinces how the mind, when it relies on memory, engenders change and loss as it accumulates, filters, transmits, and distorts. Anyone may activate the work, which stands as both an ongoing recording and a changing record of transformation instead of as a graspable object or image. It is the perceivers/participants who, in their attempt to memorize and remember, take the work out of the hands of the artist to shape and reshape it themselves. The use of the constant erasure/recording capacity of a tape recorder in this respect parallels Kozlov's *Information: No Theory* (see p. 192). Coleman's piece, however, is not about erasure, as is Kozlov's, but is about the possibility of recording and re-recording ad infinitum.

Spoken language in *Mono-Dialogue* (1972) likewise induces the active involvement of the spectator. Two hidden loudspeakers are installed at opposite ends of a room. The speakers emit phrases at alternating intervals to give a superficial impression of coherency. As described when first shown:

…a voice coming from a two track stereophonic tape delivers words or short phrases, from opposite ends of the room. The spectator (or rather, the listener) … is assailed by these vocal statements in a very complex rhythm, so that the intervals between them can be either brief or long, and the words more or less accentuated or even completely unstressed: making a greater or lesser impact on the listener and at the same time creating the impression of their being correlated, or deriving from the other by evoking their semantic meaning or phonetic value.[56]

At certain times the work lures visitors to one side of the room and, at others, entices them to the opposite side with intriguing phrases or pieces of information. Although verbal content cannot always be coherently construed or caught in time, spectators/listeners, responding as if they were in the middle of multiple conversations that stimulate their curiosity, try to assign meaning to the verbal fragments they are able to pick up within the room. Comparable to language-based installations by Nauman or Acconci, the work pulls viewers into itself, attracting their attention by auditory means.

The epistemological role played by time in the perception of an image is demonstrated by *Pump* (1972), a short Super 8 mm film projection. In association with the sequential movement of film, *Pump* calls upon the subjective faculties of vision to pry loose the conventionally static image. The image of an empty bucket hanging under the spout of a water pump at the start of the film looks exactly like the image seen at the end of the film when the bucket is filled with water. During the film water rushes from the spout into the bucket, providing information that the empty bucket has been filled. *Pump* thus elucidates the fact that whatever is seen in the present has both a past and future manifestation, which the viewer, supplied with information over time, remembers and comes to understand through knowledge.

A key early work by Coleman, *Slide Piece* (1972–73) overtly deals with viewing as a temporal, not a static, event. Although it consists of a single photographic image – a color slide of a deserted city square in Milan projected full scale on a wall in a darkened room – the work thematically embraces multiple points of view. An accompanying audiotape contains an aggregate of verbal descriptions made by nearly a dozen individuals invited by the artist to characterize the scene at hand.

The texts comprising *Slide Piece* are delivered in the voice of a single narrator. Despite the unifying quality of his voice and intonation, none of the descriptions of the essentially unremarkable image are the same. The different verbal descriptions are differentiated by each observer's particular method of analysis and selection of visual elements and details for mention. Because it gathers together a diversity of 'views' with respect to a single image, *Slide Piece* underscores the way in which verbal conceptualizations in front of the same image vary from commentator to commentator.

A composite collection of verbalizations, *Slide Piece* does not have a narrative beginning or end. The intricacies of the various descriptions, with their vivid, poetic, and often quaint and amusing turn of phrase, contribute to the richness of a work that illustrates the fact that a totality may only be perceived as an aggregate of multiple viewpoints. While it pertains to a single – and basically nondescript – image, the work as a whole takes place over time as an indefinitely extendable sum of its parts.[57]

Ensuing installations attended to the observer's position in architectural space. For the first of these, *Two Seagulls or One Seagull Twice* (1973), Coleman projected a continuous sequence of slides on two facing walls at the end of two rooms linked by a corridor. Both of the ongoing projections displayed an arriving and departing seagull that dipped down to pick up food on a river. Viewers of the work, able to face in the direction of only one sequence of slides at a time, could not determine if the bird – flying from left to right in both projections – was the same one making a complete circle or if, instead, two birds were traveling in separate circles.

A similar work, *Installation Made for Location* (1974), was exhibited several times in different architectural circumstances. In each, Coleman brought the viewer's vantage point to bear on the structure of the work. When shown in Rome in 1974 during 'Contemporanea,' a set of earphones containing pre-recorded texts were positioned on opposite sides of an underground parking lot. On each set of earphones, a viewer heard a description pertaining to the spotlit, linear car park divisions seen by the viewer at the other end of the car park. The descriptions were in past, future, and present

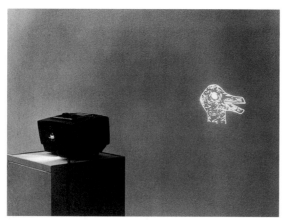

James Coleman **Playback of a Daydream** 1974

tense and thus delivered a mental image of what had been, would be, or was being observed over a period of time by the other viewer. In lieu of being confronted with a stationary object, viewers were given the opportunity of seeing through someone else's eyes.

Two other works of the same year, *Playback of a Daydream* (1974) and *Goblet* (1974), are well known textbook illustrations of the human perceptual apparatus. Ambiguous images which may be read either as a duck or a rabbit in the former and as a goblet or a face in the latter, provide each work with its respective imagery. *Playback of a Daydream* is a film projection. *Goblet* consists of half a dozen metallic paintings on paper pasted to the wall. Both of these works involve the unresolved and mentally oscillating perception of one of two images, neither of which is privileged. The unresolvable conflict between duck and rabbit is rescued from deadlocked ingemination because the image is moving forward on film as well as endlessly back and forth in the viewer's mind. The artist maintains that in creating *Goblet* he wanted 'to get in between the space of when one image became the other.'[58] Each painting represents the impossibility of the task and, kept together as a series, is slightly different. Although the perceptual present dominates, knowledge of past and future intervenes to involve viewers in and subject them to the ongoing and shifting nature of perception.

The 'ambiguous figures,' famously dealt with linguistically by Ludwig Wittgenstein, signaled the end of Coleman's purely perceptual installations. *Clara and Dario* (1975), a slide projection with audiotape, marks the juncture at which Coleman broadened his concerns to include psychological areas of experience. Two sets of color slides of over-life-sized faces are sequentially projected next to each other. When first exhibited in Milan, they were shown on either side of an existing pillar. The faces change position in relation to each other in tandem with a recorded text spoken in Italian. The text pertains to two fictional adults who intend to revisit the place of their childhood romance near Lake Como. Containing descriptive reminiscences of a time gone by and giving immediate access to the thoughts of the speaker, it begins with 'io penso che' (I think…) and continues, 'non so se ho voglia di partire in questo momento' (I don't know if I want to leave just now). During the course of the reverie, the sequence of slides completes two cycles while half of the text repeats itself both in reverse and in alternation with new material to avoid linear chronology. The proposed, but never accomplished, journey that leads to a contemplation of the past is reflected by the non-sequential flow of the narrative. The projected faces turn back and forth and to and from each other, sometimes in response to the words of the audiotape but sometimes not.

The large, life-like faces tower over spectators who, brought in on the romantic reverie, are narratively carried back and forth in time. According to the artist, he wanted to create an emotional rapport between the spectator and the two figures who personify nostalgia for the past and desire for the future, which combine in the perception of the present.[59] Whether the text of *Clara and Dario* is a monologue or dialogue is unspecified since the characters are simultaneously divided and connected as images, separate and fused as psyches. They mirror each other visually and verbally to contend with the self as a construct inclusive of present, past, and future desires in a text that, through the repetition of its content, turns back upon itself while it moves forward.

A psychological meditation about time, *Clara and Dario* paved the way for the intense psychological drama of *Box* (1977), a seven-minute, Super 8 mm black-and-white film loop with a synchronized audiotape. Incorporating original documentary footage from the 1927 boxing match between heavyweight champion Gene Tunney and Jack Dempsey, the film is meant to be projected in a tight, dark space so as to amplify the effect of its staccato bursts of sound and flashing images. The fast, abrupt appearance and disappearance of the image produces afterimages between the frames to effect 'a low

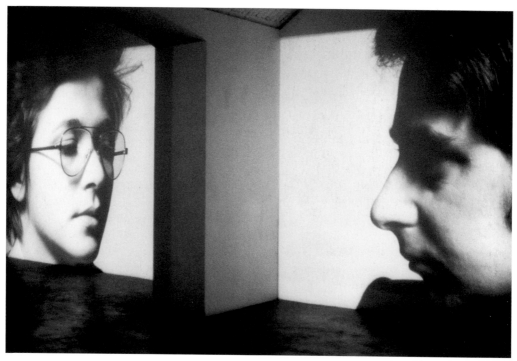

James Coleman | **Clara and Dario** | 1975

James Coleman | **Clara and Dario** | 1975

Subject as Object **[219]**

James Coleman | **So Different... and Yet** | 1980

pulse similar in frequency to that of a heart beat.'[60]
Breathy words and sighs, as if issuing from Tunney,
are uttered in the same staccato rhythm.

The idea that Tunney, world champion in 1926, had
to reclaim this distinction in a fight the following year
inspired the work. During the bout, Tunney must
struggle to reaffirm – in order to preserve – his identity,
which hung in the balance for a year. Exterior and
interior aspects of Tunney's person are portrayed in
the text accompanying the flashing images. The script
emphasizes the association between mind and body with
phrases such as 'ooh – aah – the liver – the liver,' while
it also alludes to the desire for power: 'the sticks – not
capital's – right' are the words of an individual striving
to maintain his contested role, and therefore his self-
image, within the social order. Spectators, surrounded
by the nearly total darkness of the room and having the
visceral sensation of being both in the fight and in the
mind of the fighter, are engulfed by a work whose
subject, ultimately, is the clash between self and society.

Audiovisual installations such as *Strongbow* (1978)
and *A-Koan* (1978) comment on the ambiguities and
dichotomies within the socio-political order. *The
Ploughman's Party* (1979), an installation that plays upon
the image of the plough as both heavenly constellation
and instrument of earthly labor, specifically focuses on
the rampant artificiality in society that is driven by
merchandising. The Plough, set at the end of a room,
which at its first showing was lined with white velvet,
is the centerpiece of the work. Made out of gold-leaved
iron, it assumes the curving, almost Rococo, shape of
the constellation for which it is named. With blue neon

lights highlighting it from behind and white light from
a projector illuminating it frontally, the Plough is set off
like a bejewelled corporate sign. From within the room,
the viewer hears the voice of a man who is speaking with
an affected accent in double-entendres about culture and
cultivating, products and productivity. *The Ploughman's
Party* literally speaks in this manner about the artifice
that, having permeated contemporary culture through
advertising, allows merchandising to turn productive
labor into seductive products.

The all-pervasive artifice infiltrating contemporary
culture addressed in *The Ploughman's Party* is also a
major theme of the video *So Different...and Yet* (1980).
On the video screen of *So Different...and Yet*, a female
model, who keeps shifting from one stock pose to
another, is poised on a chaise-longue. She and a male
piano player relate an intricate narrative that is
punctuated by piano music. The images on the video
screen, set against a deep blue background, are richly
colored and backlit to give them the unnatural quality of
color found in advertising brochures. The piano player
who, like a cuckold, has horns growing out of his head,
wears a black tuxedo. The female model is garbed in a
decolleté, shiny green evening dress, and one of her legs
is wound with a red ribbon. The narrators' contrived
deliveries, including lapses into culturally affected
accents, are filled with verbal cliché.

The story, which the female model and the male piano
player tell in both the first and third person, is composed
of two intertwining plots and begins on the premises of a
dress shop owned by Vanna, the female narrator, and a
woman called Laura. The narrative text of the speakers
is made up of an accumulation of the hackneyed, though
riveting, episodes associated with sensational romances
and thrillers. The two intersecting plots share several of
the same characters, while the various incidents are held
together by phrases such as 'meanwhile, back at the dress
shop...' However, any sense of a traditional narrative
with a beginning, middle, and end is clearly disrupted
and purposefully exploded into fragments of literary
convention replete with characters, who, despite
constantly changing identities, retain a stereotypical
nature. The evening dress, a symbol of revival and re-
creation, functions as the unifying element of the
interlaced, zigzagging plots of a work with multiple
interpretive possibilities. The green dress may be
considered both politically and aesthetically given that

the colour imbues it with symbolic overtones. To what extent is 'the latest creation,' asks the narrator, brought 'into line with today's fashion?' By the conclusion of the tape, it is again outmoded, like trends in art, having been replaced at a previous point by an imitation – not unlike art that attempts to trick the eye.

Viewers of *So Different…and Yet*, are, in one writer's words, 'captivated by [the speaker's] image and her unfolding narrative' and 'also alienated from it,'[61] conscious of the fact that they have been taken in by it. As the performers recount the complex series of events, the various machinations of the work's fictional structure become apparent. In lieu of providing connected incidents leading from one to another as the tale is spun, the video exposes the underpinnings of narrative fiction. Because of its attention to role playing and to the illusions of society *So Different…and Yet* foregrounds its own illusory content.

In obvious contrast to Coleman's critique of illusion through the mediums that perpetrate it, Maria Nordman ultimately rejected the use of either still or moving images in favor of producing a direct confrontation with the observable world. By the outset of the 1970s, she had begun to clarify for herself the thematic importance of the viewer – or, in her preferred terminology, of the 'person arriving by chance.'[62] Up to this point, photography and film had contributed to her initial search for methods to reconsider how a viewer is beholden to the iconic aspect of representation, but is not reciprocally recognized within the content of the work. By 1967, the year she received her Master of Fine Arts degree from the University of California, Los Angeles, she was in the process of exploring alternatives to traditional two- and three-dimensional representation. However, her early photographic works and films foreshadow her later and ongoing engagement with the city and its inhabitants. Furthermore, they contribute to the idea that art need not simply be an object of one author's invention nor one made solely for placement within specially designated exhibition spaces.

As her series of Found Rooms (1966–67) suggests, Nordman, from the beginning, was focusing her attention on public spaces rather than on objects. Each Found Room consists of at least two different photographs of a chosen city interior such as the Los Angeles train station, a downtown bank, or an abandoned home. The artist maintains that she could

'not accept the single image that refers only to the place of the person making the work,' considering such 'to be a falsification of the reality of how a person thinks and acts since an image is constantly in the process of being made.'[63] By taking more than one shot of a particular subject at different exposures, at different times of day, or with different objects in the picture, etc., she aimed to 'question the photograph's acceptance as an instigator of reality' and to diffuse its power as a solitary image.

As of 1967, Nordman had commenced her investigation into possible ways for apportioning the production of meaning between herself and others. By introducing 'people met by chance' into her work as collaborators – as she would do quite literally in the construction of much later projects – she sought to extend her authorial role to any and all recipients of her endeavor. In this regard, *Unnamed* (begun 1967) was created as a 'continuous collaborative work.'[64] A specific spatial volume between two architectural structures, according to the artist, has the potential for being conceived of as sculpture. *Unnamed* thus becomes operative with the sighting of an 'interstice between two buildings located and found – in a densely populated part of the city…. Any person is the potential co-worker in choosing, presenting an unnamed site to one or more persons.'[65] A person's observation of the interstice between two buildings anywhere in the world may be communicated to the artist or to another person. In *Unnamed*, the changing backdrop of the sky seen between buildings exists as visual fact without being fixed, as it would be in a photograph. Nordman's unlabeled volumes between edifices, which cannot be dislodged from the overall experience of city, sky, light, or atmosphere, therefore partake of a mutable and uncircumscribed totality.

A ten-minute film loop, *EAT: Film room* (1966–67), also set a precedent for works that avoid static representation and include the observer in the process of giving meaning to a work.[66] In this film, the actors, who share a meal at a table draped with a white tablecloth, are also its viewers. Nordman points out that any person, herself included, could take the place of the actors. It is filmed with two cameras, the one taking in the scene as a whole and the other narrowing in on details of the action. The two sequences are then projected from where the cameras stood during filming. A partition, perpendicular to the wall against which the

Maria Nordman **Found Room Series** 1967

work was filmed and onto which it is projected, divides the room in half.

With *EAT: Film Room*, Nordman furthered her ongoing inquiry into 'how the known and the unknown person actually relate.'[67] When the two films are screened in the same two spaces where they were created, the actors watch themselves in action. The table, cleared of food, remains in the room during the projection so that filmed reality is able to spill over onto the physical reality of the white cloth-cum-screen. Because the filmed scenario is split in two, the work comments upon the movement inherent in the medium of the motion picture. At the same time, it provides the onlookers with more than one option for its viewing. Thus standing inside the three-dimensional setting in which they had been filmed, the actors witness themselves as a series of images that unfold on the separated halves of the flat wall before them.[68]

A group of Laser Drawings (1967–68) further anticipate Nordman's works of the 1970s. They are plans for rooms to be constructed out of various kinds of coherent light, whose properties she researched in Stuttgart at the Max Planck Institute, but chose not to realize outside of the studio. *Double Planar Selection and One Observer* (1968), for example, is a plan for a dark room penetrated by the illumination produced by Argon laser light in conjunction with reflecting mirrors. Aside from the impracticalities and dangers at the time of using laser light, the Laser Drawings, in the artist's estimation, possessed inherent thematic limitations. A laser-lit environment would have successfully infused its space with bluish planes of light and, significantly, would have interacted on an equal basis with the walls of its container. Luminous planar projections both on and in lieu of walls would thus have replaced the hieratically distanced object or image. To Nordman's way of thinking, the major drawback of these works was the fact that they were ultimately exclusive and 'not randomly available to any person at any time and at any place. Their static quality was unrelated to the person who could be there' and they were not subject to the changing conditions effected by the weather and the time of day.

While experimenting with coherent, artificial illumination as a medium, Nordman also carried out projects that relied on natural light. *Garden of smokeless fire on a gypsum dry lake* (1967) is one of the Fire Performances she staged in the Mojave Desert. Using a

Hollywood technique, Nordman poured a flammable substance on the surface of a dry gypsum lake to create a smokeless fire. At this moment, the lights from the houses of the nearby town, the light from the sky before sunrise, and the intensely illuminated floor of the desert lake all acted in concert. Nordman published the piece as a large double-page color spread in *DE MUSICA*, having stamped the photograph with the word 'fragment.' She included a small inset – the identical photograph of the page-spread – in the lower right-hand corner of the right-hand page. The small-scale duplicate photograph, like the word 'fragment,' questions the fact that this image, no matter what its size, is merely a partial record of a changing scene created at dawn in the vicinity of a gypsum plant in Trona, California.

With the construction of moveable walls in her studio at 1014 Pico Boulevard, Los Angeles for *Untitled 1969–70* (1969–70), Nordman took a final step toward the overt definition of natural illumination as the unifying component of her work. When the work is set up, sunlight coming in through a slit in the door casts beams into the room, which is entirely painted black. In the course of a day, the light moves around the walls and/or is absorbed by them. The work depends on the intensity of the light as well as on the placement of the walls that, sitting on wheels, may be repositioned. These variations continuously shift the relationship between the shafts of light and the walls, the former at times rivaling the latter in their apparent materiality. In reverse, the latter often seem to dissolve into an immaterial darkness. As Germano Celant has suggested, in such a work, it is 'the dynamic of light which forms planes and masses.'[69]

Nordman's description of *Untitled 1969–70* encapsulates the most significant aspects of this and subsequent works:

This work takes place on the street, and uses only that light coming in from the door.
The door is open to whomever passes by chance on the sidewalk.
The chosen location for the work has a wide usership, as the street at that point is surrounded by many small service shops, a laundry, a college, and one- to two-story apartments.
Into a black room with a rectangular floor plan are placed six black walls on omnidirectional wheels.

Four walls are eight by eight feet, and two are four feet wide and eight feet high. They are made of prefabricated gesso panels nailed to a frame of wood.
Every area before and behind the walls, as well as all parts of the room are open to the entry of people and daylight.
The sound of the work is dependent on the people there, on the given position of the walls, and the sound that enters from the street.
The work is ongoing.
From its first use in Santa Monica street level rooms (1969–70), I find the possible placement of walls inmidst of the arriving light to be unlimited.[70]

Untitled 1969–70, with its moveable walls, firmly established the major working principles of an oeuvre devoted to the dismantling of stationary images affixed to stationary walls. Having put aside the camera (itself a small 'room' or chamber, as the artist herself points out, through which one looks at the world),[71] Nordman opted for the use of humanly-scaled rooms, big enough for one or two persons, through which light could enter and which would be continuously open to passers-by as much as to an informed art-viewing public.

Other works were realized by Nordman on the premises of her first studio. For *Untitled: 1014 Pico* (1969), Nordman covered the window of her workspace with two-way mirror. This workspace also serves as a 'workroom' that 'could be used by different people for any kind of work' particularly since it exists in 'a cross-cultural neighborhood, amidst apartments, and where people work.'[72] During the day, passers-by catch a glimpse of themselves within the context of the street while those inside may peer out through the window at the urban environment as it meets the sky. The situation is reversed after dark when those inside may observe themselves in the mirror and/or be seen by those outside when a light in the back room is turned on. The height of the floor is flush with the base of the window so that the window, on a level with the horizon line, sets interior and exterior reality on a par. Whether looking inside or outside, at oneself or one's surroundings, a person may commune with the work in the company of his/her own thoughts yet be connected with the community at large. Transmitted through or reflected by glass, light causes the window to function as both screen and image. The

rectangle of the window thereby frames the perpetual movement of pedestrians and vehicles passing from one urban point to another.

Throughout the 1970s, as well as in the 1980s and 1990s, Nordman's works have been open to the 'unknown person,' to whom she dedicated *DE MUSICA* and to 'whomever might arrive,' for whom *DE SCULPTURA* was written. Her works receive their physical definition by means of sunlight, an invisible substance that, constantly changing in intensity, passes through or is reflected by glass, seeps through crevices, bounces off walls, permeates interior cavities, and, ultimately, makes vision possible.

Works closely following upon *Untitled: 1014 Pico*, along with several others realized in her Santa Monica studio, were created by Nordman elsewhere in the Los Angeles vicinity or in response to invitations from museums in neighboring cities.[73] *Untitled: 12 South Raymond* (1972), for example, took place in the upstairs space of a warehouse in Pasadena lent to her for about a month.[74] Nordman painted the entire room black and incised a $1\frac{1}{2}$-inch wide slit across the expanse of the roof to guide daylight into it. When a narrow slit is made in this manner, a room is divided into two distinct bodies of light – one of changing luminosity and the other of unchanging darkness – with a common plane of illumination between them. Nordman emphasizes that she has always been 'interested in the physical qualities of things and not at all in imitation or illusionism.' The work does not play optical tricks on the viewer, but lends itself to experiential exploration on the part of each person as per their chosen position in the room. Individuals, interacting with/in the image, assemble visual meaning on their own from the visual phenomena provided. Work and image, one and the same, are deliberately left open by the artist, not only to literal physical entry but also to participatory mental engagement.

A work at the Newport Harbor Art Museum, Newport Beach, California in early 1973 and another at the Art Gallery of the University of California, Irvine in the autumn exemplify Nordman's treatment of light from the sun as a primary and active force. As these works demonstrate, daylight activates and links together many variables. *Untitled: Newport* (1973), a room-sized wedge built into the museum behind the sliding door frame of the loading dock and painted white, gave onto an alley.[75] To see the work, museum visitors had to leave the museum and go to the back of the building, although its external construction was visible from indoors. Anyone walking to and from the Pacific waterfront passed it as well. Nordman arranged for a host/ess to inform people about the existence of the work, which had been virtually 'pushed into the street' where, Nordman affirms, 'there are no preconceptions about art.'

The work at the Newport Harbor Art Museum was 'an event initiated by the sun' insofar as it was designed to be totally filled with sunlight at 12:30 p.m. on 28 February, 1973, the time and date the exhibition opened.[76] When this or a related work is built, the luminosity permeating the open construction is computed in advance to reach its peak at a precisely specified instant marking the relationship between the rotational patterns of the earth and sun. This occurrence, weather allowing, is repeated at slightly different times on every day of the week thereafter. At these times, the sun completely obliterates the angular lines of the wedge-shaped interior hollow as if to cover the door frame with a planar screen of intense white light. As the sunlight slowly withdraws, the structural articulation of the interior gradually becomes more evident, although at certain times shadows, too, erase the diagonals of its three-dimensional construction and similarly imbue it with volumetric materiality. Constructed in precise relationship to time gauged by the angle of the sun, *Untitled: Newport* also incorporates the idea of time held in memory. In the best of circumstances, a work by Nordman is meant to be a permanent part of the city where it may be registered by any passer-by/viewer, seeing the work by happenstance or by plan, as an ongoing accumulation of shifting luminosities engendered by weather and the sun.

Saddleback Mountain (1973) took place inside the university museum in Irvine, California. In this work, built within the existing gallery according to her specifications, Nordman staged a meeting of indoors and outdoors by directing natural light and real sounds through a narrow passageway, or channel. At the end of the passageway, a slightly curved wall held a floor-to-ceiling mirror. The channel, admitting visitors one by one along an anti-perspectival corridor, led to an open room. The artist wrote at the time that 'Saddleback Mountain is a construction, a performance place for one person.'[77] When light passes through a channel,

it bounces off the mirror into the open room to produce a diagonal wall of light that divides the room into two rooms of distinctly different luminosities. 'The dividing wall of light,' she emphasizes, 'is more tangible than cement or drywall as it is a part of each person's bodily presence.' While the work was on view, it also was 'filled with the sounds "selected" by the channel entrance, like a bird a block away, a passing jet, or tree sounds.'[78]

Saddleback Mountain embodies its – and the museum's – own natural setting as an image. The mirrored panel at the end of the channel serves as a junction that, on the one hand, delivers light into the interior room and, on the other, keeps the exterior environment visible to the arriving person. Alternatively, when a visitor departs from the inner room bisected by light, he or she is able to witness the view of Saddleback Mountain through the open door at the end of the channel. 'The force of luminosity has its own presence,' according to Nordman, and the experience of 'its emotion/motion cannot be expressed by one person for another.' Being entirely experiential, the work does not harbor 'concealed or hidden conditions.' The image of contrasting volumes of light, moreover, is not ideationally isolated from the image of the mountain landscape beyond the doorway. On the contrary, the interior image is bracketed by, and is a continuum of, the reality outside of the gallery.

By the end of the decade Nordman had completed more than a dozen works not only in California but also in Europe. These works continue, with whomever is there at their nexus, to create a cohesive cognitive connection between an existing site and the city or an indoor spatial environment and its outdoor environs. Each work has its specific qualities in relation to the givens of each place and the nature of its surroundings. *Untitled: Via Melzo* (1974) at the Toselli Gallery, Milan took place in an old, residential part of the city surrounded by apartment buildings whose facades are punctuated by an abundance of doorways and windows and accentuated by protruding balconies. Within the darkened gallery, a sheath of sunlight, contingent with and perpendicular to a drywall partition added by the artist, spans the length of the room. Additionally, the rays from the sun fill the two rooms with different degrees of luminosity.

An exhibition at the Saman Gallery, Genoa, represented a departure for Nordman. *Untitled: Salita Tre Magi* (1979) was carried out, as before, in contrapuntal

MARIA NORDMAN *Untitled 1973-* (first realization Newport Beach California) Alameda and Temple 1996
a work open to any person passing a loading dock ajar on the sidewalk of a street named "Central Meeting Place" (Alameda) with a built entry in relation to a time between the earth and the sun 12' 4" height x 25' 4" given length, diagonal entry of 18'. Sunlight, steel bracing, paint and cement. The work's interior is outside of the building and reconnects with the street during daytime. The outside construction of the work juts into the interior area of a museum.

A chosen door location - as found - using its given conditions as the choice of the work, uses a time of day constructed for any person passing. The choice of place (building facade with loading dock at a sidewalk) has an authorship that continues with the steel and concrete constructors of the building, and the builders of Alameda Boulevard, together with anonymous persons passing on Alameda, who may or may not identify the site as a work of art. Horizon and personal and interpersonal areas of use, are reconnected to the whole of the landscape, using the sun as their determinant.

Plan and three photo-fragment contacts (Maria Nordman) Alameda and Temple, Los Angeles 1996-.
By invitation for realization of any work by the exhibition Reconsidering the Object of Art, Museum of Contemporary Art, T.C. Los Angeles, 1996. The back of this museum building is seen as a downtown warehouse by the passerby, from the nature of its construction. These conditions continue to have the potential of being named a work of art during the maintaining of chosen open times of the loading dock, with the radiants of the sun tangent to an unfettered diagonal white painted surface onto a white ground.
A work in a potential continuum of cooperation with members of a museum, and persons of the city and its visitors.

Maria Nordman **Untitled** 1973

relationship between interior and exterior. The artist, in this case, transposed the square shape of the gallery's ground plan onto the grounds of an unused clearing in the city. The square consisted of gleaming white marble pebbles. During its twenty-four-hour presence, it created a visual and social focal point within the context of weeds and rubble in a neighborhood of medieval churches and houses. Bearing comparison with Dennis Oppenheim's *Gallery Transplant* of 1969 (see p. 116, ill. p. 117), Nordman's piece differs radically in that it was not translated into a photograph but was defined only in terms of its material, on-site construction.

A group of double-sided, cut-out drawings for Public Squares begun in 1977 was exhibited inside the Saman Gallery on glass shelves, but was a separate project from *Untitled: Salita Tre Magi*. Nordman's method of

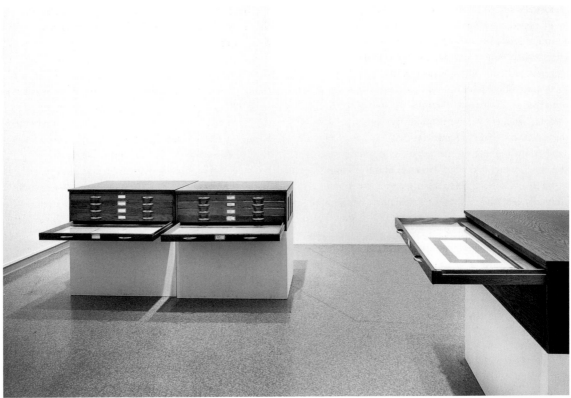

Maria Nordman | **Public Proposals for an Open Place** | Installation at The Art Institute of Chicago 1978

placement emphasized the drawings' two-sidedness while it kept their surfaces parallel to the earth's surface. Related drawings had been shown a few months earlier at the Rosamund Felsen Gallery, Los Angeles in a horizontal cabinet whose drawers were to be pulled open and closed by visitors.

The shape of a square for Nordman 'is only acceptable if it is populated.' The Public Square drawings are proposals for public parks formed by an ambulatory of trees. They present ground plans and verbal specifications for trees and consider the path and inclination of the sun in relation to the site. And, by means of a phrase stamped in small letters on the paper, they stipulate: 'Right of Passage From Every Direction.' To date, Nordman has realized four parks, the first having been planted in the fall of 1978 at California State College in Bakersfield. Shortly thereafter, in the summer of 1979, she participated in the 73rd American Exhibition at the Art Institute of Chicago with *Public Proposal for An Open Place* (1978). The proposal

envisaged that the large, 150-foot long rectangular exhibition space in the museum's Morton Wing be reinstated as a four-sided allée of native trees.[79] Unlike rooms in a museum, enclosures made by walls of trees remain open without interruption – to the sky and to the public – and are accessible at all times to each and every person.

Whether associated with or conceived independently from an institution, a work by Nordman is always placed on an equal footing, materially and metaphorically, with any person who might chance to see it. Her works are constructed for actual entry and have utilized, or refer to, the interiors of existing buildings such as vacated warehouses or small storefronts as well as those of museums and galleries. Avoiding artificiality of all kinds, especially that of light, Nordman's work takes issue with the singular and fixed image as a purveyor of truth. Committed to the idea of dialogue as an integral part of the work and to the erasure of preconceived thought processes, she revises the notion of art as an object set

before the spectator in a space reserved for its exclusive viewing. Nordman requires that the work of art should grant universal accessibility by guaranteeing its availability for anyone who takes part in the visible and experiential phenomena orchestrated by the artist.

Nordman's works, wherein viewing subjects participate in the artist's conjoining of architectural settings and natural light conditions, leave no disparity between what is seen at any one moment and a person's immersion in the ever-changing visual components of the work. Activated when a person comes in contact with them, works by Nordman are performative, as are those by Graham, Acconci, and Coleman. Collectively considered, all four artists have forfeited the making of self-sufficient or static objects and images in the interest of creating works that 'take place' in time.

Whereas actual spectators are present within the visual construction of his works, Graham overcomes the traditional disjunction between the observer and the object observed through recourse in many instances to time-based media. In all phases of his oeuvre and in his engagement with a range of media, Graham has fully put in practice the radical ideas underlying works by artists such as Kaprow, Morris, or Nauman, with their similar attention to the surrounding environment and acknowledgment of the spectator. Because of its analysis of society's facades and fictions, his art re-evaluates the self-sufficient nature of sculpture that in the past has been separated from its social context and the spectator.

Alternatively, works by Acconci, wherein the artist treats himself objectively as a sensate object, are to be seen or heard either in an actual space or on film or video. They metaphorically give voice to viewers as silent partners in the challenge to the fixed, material object as a definitive sculptural form. Performed and photographic works involving physiological or psychological discomfort act upon a perceiver's mental processes of self-identification, empathetical response, or revulsion and disgust. Installations built on language address viewers directly in order to bring them into the construct of the work. Bearing some relation to early works by Nauman, in which the artist is bodily present as an object, Acconci's works are layered with psychological and/or political content. In installations

before 1975, in which Acconci was actually present, the artist set up situations in lieu of creating space-occupying objects. In those of the second half of the decade, in which he extended his area of concern to the social realm by means of audio recordings, viewers are treated as a necessary component of the work as a whole.

Much of Coleman's oeuvre, referring to the tradition of oral narration and to theatre, provides a framework for looking at the fictional constructs of the self and society. Concerned with mechanisms of visual apprehension, his work investigates questions of subjectivity and expresses them via audiovisual modes of production. With the intent of revealing the reality of their own fictional structure – able to enthrall by holding an audience in its sway – his works illuminate the subjective and social factors that influence how something is seen. Most often by means of verbal and visual dramatization, they feature the perceptual act in lieu of personal expression.[80] Identifying preconceptions and deceptions inherent in both the perceptual and the social apparatus, Coleman substitutes representational forms that remain temporally fixed with those that coincide with the mental and physical activity of spectatorship.

In their various ways, Graham, Acconci, Coleman, and Nordman have each pursued the goal – articulated in the 1920s by El Lissitzky and fully defined in the 1950s and 1960s by Kaprow, Morris, and Nauman – to collapse the interval between a viewer or the viewing process and that which is viewed. Their diverse oeuvres share the premise that, as Marcel Duchamp cogently expressed it, 'the creative act is not performed by the artist alone'[81] but is an act of co-production. By performative, linguistic, technological and/or architectural means, their works incorporate the spectator, literally and/or ideationally, or include aspects of the phenomena of viewing within their internal structure. Furthermore, in the acknowledgment of the viewer and the viewing process within their thematic structure, their works are characterized by social or psychological content. By the deployment of non-traditional methods and media they endeavor to surmount unquestioned or uncompromising mindsets and rifts – including those between an artwork and its viewers – that threaten clarity of thought or contribute to intransigent vision.

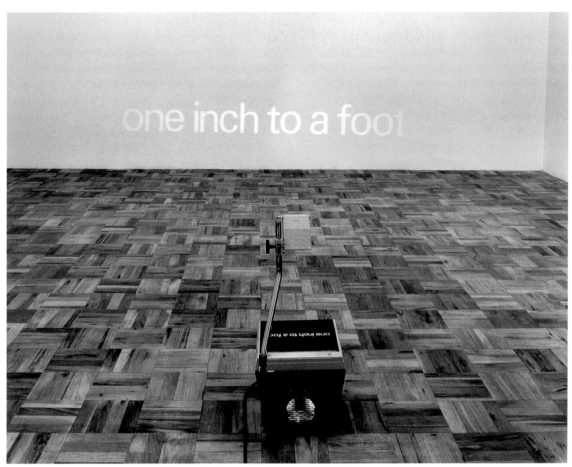

John Knight **One Inch to a Foot** 1971

Context as Content: Surveying the Site

Language, photography, serial systems, time-based media, and acknowledgment of the viewer enter into the realization of environmental works and so-called installations. The term 'installation' has long been used in connection with the curatorial arrangement of objects for museum and gallery display, but has come also to refer to works that diverge from the discreteness of individual paintings and sculpture. Installation pieces have, since 1968, been realized both within the four walls of institutional enclosures and outside of these boundaries. When the thematic content of an installation derives from its place of display, it is deemed to be 'site-specific.'

The oeuvres of Marcel Broodthaers (1924–76), Daniel Buren (b. 1938), Michael Asher (b. 1943), Lothar Baumgarten (b. 1944), John Knight (b. 1945), and Hans Haacke (b. 1936) focus on how aesthetic production is rooted in and sustained by society's institutions. By the late 1960s, each of these artists had begun to formulate methods for disputing the self-sufficiency of framed depictions and volumetric objects in favor of works that surveyed the nature of their site from a social as well as a physical standpoint.

The liaison of works of art with their physical installation sites has a long history as witnessed by past periods of art that include cave paintings, Pompeiian wall decoration, medieval church decoration, Renaissance fresco cycles, and Baroque ceiling paintings, as well as architectural sculpture found throughout the history of art. Projects from the earlier part of the twentieth century such as *Merzbau* (begun *c.* 1923) by Kurt Schwitters (1887–1948) or *Salon de Mme. B..., à Dresden* (1926) by Piet Mondrian (1872–1944) demonstrate these artists' respective interests in expressing abstract, painted form within the confines of an enterable interior instead of within the limits of a frame. However, such works (which further include works like El Lissitzky's

Proun Room, discussed in Chapter 5, p. 195), inseparable from their venue, may be viewed as anomalies in a society wherein works of art easily change hands on the open market.

Schwitters gave the evolving environmental construction that filled his house in Hanover the title of *Merzbau*, or 'Merz building,' deriving 'Merz' from the German word *Kommerz* used in an earlier work. This unusual and private work was a direct outgrowth of his collages, wherein the useless fragments cast off by a technological society are reassembled. In the process of creating *Merzbau*, Schwitters combined pieces of wood and plaster whose undulating and geometrical shapes projected three-dimensionally into the rooms of his house. With its eccentric nooks and crannies, his home accommodated a great variety of mementoes and objects from the material world and took on the form of an over-lifesize, inhabited collage. Schwitters maintained in 1936 that he was 'building an abstract (cubist) sculpture into which people can go.'[1]

Mondrian's *Salon de Mme. B..., à Dresden*, never executed by the artist, is known only from drawings.[2] Constructed later out of Formica for exhibition at the Pace Gallery, New York in 1970, it comprises an entire room. Walls, ceiling, and sparse furnishings contribute to a work that coincides with the architecture of basic living quarters. Mondrian believed that his paintings, which involved the expression of reduced and harmonious relationships between rectangles of primary colors, represented details of a universal order that transcended the chaos of the perceivable world. The artist similarly had turned his Paris studio into a painted environment by installing panels of black, white, and grey that resonated with his easel paintings. Mondrian's atelier thus served as a kind of showcase for his philosophical position. 'As my painting,' he stated, 'is an abstract surrogate of the whole, so the abstract-plastic

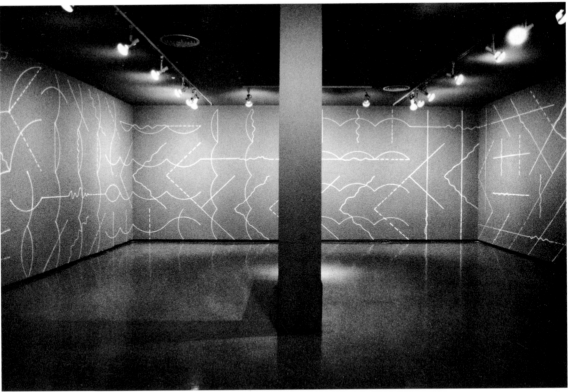

Sol LeWitt | **All Combinations of Arcs from Corners and Sides; Straight Lines, Not-Straight Lines, and Broken Lines** | 1973

'draw' the mural surface of their support into the content of the work as a whole. No longer serving as a background support, the wall, in place of a sheet of paper, becomes an integral part of the drawing. For a group exhibition at the Paula Cooper Gallery, New York in October 1968, LeWitt made his first drawing directly on a wall instead of on an intermediary surface. A year later, for an exhibition at the Dwan Gallery, New York, he arrived at the idea of using the totality of an enclosed space. LeWitt thereafter continued to record the visual complexities of basic linear elements in terms of the expanse of the wall and spatial enclosures according to a preset plan. Demonstrating a certain affinity with the instructional language found earlier in Fluxus pieces, the title of each Wall Drawing spells out a chosen directive. A pen-and-ink drawing of 1973, for example, sets forth one series: *All Combinations of Arcs from Corners and Sides; Straight Lines, Not-Straight Lines, and Broken Lines*, which was used for numerous wall drawing installations. According to the artist, 'no matter how many times the piece is done it is always different visually if done

on walls of differing sizes,'[6] or of differing shapes.

LeWitt's first Wall Drawings fused a predetermined system for generating lines and shapes with the existing architectural space. In comparison, the contemporaneous Wall Drawings and Paintings of Blinky Palermo of the same period melded their background support with forms obtained from existing architectural reality. While architectural reality – or forms found within it such as an actual staircase – prescribed how a work by Palermo would take shape, in LeWitt's Wall Drawings, verbally designated, modular systems imbue the work with form. In Palermo's work, elements of the work's architectural context, extracted from reality rather than being invented, provided formal imagery in correlation with the exhibition space. In LeWitt's work, preset linear systems interlock with their support to create a unified whole.

The Location Drawings of LeWitt, begun in the early 1970s, stress the verbal elements that generate and prefigure the form the work will take. They stipulate exactly how and where the elements of each work are to

THE LOCATION OF A RECTANGLE
A RECTANGLE WHOSE LEFT AND RIGHT SIDES ARE TWO-THIRDS AS LONG AS ITS TOP AND BOTTOM SIDES AND WHOSE LEFT SIDE IS LOCATED WHERE A LINE DRAWN FROM A POINT HALFWAY BETWEEN THE MIDPOINT OF THE TOP SIDE OF THE SQUARE & THE UPPER LEFT CORNER TO A POINT HALFWAY BETWEEN THE CENTER OF THE SQUARE AND THE LOWER LEFT CORNER AND THE MIDPOINT OF THE BOTTOM SIDE IS CROSSED BY TWO LINES, THE FIRST OF WHICH IS DRAWN FROM A POINT HALFWAY BETWEEN THE MIDPOINT OF THE LEFT SIDE AND THE UPPER LEFT CORNER TO A POINT HALFWAY BETWEEN A POINT HALFWAY BETWEEN THE CENTER OF THE SQUARE AND THE UPPER RIGHT CORNER AND THE MIDPOINT OF THE RIGHT SIDE, THE SECOND LINE FROM A POINT HALFWAY BETWEEN THE POINT WHERE THE FIRST LINE ENDS AND A POINT HALFWAY BETWEEN THE MIDPOINT OF THE BOTTOM SIDE AND THE LOWER RIGHT CORNER TO A POINT HALFWAY BETWEEN A POINT HALFWAY BETWEEN THE CENTER OF THE SQUARE AND THE LOWER LEFT CORNER AND THE MIDPOINT OF THE LEFT SIDE.

THE LOCATION OF A TRAPEZOID
A TRAPEZOID WHOSE TOP SIDE IS HALF AS LONG AS ITS BOTTOM SIDE AND WHOSE LEFT SIDE IS ONE AND A HALF TIMES AS LONG AS THE TOP SIDE AND IS LOCATED WHERE A LINE DRAWN FROM A POINT HALFWAY BETWEEN THE CENTER OF THE SQUARE AND THE UPPER LEFT CORNER AND A POINT HALFWAY BETWEEN THE MIDPOINT OF THE TOP SIDE AND THE UPPER LEFT CORNER TO A POINT HALFWAY BETWEEN THE MIDPOINT OF THE RIGHT SIDE AND THE UPPER RIGHT CORNER IS CROSSED BY TWO LINES; THE FIRST OF WHICH IS DRAWN FROM A POINT HALFWAY BETWEEN THE MIDPOINT OF THE TOP SIDE AND A POINT HALFWAY BETWEEN THE MIDPOINT OF THE TOP SIDE AND THE UPPER LEFT CORNER TO A POINT HALFWAY BETWEEN THE CENTER OF THE SQUARE AND THE MIDPOINT OF THE BOTTOM SIDE AND A POINT HALFWAY BETWEEN THE MIDPOINT OF THE BOTTOM SIDE AND THE LOWER LEFT CORNER, THE SECOND LINE IS DRAWN FROM A POINT HALFWAY BETWEEN THE MIDPOINT OF THE TOP SIDE AND THE UPPER RIGHT CORNER TO THE CENTER OF THE SQUARE, THE LEFT SIDE IS DRAWN TO A POINT HALFWAY BETWEEN A POINT HALFWAY BETWEEN THE CENTER OF THE SQUARE AND THE LOWER LEFT CORNER AND A POINT HALFWAY BETWEEN THE MIDPOINT OF THE LEFT SIDE AND THE LOWER LEFT CORNER.

THE LOCATION OF A PARALLELOGRAM
A PARALLELOGRAM WHOSE TOP AND BOTTOM SIDES ARE TWO AND A HALF TIMES AS LONG AS ITS LEFT AND RIGHT SIDES AND WHOSE TOP SIDE IS LOCATED BETWEEN THE POINTS WHERE TWO SETS OF LINES CROSS; THE FIRST LINE OF THE FIRST SET IS DRAWN FROM A POINT HALFWAY BETWEEN THE CENTER OF THE SQUARE AND A POINT HALFWAY BETWEEN THE MIDPOINT OF THE TOP SIDE AND THE UPPER LEFT CORNER TO A POINT HALFWAY BETWEEN THE MIDPOINT OF THE BOTTOM SIDE AND THE LOWER RIGHT CORNER, THE SECOND LINE OF THE FIRST SET IS DRAWN FROM THE MIDPOINT OF THE TOP SIDE TO A POINT EQUIDISTANT TO THE CENTER OF THE SQUARE, A POINT HALFWAY BETWEEN THE CENTER OF THE SQUARE AND THE MIDPOINT OF THE BOTTOM SIDE AND A POINT HALFWAY BETWEEN THE MIDPOINT OF THE LEFT SIDE AND THE LOWER LEFT CORNER, THE FIRST LINE OF THE SECOND SET IS DRAWN FROM A POINT HALFWAY BETWEEN THE MIDPOINT OF THE TOP SIDE AND THE UPPER RIGHT CORNER TO THE LOWER RIGHT CORNER, THE SECOND LINE OF THE SECOND SET IS DRAWN FROM A POINT HALFWAY BETWEEN THE MIDPOINT OF THE RIGHT SIDE AND THE UPPER RIGHT CORNER TO A POINT HALFWAY BETWEEN THE CENTER OF THE SQUARE AND THE UPPER LEFT CORNER AND A POINT HALFWAY BETWEEN THE MIDPOINT OF THE TOP SIDE AND THE UPPER LEFT CORNER, THE LEFT SIDE IS DRAWN ON A LINE TO A POINT HALFWAY BETWEEN THE POINT WHERE THE SECOND LINE OF THE FIRST SET OF LINES ENDS AND A POINT HALFWAY BETWEEN THE MIDPOINT OF THE BOTTOM SIDE AND THE LOWER LEFT CORNER.

Sol LeWitt **The Location of Three Figures** 1974

be situated. For example, the text for one of a series of five Location pieces entitled *Location of Two Lines*, first exhibited at the L'Attico Gallery, Rome in 1973, reads:

> A line from the center of the wall to a point halfway between the center of the wall and the midpoint of the right side; and a line equal in length to the first line, drawn from the midpoint of the first line toward the lower left corner.[7]

As the artist has explained, 'Lines, points, figures, etc., are located in [the space] by words. The words are the paths to the understanding of the location of the point. The points are verified by the words.'[8] The verbal elements of such works, almost like a musical score, rely on linguistic directives to produce a visual experience. From within the spatial setting of an exhibition space, the Location Drawings illustrate the unseverable connection between concept and realization.

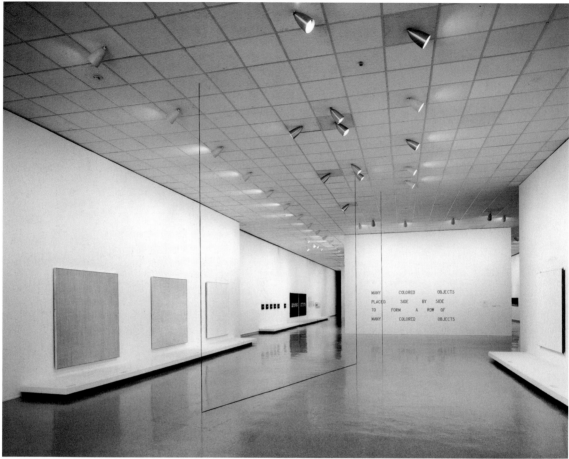

Fred Sandback | **Untitled** | 1979

By foregoing the conventional canvas support, LeWitt
and Palermo each confronted the concrete reality of the
exhibition premises so as to tie together the visual
content and visible context of each work. Suppressing
signs of authorial decision-making, they established an
interdependent relationship between exhibition space
and exhibited work of art. As opposed to Mondrian's
painted environment wherein the space of the room is
transformed by the superimposition of formal elements
onto the wall, their works disclose the wall.

With the advent of environmental wall installations
by Flavin, LeWitt, and Palermo, the physical exhibition
space discarded its definition as a vacant shell to be
conceptually and visibly absorbed into the totality of the
work. Paintings of the late 1960s by the film-maker
Robert Huot and sculptures by Fred Sandback similarly
have taken account of their architectural surrounds. The

titles of Huot's three works shown in his 1969 exhibition at the Paula Cooper Gallery, and documented in a small catalogue, describe them:

TWO BLUE WALLS
(PRATT & LAMBERT #5020)

SANDED FLOOR
COATED WITH POLYURETHANE

SHADOWS CAST BY
ARCHITECTURAL DETAIL AND FIXTURES
USING AVAILABLE LIGHT

Each work demarcated a component of the exhibition space. The highlighted architectural elements were left structurally intact and the walls or floor remained as they were except for changes in color or surface texture.

Sandback began his exploration of methods by which 'to make sculpture that didn't have an inside,'[9] soon after his enrollment in Yale University School of Art and Architecture in 1966. His first sculpture, *Untitled* (1967), an outline on the floor of a small rectangular solid in wire and string, led to sculptures that may be defined as three-dimensional drawings in open space. Initially by means of elastic cord (in colors such as silver grey, red, yellow, purple, or fluorescent orange) and subsequently, in the early 1970s, by means of colored yarn, Sandback reconfigured sculpture to intersect with what he has termed 'pedestrian space' – a space that may be thought of as 'literal, flat-footed, and everyday.'[10] His sculptures are nearly coincident with their architectural surrounds since their thin, taut, and colored lines delineate planes in space occupied by and shared with the viewer.

Works by Huot and Sandback reach toward the point at which form and material dissolve into architectural reality. With related intent, the Projector Pieces of Giovanni Anselmo merge with their architectural surrounds. In 1969 Anselmo wrote that what interested him was 'the world, things, life – situations involving energy,' and further noted that it is important not to 'crystalize' these situations.[11] His initial concern with conveying ideas about real experience, without resorting to absolutes, links his materially based Arte Povera sculptures of the late 1960s with his projector installations of the early 1970s.

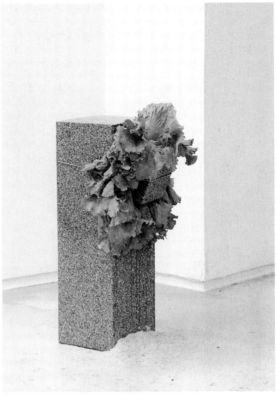

Giovanni Anselmo **Untitled** 1968

Energy emanates from Anselmo's early three-dimensional objects, such as *Senza titolo* (Untitled, 1968) and *Torsione* (Torsion, 1968). The former consists of a modestly scaled, upright, rectangular granite block resembling a pedestal. A fresh, leafy head of lettuce is sandwiched between this and a matching cube of stone attached by a wire. By means of the lettuce, an organic and perishable material, the sculptural block, which metaphorically appears to be consuming the lettuce, questions the traditional inertness of sculpture. Also seeking to throw off the dead weight of sculptural tradition, *Torsione* presents itself in a state of being wound up. An iron bar, suspended from a tightly twisted, fustian cloth, hangs on the wall as if ready to unwind and spin.

Following from works that preserve their materiality, Anselmo's slide projection installation *Particolare* (Detail, 1972) supersedes material form to bring about its substantiation as part of the architectural actuality of interior spaces. Since its first showing in the

Giovanni Anselmo | **Particolare (Detail)** | 1972/75, 1972/95, 1972/74 (top to bottom)

early 1970s, *Particolare* has been installed in many different spaces. When the Italian word 'particolare' is projected onto the various components of the exhibition area, the work animates the room it occupies. By labeling the floor, wall, and ceiling in this way, along with a possible vent, molding, or radiator, etc., or even a passer-by, Anselmo articulates the entire context in which the work is inscribed. Issuing from slide projectors dispersed throughout the exhibition space, the small, illuminated word identifies the components of the work's setting. Pointing to and becoming one with its architectural confines, *Particolare* presents itself as the ineluctable aggregate of its parts.

The aim of highlighting the contextual condition of art rather than fabricating commercially desirable, collectible objects in some cases led to the creation of works that could exist outside the walls of the self-contained exhibition enclosure, as in the case of works by Gordon Matta-Clark (1943–78), Robert Smithson, and Stephen Kaltenbach (b. 1940). *Circus or The Caribbean Orange* (1978) by Matta-Clark, created for the Museum of Contemporary Art, Chicago in its former quarters, it was the last project (but first museum commission) by the artist, who is known for his dissections of buildings slated for demolition.[12] 'Why hang things on a wall,' Matta-Clark asked, 'when the wall itself is so much more a challenging medium?' Like earlier pieces, *Circus or The Carribean Orange* concerned itself with 'suggesting ways of rethinking what is already there.'[13]

Matta-Clark's work for the Museum of Contemporary Art came about as the result of the impending renovation of an adjacent three-story townhouse acquired by the museum during a period of expansion. Invited to do a work in what later became the Annex for the permanent collection, he cut through the walls, floors, and roof of the townhouse edifice with a chainsaw.[14] Three twenty-foot circular incisions, measuring the width of the building and plotted on a diagonal from basement to roof, pierced through the once divided levels of an existing structure exhibiting vestiges of domestic functionality. Arcs and spheres produced by large, circular cuts effected layered vistas. Seen from above and below, they paradoxically joined together all of the carved-through sections of the house to create a large-scale, dynamic,

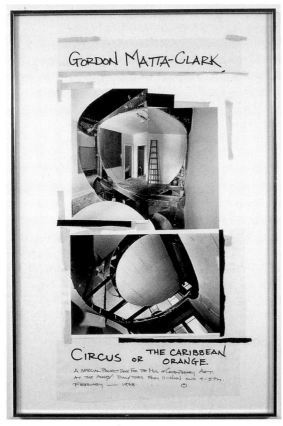

Gordon Matta-Clark | **Circus or The Caribbean Orange** (detail) 1978

Robert Smithson | **Nonsite: Franklin, New Jersey** 1968

formal entity. *Circus or The Caribbean Orange* revealed hidden enclosures and strata imposed by architecture that reflect the contemporary social structure while it functioned as an enormous, multifaceted sculpture made from a building rather than being housed within one.

Built on the grand scale of nature, the earthwork sculptures of Robert Smithson from the early 1970s forego the exigencies of architecture altogether. Along with artists notably including Michael Heizer (b. 1944) and Walter de Maria (b.1935), who also created huge, remote, outdoor sculptures, Smithson placed his earthworks far from urban centers and outside of urbane exhibition spaces. The most famous of these, *Spiral Jetty* (1970) at Rozel Point, Great Salt Lake, Utah was created out of mud, salt crystals, rocks, and water with use of a bulldozer.[15]

Prior to his earthworks, Smithson had exhibited his Nonsites of 1968 in museums. By means of linguistic and cartographic representation, he allied institutional exhibition contexts with non-art environments that hovered on the industrial fringes of cities or maintained a bond with nature. Such imported industrial and/or natural debris are presented in one or more geometrically shaped, painted metal bins. A typed description and a map accompany untransformed, non-art materials such as rocks, sand, or cinders. The identifying map and descriptive textual documentation reconnect the imported, industrial or natural debris of the Nonsite with its former site. By uniting the object on view with information on the source of its material components, the Nonsites question art's autonomous standing within the museum or gallery.

Overtly interested in rerouting art away from well trodden paths, Stephen Kaltenbach is responsible for a number of works that counter expectations with regard to their placement. His bronze Sidewalk Plaques (1968)

Stephen Kaltenbach | **Sidewalk Plaques: Fire, Air, Skin, Water** | 1968

were conceived for installation in the pavements of New York City where the word 'blood,' 'fire,' 'air,' 'bone,' or 'water' was to appear in raised relief. When Kaltenbach positioned these single and elemental words in the street, he succeeded in integrating the work with the quotidian reality of the city. Without a pedestal, the Plaques provided an alternative presentation of sculpture. Kaltenbach soon concluded that the Plaques 'brought the museum out into the street and [that] they identified what was going on as an art work.'[16] For this reason, he subsequently pursued other methods by which to discard conventions identified with art and its accompanying commodification.

From November 1968 through December 1969, a series of twelve consecutive works by Kaltenbach appeared in the section of *Artforum* where gallery exhibitions are announced. Appearing in the advertising 'space' of a prestigious art magazine – and, on a page rather than in a museum – the first work consists of the phrase 'Art Works.' The second, in the next issue, is a

modestly scaled, lozenge shape based upon the 'blp' of Richard Artschwager (b. 1923), installed anonymously in a great variety of locations after 1969 to punctuate a given space. Made of materials including painted wood (the earliest), glass, or horsehair or stencilled on indoor and outdoor surfaces, the 'blps' are 'portable,' according to Artschwager, 'but once you put one in place it becomes locked into its context.'[17] In his appreciation and appropriation of Artschwager's 'blp,' which in *Artforum* is inscribed with the name of the American folklore hero, 'Johnny Appleseed,' Kaltenbach reiterated the idea of combining authorial anonymity with the act of sowing ideas through institutional intervention.

Other pieces in the *Artforum* series consist of succinct phrases such as 'Expose Yourself' or 'You Are Me' that offer incursions into the perceived weightiness of the magazine's didactic writing. Semi-subversive, antisocial injunctions play upon the 'forum' in which the so-called ads appear. Made to be provocative and eye-catching, Kaltenbach's *Artforum* interventions fly in the face of

convention with respect to visual decoration and social decorum. They provoke by enjoining viewers, for example, to 'Smoke' or 'Tell a Lie.' Even the injunction 'Teach Art,' juxtaposed with the magazine's advertisements for forthcoming exhibitions, are out of line with the rest of the material on the page.

Differing from artists like Matta-Clark, Smithson, or Kaltenbach in their attempt to do away with the institutional barriers separating art and non-art exhibition contexts, Iain and Ingrid Baxter (b. 1936 and 1938) declared artmaking to be a business. With the founding of the N.E.Thing Co. (NETCO) in their home in Vancouver, they executed works between 1966 and 1978 under their own invented corporate aegis. With an ironic and humourous touch, their many works openly define art as a commercial activity. Although the majority of NETCO's projects made use of photographic and linguistic means, the Baxters were also responsible for a foresighted installation piece realized in 1969. For a month-long summer exhibition in the Lorne Building where the collection of the National Gallery of Canada, Ottawa was being shown at the time, the artists set up mock corporate headquarters. This involved constructing office walls, supplying office furnishings and equipment, hiring a receptionist, and having products – i.e., their own works – for sale, as in a corporate showroom. The installation functioned as a working office as well, with the company president on hand to transact business by greeting viewers, who were treated as if they were customers. As Iain Baxter later described:

> People would come in and they would go back out, and look to see if they were really in the National Gallery. It was a total change of art for them. A real estate man came in and asked, 'How did you rent this building?'[18]

Having introduced the trappings and activities of the business world into the rarefied atmosphere of the museum, and having thus converted a contemplative context into a corporate one, the Baxters put on display an instance of the intersection of art and business.

During his short but highly influential career, Marcel Broodthaers directed his aesthetic practice toward a consideration of the museum's place in contemporary culture. His series of investigative installations initiated

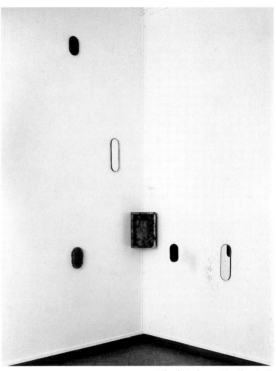

Richard Artschwager **Locations** 1969

Marcel Broodthaers | **Catalogue covers for Der Adler vom Oligozän bis heute (The Eagle from the Oligocene to the Present)** | 1972

Marcel Broodthaers | **Museum of Modern Art,
Department of Eagles, 19th Century Section** | 1968

in 1968 concur with the Baxters' comparable understanding of art's affiliations with commerce. Whereas NETCO's Ottawa work was a deliberate interruption of normal museum installation procedures, installations by Broodthaers were self-reflexive ruminations on museological operations rather than reproductions of corporate ones.

Broodthaers is recognized for a body of work that includes books, films, and prints, as well as installations. Speaking from his awareness of art's existence within 'the context of a world devoted to advertisements, overproduction, and horoscopes,'[19] the artist expressed 'the hope that the viewer [of one of his works] runs the risk – for a moment at least – of no longer feeling at ease.'[20] From 1964, when he formally announced his decision to abandon the writing of poetry, until his death

just over a decade later, Broodthaers never ceased to be motivated by the idea that, as he put it, 'it is perhaps possible to find an authentic means of calling into question art, its circulation, etc.'[21]

Broodthaers inaugurated his series of fictional museum installations on the ground floor of his Brussels residence in the Rue de la Pépinière under the heading *Musée d'Art Moderne (Section XIXe siècle) Département des Aigles* (Museum of Modern Art, nineteenth-century section, Department of Eagles, 1968–75). The museum opened on 27 September 1968 with a ceremonial speech by Johannes Cladders, Director of the Städtisches Museum Mönchengladbach, who was invited for this occasion, although the museum's self-appointed director was Broodthaers himself. 'Section XIXe siècle,' the first manifestation of the museum, consisted of art transport containers borrowed from the Palais des Beaux-Arts, Brussels. Stamped with words such as 'fragile' and 'keep dry,' the packing cases remained on view at the Rue de la Pépinière for one year. Postcards of nineteenth-century French paintings from the Louvre attached on a wall accentuated Broodthaers's inversion of traditional art production. Not only did the work take form as a museum outside of a museum in the artist's house, but also its contents consisted of shipping crates emptied of art. The postcards sold by the museum, indicative of the reduction of masterpiece to souvenir through photographic reproduction, ironically took the place of 'real' paintings.

In his poetic and alluring installations, Broodthaers sought to establish an alternative to the creation of objects that travel through the commercial system without serving a critical and social function. 'Der Adler vom Oligozän bis heute' (The eagle from the Oligocene to the present), subtitled 'Section des Figures' (Figure section),[22] belongs to the larger enterprise of Broodthaers's *Musée d'Art Moderne, Département des Aigles*. This work was realized as a temporary exhibition at the Städtische Kunsthalle Düsseldorf in 1972. Occurring within a bona fide museum, it reflected upon art 'in the place of its official acculturation, the museum.'[23] The 'Section des Figures' epitomizes Broodthaers's aesthetic investigation into the role played by the museum in the presentation and reception of art.

Aiming, as he stated in the catalogue, 'to provoke critical thought about how art is represented in public,'[24] Broodthaers reversed the traditional practice of

Marcel Broodthaers **Pages from catalogue for The Eagle from the Oligocene to the Present** 1972

participating in a museum exhibition by organizing the exhibition himself as if he were the curator. He followed the standard curatorial procedure of borrowing objects from elsewhere to illustrate a particular theme, having chosen the eagle as his subject. For the purpose of preparing what would be an exhaustive survey – as if it were the ultimate 'eagle throughout the ages' exhibition – Broodthaers secured the loan of 266 objects from a wide variety of museums and collections throughout Europe and America. The exhibited works dated from prehistoric to present times and encompassed a variety of media including paintings, sculptures, drawings, prints, and decorative arts.

A two-volume catalogue, conceived and designed by the artist, records the broad range of works pertaining to the eagle shown in the exhibition. The eagle appears, for example, as a fossil, a mythological creature or ideological symbol, a depiction in the story of Ganymede in a reproduction of Rubens's painting from the Prado Museum, Madrid, and on a coat of arms in a sixteenth-century tapestry from the Kunsthistorisches Museum, Vienna. The exhibited works belonged not only to different categories of the fine arts but also included representations of the eagle in non-art contexts – on cigar boxes or wine bottle labels, in comics, or on national emblems. In addition, a number of pieces from contemporary popular or commercial culture were lent from Broodthaers's private collection, the 'Sammlung Département des Aigles' (Collection of the Department of Eagles).

The image of the eagle unified the vast array of material hung on the walls of the museum or placed in

Marcel Broodthaers | **Pages from the catalogue for The Eagle from the Oligocene to the Present** | 1972

Marcel Broodthaers | **Un Jardin d'Hiver (A Winter Garden)** | 1974 (installation at The Art Institute of Chicago 1977)

glass vitrines. Objects of all kinds were treated as if they had the same aesthetic, historical, or functional importance, since Broodthaers did not submit them to any discernable system of ordering.[25] Although numbered and identified in the standard museological manner, the works in the catalogue are listed alphabetically – from Basel to Zurich – according to the city from which each was borrowed, not chronologically or by artist's name as is customary.

Most notably, each item in the eagle exhibition was labeled with its catalogue number and a qualifying statement that alleged in French, German and English: 'Ceci n'est pas un objet d'art' / 'Dies ist kein Kunstwerk' / 'This is not a work of art'. With this ubiquitous statement – taken from René Magritte's *La Trahison des Images* (The Betrayal of Images, 1929), famously representing the image of a pipe and the painted words 'Ceci n'est pas une Pipe' (This is not a pipe) – Broodthaers opened the assembled objects to question. If objects long acknowledged to be art were not art, then one had to ask what criteria had allocated them to museum sanctuaries in the first place and then to Broodthaers's fictional 'art museum.' One also had to wonder if the artist, by means of language, possessed the sole power to determine whether or not these were works of art. As explained in his catalogue, Broodthaers combined one aesthetic strategy from Magritte with another from Marcel Duchamp, when he raised a urinal to the status of sculpture by entering it into an art exhibition in 1917 as an object of his authorial choice.[26] Broodthaers further proposed that what had sustained Duchamp's move was not the artist's authorial prerogative alone, but the authority of the museum exhibition context.

Being an exhibition, not simply a work *in* an exhibition, 'Der Adler vom Oligozän bis heute' exemplified the way in which museums of art are able to subsume their contents into a seemingly unified ensemble. It demonstrated the way in which the museum is able to accord a deceptive wholeness to works and actual fragments from other periods and cultures that have been taken from their original historical and physical settings. By bringing together a cross-section of objects unrelated to each other except through the image of the eagle, Broodthaers relocated and reclassified works already relocated and reclassified within the respective museums or collections from which

he had borrowed them. Since the myriad examples of eagles did not add up to a single, cohesive statement about this bird, Broodthaers's work commented upon the amassing of objects as an activity engaged in for its own sake. It thus subordinated a broad range of objects to decontextualization and reassembly so as to 're-view' such processes. Finally, the work itself could not travel elsewhere nor be bought or sold – only 're-collected.'

By means of his explicitly fictional museum, Broodthaers revealed unspoken fictions empowering museums to give value to their contents. Just as he subjected the eagle – who 'is even scared of a bicycle'[27] – to scrutiny, bringing it down from its lofty emblematic position through a process of leveling, Broodthaers pointed to the mythic proportions that art can assume when divorced from the original conditions of its creation. The 'Section des Figures' represented an accumulation of objects in the possession of others, but ultimately defied its own recontextualization and commodification since *it* could not be disassociated from the institutional support to which it paid circumspect and guarded homage.

Broodthaers's work further called the museum into question insofar as it bestows monetary value on art by emphasizing qualities such as uniqueness, antiquity, originality, authenticity, or fragility. Attentive to the potential of art's fossilization – like that of the fossil eagle included in the 'Section des Figures' – and the threat of its 'failing social relevance,'[28] Broodthaers paired the fictions of his museum with art in its splendid isolation from society. He thereby labored to ensure the continued survival of art in a social system founded on merchandizing by pointing to the circumstances that tend to veil its commodity status.[29]

Broodthaers's Düsseldorf installation dealt with institutional context and aesthetic fiction by means of real objects in real space as did his *Un Jardin d'Hiver* (A Winter Garden, 1974), realized two years later. *Un Jardin d'Hiver* was originally conceived for a group exhibition in the winter of 1974 at the Palais des Beaux-Arts, Brussels, where it was allocated a room of its own (see ill. p. 2).[30] The winter garden installation, whose vegetation imported from tropical colonies is modeled on the palm court, which once graced many northern European bourgeois interiors. In addition to potted palms and folding garden chairs, the work comprises six framed black-and-white reproductions of nineteenth-

Marcel Broodthaers **Un Jardin d'Hiver (A Winter Garden, detail)** 1974

Camel entering the Palais des Beaux-Arts, Brussels 1974

century English engravings, a rolled-up red carpet, and video monitor and camera on a pedestal. Two old-fashioned, wooden table vitrines, placed along the side of one wall, contain the original, engraved colored bookplates from which the engravings on the wall were photographically copied and enlarged; the opened pages designed by the artist for his pages in the exhibition catalogue; and the printed invitation to the private view. The six bookplates represent mammals, birds, and insects appropriately grouped to illustrate, respectively, camels, elephants, falcons, peacocks, beetles, and bees. Taken from a book on natural history, the engravings portray the diversity of animal types belonging to separate species.

The theme of captivity reverberates throughout *Un Jardin d'Hiver* with the assembled objects running the gamut from living plants to reproductions of living creatures encased in vitrines and reproductions of reproductions secured in frames on the wall. The large-scale reproduced engravings on the wall allude to the

capturing of other lands in the process of colonization as well as referring to the capturing of an image. The red carpet rolled up in a corner is a reminder of the social pomp and circumstance in the days of colonial rule (and may have been a silent reference to Carl Andre's neighboring – and potentially encroaching – floor 'rug'),[31] while the video monitor, displaying the winter garden environment and viewers within its purview, grounded the work in its own reality as a composite of extant objects.

The bookplates in the vitrines and the framed black-and-white reproductions on the wall present reality at various removes from the actuality of life. Contributing to the decor of *Un Jardin d'Hiver*, the reproduced engravings, whose 'subjects' from the animal kingdom are imprisoned within their frames and confined to their designated classification, may be taken metaphorically to refer to imperialistic domination and acts of recontextualization.[32] If the images on the video monitor in *Un Jardin d'Hiver* simultaneously anchor the work within its own context and within the context of observed reality, the pages from the exhibition's catalogue on view in the vitrine are directed toward language and typography. The phrase 'The Art of Fine Printing,' printed in a series of different fonts, directly allies the work as a whole with the independent representational domain of language.

Language is called upon by Broodthaers throughout his work to mediate between reality and illusion in order to deliver art from the deception wrought by pictures. Whereas language in the art of Lawrence Weiner provides the material from which a work is fashioned, in the art of Broodthaers, language is not only a tool but also a theme of aesthetic investigation. Proceeding from the ideas of his compatriot and predecessor René Magritte, whose paintings substitute words or phrases for images or employ them in combative association, Broodthaers labored to extricate language from subordination to a painted image. In *Les Animaux de la Ferme* (Farm Animals, 1974), a lithograph that parodies the two parts of a well known educational poster devoted to cows, he replaced the captions under the different varieties of cows, pictured in rows, with names of cars, including 'Chevrolet,' 'Maserati,' 'Rolls Royce,' and 'Volkswagen.' Broodthaers thereby liberated pictorial and linguistic sign systems from dependence on one another, since images of cows and names of cars, even

Marcel Broodthaers **Les Animaux de la Ferme (Farm Animals)** 1974

when paired, are clearly understood to be separate. Whereas Magritte provocatively links unrelated words and images as a method of destabilizing painted renditions of factual reality, Broodthaers, for his part, emphatically severs connections between word and image.

Les Animaux de la Ferme wittily disrupts commonplace modes of conveying knowledge with the intent of actually illustrating the autonomy of language as an informational system that may operate within the framework of aesthetic production. Believing that 'the language of forms must be united with that of words,'[33] based on the idea that language serves as the essential unit of any true construction (and, by extension, in any re-forming of present reality), Broodthaers envisioned an art that might 'make a dent in the falsity inherent in culture.'[34] In utopian anticipation of a reality founded on language in lieu of pictorial illusion, he endeavored to retain the value of art as a poetic and social force that might resist its own possible demise at the hands of commerce.

Daniel Buren | **Photo/souvenir: Affichages sauvages (wild signboards)** | 1968

Intimately identified with processes of collecting and exhibiting art, works by Broodthaers concomitantly recognize the affiliation of the museum with marketing. The work of Daniel Buren also bears witness to the idea that exhibition spaces are by no means neutral or exempt from certain conditions. In Buren's work, the art institution is perceived in terms of specific sites or buildings that provide architectural and/or institutional points of reference, while in Broodthaers's the art institution is more generally understood as a cultural construct.

Buren's work is rooted in his early search for ways to strip painting of illusionistic and expressive reference, which culminated in 1965 with his decision to reduce the pictorial content of his canvases to the repetition of mechanically printed, alternating white-and-colored vertical bands 8.7 cm in width. Commercially obtained,

prefabricated material with vertical stripes is intended to be an anonymous, painted sign/design. This sign, which 'remains immutable,'[35] varying only with respect to its color, has been used by the artist throughout his career to provide the 'internal structure' of each work. The color of the stripe alternating with white is not necessarily chosen by Buren, inasmuch as color in his aesthetic scheme lacks associative or metaphoric meaning.

Since the end of 1967, Buren has worked *in situ.* Possibly the first artist to adopt this Latin phrase to describe pieces made with reference to a particular location or situation, he associates the term with the hundreds of works he has produced worldwide over more than three decades. The form and content of these works, most of which have been conceived for temporary exhibitions, are governed by how and where the artist

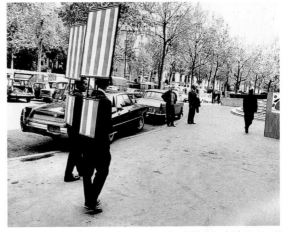

Daniel Buren | **Photo/souvenir: Affichages sauvages (wild signboards)** | 1968 Daniel Buren | **Photo/souvenir: Les Hommes Sandwiches (Sandwich Men)** | 1968

decides to place the striped material in relation to other materials. Having elected to direct his concerns away from the canvas field by means of his generic painted stripes, Buren integrates each work with its visible context and invisible institutional frame. Thus inseparable from the non-art reality into which it is inserted, a work by Buren more often than not circumvents the delegated exhibition space of the museum or gallery under whose auspices it is shown.

Two works of 1968 are seminal. The first was realized in March in the middle of the night, when Buren pasted single, rectangular sheets of green-and-white striped paper on approximately two hundred billboards and surfaces with signs throughout Paris and its environs. He placed the striped rectangles randomly over or beside existing texts, advertisements, or graffiti, thus juxtaposing stripes – his sign for painting – with signs

having nothing to do with art. In speaking of this work, Buren has emphasized that he accomplished it anonymously and without permission; that is, 'without invitation, and without commercial support and without a gallery.'[36] Unsigned by the artist and possessing only the 'backing' of the signboard, the two hundred 'paintings,' dispersed throughout the urban landscape, commingled with the everyday reality of street images and messages. Through the deliberate negation of traditional presentational methods, along with his authorial self-effacement, Buren brought together art and non-art representational systems.

The second work in April/May took issue, once again, with preconceived assumptions about the institution *of* art in relation to the institutions *for* it. For the first half of a two-part work in the invitational 'Salon de Mai' exhibition of 1968 at the Musée d'Art Moderne de la

Daniel Buren | **Photo/souvenir: Travail in situ (Exterior)** | 1969
(Wide White Space Gallery, Antwerp)

Ville de Paris, he adhered a fifty-four-foot long and fifteen-foot high, green-and-white striped paper rectangle to a wall in the exhibition space. Secondly, he hired two so-called 'sandwich men,' frequently seen in Paris in those years, to walk in the vicinity of the museum wearing their customary placards. In place of the usual publicity for shops, announcements of films, etc., the placards, front and back, of Buren's sandwich men were covered with the same green-and-white striped paper that appeared on the wall in the museum. Circulating through the streets, the striped placards referred to the work inside the exhibition while they denounced the divide between art and non-art frameworks of display.

The first solo exhibition by Buren took place in 1968 at the Apollinaire Gallery, Milan, where he glued green-and-white striped material to the outside of the gallery's door. This was not a work about empty space on the model of Robert Barry's *Closed Gallery Piece* (see p. 87), but was a work that literally closed the door to the exhibition area so as to metaphorically open it up for questioning. By covering the door with stripes, Buren substituted the door frame for a traditional frame and by using the door in place of a canvas, he furthered his nascent rebellion against traditional installation modes. As his many works throughout the next decade would demonstrate, this rebellion was to be accompanied by an ongoing debate between painting and the physical and intellectual premises of its presentation.

A work at the Wide White Space Gallery, Antwerp in 1969 linked together the interior exhibition space and the exterior of the building in which the gallery was located. In this instance, Buren applied striped paper, scaled to the show's invitational poster, to a flat plinth outside the building. The striped material extended from a hydrant at the side of the building to the doorway, and from the doorway into the gallery itself. Instead of hanging traditional paintings on the gallery walls, Buren gave shape to the work on the basis of architectural detailing and the extension of the stripes from the building's exterior to its interior. As Buren commented, 'the piece inside the gallery, thus dictated by the situation outside, uses only the space available as a result of the given architecture.'[37]

Included in the group exhibition '18 PARIS IV 70,' *140 stations du métro parisien* (1970) was not installed in an exhibition space but in the Paris Métro and was in

Daniel Buren **Photo/souvenir: Travail in situ (Interior)** 1969
(Wide White Space Gallery, Antwerp)

operation before the exhibition opened. To accomplish this work (redone in 1973 using orange and white stripes), Buren glued blue-and-white striped rectangles in the upper right-hand corner of all of the large billboards found in one hundred and forty stations of the underground transportation system. The striped rectangles took their place among the commercials and entertainment publicity occupying the billboards, each of which, fortuitously and ironically, was set apart from the underground station wall by a large ceramic tile frame. Thus placed within actual frames, *140 stations...* interposed painting with mass-media imagery and advertising. It could be seen, moreover, at many different intervals as a matter of course during routine travel throughout the city.

Like *140 stations...*, *Voile/Toile, Toile/Voile* (Sail/Canvas, Canvas/Sail, 1975) overcomes the dichotomy between non-art and exhibition contexts in that it both exposes and mends the gap between the two. A work in two phases, the first takes place on an expanse of water where, on an appointed day, a regatta of nine boats, rigged with striped sails of different colors, participate in a race. With 'paintings setting sail,'[38] canvas sails and painted canvases serve two normally separate functions at once. For the second part of the work, the sails are later mounted on the walls of a museum in the order of their boat's arrival at the finish

Daniel Buren | **Photo/souvenir: A partir de là (Starting from there)** | 1975

Daniel Buren | **Photo/souvenir: Voile/Toile, Toile/Voile, Part One** | 1975

Daniel Buren | **Photo/souvenir: Voile/Toile, Toile/Voile, (Sail/Canvas, Canvas/Sail) Part Two** | 1975

Daniel Buren | **Photo/souvenir: Up and Down, In and Out, Step by Step: A Sculpture** | 1977

line of the race. When installed on a wall, the sails – thus detached from their masts and bereft of their usefulness – function purely as large, decorative, shaped canvases.

Buren derives the content of each of his works by uncovering aspects of its surrounding context. Having set himself the task of wiping out illusion by applying vertical stripes to existing surfaces, he has been able to work within delegated exhibition spaces as well as outside them. *A partir de là* (Starting from there, 1975) was an exhibition that addressed conventions of exhibiting art. In preparation for this solo exhibition at the Städtisches Museum Mönchengladbach, Buren, with the director, Johannes Cladders, researched nearly ten years of the museum's history and learned that it had consistently followed the same approach to installing paintings. For the exhibition, he covered the walls of all of the rooms of the museum, formerly a private house, with vertically striped linen. On the first floor Buren used blue, on the second red, and on the staircase brown, as the alternating color. Rectangular voids formed by cut-outs from the striped linen represented the spaces where paintings, selected from a cross-section of the museum's numerous exhibitions, had at one time been hung on the wall in the very same place.

Buren's exhibition may be thought of as a retrospective survey of the Städtisches Museum's exhibition history as well as being a solo exhibition of one artist. Rhetorically asking, 'is the wall a background for the picture or is the picture a decoration for the wall?,' Buren has observed that 'in any case, the one does

not exist without the other.'[39] With its emphatically striped walls pierced by rectangular voids that represented absent paintings, *A partir de là* could not be cut out from the encompassing framework of the museum. Bringing all of the museum's walls into active service in the production of pictorial content, the work negated the neutrality of passive wall surfaces.

A work in the permanent collection of the Art Institute of Chicago, conceived for 'Europe in the Seventies: Aspects of Recent Art' held at the museum in 1977, demonstrates the complete coincidence of a work with its architectural and institutional setting. *Up and Down, In and Out, Step by Step: A Sculpture* (1977) utilizes the interior staircase (known as the Grand Staircase) that, leading from the museum's main entrance to the permanent collection on the second floor, provides access to galleries containing art from different centuries. When striped paper is cut and glued to the risers of its steps, the Art Institute's staircase becomes an object with a sculptural presence of its own. Comparable to the sails of *Voile/Toile…*, the steps similarly retain their functional purpose, or, as the Marxian term would have it, their 'use value.' Simultaneously a sculpture and a staircase, *Up and Down…* may be said to 'elevate' visitors en route to look at art in the museum's 'hallowed halls.'

In contrast to other works in the Art Institute's collection, *Up and Down…* is exempt from placement within rooms exclusively devoted to the permanent collection and interacts with the museum as an architectural and cultural whole. Fusing sculptural form

Daniel Buren | **Photo/souvenir: Watch the Doors Please** | 1980–82

with architectural function, it defines the museum's main stairway, in all of its grandeur, as the institution's symbolic pedestal and core. While other works are subject to classification and relocation, generally in isolation from their original historical or cultural conditions, *Up and Down...* cannot be considered apart from the architectural and institutional reality with which it coexists. Because it ceases to exist when the striped paper is removed, it can never be confined to storage. However, it may reappear at any time at the curatorial staff's discretion either with its green-and-white stripes or in another color.

In each new set of circumstances, Buren discovers aspects of a site or situation that he turns to the purposes of his art. *Watch the Doors Please* (on view October 1980–May 1982) had been proposed in 1976 for inclusion in the Art Institute of Chicago's exhibition in which *Up and Down...*, for logistical reasons, was shown instead. *Watch the Doors Please* took advantage of the fact that the Art Institute of Chicago extends over an active railroad line. A large window overlooks the tracks, which run beside and under the building. With permission from Chicago's Regional Transportation Authority, Buren adhered weatherproof vinyl printed with five differently colored stripes – white with red, blue, yellow, purple, and green – to the central double doors of the entire fleet of 165 commuter train cars that service the city's south side and suburbs. A schedule at the window informed visitors when to expect a two- or four-car train to pass by – the sequence of door colors having been determined randomly each day at the railroad yard.

Watch the Doors Please, a work in motion as well as *in situ*, reversed traditional modes of viewing art. Subject to the conditions of real time and place, it came to viewers, who had to wait for the work as well as for the train. Significantly, the expansive glass window functioned like a huge transparent canvas in that its black horizontal and vertical mullions resemble gigantic, over-lifesize stretcher bars. The passing trains with their striped doors – like emblematic paintings freed from stationary walls – were not an illusionistic image but an actuality. Replacing both picture frame and canvas, the window made possible the total fusion of observed reality and art.

When commuter trains pass under the Art Institute, commerce and culture visibly intersect. Because of the coincidence of railroad line, museum building, and window frame, Buren was able to capture everyday

reality within the physical and cultural frame of a prestigious art museum. Outside of the museum, the colored rectangular doors of the trains could be viewed at station platforms as they opened and closed, as transitory flecks of color flashing past trestles, houses, and shrubbery, or in relation to the Chicago skyline. Traveling back and forth between the institutional framework of art and the reality of the city outside the discourse of art, *Watch the Doors Please* operated on various levels: as painting and/or as decoration, and/or even simply as a safety feature alerting passengers to watch their step upon boarding the train. It was a work that totally fulfilled Buren's aspiration for an art that, dispensing with the traditional canvas, does not hide the context in which aesthetic practice is conducted.

A work realized at the University Art Museum, Berkeley, California for 'Andre, Buren, Irwin, Nordman: Space as Support' marked an important transition in Buren's career. Rather than single out one aspect or detail of an architectural whole, as he had done in the Art Institute's *Up and Down...*, Buren here dealt with the entirety of the museum's interior space. *Stalactic/Stalagmitic: A Drawing in situ and Three Dimensions* (1979) confronted the complexity of the museum's architectural space in which domineering, multi-level planes of concrete, projecting into the interior, intersect one above another at emphatic angles. The exhibition areas of the museum, located on six different levels, are connected by ramps whose railings form low, concrete parapets that continue from the inside to the outside of the building. Buren adhered perpendicularly cut blue-and-white striped paper to the tops of all of the museum's interior and exterior parapet walls. He also glued paper – cut parallel with its printed stripes and defined by the width of the wall section – from the top to the bottom of all wall surfaces. By means of these ribbon-like bands, he demarcated the juncture of the walls' many intersecting axes. The vertically cut stripes broke up the severity of the harsh, concrete space, while the repetition of the stripes as rectangles along the tops of all the parapets analyzed the nature of the fractured space diagrammatically, tying it together visually. The vertical stripes also connected the indoor space of the museum with the outdoor space.

All in all, the Berkeley installation transformed the architectural barriers of the museum into unifying, rather than divisive, structures in that Buren interpreted

the wall partition as an independent element of the work, not as a neutral element of an enclosure. This installation anticipated works by Buren of the early 1980s in which the walls of a given exhibition space, constructed out of vertically striped canvas, were to become material entities in their own right rather than mere backdrops. In ensuing works, painting was set on a par with architecture and vice versa.

Buren has articulated the theoretical basis of his work in an extensive body of writings. In 'Function of the Museum,' he pertinently wrote: 'The Museum is an asylum. The work set in it is sheltered from the weather and all sorts of dangers, and most of all protected from any kind of questioning.'[40] He further stated that a work, which 'does not explicitly examine the influence of the framework upon itself, falls into the illusion of self-sufficiency – or idealism.'[41]

Sharing affinities with the oeuvre of Buren, Michael Asher's protean production rests on his analysis of the contextual conditions affecting an exhibition site. Whereas Buren's aesthetic endeavor principally pertains to the redefinition of painting, Asher's pertains to sculpture. Just as Buren has succeeded in the task of avoiding illusionistic forms of representation through the agency of architecture and other functional structures, Asher has sought to reveal facets of reality without creating a previously non-existent material object.

Asher's participation in two major exhibitions in New York in 1969, 'Anti-illusion: Procedures/Materials' at the Whitney Museum and 'Spaces' at the Museum of Modern Art, presage works that survey and portray their support systems. In both these works, Asher created perceptual conditions rather than perceivable objects. At the Whitney, an invisible current of air, barely detectable to the touch, was produced by an air blower concealed in the ceiling above a passageway between two of the exhibition areas. Fully satisfying the theme of the exhibition by virtue of its materiality, the work – made of the all-pervasive, ubiquitous substance pertaining to existence – in no way visibly altered its surroundings.

For the 'Spaces' exhibition, Asher constructed an enterable room whose walls absorbed sound in proportion to a visitor's distance from the two openings for entry/exit located diagonally opposite from each other. As visitors moved away from/toward the openings, ambient sounds from the street and the

museum progressively diminished/increased as did the level of light coming through the doorways. In the corners of the room, sound was completely muffled and the level of incoming light was at its lowest. By linking the interior of the room with the sounds and light issuing from outside its confines, Asher expressed the idea that the work was not self-contained, but was connected acoustically and visually with the museum.

Two slightly later works, one for the Toselli Gallery, Milan in 1973, the other for the Claire Copley Gallery, Los Angeles in 1974, furthered the artist's effort to feature contextual aspects of the exhibition space within the content of the work. For realization of the Toselli work, Asher requested that the paint covering the walls and ceiling of the gallery be removed. Four days of sandblasting yielded a rich brown surface that united walls and ceiling with the raw surface of the concrete floor. By taking away the white surface of the encompassing exhibition walls, Asher, effectively, put the entirety of the exhibition space on view. As he noted, 'the withdrawal of the white paint, in this case, became the objectification of the work'[42] in that the work's content and its container were the same.

For the Claire Copley Gallery exhibition, Asher followed a similar procedure of objectification by means of subtraction when he dismantled the internal, free-standing partition of the gallery separating the exhibition space from its office area where the owner's desk was placed and where works for sale were stored. In lieu of importing an object into the exhibition space, he brought the inner workings of the gallery into full view. In this way, he laid bare the economic and commercial underpinnings of the exhibition while orienting the gallery, via its picture window, with the reality of street life outside. 'Just as the work served as a model of how the gallery operated,' Asher pointed out, 'it also served as a model for its own economic reproduction,'[43] without defining itself as a commodity.

Subsequent works by Asher similarly have derived their content from a probing of the contextual factors of their display. His solo exhibition at the Stedelijk Van Abbemuseum, Eindhoven in 1977 took place in one half of the museum, which, built on a symmetrical plan, comprises ten separate viewing areas arranged around a central core. The work availed itself of the building's architecture insofar as Asher utilized the rectangular glass light-diffuser panels in the dropped ceiling above the museum's galleries. To accomplish the exhibition, Asher instructed a crew of workmen hired by the museum to remove these panels and then, having stacked them in an attic under the roof, to gradually clean and return them to their proper location in the ceiling. The closing date of the exhibition was not set in advance, but was determined by the time required to reposition all of the panels. While Asher's exhibition was in progress, no other works were installed in his half of the museum, but selections from the museum's permanent collection, by way of contrast, were installed in the other half.

Rather than occupying space with pre-existing objects of the artist's own making, Asher's Eindhoven exhibition took time and yielded a 'finished,' though non-material, work. If the Toselli Gallery exhibition put the work's physical container on view and the Copley Gallery exhibition made manifest the marketing of art, the Van Abbemuseum work exhibited its mounting and dismantling. The team, who worked every weekday morning, maneuvered the panels from above rather than in front of the public in a staged or performative manner. The removal of the light-diffusers revealed the intricacies of the building's structure directly under the roof. As the panels were gradually replaced, lighting conditions in the affected gallery spaces changed. Asher thereby framed his exhibition temporally according to necessity and spatially according to the given architecture and, in a further non-traditional move, substituted hired labor for his own aesthetic handiwork.

Also in 1977, Asher participated in the group exhibition 'Skulptur,' organized by the Westfälisches Landesmuseum für Kunst und Kulturgeschichte, Münster. Unlike the Van Abbemuseum work, which dealt with the nature of the museum exhibition from within its galleries, the work for Münster revolved around the production of an outdoor sculpture in affiliation with its site, which Asher defined as the entire urban and suburban context of the Landesmuseum. He rented an eleven-foot, white trailer as the vehicle for engendering the work. During the exhibition's nineteen-week period, the trailer was parked at nineteen different locations. Thus stationed for one week at a time in a succession of locations around Münster, it moved away from the museum during the first half of the exhibition period and back toward it during the second half. The trailer was thus absorbed into a variety of environments. A seemingly self-contained but symbiotic unit meant to

be hooked to a motor vehicle, it metaphorically latched on to its context. Connected as well to the museum under whose auspices it was conceived, the Münster work was not based in any one place but accommodated itself within the town and its environs by virtue of the trailer's continual repositioning.

The reconstruction of this work for 'Skulptur Projekte in 1987 Münster,' organized a decade later (and again two decades later in 1997) under the same auspices, in the same location – and using a trailer of the same model, make, and year as before – reiterated its original meaning. Unlike the majority of works by others, Asher's neither clung to areas near the museum nor claimed territory, near or far, for itself. Without cutting itself off from its institutional auspices, it encompassed disparate areas and neighborhoods of the city and escaped material confinement to one time and place.

In the summer of 1979, two related works by Asher were exhibited by coincidence in the same city: at the Art Institute of Chicago and at Chicago's Museum of Contemporary Art. Each furthered the artist's investigation into relationships between sculpture and architecture and between art and its institutional support. The work for the Museum of Contemporary Art responded to the museum's newly renovated premises and decision to form a permanent collection. The building, once a bakery and later housing offices for *Playboy* magazine, was converted to a museum in 1966. The architects at that time transformed the front of the museum by applying stucco to its brick facade. The architects subsequently involved with the remodeling in 1979 connected the existing building to a newly acquired adjoining three-story brownstone by adding a trussed causeway to provide exhibition space on the floor above street level. The design for the renovated building was based on a five-and-one-half-foot square module. An overlay of brushed stainless-steel panels covered over the former, more modest stuccoed facade with a decorative grid pattern based on this module. The panels, wrapping part-way around the facade, turned the corner of the building to stop short of the underlying concrete structure.

The Museum of Contemporary Art's work attended to the second-story, trussed causeway of the renovated building. Referred to as the Bergman Gallery in honor of donors, the causeway 'function[ed] as a showcase so that art [was] visible from the street.'[++] The two rows of

Michael Asher **Skulptur, Westfälisches Landesmuseum für Kunst und Kulturgeschichte, Münster, Germany, July 3–November 13, 1977 (detail)** 1977

Michael Asher | **Museum of Contemporary Art, Chicago, June 8–August 12 1979 (exterior)** | 1979

Michael Asher | **Museum of Contemporary Art, Chicago, June 8–August 12 1979 (interior)** | 1979

glass windows of this showcase carried through the square module of the decorative grid pattern and lined up with the two rows of stainless steel panels on either side. In advance of the building's construction, Asher arranged for the two rows of exterior panels that flanked the showcase windows to be unhinged from the facade and rehung indoors on the Bergman Gallery wall. As he pointed out, 'the ten panels from the east side of the building and the eight from the west [were] arranged inside so that they correspond[ed] exactly to their previous positions outside.'[45] This still left sufficient space to show the work of another artist in between the aluminum panels that had been 'lifted' from the facade.

Architectural decoration and the elements of sculptural form were defined in this work as interchangeable components beholden to contextual function. When on view, the rectangular units of metal cladding hanging on the wall of the Bergman Gallery took the form of abstract, metallic reliefs whose serial components and sleek industrial surface evoked qualities of Minimal sculpture. When the metal panels were not hanging in the Bergman Gallery, having been replaced on the facade, the work, as the artist put it, was 'stored in full public view.'[46] An inseparable part of the building, it vanished into its architectural container pending later re-installations.

The work for the Art Institute of Chicago represented Asher's participation with fifteen other artists in the '73rd American Exhibition,' a biennial that allowed the museum to present selections of current art at regular intervals. Instead of being placed on view in the gallery assigned for the exhibition, Asher's work took cognizance of the museum as an architectural and institutional entity. In this instance, he repositioned a lifesized, patinated bronze statue of George Washington – which had stood at the main entrance of the museum for over half a century – within the permanent collection galleries of the museum. The sculpture is a twentieth-century cast of the original marble statue of 1788 by French sculptor Jean-Antoine Houdon (1741–1828) in the rotunda of Virginia's state capitol. The bronze had previously served, on the one hand, as a commemorative monument to the first president of the United States dressed as leader of the American Revolutionary War, and, on the other, as a decorative object firmly ensconced on its stone pedestal in front of the central

Jean-Antoine Houdon **George Washington** 1788/1917

Michael Asher **73rd American Exhibition, Art Institute of Chicago** Jun.9–Aug.5 1979

arch of the Art Institute's neo-Renaissance facade.

To realize this work, Asher had the sculpture of Washington removed from its base and reinstalled in the center of Gallery 219, which at that time was devoted to eighteenth-century European painting, sculpture, and decorative arts. Relatively small and nearly square, the room was painted a greyish blue-green. In an attempt to

evoke a period setting, the museum's director, following his own fancy, had placed objects along the walls of the gallery in a symmetrical fashion and hung paintings to the ceiling.

In a short text for guiding visitors from the exhibition on the first floor to Gallery 219 on the second, Asher stated: 'In this work I am interested in the way the sculpture [of George Washington] functions when it is viewed in its 18th-century context instead of in its prior relationship to the facade of the building … Once inside Gallery 219 the sculpture can be seen in connection with the ideas of other European works of the same period.' The removal of Houdon's *George Washington* from its centralized position in front of the building's facade and placement in the center of Gallery 219 altered the statue's meaning. Divested of its imposing, outdoor monumental and decorative function in front of the museum, it subtly and humorously sounded a discordant note within the gallery. The mediocre quality and late date of the cast, along with its weathered green surface (coincidently, nearly blending in with the blue/green color of the gallery walls), highlighted the disparity between the sculpture and the works surrounding it despite its historical and stylistic credentials.

Standing assuredly in the middle of the gallery, the statue of Washington served as a reminder of the selection, categorization, and contemporary repositioning that affect the way in which the past is recreated in accordance with a museum's holdings. For the construction of this work, Asher followed standard museum procedures for installing works that have been extracted from the conditions of their original conception and arranged in chronological sequence and/or geographical groupings. As a result, he created a work that, much like Broodthaers's *Un Jardin d'Hiver* or Buren's *Up and Down…*, could not be subjected to dislocation or relocation. By imitating museum procedures, Asher drew attention to them and wove them into the fabric of his work.

Whereas the '73rd American Exhibition' furnished the institutional framework for Asher's work, Gallery 219 containing the sculpture of George Washington defined the work visually. The artist explained in the written handout: '[In the process of] locating the sculpture within its own time frame in Gallery 219, I am placing it within the framework of a contemporary

exhibition, through my participation in that exhibition.' Notably, though anchored in the past, Asher's work did not quote from it and knowingly avoided the pitfalls of postmodern pastiche.

The Art Institute work epitomized the erasure of the traditional division between a material object and its physical setting. Since Gallery 219 never ceased to serve the purpose of displaying eighteenth-century objects of art, the space of the work and the space of the gallery were the same. By extension, the paintings on the walls, necessarily retaining their status as art, also became elements of existing reality because of their incorporation into another work of art. The work thus inverted traditional perspective in that the eighteenth-century paintings on the walls became reality-in-the-context-of-art as opposed to art-in-the-context-of-reality. At the same time, the statue of Washington, deprived of its former, independent status as a monument, served simultaneously as the catalyst for another work of art and as a point of reference for, or reminder of, the traditional autonomous object that remains oblivious to its site and situation.

In parallel manner to the work for the Museum of Contemporary Art, the work for the '73rd American Exhibition' expressed the unspoken role played by institutional context in organizing modes of perception. Along with Broodthaers and Buren, Asher is responsible for developing aesthetic strategies sometimes referred to in critical terminology as 'institutional critique.' Not only do works involving such a critique divulge the contextual conditions of art's display but, even more profoundly, deliver themselves from the previously imposed rules and regulations of production and presentation.

Works by Lothar Baumgarten, attendant to their location as are those by Buren and Asher, point beyond their immediate architectural and temporal frame. In the late 1960s, before completing his studies at the Kunstakademie in Düsseldorf, Baumgarten had begun to reappraise the means and ends of two- and three-dimensional representation. By the middle of the next decade, this reappraisal had led to works that, by means of language, expanded the meaning of a given site.

Baumgarten's early works investigate methods for encompassing other times, places, societies, or cultures

within a representational whole without resorting to imitative replication or static materiality. The Pyramids (1968–69), reflecting the artist's discontent with the commercialism he experienced at the Cologne Art Fair in 1967, privilege the ephemeral over the eternal and the perishable over the portable. Variously colored (blue, red, yellow, or white) and under one foot high, the Pyramids, which consist of finely powdered pigment, make the process of time visible. The first of this group of sculptures, *Tetrahedron (Pyramid)* (1968), was cobalt blue and was installed on a concrete floor. *Pigment geschichtet* (Stacked Pigment, 1968) in red, was displayed on the ground cover of a forest. After a number of weeks, these geometric shapes made of pure pigment fall apart of their own accord. If touched, they disintegrate into a pile of dust. The Pyramids are materially non-lasting and cannot be repositioned without being reconstructed.

At the time Baumgarten was constructing the Pyramids, he was also devising strategies by which to counter the notion of the timeless art object. His use of found objects, photography, and linguistic nomenclature made it possible for him to bring alternate realities into existence under the banner of representation. *Mosquitos* (1969), for example, was created from pigeon feathers inserted into small loaves of bread. Bread and feathers, looking like buzzing insects, transcend their respective identifying characteristics to form a new whole and transform the character of a room by their presence.

During the late 1960s and early 1970s, Baumgarten created many other sculptures that answer to his term 'manipulated reality.' Because of the infeasibility of preserving them, he documented them photographically to freeze them in time. Works in this vein, which now exist only as photographs, juxtapose the artificial or manmade with the natural to create images that, (con)fusing the two, proffer another reality. In *Augapfel* (Eyeball, 1968), the blue ping pong ball poised at the center of a leafy aquatic plant floating in a pond is about the fragility of the eye ball and the intangibility of the site of vision. In *Antizipierte Gürteltiere* (Anticipated Armadillos, 1969), a section of the profile of a rubber tire looks like a scaly animal creeping through the wooded undergrowth. In *Verlorene Früchte* (Lost Fruits, 1969), red shoe trees appear to have sprouted from the ground amidst growing lily leaves and grasses. In *Der Jaguar kann niemals seine Flecke verlieren* (The Jaguar Can Never

Lothar Baumgarten | **Tetrahedron (Pyramid)** | 1968

Lothar Baumgarten | **Augapfel (Eyeball)** | 1968

Lothar Baumgarten | **Feather People (The Americas)** | 1968

Lose its Spots, 1970), a solitary music stand in a swampy forest supports a close-up black-and-white photograph of spotted fur, which, positioned like a musical score, plays upon representation's capacity to invert fact and fiction within its own parameters. Appropriately, the title is based on a Brazilian saying that correlates with 'you are what you are.'

These works capture what the artist refers to as the 'psyche of things,' which resides in complex, unspoken understandings that produce a kind of 'silent enigma' arising from processes of perceptual association. Elaborating on his early works, in which objects in lieu of linguistic elements are connotatively employed, Baumgarten has suggested:

The ephemeral sculptures and the concept of their specific model characteristics became a draft for a grammar, creating an interaction between language

and form. They belong to a cultural critique that is rooted in their time-limited nature and in the silent manipulation of found circumstances and things. They were mostly realized outdoors in parks, on the outskirts of the city, or in the anonymous context of the street. Things left behind in the no-man's land of present-day culture create an anthropology of place without incumbent metaphor.[47]

Linguistic elements in the form of place names found on maps and the names of indigenous groups once freely inhabiting the pre-industrial world of the Americas had entered Baumgarten's aesthetic vocabulary by 1968. North and South American tribal societies are remembered in *Feather People (The Americas)* (1968) by means of feathers, maps, and nomenclature. The feathers are glued to a map of the two American continents,

which are printed side by side on a page torn from an atlas. Names of previously reigning populations, such as the Cayapo or the Cheyenne Navaho, have been either hand-painted or rubber stamped by the artist on the feathers. The adhesion of labeled feathers to printed place names on a map anticipates the cohesion of sign and site in later works wherein architecture would replace cartography as a presentational ground and structure.

A twelve-and-a-half minute projection of eighty-one slides – entitled *Eine Reise oder 'mit der MS Remscheid auf dem Amazonas': oder der Bericht einer Reise unter den Sternen des Kühlschranks* (A Voyage or 'With the MS Remscheid on the Amazon': or the Account of a Voyage under the Stars of the Refrigerator, 1968–71) – is a multi-layered meditation on travel through the channels of the imagination via photographic and linguistic representation. The projection draws upon three ethnographic accounts of South America published in the early twentieth century: *Die Sammlung Boggiani: Indianertypen aus dem Centralen Südamerika* (The Boggiani Collection: Types of Indians of Central South America, 1904) by the Italian artist Guido Boggiani; the German anthropologist Theodor Koch-Grünberg's *Zwei Jahre Unter den Indianern: Reise in Nordwest-Brasilien* (Two Years among the Indians: Travels in Northwest Brazil, 1903–5) and his five-volume *Vom Roroima zum Orinoco: Ergebnisse einer Reise in Nord-Brasilien und Venezuela in den Jahren 1911–1913* (From Mount Roroima to the Orinico: Results of a Journey in North Brazil and Venezuela in the Years 1911–1913). Photographs taken by Baumgarten of his ephemeral pieces and the lower Rhine landscape are interspersed with texts and images from these early ethnographic sources. The title of the work refers, first of all, to the freighter that took goods back and forth between Germany and Brazil and, secondly, to works by the artist realized inside of his refrigerator. *Fauna-Flora* (1969) is just one of several installations incorporating butterflies that took wing from cocoons. Stored in the icy, crystalline environment of the refrigerator – which, in this instance, contained a package of margarine with the brand name of 'Flora' – they came to life when the fridge door was opened to let in warm air, 'flying into the room like a battery of airplanes leaving their parked positions.' The image of tropical and exotically colored butterflies put on ice and then set free fits in with the artist's involvement more

Lothar Baumgarten **Fauna-Flora** 1969

generally with capturing and preserving that which is transient or vulnerable.

Eine Reise… covers a vast amount of territory – from the artist's home and studio to distant lands inhabited by foreign, nomadic peoples with non-Western lifestyles and customs. The use of found objects and the introduction of unexpected, fragile materials, moreover, mirrors the ephemeral characteristics of nomadic lifestyles. Rather than being asked to stand in front of a stationary object or image, viewers are taken by way of language and photography to times and places characterized by other mindsets. Overall, *Die Reise…* looks ahead to Baumgarten's method of bringing elements of locution to bear on aspects of a work's location.

Ensuing works of the early 1970s likewise call to mind earlier, non-European cultures from within their representational and thematic boundaries. A retouched

Lothar Baumgarten | **The Origin of Table Manners** | 1971

silver print, *Amazonas-Kosmos* (Amazon-Cosmos, 1969–70), delivers its pictorial message by means of language. The names given to some two dozen South American indigenous societies are printed on the surface of an image appearing to be a tropical forest landscape. By photographing a form of European broccoli at short range, Baumgarten created the semblance of a dense jungle environment. Names such as Tapirape, Xikrin, Urubu, Bororo, Tupamaro, or Tupi, superimposed on the image of jungle vegetation, linguistically make reference to peoples whose cultures, based in nature, have been altered by Western values and practices. The name Tupamaro refers not to a society but to a left-wing guerilla group of the 1960s in Peru.

When Baumgarten laid a single, large, red, wing feather from a macaw in an opened panel of parquet floor for the realization of *Kultur-Natur: Parkett I* (1971), he pointed to the 'unnatural' separation between nature and culture fostered by Western society. In *Kultur-Natur: Parkett II* (1971), the bright red feather, alluding to 'the

invisible, animistic cosmos of non-writing cultures,' lies hidden beneath unopened floor boards. Like the isolated word in a text, the feather garners meaning by virtue of its placement within a structured framework. Belonging to the plumage of a large parrot and not to the parquetry of an apartment, it seeks to ensure a permanent presence for non-Western thinking given its near demise. Because of the feather's vibrancy, it serves on a purely aesthetic level to rule out handmade or painted artifice as a requirement of visual representation while it also signifies the transformation of trees into parquetry patterns. Anticipatory of Baumgarten's later oeuvre, *Kultur-Natur: Parkett I* and *II*, in sum, create a dialectic between imported symbol and existing architecture.

Feathers used by Baumgarten in *The Origin of Table Manners* (1971), whose title is taken from the well known anthropological text by Claude Lévi-Strauss, played a signifying role within an unorthodox contextual situation during his 1973 exhibition at the Sperone Gallery, Rome. A limited edition packaged in a box, the

multiple consists of a table setting with dinner plate, soup bowl, and napkin as well as two arara feathers and two porcupine quills instead of silverware. The Sperone exhibition was held in a restaurant where the artist laid a table for four with the plates, feathers, and quills. Within the 'setting' of the Roman restaurant, the feathers and quills were 'out of place,' but within the site-specific context of art, they made a place for themselves.

Contained within a box lined with lizard-skin bookbinding paper, fifty eagle feathers comprise *Section 125-25 64-68: Hommage à M.B.* (1972–74), a collaboration between Baumgarten and the anthropologist Michael Oppitz. Except for one feather, left blank as a catch-all for any group not specifically mentioned, each has been painted in freehand with the name of a North American native society such as Arapaho, Blackfoot, or Delaware. Information and bibliographical material pertaining to the numerous uses of feathers by indigenous peoples is also provided along with five assorted texts by the artist and other authors related to the subject of the eagle and five anthropological photographs. The numbers in the work's title refer to the geographical co-ordinates for a large area of the North American continent including parts of Canada and the United States.

Section 125-25 64-68: Hommage à M.B. metaphorically plucks the feathers from the eagle in order to scrutinize its many pre-industrial appearances. As free-floating signs, the labelled feathers (which Baumgarten had begun to collect many years before) allude to the numerous dispossessed populations of North America. When unpacked for exhibition purposes, they may be laid out in a vitrine in a geographical ordering or pinned to a wall in a configuration suggesting the shape of the continent. The auxiliary information about the eagle, left in the box, remains in full view for consultation. A transportable work that travels from one site to another, it refers not only to the emblematic eagle of Broodthaers's Düsseldorf exhibition but also to the cultures, eclipsed by modernity, where the eagle had relevance to everyday life.[48]

Tropenhaus (1974) represented Baumgarten's participation in the exhibition 'Kunst bleibt Kunst' at the Cologne Kunsthalle in 1974 and was realized within the context of an architectural site – in this case, in the large glass conservatory on the grounds of Cologne's botanical garden. Occurring within a greenhouse where

Lothar Baumgarten **Tropenhaus (detail)** 1974

tropical trees and vegetation were on public view, Baumgarten's work supplemented the conservatory's perfunctory labeling system with some five hundred citations, all of which were related to the regions where the plants originated. He used green plastic labels identical in size and typeface to those already in use, which were hand-lettered by one of the botanists on staff, but greatly expanded upon the existing didactic information, which had merely supplied the Latin name of each plant.[49]

Baumgarten's extensively researched texts varied in length from a word to a paragraph. Larger, one-word labels presented the names of Brazilian native peoples such as the Caduveo, Xamacoco, Bororo, Yanomami, Nambiquara, Shipibo, Parintintin, Waura, or Tirijo on the one hand and, on the other, the names of explorers, chroniclers, conquistadors, geographers, ethnographers, merchant travelers, etc. who, over the last five centuries,

have left their mark on the body of knowledge concerning the tropics. These included names such as Humboldt, Nimuendajú, J. de Léry, F. de Orellana, L. de Aguirre, Sir W. Raleigh, A. de Berrio, and H. Staden. Small labels provided the names of principal South American rivers – the Tapajoz, Rio Negro, Orinoco, Amazonas, Xingu, Uaupés, Tocantins, and others. Taken as a whole, Baumgarten's texts opened up new horizons against which to consider the transplanted tropical specimens. Animal names like 'ant-eater' or 'tapir,' phrases like 'in between times' or 'land of the mute dogs,' observations like 'occasionally the intoxicating smell of invisible blossoms fills the air' or 'the world's tropical rainforests are the most impressive sites of biological diversity,' filled the greenhouse with a mind-expanding amalgamation of quotes and excerpts from a broad selection of writings and from the myths and stories handed down by societies without written language. Dispersing the labels throughout the tropical greenery, Baumgarten staked some of them in the ground among the pre-existing botanical labels, and strung others between plants. Still more were suspended from branches, lodged in the forks of trees, or attached to tree trunks. Without disrupting the greenhouse display and nearly camouflaged within it, *Tropenhaus* freed the plants from exclusive classification in the dead, European language of Latin. Baumgarten's labels animated the artificial hothouse atmosphere, where 'an entire cosmos only exists when the heat is turned on and an artificial rain falls twice a day'[50] through the unobtrusive yet ubiquitous presence of informational and associative language. Proper names, adjectives, and descriptive passages interpenetrated the vegetation and connected the transplanted tropical growth with its former climatic, historical, cultural, and/or socio-economic conditions. By means of language, *Tropenhaus* imported otherwise unapprehended aspects of a larger geographical totality into an architectural framework that had previously 'excluded the voices of the rainforest through the silent presence of an imposed scientific order' based on Western systems of thought and nomenclature. The work, in this way, established alternative points of reference and evoked past or perishing landscapes and cultures.

The art of John Knight rests, as does that of Baumgarten, on the interplay between its representational, formal, and contextual components.

Relying primarily on language and numbers during the first half of the 1970s, Knight had, by the second half of the decade, expanded his representational vocabulary to include other visual sign systems. Conflating art and non-art representation, works by Knight are usually site-specific. In certain instances, they are able to move from one site to another but, despite their peripatetic nature, they bespeak their contextual condition.

The task Knight initially set for himself was to question the formal self-sufficiency of Minimal sculpture. The Levels (1969), a series he first executed on the floor of his studio, consist of carpenters' levels configured in circles, squares, or lines. Simultaneously geometrical forms and functional tools – both of representation and construction – they comment upon their topological placement. As opposed to Minimal structures, to which their primary configurations refer, they deliver information pertaining to both their site and their positioning.

Upon completion of undergraduate studies at California State College, Los Angeles, Knight presented works at the school's Fine Arts Gallery in two installments, in December 1969 and in January 1970. Prescient for the period when other artists, with very few exceptions, were using video simply to record and play back, these works employed closed-circuit video to represent present time. In the first work, a video monitor in a corner of the gallery displayed the room's adjacent corner on its screen. In the second, Knight placed the monitor in the center of the gallery and the camera – with its large tripod and connecting wires – in a home economics classroom located down the hall. Visitors to the gallery were thus made privy to the activities of a space located outside the exhibition area. Knight's first experiments in 1969 with closed-circuit video had entailed pointing the camera out of a window to capture an image of the busy street and parking lot on a monitor screen inside his studio.[51] Ensuing works employing closed-circuit video – which the artist did not title, but referred to as Displacements and Replacements – considered a variety of ideas for images that might be conveyed from a non-art to an art context. For example, Knight's proposal to the La Jolla Museum of Contemporary Art in 1970 was to display the daily activities transpiring in one of its staff offices on a monitor in the exhibition space. The video installations, unlike the Levels, embraced their architectural and

institutional setting while insinuating themselves into spaces beyond those relegated to showing art. Because of high rental fees for the equipment at a time when video was still in its unwieldy infancy and the reluctance of institutions to pay for work of this kind, Knight abandoned the use of video after 1973.

In the years following, Knight developed other methods by which to combine representational form and contextual fact. *One Inch to a Foot* (1971), first exhibited in 1973 at the Riko Mizuno Gallery, Los Angeles, integrates the verbal and graphic elements of the title's statement with the overall exhibition space. The words 'one inch to a foot,' with obvious reference to scale notations on architectural plans, are etched in one-inch high, Helvetica letters on the glass plate of a floor-mounted, standard overhead projector. The statement illuminates the wall onto which it is projected in one-foot high letters near its baseboard. In this work, Knight fuses language, light, and architecture with words used to articulate the work's spatial confines. The meaning of the phrase 'one inch to a foot' and the measured size of the letters etched on the glass projector plate and projected onto the wall serve in both a representational and fact-bearing capacity. The letters themselves function as elegantly designed forms set within the framing architecture. As in the case of the Levels and the video pieces, *One Inch to a Foot* may be moved from one exhibition space to another. Nevertheless, it is always joined in sign-like fashion with its place of presentation by virtue of Knight's compression of meaning and graphics into a single signifying function.

A slightly later work, *I Assumed...* (1972), was conceived in response to an invitation from an early, relatively short-lived alternative space, Project Inc., in Cambridge, Massachusetts. Unable to visit the gallery, Knight imagined approximately fifty features that it might have. He printed his conjectures as statements of possible fact on separate index cards, using phrases such as: 'The space to appear new but be quite old'; 'The space to be on the third floor'; 'Three of the walls to be constructed of mortar and brick', etc. and exhibited them in a reddish brown, expandable file folder. Taking the exhibition site – here treated both specifically and generically – into full account in the construction of the work, Knight characterized it by means of language with respect to its probable and particular attributes.

A work for the Otis Art Institute Gallery, Los Angeles in 1977 took the form of a publication of all the names preceding his own that were on the gallery's membership mailing list.[52] In his publication, Knight maintained the institution's organization of its lists according to different membership levels, from major donors at the beginning to artists at the end. Without specifying membership categories and presenting nine names per page, the book begins with 'Mr. & Mrs. Robert Ahmanson' from the donors' section and ends with 'John Knight' in the artists' section a little over a hundred pages later. Of special note, Knight not only published the mailing list up through his name (which provided an ironic as well as a practical and authorial cut-off point), but he also allotted equal segments of time to each of the listed members. A nine or ten-minute period, carved out from the time span defined by the exhibition's opening in September until 4 October at 11:07 a.m. (when the list ended), was assigned each to a different member. Under each member's name, date and time are given on three following lines. Thus, the book commences as follows:

Mr. and Mrs. Robt. Ahmanson
September 14
Wednesday
6:00 p.m.
Mrs. Lemuel E. Bancroft
September 14
Wednesday
6:09 p.m.
Mr. and Mrs. Robert Barley
September 14
Wednesday
6:19 p.m.

Leaving the gallery's display space empty of his work (but open for use by another exhibiting artist), Knight placed several copies of the book in the vestibule vitrine and stacked the rest on the front desk for consultation or purchase. Reading somewhat like a concrete poem in a manner similar to On Kawara's *I Met*, the Otis publication, long after its display, maintains its reference to a specific site. Still recognizable names of Hollywood celebrities and art patrons are interspersed with the names of unknown persons who, as paying members, contributed to the gallery's program. All those listed may be considered 'pillars' of the community responsible

for Otis's support. By reproducing the gallery's mailing lists without alteration or correction of its duplications and misspellings, Knight made visible the support groups of the Institute's gallery and leveled its hierarchical social structuring by temporal and typographic means. Moreover, those who, as art collectors, might have been listed in a catalogue as lenders to an exhibition, in this case owned only slots of time, thus becoming part of an exhibition that was defined with regard to duration rather than materially or spatially.

The (unrealized) first concept for the Otis work, proposed by Knight in 1976, specified that the gallery's mailing list would have been printed to scale in three-column segments on the framed advertising placards attached to the sides of Wilshire Boulevard buses. Furthermore, the bus schedule for the Wilshire line would have been displayed in the Institute's outdoor window vitrine along with announcements of upcoming events, thus creating a meeting ground for art and non-art notifications alike. Comparable to works by Buren that likewise have used urban transportation systems to extend a work's reach beyond the physical parameters of the art institution, Knight's initial proposal for the Otis work recontextualized a body of existing information within an otherwise incongruous, non-art format.

The site for *Untitled ('The Don and Maureen Campbell diagram to be applied in any metaphoric manner they wish')* (1977) is a tripartite, folding greeting card with a shiny, green exterior finish containing a fictional, visual narrative inside.[55] Knight first had published *Untitled* as a sequence of four pages in the April issue of the *Journal* of the Los Angeles Institute of Contemporary Art, which was guest-edited by artist and film-maker Morgan Fisher (b. 1942) and devoted to cross-overs between art and film. Illustrative diagrams and captions convey the story. The first panel of the narrative inside the card displays a floor plan of a typical American suburban house, which the artist had cut out from the real estate section of the *The Los Angeles Times*. The second plots the frenetic activity of filming the home's interior. As the text on the front of the card explains:

> Thrilled by the realization of their first home, Don and Maureen Campbell decided to have a film made of their new environment. Don plans to send prints to close friends and business associates in lieu of Xmas cards.

All the arrangements have been made for production to begin the latter part of the month. The floor plan was supplied by the Campbells for use by the crew.

The final panel of the card presents a jagged shape with jutting points that, one learns from the caption, represents the outline of the diagrammed activity of filming, whose shape is to be used 'as a design for the rumpus room' planned by the Campbells as a later addition.

The narrative content of the card provides a comic parable about the removal – or, literally, the abstraction – of form from social reality as well as being a spoof on Conceptual art's text and image modalities. The resulting outlandish, disembodied shape parodies the image-consciousness of the fictitious Campbells who, straining to keep up with the times (and, of course, with the Joneses), are already out of date since a 'rumpus room' is a term and concept from the 1950s. Knight's work, which may be placed in any ornamental context within a room, deals with the formal arbitrariness, sometimes leading to absurdity, that issues from subjective decision-making when it is 'uninformed' by or disengaged from social actuality. The card is also a personal manifesto regarding Knight's own aesthetic modus operandi, whose goal is to have

Ten days of production has provided an interesting body of film.

The Campbells like the film so much that they have decided to use it as a design for the rumpus room they had planned as an addition in the spring.

John Knight **Untitled ('The Don and Maureen Campbell diagram...')** 1977

abstract shape converge with functional representational form. In this way, social fictions, which minister to people like the misguided Campbells, do not escape observation.

Following shortly after the Don and Maureen Campbell card, *Journals Series* (begun 1978), an ongoing work, depends on the postal service. With this work, Knight once again conjoined and contrasted normally separate systems of art and non-art representation. In realizing *Journals Series*, Knight procured one- year or six-month gift subscriptions to high-gloss, popular journals for approximately one hundred artists, collectors, curators, art dealers, architects, etc. whom he knew personally. Choosing magazines devoted to particular subjects and easily obtainable, the artist took the specific interests or lifestyle of each recipient directly into account. This allowed him to throw into relief the nature of each magazine's presentation of contemporary life. Irony is achieved when *Metropolitan Homes* featuring sumptuous, color-coordinated interiors, is sent to someone who lives modestly but tastefully, or *Arizona Highways*, with a spectacular landscape view in 'living' technicolor on its cover, to someone who travels

extensively. *Apartment Life*, *Bon Appétit*, *Field and Stream*, and *Town and Country* are among the numerous magazines Knight has sent to a wide variety of his contemporaries such as Michael Asher, Daniel Buren, Dan Graham, and On Kawara or to high-profile trend-setters such as Frank Gehry whose own work has been absorbed into the popular media. Whatever a particular journal's focus happens to be – interior design, cooking, fashion, nature, or art – it sets forth its subject matter in glowing terms and in the light of society's touted values.

Knight relies on the fact that although the magazines themselves are not art, they perform some of the same roles: as decorative objects (displayed on coffee tables, for example), or as items that are collectible once they have become rare with the passage of time. Through their manipulation of pleasing design practices, each magazine, varying its cover image from issue to issue, continues to employ the same devices for its basic formal and compositional layout. Without disrupting the reassuring effect of cumulative uniformity, however, each new cover preserves its stock of visual formulas beneath the guise of diversity.

John Knight **Journals Series** 1978–

The subscriptions sent by Knight attain art status as a result of how they are 'read' by the recipient – either as the magazines that they are or as an artist's work which must be 'handled with care,' or both – and by how they are, or are not, assigned value by the culture. Treatment at the hands of individual owners, as well as by museums when the work is borrowed for temporary exhibition, invests the work with added meaning. Denuded of the traditional, material attributes of art, but set within the context of an institutional display, the magazines belonging to *Journals Series* highlight museum installation methods such as the placement of objects on pedestals or their ordered and tasteful arrangement within protective vitrines.

Journals Series presents already existing, non-art representation within the framework of art as a means to discover the point at which art and non-art systems overlap. To this end, the work inquires into what factors are potentially responsible for determining an object's worth beyond purely visual qualities of color, form, and image. *Journal Series* explores the idea and meaning of authorship; the compliance of the receiver/owner in giving a work value; the role of an object's scarcity or age as well as its surface appeal as interior decoration. Above all, it demonstrates how an object's display within an institutional context unwittingly assigns it to the category of art. Comprising ordinary magazines whose medium is mass media reproduction, *Journals Series* is left untouched by the hand of the artist and instead is rechannelled through the contextual conduits dedicated to art's reception. At the same time, it assesses the

illusions and fantasies proffered as real by the media.

Involved with laying bare social realities, Hans Haacke has dedicated his career to fact-finding missions that bring to light connections between art and politics. Whereas works by Knight knit together previously unaffiliated representational forms and formats, works by Haacke evidence the existing, yet obscured, linkages between the world of art devoted to collecting and exhibition and socio-economic systems. Haacke's 'working premise' has always been 'to think in terms of systems,' which 'can be physical, biological or social.'[54]

Prior to 1969, when his focus shifted from the physical and biological to the social, economic, and political, Haacke dealt with a range of phenomena involving movement and, by the mid-1960s, was participating in a number of international exhibitions revolving around this theme. Unlike many of the other participants, however, Haacke was not interested in the effects of motion per se. Rather, he built movement – and by extension, change – into these early works to illustrate environmental contingency. Regarding his polished steel 'mirror-objects' of 1961, the artist noted that 'their environment – the observer is included – is an integral component of them.'[55] Soon after their completion, he wrote that 'the never-ending communication – seeing and being seen – of the mirror-objects with the world and the viewer…is what fascinates me.'[56]

The ongoing interaction between a work and its physical environment defines Haacke's sculptural production of 1963–69. Haacke's first pieces of this kind, such as *Rain Tower* (1963), the Wave pieces (1964–65), and *Condensation Cube* (1963–65), are activated by external factors while being contained within plexiglas boxes. In the case of the two-foot high *Rain Tower*, a viewer is meant to turn the partitioned plexiglas box upside down. Water droplets then fall through perforations in the horizontal dividers to simulate rain. Plexiglas containers with two differently colored liquids that do not mix (such as oil and water) are supposed to be picked up and tipped in different directions. Often suspended by wires from the ceiling, the Wave pieces also depend on viewers to actuate their meandering patterns.

Light and heat in lieu of a spectator's action upon the work determine the cycle that takes place in *Condensation Cube*. After evaporating, water forms drops and runs down the sides of the box according to changes

in climate. *Ice Stick* (1964) likewise assumes its form in direct relationship to weather conditions. A tall, upright metal rod, it contains a motorized freezing coil inside that causes ice – becoming thicker or thinner in accordance with air temperature and humidity – to form around it. Presenting only what is there to be seen, the artist has pointed out that *Ice Stick* possesses 'no mysteries,' and 'psychological investigations would not reveal my secrets.'[57]

Instead of being formed by the artist, Haacke's sculptures of the 1960s shape themselves in response to external stimuli that act upon them. 'Make something, which cannot "perform" without the assistance of its environment,'[58] he stipulated in 1965. Air currents and gravity, in this regard, are utilized in *Floating Sphere* (1964–66) and *Sphere in Oblique Air Jet* (1967) to allow balloons to hover above bases housing motorized fans without the visible support of a traditional pedestal. In *Blue Sail* (1965–67), fans hidden beneath blue chiffon hanging from the ceiling induce billowing movement in ever-changing configurations. When installed on the floor under a large sheath of white rayon, fans in *White Flow* (1967) cause the material to ripple like water. 'The wind driven fabric behaves like a living organism, all parts of which are constantly influencing each other' since 'the sensitivity of the wind player determines whether the fabric is given life… and breathes.'[59] For his solo exhibition at the Hayden Gallery at the Massachusetts Institute of Technology in October 1967, Haacke repeated a work realized in New York City's Central Park several months earlier. This work comprised a 700-foot long string of helium balloons attached to one another at four-foot intervals. The balloons behaved according to prevailing winds so that their formation in the sky, directed by the weather, kept changing while they were afloat. 'Changes are desired and are part of the program – they are not due to the shifting experience of the viewer,'[60] Haacke maintained in an effort to distinguish his work from objects fixed in time or controlled by the artist.

Following from the use of gravity, light, temperature, and air, the biological mechanism of growth was enlisted by Haacke as yet another sculptural method. *Grass Grows* (1969), shown in 'Earth Art' at the Andrew Dickson White Museum of Art, Cornell University, New York in the winter of 1969, elaborated on *Grass Cube* (1967), which consisted of grass sprouting on the top of

Hans Haacke | **Blue Sail** | 1965

Hans Haacke | **Condensation Cube** | 1963/65

Hans Haacke | **Shapolski et al. Manhattan Real Estate Holdings, A Real-Time Social System, as of May 1, 1971** (detail) | 1971

a plexiglas cube. At Cornell, the artist placed a three-foot high mound of soil, nine feet in diameter, on the floor of one of the museum's windowed galleries and seeded it with fast-growing, winter rye. During the course of the exhibition, the seeds yielded a thick growth over the entire surface of the mound. Some months later, Haacke included *Chickens Hatching* (1969) in the Art Gallery of Ontario's 'New Alchemy' exhibition. Each week during the course of the month-long exhibition, a brood of chicks broke out of eggs installed in a series of eight incubator boxes. Like the grass, the cracked eggs and fuzzy baby birds, taking the place of traditionally handled materials, resulted from biological processes. Significantly, these and prior works are premised on the fact that 'a system is not imagined; it is real.'[61]

With his understanding that 'an artist is not an isolated system,' Haacke maintains that 'in order to survive…he has to continuously interact with the world around him.'[62] Not long before the incubators full of hatching chickens were shown in Toronto, he had set

up a teletype machine in the Kunsthalle Düsseldorf during 'Prospect 69.' The machine received printouts that recorded an entire day of news from the German press agency, Deutsche Presse Agentur. Shortly thereafter, for a solo exhibition at the Howard Wise Gallery in New York, where he had shown work since the beginning of 1966, Haacke exhibited *Nachrichten* (News, 1969–70) again, this time using a teletype machine provided by United Press International. A year later at the Jewish Museum, New York during its 'Software' exhibition, *News* was expanded to five teletype machines receiving transmissions from different wire services. In this case, the printouts piled up on the floor, whereas previously they had been posted on the wall. Comparable to the drops of water on the sides of *Condensation Cube* formed in response to climate, the ideologically loaded language of *News* registered the political atmosphere – at the time of West German federal elections – in the hard-and-fast reality of print.

Also shown in the Howard Wise Gallery exhibition, *Gallery-Goers' Birthplace and Residence Profile, Part 1* (1969) delivers factual information via maps. Visitors to the exhibition were asked to put red and blue pins on maps of the boroughs of New York City, its immediate metropolitan area, the United States, and the world. The red pins designated where a person was born and the blue where he or she was living, if different. By the end of the exhibition, 2312 birthplaces and 2022 residences had been pinpointed.

Gallery-Goers' Residence Profile, Part 2 (1970), primarily using photographs that correlated with the information garnered from the first visitors' profile, was exhibited one year later at the Paul Maenz Gallery, Cologne. Photographs of the building facades of the Manhattan residences pinpointed during the Howard Wise exhibition were mounted on the wall as per their geographical location. Addresses of each building were typed on accompanying index cards. Insofar as information about residence serves to foreground the cumulative socio-economic 'backgrounds' of the spectators, Haacke's two Gallery-Goers' profiles detail where the 1969 viewers, in a sense, were 'coming from.' The two works thus succeeded in embodying sociological information about their own viewers, who provided the statistical 'material' on which each is based.

The content of poll pieces such as *MOMA-Poll* (1970) relies on information provided by viewers' responses to questions. During the Museum of Modern Art's 'Information' exhibition, visitors cast ballots in a 'yes' or 'no' box installed beneath a sign with the question: 'Would the fact that Governor Rockefeller has not denounced President Nixon's Indochina policy be a reason for you not to vote for him in November?' The ballots given to each visitor, tabulated and posted each day, were color-coded according to whether the visitor was full-paying, had come on a free day, possessed a courtesy pass, or had entered free of charge as a member. Final results at the end of the twelve-week exhibition yielded 25,566 'yes' votes and 11,563 'no' votes. *MOMA-Poll* took statistical investigation beyond the spectrum of visitors' biases. By choosing a question related to the policy of the New York State Governor, Haacke drove in the work's main point: that the Museum of Modern Art, on whose board Rockefeller served, was not an ivory tower but tainted, like any social institution dependent on funding, and not free of the biases of politics.

Throughout the 1970s, Haacke approached his art somewhat like a social scientist gathering empirical data in order to frame social realities and economic inequalities.[63] To produce *Shapolski et al. Manhattan Real Estate Holdings, a Real-Time Social System, as of May 1, 1971* (1971) the artist researched relationships between individuals, geographical location, and housing. This multi-panelled work comprises two enlarged maps of the Lower East Side and Harlem in New York City and 142 black-and-white photographs of building facades or empty lots placed above typed data sheets. Each data sheet gives the address of the piece of property concerned, its block and lot number, lot size, and building code. Also indicated are the name of the corporate or individual holding title, the addresses and names of officers, and the property's date of acquisition, as well as its prior owner, mortgage amount, and assessed tax value. Six charts of business transactions connected with the ownership of the buildings complete the work. Put together from information available in public records, the work is a sweeping survey of one family's real estate holdings in the lower income sectors of one city. Pointedly bringing the particulars of a situation together under one roof, *Shapolsky et al* opens the door to viewing hidden economic connections between many separately located building facades.

Both *Manet-PROJEKT '74* (1974) and *Seurat's 'Les Poseuses' (small version), 1888–1975* (1975) pertain to the passage of works through many hands and economic transactions. These two works document the provenance of the paintings in question by means of individually framed panels. Accompanied by a portrait, they provide in-depth biographical information about the successive owners of the paintings from the late nineteenth century on. *Bunch of Asparagus* (1880) by Edouard Manet (1832–83), the subject of *Manet-PROJEKT '74*, has ended up in the collection of the Ludwig Museum (formerly the Wallraf-Richartz Museum) in Cologne. A color reproduction of it is accompanied by ten panels, the first pertaining to Manet himself. The last panel lists all of the donors to the Wallraf-Richartz Museum who made acquisition of the Manet possible. Hermann J. Abs, then chairman of the Friends of the Museum, appropriately – as well as alphabetically – heads the list. The preceding panel outlines the particulars of his life and his high-level, high-profile affiliations with the German government and the country's large companies,

Hans Haacke **Seurat's 'Les Poseuses' / (small version) 1888–1975** (detail) 1975

Hans Haacke **Seurat's 'Les Poseuses' / (small version) 1888–1975** (detail) 1975

consortiums, and banks during the Nazi period and after World War II.

Les Poseuses (small version) (1888) by Georges Seurat (1859–91) had, by 1975, made its way as a loan to the Bavarian State Museum, Munich after having passed from one collector, art dealer, or art investment company to another for nearly a century. Fourteen text panels accompany a color reproduction of the painting and similarly document the painting's trajectory from artist's studio to institutional resting place. In the same way as *Manet-PROJEKT '74*, it highlights the way in which art is not free from the market system and that, as property, survives over the decades because of business transactions carried out by those who often are active in the political arena. As the artist affirmed in an interview, 'the social forces that have an effect on the art world naturally are the same social forces that affect everything else in the country, and in the world. The art world is not an isolated entity.'[64]

Ensuing works by Haacke have continued 'to look into the economic and political underpinnings of the institutions, individuals and groups who share in the control of cultural power.'[65] *On Social Grease* (1975) was the first of a later body of work dealing with corporate sponsorship. Statements by six high-level executives who were on museum boards and/or whose companies made sizeable contributions to the support of museum exhibitions, were excerpted by Haacke from published sources. The statements are embossed on a series of six large metallic plaques with a corporate appearance. Robert Kingsley, representing Exxon, cuts to the quick of the work's self-reflexive point that the wheels of society are turned by the opportunism of big business:

EXXON'S support of the arts serves the arts as a social lubricant.
And if business is to continue in big cities, it needs a more lubricated environment.

Through his assembly of facts and figures or by direct quotation, Haacke lays bare the connections between art and business. Thus divulging ties between self-serving economic interests and the collection and exhibition of art, he endeavors to give aesthetic practice a political voice of its own.[66]

Like Haacke, Broodthaers, Buren, Asher, Baumgarten, and Knight have essayed from within the thematic

boundaries of their work to withstand the demands of a culture founded on consumerism. In diverse ways, they have contributed to the aesthetic formulation that works of art are subject to the laws of the commercial system that, in turn, bear upon the social environment. In the belief that art might provide an antidote to commodification rather than remain, unawares, a party to it, Broodthaers overturned conventions of aesthetic perception and reception. Major installations like his 'Der Adler vom Oligozän bis heute' and *Un Jardin d'Hiver*, with the aid of language, eliminate the deceptive nature of depicted images conjured up by the artist in order to forestall the concomitant 'transformation of Art into merchandise.'[67] Ever attentive to the danger of 'making and remaking things one is tired of, but sell well,' he affirmed in an interview, 'I actually want to criticize society and culture with each piece.'[68]

Also reappraising the autonomy of art, Buren liberates his work from dependence on subjectively determined solutions to painted or sculptural form by deferring to the realities of an exhibition site. 'Right from the start,' he has said, 'I have always tried to show…that indeed a thing never exists in itself.'[69] Specifically, the authority of the museum, where objects risk being merely deposited, in all senses of the word, is made apparent and contested. Institutional barriers, which cordon art off from non-art reality, are overcome without being overthrown. Although complicit with the museum and gallery spaces they critique, Buren's works retain their *self*-criticality in order to examine and expose – but not destroy – their visible and invisible frames of reference.

In works that adhere, as do those by Buren, to principles of institutional site-specificity, Asher endeavors to mend the division between form and function and between real and artificial space. By dissolving distinctions between the materiality of a work and its support, he has revised the conventional notion of sculpture as a *free*-standing object. Coincident with observable, extant reality, his works bring into the open otherwise unobserved situations and conditions.

Analogously, the work of Baumgarten is motivated by the 'desire to anchor an esthetic dialectical praxis in the social and political conditions' of the present by 'making an analytical effort to free the historically and socially based reality from the imposed myths cloaking it.'[70] Differently, however, from Buren and Asher, he achieves this goal by the introduction of culturally coded linguistic elements of language into architectural frameworks. Using language to create a window onto intangible but forcible realities, Baumgarten attends to a work's specific siting with reference to the commercially driven destruction of culture(s). With an eye toward future, irreconcilable rifts between culture and nature, his work – farsighted in its global perspective – envisages a more comprehensive, less ethnocentric, world view.

Knight is primarily interested in non-aesthetic representational systems based on language, design practices, and the signifying strategies underlying popular imagery. In contradistinction to the work of Baumgarten, in which linguistic signs unite with an appointed architectural site, sign systems in Knight's work are treated as sites in and of themselves. Challenging ironclad distinctions between conventional high art form(s) and non-art – or 'low' art – forms, he employs the latter to re-evaluate the former without losing sight of the different meanings accorded representation by virtue of its contextual positioning.

The expansion of art's thematic parameters to include issues of context has led to the redefinition of traditional materiality and the notion of the autonomous, transcendent object. It has also led to the recognition that a work of art is not, both literally and figuratively speaking, detached from society's interwoven support structures, which encompass the institutional (museological), economic, cultural, political, and historical as well as the purely architectural. As suggested by the aesthetic production of these artists, whether a work interfaces with its physical context or with intangible conditions not visibly apparent, it furthers the grander project of destroying illusion in all of its possible manifestations.

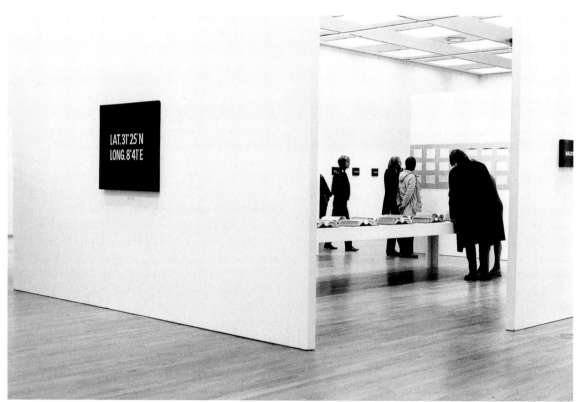

On Kawara | **Location** | 1965

[. . .]

Conclusion

The assault on deception mounted by artists from within the Conceptual arena has transformed the playing field of art. The gains from the revolution in aesthetic thinking initiated after 1965 by those who questioned, revised, or abandoned the traditional categories of painting and sculpture are now taken for granted. Benefitting from the changes wrought earlier by their immediate forerunners, many artists worldwide now work with language, photography, video or other time-based media, and/or create installations in lieu of discrete objects. Liberated by their predecessors from the constraints of the once preordained media of painting and sculpture, artists of a later generation have taken their aesthetic concerns in different directions from those whose strategies they inherited. Thus, a number of now well established artists who emerged at the end of the 1970s have examined how language and photography operate in present-day culture and, in doing so, place doubt on the assumed neutrality of these representational means. Others, sometimes applying time-based media and/or installational modes as well, make statements with overt socio-political content, which in many cases revolve around issues of gender, class, and race.

Crossing the divide between the Modernist belief in the self-contained object and Postmodernist attention to relational, non-autonomous, multifaceted open-endedness, works of the late 1960s and 1970s reflect on aspects of physical and/or social reality without forfeiting their self-critical reflexivity. Self-criticality in direct association with reality has been accomplished by the continued thematic suppression of authorial presence and subjectivity. In the endeavor to convey their independence from an ostensible creator, works of a Conceptual nature replace signs of personal invention with signs that evince the idea of their self-creation.

With the intent of describing their own reality as art, many of the works considered in this book self-analytically comment on, while attempting to counter, the ultimately inescapable fact of a work's commodity value. Still other works have represented their place – and often that of the viewer – within the co-ordinates of time and space or with explicit consideration to their existence on a social plane. Each has variously accomplished its task through the utilization of representational modes that, supplying information without illusionistic device, connect the work of art with aspects of the non-art world by their employment of linguistic elements, mechanical reproduction, numbers, maps, the body, or architecture. These different forms of representation function separately or in combination with each other within a single work. As suggested by the particular oeuvres discussed, language, photography, and other ontological indicators play dominant roles in works that, as part of their content, equate knowledge with perception and the mental with the visual.

The artists of the late 1960s and 1970s have paved the way for artists of the 1980s and 1990s who use the new-found vehicles of representation to observe a world defined by rampant consumerism, media obfuscation, social inequity, and the precarious state of the environment. While they have established new ideas about the very nature of representation, these artists have also laid the groundwork for addressing the consequences of one-sided, self-promoting vision. Whether or not works of art from the late 1960s and 1970s make overt political statements or directly comment on the current social situation, all of them, in one form or another, present themselves as models of resistance to a status quo. Challenging long-held concepts of art and the idea of their own self-sufficient transcendence, these works contend with whatever aspect of reality they have chosen to envision.

Acknowledgments

A great many artists, colleagues and friends over many years have helped me to realize this book. My gratitude is unbounded and cannot be adequately articulated within the normal limits of time and space. The acknowledgments I initially had envisaged for thanking all those who have aided me with research and the collection of photographs, supplied me with information and shared their insights, or given me unconditional advice and support, could not be satisfactorily accommodated here. Nevertheless, a number of individuals who went out of their way editorially with the preparation of this book should be singled out.

First, I express my appreciation to Tamara Blanich, who tirelessly worked with me on numerous weekends and evenings from the beginning of the book to the end. Always attentive to any awkwardness or inexactitude of phraseology, she applied her intellectual acumen to first and later drafts.

Equally, I have benefitted from the insights of Sarah Jackson, who read all chapters from start to finish with a sharp eye. Subsequently, Graham Harles, also with much dedication, lent his editorial and research expertise to filling in omissions and correcting inconsistencies in the main text, endnotes, and bibliography. Sarah Guernsey assisted me with a range of editorial complexities, and advised me on the selection of photographs. Additionally, Cisley Celmer did much to help with procuring photographs from institutions, while Michael Tropea pitched in to take photographs where needed. Those who have been constantly on call for sporadic, yet sometimes urgently requested comment include Ann Goldstein, Andrea Kirsh, Steven Leiber, Birgit Pelzer, Jim Purdon, Katherine S. Rorimer, Constance Rosenblum, Ellen Steinberg, Cora Rosevear, and John Vinci.

Finally, without the infinite wisdom and patience of Nikos Stangos, who in association with the Thames and Hudson staff has guided me through the endeavor of writing a book, this book would never have become a reality.

Notes to the Text

Introduction

1 Clement Greenberg, 'Modernist Painting,' in Gregory Battcock (ed.), *The New Art: A Critical Anthology*, New York: E. P. Dutton & Co.,1966, p. 101.
2 Greenberg, 'Avant-Garde and Kitsch,' in *Art and Culture: Critical Essays*, Boston: Beacon Press, 1961, pp. 5–6.
3 Greenberg, 'Modernist Painting,' p. 101.
4 Ibid., p. 104.
5 Greenberg, 'The New Sculpture,' in *Art and Culture*, p. 145.
6 Quoted in *Piero Manzoni: Paintings, Reliefs and Objects* (exh. cat.), London: Tate Gallery, 1974, p. 47.
7 Ibid.
8 Ibid., p. 17.
9 Alberto Burri, in Gerald Nordland, *Alberto Burri: A Retrospective* (exh. cat.), Los Angeles: The Frederick S. Wight Art Gallery, 1977, p. 50.
10 Ad Reinhardt, Notes on the Black Paintings, in Barbara Rose (ed.), *Art-as-Art: The Selected Writings of Ad Reinhardt*, Berkeley: University of California Press, 1991, p. 104.
11 Quoted in Naomi Vine, 'Mandala and Cross,' *Art in America*, 79, 11, November 1991, p. 129.
12 Yves Klein, 'The Monochrome Adventure,' in *Yves Klein, 1928–1962, A Retrospective* (exh. cat.), Houston: Institute for the Arts, Rice University, 1982, p. 220.
13 Reinhardt, quoted in Margit Rowell, 'Ad Reinhardt: Style as Recurrence,' in *Ad Reinhardt and Color* (exh. cat.), New York: The Solomon R. Guggenheim Museum, 1980, p. 23.
14 Yves Klein, 'The War: A Little Personal Mythology of the Monochrome,' in *Yves Klein, 1928–1962*, p. 218.
15 See Rowell, 'Ad Reinhardt: Style as Recurrence,' p. 26.
16 Klein, quoted in *Yves Klein, 1928–1962*, p. 221.
17 Ibid., p. 224.
18 Frank Stella, in 'Questions to Stella and Judd: Interview by Bruce Glaser Edited by Lucy Lippard,' in Gregory Battcock (ed.), *Minimal Art: A Critical Anthology*, New York: E. P. Dutton & Co.,1968, pp. 157–58.
19 Frank Stella, quoted in William Rubin, *Frank Stella* (exh. cat.), New York: The Museum of Modern Art, 1970, p. 60.
20 Quoted in G. R. Swenson, 'What is Pop Art?' in John Coplans (ed.), *Roy Lichtenstein*, New York: Praeger Publishers, 1972, p. 55.
21 Ibid., 'Talking with Roy Lichtenstein,' p. 86.
22 Andy Warhol, in Rainer Crone, *Andy Warhol*, New York: Praeger Publishers, 1970, p. 11.
23 See Germano Celant, 'Chronology,' in *Piero Manzoni: Paintings, Reliefs and Objects*, pp. 11–12. Manzoni had planned to create phials of 'Artist's Blood' as well.
24 Ibid.
25 In conversation with the author in 1970. Smith stressed the idea that the cardboard modules freed him from the necessity of having a predetermined result in mind. With regard to *Wandering Rocks* (1967), for example, he stressed that he only used the cardboard that he happened to find in

his basement one evening. 'I used only the pieces that were there and was not analytic about it. One would never recognize what I started with. It's not as if I knew what I was doing.'

26 Robert Morris, 'Notes on Sculpture, Part IV: Beyond Objects,' *Artforum* 7, 8, April 1969, p. 54.

27 Carl Andre, in David Bourdon, 'A Redefinition of Sculpture,' in *Carl Andre: Sculpture 1959–77* (exh. cat.), Austin, Texas: Laguna Art Museum, 1978, pp. 26 and 19 respectively.

28 Quoted in *Sol LeWitt* (exh. cat.), New York: The Museum of Modern Art, 1978, p. 53. In the original quote 'lacquer' is used instead of 'acrylic.' The artist, in a fax to the author (April 2000), stipulates the latter.

29 'Anti-form' was used at the time in connection with these works to refer to their unstructured appearance relative to figurative or compositionally based abstract sculpture. See Robert Morris, 'Anti Form,' *Artforum* 6, 8, April 1968, pp. 33–35 for his understanding of this term.

30 Eva Hesse, in Cindy Nemser, 'An Interview with Eva Hesse,' reprinted from *Artforum* 8, 9, May 1970, p. 60.

31 Lucy Lippard, *Eva Hesse*, New York: New York University Press, 1976, p. 96.

32 Joan Simon (ed.), *Bruce Nauman* (exh. cat.), Minneapolis: Walker Art Center, 1994, p. 192.

33 See ibid., cat. no. 5. During a half-hour performance sometimes titled *28 Positions Piece: Wall-Floor Positions: Seven Consecutive Poses*, Nauman used his body – as he would do in his films and videos – to enact sculptural form. In analogous manner, his fiberglass forms may be said to lean out from the wall, bend as if from the waist, squat, sit, or lie on the floor.

34 Willoughby Sharp, 'An Interview with Joseph Beuys,' *Artforum* 8, 4, December 1969, p. 45.

35 In 1961 Beuys was appointed Professor of Sculpture at the Kunstakademie Düsseldorf, where he was one of the art school's most influential professors until he was dismissed a decade later.

36 Ursula Meyer and Ingrid Krupka, 'Joseph Beuys: I Speak for the Hares,' *Print Collectors Newsletter*, 4, 4, September-October, 1973, p. 8.

37 See Joseph Beuys, in Caroline Tisdall, *Joseph Beuys* (exh. cat.), New York: The Solomon R. Guggenheim Museum, 1979, p. 7. Reprinted in Carin Kuoni (ed.), *Energy Plan for the Western Man: Joseph Beuys in America: Writings by and Interviews with the Artist*, New York: Four Walls Eight Windows, 1990, p. 19: 'My objects are to be seen as stimulants for the transformation of the idea of sculpture or of art in general. They should provoke thoughts about what sculpture *can* be and how the concept of sculpting can be extended to the invisible materials used by everyone.' Beuys's definition of Social Sculpture reads: 'how we mould and shape the world in which we live: *Sculpture as an evolutionary process; everyone an artist.*'

38 Achille Bonito Oliva, 'A Score by Joseph Beuys: We Are the Revolution' (interview with Joseph Beuys), Naples: Modern Art Agency, 1971, n.p.

39 Sharp, 'An Interview with Joseph Beuys,' p. 47.

40 Ibid.

41 Tisdall, *Joseph Beuys*, p. 72.

42 Sharp, 'An Interview with Joseph Beuys,' p. 46.

43 Bruce Nauman, in Jane Livingston, 'Bruce Nauman,' in *Bruce Nauman* (exh. cat.), Los Angeles: Los Angeles County Museum of Art, 1972, p. 11.

44 Beuys in Tisdall, *Joseph Beuys*, p. 72.

45 Ibid.

46 Marcel Duchamp, in Pierre Cabanne, *Dialogues with Marcel Duchamp*, New York: The Viking Press, 1971, p. 48.

47 Duchamp, in Anne d'Harnoncourt and Kynaston McShine (eds), *Marcel Duchamp* (exh. cat.), New York: The Museum of Modern Art and Philadelphia: Philadelphia Museum of Art, 1973, p. 283.

48 Ibid., p. 235.

49 Willem de Kooning in Anne d'Harnoncourt and Walter Hopps, 'Reflections on a New Work by Marcel Duchamp,' Philadelphia Museum of Art *Bulletin* 64, 299/300, April–September 1969, second reprint 1987, p. 43.

50 Claes Oldenburg, 'The Street: A Metaphoric Mural,' in Barbara Rose, *Claes Oldenburg*, New York: The Museum of Modern Art, 1976, p. 191.

51 Claes Oldenburg, in Ellen Johnson (ed.), *American Artists on Art from 1940 to 1980*, New York: Harper & Row Publishers, 1982, p. 98.

52 Ibid., p. 59: Allan Kaprow wrote in 1966 that after the term 'happening' was used in his *18 Happenings in Six Parts* (1959) at the Reuben Gallery, 'a number of artists picked up the word informally and the press then popularized it. I had no intention of naming an art form and for a while tried, unsuccessfully, to prevent its use.'

53 See Kaprow, 'The Legacy of Jackson Pollock,' *Art News* 57, 6, October 1953, p. 56. Kaprow writes that Pollock's mural-scale paintings 'ceased to become paintings and became *environments.*' And further: 'Pollock, as I see him, left us at the point where we must become preoccupied with and even dazzled by space and objects of our everyday life…. Not satisfied with the *suggestion* through paint of our other senses, we shall utilize the specific substances of sight, sound, movements, people, odors, touch.'

54 Reproduced in Owen F. Smith, 'Fluxus: A Brief History and Other Fictions,' in *In the Spirit of Fluxus* (exh. cat.), Minneapolis: Walker Art Center, 1993, p. 24.

55 Kaprow, in Helena Kontova and Giancarlo Politi, 'Allan Kaprow Happens to be an Artist,' *Flash Art* 25, 162, January–February 1992, p. 92.

56 For example, see Ken Friedman (ed.), *The Fluxus Reader*, Chichester: Academy Editions, 1998, and Michael Nyman, *Experimental Music: Cage and Beyond*, Cambridge: Cambridge University Press, 1999, p. 74 regarding Nam June Paik (b. 1932), who, in the words of Al Hansen (1927–1995), would 'move through the intermission crowd in the lobby of a theatre, cutting men's neckties off with scissors, slicing coats down the back with a razor blade and squirting shaving cream on top of their heads.'

57 Barbara Haskell, *Blam! The Explosion of Pop, Minimalism, and Performance 1958–1964*, New York: Whitney Museum of American Art, W. W. Norton & Company, 1984, p. 49.

58 Alison Knowles, in Estera Milman, 'Road Shows, Street Events, and Fluxus People: A Conversation with Alison Knowles,' in *Fluxus: A Conceptual Country* (exh. cat.), New

York: Franklin Furnace et al., 1992, p. 100.

59 Robert Pincus-Witten, 'Fluxus and the Silvermans: An Introduction,' in Jon Hendricks, *Fluxus Codex*, Detroit: The Gilbert and Lila Silverman Fluxus Collection in association with Harry N. Abrams, Inc., New York, 1988, p. 15.

60 George Maciunas, in Clive Phillpot, 'Fluxus: Magazines, Manifestos, *Multum in Parvo*,' in *Fluxus: Selections from the Gilbert and Lila Silverman Collection* (exh. cat.), New York: The Museum of Modern Art, 1988, p. 13.

[One] Painting at Issue after 1965

1 In Magdalena Dabrowski, 'Aleksandr Rodchenko: Innovation and Experiment,' in *Aleksandr Rodchenko* (exh. cat.), New York: The Museum of Modern Art, 1998, p. 43.

2 *Robert Mangold* (exh. cat.), Xunta de Galicia: Centro Galego de Arte Contemporáneo, 1999, pp. 114–17.

3 Ibid.

4 Ibid.

5 Baer, in 'I am no longer an abstract artist,' *Jo Baer: Paintings 1960–1998* (exh. cat.), Amsterdam: Stedelijk Museum, 1999, p. 16.

6 Ibid., p. 40.

7 Ibid., p. 42.

8 Linda Shearer, 'Brice Marden's Paintings,' in *Brice Marden* (exh. cat.), New York: Solomon R. Guggenheim Museum, 1975, p. 14.

9 Ibid., p. 28.

10 In Phyllis Tuchman, 'An Interview with Robert Ryman,' *Artforum* 9, 9, May 1971, p. 53.

11 In *Wall Painting* (exh. cat.), Chicago: Museum of Contemporary Art, 1979, p. 16.

12 Ryman, in *Art in Process IV* (exh. cat.), New York: Finch College Museum of Art/Contemporary Study Wing, 1969, n.p.

13 Ryman, in 'An Interview with Robert Ryman,' p. 49.

14 Ryman, in *Robert Ryman* (exh. cat.), London: Tate Gallery and New York: The Museum of Modern Art, 1993, p. 70.

15 For this account and further details, see Michel Claura, 'Actualité,' *VH101*, 5, Printemps 1971, pp. 40–47

16 Niele Toroni, quoted in Jeanne Siegel, 'Real Painting: A Conversation with Niele Toroni,' *Arts Magazine*, 64, 2, October 1989, p. 49.

17 Toroni, in conversation with the author, October 1991.

18 Toroni, in conversation with the author, February 1978.

19 See Niele Toroni, 'Banalités à Dire et Redire dans les Milieux Artistiques,' in *Actualités d' Un Bilan*, Paris: Yvon Lambert, 1972, p. 119, a text in which Toroni directly refers to the commercial aspect of art. In humorous manner, for example, he draws attention to the phonetic equivalence between '*de l'art*,' '*de lard*,' and 'dollar' (art, fat, and dollar).

20 *Niele Toroni: catalogue raisonnable, 1967–1987, 20 ans d'empreintes*, Nice: Villa Arson and Grenoble: Musée de peinture et de sculpture, 1987, p. 17.

21 Ibid., p. 19.

22 Ibid., p. 21.

23 Toroni, in conversation with the author, September 1991.

24 Bruce Ferguson and Jeffrey Spalding, 'Gerhard Richter' (interview), *Parachute*, 13, Hiver 1978, p. 32.

25 Dietrich Helms, 'On Gerhard Richter' (interview), in *Gerhard Richter*, 36th Venice Biennale, 1972, p. 14.

26 Rolf Schön, 'Interview,' in *Gerhard Richter*, 1972, p. 23.

27 Richter's corollary, ongoing project begun in 1964, entitled *Atlas*, principally consists of photographs collected or taken by the artist and includes sketches as well. When exhibited at the Dia Center for the Arts, New York, in 1995–96, it comprised nearly six hundred panels accommodating about five thousand photographs. *Atlas* is to be understood as an ongoing compendium, which is both a source book for unrealized paintings and a storage bank of images.

28 Ferguson and Spalding, *Gerhard Richter*, 1978, p. 31.

29 Schön, *Gerhard Richter*, 1972, p. 23.

30 Ibid.

31 See B. H. D. Buchloh, 'Ready-made, photography and painting in the painting of Gerhard Richter,' in *Gerhard Richter. Abstract Paintings*, London: Whitechapel Art Gallery (exh. cat.), 1979, pp. 5–20. See also Gerhard Richter, 'Notes, 1990' in *Daily Practice*, p. 218: 'It seems to me that the invention of the Readymade was the invention of reality. It was the crucial discovery that what counts is reality, not any world-view whatever.'

32 According to Sean Rainbird, 'Variations on a Theme: The Theme of Painting,' in *Gerhard Richter* (exh. cat.), London: The Tate Gallery, 1991, p. 12, Richter took the photograph used for this painting himself, although he was mostly using photographs from published sources or those taken by others during these years.

33 Ferguson and Spalding, *Gerhard Richter*, 1978, p. 32.

34 Rolf Gunter Dienst, 'Interview,' *Gerhard Richter*, Venice, p. 20–21.

35 Quoted in Jürgen Harten, 'The Romantic Intent for Abstraction,' *Gerhard Richter: Bilder/Paintings 1962–1985* (exh. cat.), Düsseldorf: Städtische Kunsthalle Düsseldorf, 1986, p. 32.

36 See Jean-Philippe Antoine, 'Photography, Painting and the Real: The Question of Landscape in the Painting of Gerhard Richter,' in *Gerhard Richter*, Paris: Editions Dis Voir, 1995, pp. 53–89.

37 The use of chance by Richter is not a featured end in itself as in Dada collage but a method for ensuring that subjective personal preference in the process of color selection/placement be held in check. It might be noted that the arrangement of different color squares in Ellsworth Kelly's much earlier *Colors for a Large Wall* (1951) in the collection of the Museum of Modern Art, New York was also made arbitrarily but, in this case, according to personal taste. See E. C. Goossen, *Ellsworth Kelly*, New York: The Museum of Modern Art, 1973, p. 45. Whereas Kelly's painting is based on the understanding that chance and taste are interconnected, Richter's Color Charts take issue with this alliance in order to challenge the latter by means of the former.

38 Statement in *Kunst bleibt Kunst. Projekt '74* (exh. cat.), Cologne: Wallraf-Richartz-Museum, Kunsthalle Köln, Kunst- und Museumsbibliothek, Kölnische Kunstverein, 1974, p. 295.

39 Statement in *Fundamentele Schilderkunst/Fundamental Painting* (exh. cat.), Amsterdam: Stedelijk Museum, 1975, p. 57.

40 This approach is anticipated in a series of Details from 1970 whose abstract imagery Richter derived from taking close-up photographs of small paint globules. The camera serves in these works to translate the materiality of paint into the reality of painted subject matter.

41 Suggested by the artist in conversation with the author, January 1985. Kawara has also commented in conversation on the relationship of the date paintings with cave painting insofar as the latter emerged from darkness as a result of light imported into the cave. Although cave paintings exist in darkness, they reflect reality observed in the light of day.

42 See *On Kawara: continuity/discontinuity 1963–1979* (exh. cat.), Stockholm: Moderna Museet, 1980, for a list of subtitles used from 1966 to 1972. Subtitles in January 1966 included 'New York's traffic strike;' 'I thought about memory and sense;' 'I am painting this painting;' and 'USA began to bomb North Vietnam again.'

43 Blinky Palermo was the name of the manager for Sonny Liston, the boxer. Joseph Beuys is said to have told Palermo that he looked like him when wearing a certain hat. Palermo assumed this name in 1963 instead of continuing to use the name Peter Heisterkamp.

44 Giulio Paolini, in Germano Celant, *Giulio Paolini*, New York: Sonnabend Press, 1972, p. 16.

45 *Giulio Paolini: Survey of Works 1960–1980* (exh. cat.), Stedelijk Museum, Amsterdam and The Museum of Modern Art, Oxford, 1980, p. 12.

46 Craig Owens, *Giulio Paolini* (brochure), New York: Marian Goodman Gallery, 1987, specifically notes how the gaze of the artist himself, wearing sunglasses, is obscured by the stretcher bars. See also Celant, *Giulio Paolini*, p. 52ff for a discussion of this work in relation to the development of Paolini's work after 1965.

47 Paolini, in Susan Taylor, 'A Conversation with Giulio Paolini,' *The Print Collectors Newsletter* 15, 5, November/December 1984, p. 166.

48 In *Giulio Paolini: Survey of Works 1960–1980*, p. 28.

49 Paolini, 'Identikit,' *Artforum* 30, 7, March 1992, pp. 74–75.

50 Toroni, in Catherine Lawless, 'Entretien avec Niele Toroni,' *Les Cahiers du Musée national d'art moderne* 25, Automne 1988, p. 113.

51 In *Documenta 7* (exh. cat.), Kassel, 1982, Vol. I, pp. 84–85. This translation by Stefan Germer.

[Two] Medium as Message/Message as Medium

1 Clement Greenberg, 'Modernist Painting,' in Gregory Battcock (ed.), *The New Art: A Critical Anthology*, New York: E. P. Dutton & Co., 1966, p. 102.

2 Greenberg, 'The New Sculpture,' in *Art and Culture: Critical Essays*, Boston: Beacon Press, 1961, p. 139.

3 See *Word/Image in Contemporary Art: (Pour un art de l'écriture)* (exh. cat.), Union, New Jersey, The James Howe Gallery, Kean College of New Jersey, 1992, with text by Lewis Kachur, pp. 1–16, for a concise introduction to pictorial uses of language since 1960 including reference to Smithson's early drawings with words such as 'algae' or 'ice' (that look like what they signify).

4 See *David Lamelas: A New Refutation of Time* (exh. cat.), Munich, Kunstverein and Rotterdam, Witte de With,

Center for Contemporary Art, 1997, p. 74.

5 Works are identified according to the artist's cataloguing system. See *SPECIFIC & GENERAL WORKS*, Villeurbanne: Le Nouveau Musée/Institut d'Art Contemporain, 1993. Works are dated according to when they were first presented.

6 See Weiner, in Lynn Gumpert, 'Lawrence Weiner: Interview by Lynn Gumpert,' in *Lynda Benglis, Joan Brown, Luis Jimenez, Gary Stephan, Lawrence Weiner: Early Work* (exh. cat.), New York: New Museum of Contemporary Art, 1982, p. 48.

7 Ibid., p. 45.

8 Ibid., p. 49.

9 In Lucy Lippard (ed.), *Six Years: The Dematerialization of the Art Object from 1966 to 1972*, New York: Praeger, 1973, pp. 131–32.

10 See Birgit Pelzer, 'Dissociated Objects: The Statements/Sculptures of Lawrence Weiner,' *October* 90, Fall 1999, pp. 91–92, for further analysis of these drawings, also called 'grid time drawings' by Weiner, who has pointed out that the 'm' stands for 'mass.'

11 Weiner, in Willoughby Sharp, 'Lawrence Weiner at Amsterdam,' *Avalanche* 4, Spring 1972, p. 71.

12 For the first exhibition of its kind, in which works were actually constructed according to how either invited individuals or the artist decided to envision them, see *Lawrence Weiner: Werke & Rekonstructionen/Works and Reconstructions* (exh. cat.), Bern, Kunsthalle Bern, 1983.

13 See Alexander Alberro and Alice Zimmerman, 'Survey: NOT HOW IT SHOULD WERE IT TO BE BUILT BUT HOW IT COULD WERE IT TO BE BUILT,' in Alexander Alberro and Alice Zimmerman, Benjamin H. D. Buchloh, David Batchelor, *Lawrence Weiner*, London: Phaidon Press, 1998, p. 38.

14 See Weiner, in Gumpert interview, 1982, p. 48.

15 Weiner, in David Batchelor, 'I Am Not Content: Lawrence Weiner interviewed by David Batchelor,' *Artscribe International* 74, March/April 1989, p. 50.

16 See Benjamin H. D. Buchloh (ed.), *Lawrence Weiner: Posters November 1965–April 1986*, Halifax: The Press of the Nova Scotia College of Art and Design, 1987, pp. 14–15, where it is incorrectly catalogued as 'street poster' by 'unknown publisher.'

17 Weiner, in Sharp, 'Lawrence Weiner at Amsterdam,' p. 71.

18 In Robert C. Morgan, 'A Conversation with Lawrence Weiner,' *REALLIFE*, 11/12, Winter 1983, p. 36.

19 Weiner, in Naomi Gilman, 'The Printed Brushstroke,' *Grey City Art Journal*, 3 February 1978, p. 7.

20 Weiner's oeuvre may be owned privately yet shared publicly (through publication and/or exhibition with the owner's permission). He has assigned a certain percentage of his works to a personally designated category of ownership titled 'Collection Public Freehold.' These works, assigned to the public domain, are not available for private or institutional purchase.

21 Weiner, in conversation with the author, 1987.

22 See Robin White, 'Interview by Robin White,' *View* I, 2, Oakland, Calif.: Crown Point Press, May 1978, p. 9.

23 Barry, in an unpublished taped symposium, Feb. 8, 1968, in

conjunction with the exhibition, *Carl Andre, Robert Barry, Lawrence Weiner*, Bradford Junior College, Bradford, Mass., quoted in Lippard (ed.), *Six Years*, p. 40.

24 See Arthur R. Rose, 'Four Interviews: with Barry, Huebler, Kosuth, Weiner,' *Arts Magazine*, 43, 4, February 1969, p. 22 for the artist's description of the logical steps in his development. (Arthur Rose is a pseudonym for Joseph Kosuth. The artists wrote their own sections rather than meeting for an interview.) See also René Denizot/Robert Barry, *mot pour mot/word for word: It's about time–il est temps*, Paris: Yvon Lambert, 1980, p. 9: according to Barry all his work 'probably comes out of the same concerns: isolated instances in space and time, for one.'

25 Barry, in Erich Franz (ed.), 'Discussion: Robert Barry & Robert C. Morgan,' *Robert Barry*, Bielefeld: Karl Kerber Verlag, 1986, p. 71.

26 Barry, in 'Four Interviews,' p. 22.

27 In conversation with the author, September 1993.

28 As of 1972 the words were professionally printed, whereas previously Barry had photographed words that he had typed himself, initially using the negatives of photographs taken directly from the Index Card pieces. In *Blue Circle* (1973), Barry introduced imagery into the Projections, consisting, in some cases, of old photographs or photographs he himself had taken much earlier. In all cases, projected images are framed within a circular format to emphasize their character as details of a larger whole. In certain Projections Barry also has used colored shapes that intervene between the presentation of individual words.

29 Wilson, in *Conceptual Art and Conceptual Aspects* (exh. cat.), New York: New York Cultural Center, 1970, p. 33.

30 See 'Ian Wilson, November 12, 1969,' in Ursula Meyer, *Conceptual Art* (New York: Dutton, 1972), p. 220: 'It occurred to me when I looked at a Robert Morris sculpture it would be possible for me to say it, to describe it quite easily. I went away thinking that it was not necessary for me to see that sculpture again, I could just say it – not even say it – but think it. It was so primary, so reduced to one unit.'

31 Unless otherwise noted, this and ensuing information about Wilson's methodology was obtained by the author in conversation with the artist, September 1993.

32 Wilson, letter to the author, December 1993.

33 Wilson, in conversation with the author, 6 December, 1993.

34 'Ian Wilson, An Interview,' *Data* 1, September 1971, p. 32.

35 'Ian Wilson, November 12, 1969,' in Meyer, *Conceptual Art*, p. 221.

36 Ibid., p. 220.

37 Kosuth, in 'Art as Idea as Idea: An Interview with Jeanne Siegel,' *Art after Philosophy and After: Collected Writings, 1966–1990*, Cambridge, Mass.: The MIT Press, 1991, p. 49.

38 Kosuth, 'Art After Philosophy,' in *Collected Writings*, pp. 24, 21.

39 'Interview with Jeanne Siegel,' *Collected Writings*, p. 50.

40 Kosuth, 'Art After Philosophy,' in *Collected Writings*, p. 19–20.

41 Kosuth, '[Notes] on an anthropologized "art,"' in *Collected Writings*, p. 99.

42 *Roget's International Thesaurus*, New York, 1961, p. x.

43 In *When Attitudes Become Form* (exh. cat.), Bern: Kunsthalle Bern, 1969, n.p.

44 Lewis Carroll, 'Introduction to Learners,' in William Bartley III (ed.), *Lewis Carroll's Symbolic Logic*, New York: Clarkson N. Potter, 1977, pp. 52–53.

45 Michael Baldwin and Mel Ramsden, in literary and conversational association with Charles Harrison, continue to work under the name of Art & Language. See Charles Harrison, *Essays on Art & Language*, Oxford: Basil Blackwell, Ltd., 1991.

46 This exhibition featured Bainbridge's *Loop*, whose presence was made tangibly rather than visibly known to spectators by means of electrical circuitry. See William Wood, 'The Fish Ceases to be a Fish: A Critical History of English Conceptual Art,' unpublished thesis submitted to the University of Sussex, January 1998, pp. 139–41 regarding this work and the genesis of Art & Language.

47 Baldwin and Ramsden in letter to the author, 22 March 1995.

48 'Soft-Tape 1966–67,' in *Art & Language* (exh. cat.), Eindhoven: Municipal Van Abbemuseum, 1980, p. 18.

49 Ibid., p. 17.

50 See Michael Baldwin, Charles Harrison, Mel Ramsden, *Art & Language in Practice*, Vol. 1 (exh. cat.), Barcelona: Fundació Antoni Tàpies, 1999, p. 145.

51 *Ian Burn: Minimal-Conceptual Work* (exh. cat.), Perth: Art Gallery of Western Australia, 1992, p. 70. For a critical overview of Burn's early work, see Michiel Dolk, 'It's only art conceptually,' pp. 17–44.

52 See *Ian Burn* (exh. cat.), p. 75: 'The *Mirror Pieces* and the *Undeclared Glasses* were questioning the qualification of things to an art-status....'

53 Burn in Baldwin et al., *Art & Language in Practice*, Vol. 1, p. 25.

54 *Ian Burn* (exh. cat.), p. 93.

55 Ramsden, in conversation with the author, March 2000.

56 Baldwin et al., *Art & Language in Practice*, Vol. 1, p. 125.

57 Ibid., illustration, p. 234.

58 'Frameworks,' *Art & Language*, p. 4.

59 Ibid., p. 5.

60 Ibid., p. 23 (reprinted from 'Introduction,' in *Art-Language* Volume 1, Number 1, May 1969) regarding the 'Air Show' as being 'a series of assertions concerning a theoretical usage of a column of air comprising a base of one square mile and of unspecified distance in the vertical dimension.' Excerpts from some of the artists' preliminary notes are included.

61 Ibid., pp. 3–4.

62 See Charles Harrison and Fred Orton, *A Provisional History of Art & Language*, Paris: Editions E. Fabre, 1982, p. 26.

63 Charles Harrison, 'Art & Language: Some Conditions and Concerns of the First Ten Years,' in *Art & Language: The Paintings* (exh. cat.), Brussels: Société des Expositions du Palais des Beaux-Arts, 1987, p. 6.

64 According to a letter to the author from Baldwin and Ramsden, 15 March 2000, *Index (01)* came about when Joseph Kosuth, invited to participate in Documenta V, proposed a collaboration with A&L. In England, Atkinson, Baldwin, Howard, Lemaster, Pilkington, and Rushton contributed to the initial collection of materials and conceptualization of the work. In Kassel, Hurrell, Kosuth, and Ramsden added further items to the cabinets as did

Charles Harrison. The work was also discussed with Burn. I am grateful to Mayo Thompson for sharing his insights into this work, December 1995.

65 See Michael Corris, 'inside a new york art gang: selected documents of art & language, new york,' in Alexander Alberro and Blake Stimson (eds), *Conceptual Art: A Critical Anthology*, Cambridge, Mass.: The MIT Press, 1999, pp. 470–85.

66 See Nancy Marmer, 'Art & Politics '77,' *Art in America* 65, 4, July–August 1977, pp. 64–66, for contextual background on the founding of these magazines and an account of the many individuals involved.

67 In Clive Phillpot (ed.), 'Words and Word Works (4 pages),' *Art Journal*, Summer 1982, p. 122.

68 In Franz (ed.), *Robert Barry*, p. 75.

69 Lippard (ed.), *Six Years*, p. 182.

70 Wilson, in 'Conceptual Art,' *Artforum* 22, 6, February 1984, p. 60.

71 Kosuth, *Collected Writings*, p. 181.

[Three] **Photography: Restructuring the Pictorial**

1 Robert Rauschenberg, in Charles F. Stuckey, 'Rauschenberg's Everything, Everywhere Era,' in *Robert Rauschenberg: A Retrospective* (exh. cat.), New York, Solomon R. Guggenheim Museum: 1997, p. 36.

2 In Georgia Lobacheff, 'Interview,' in *Richard Long: São Paulo Bienal 1994*, London: The British Council, 1994, p. 7.

3 Long, in Martina Giezen, *Richard Long in Conversation: Bristol 19.11.1985*, Noordwijk, Holland: MW Press, 1985, p. 3.

4 See Nancy Foote, 'Long Walks,' *Artforum* 18, 10, Summer 1980, pp. 42–47.

5 Giezen, *Richard Long in Conversation*, p. 1.

6 Ibid.

7 Ibid., p. 18.

8 See Alanna Heiss, 'Another Point of Entry: An Interview with Dennis Oppenheim,' in *Dennis Oppenheim: Selected Works 1967–90* (exh. cat.), New York: The Institute for Contemporary Art: 1992, p. 145: 'You can't understand how strange it was to be a sculptor who exhibited photographs. You operated on a truly large scale, but when photographs represented the work everything closed down into a pictorial configuration.'

9 Oppenheim in 'Excerpts from a Symposium on Earth Art held at Cornell University, 6 February 1969,' in *Earth Art* (exh. cat.), Ithaca, New York: Cornell University, Andrew Dickson White Museum, n.p.

10 See *Dennis Oppenheim: Selected Works 1967–90*, pp. 24–25, for a complete description.

11 *Earth Art*, n.p.

12 See *Dennis Oppenheim: Selected Works 1967–90*, p. 62; Oppenheim sees the work as being a 'reversal of energy expenditure,' with the sun being the driving force for bringing about color change.

13 The photographs were taken by Richard Steinmetz.

14 'Eleanor Antin,' in John T. Paoletti (ed.), *No Title: The Collection of Sol LeWitt* (exh. cat.), Middletown, Conn.: Wesleyan University in association with the Wadsworth Athenaeum, Hartford, 1981, p. 21.

15 For a couple of years, until about 1961, Hilla Becher taught her own photography class to interested fellow students. Photography was considered a trade at this time and therefore was not included in the curriculum of German art schools. A decade and a half later, the Academy established a professorship in photography. Bernd Becher was invited to fill this position, which he still holds.

16 Bernd Becher, in Angela Grauerholz and Anne Ramsden, 'Photographing Industrial Architecture: An Interview with Hilla and Bernd Becher,' *Parachute* 22, Printemps 1981, p. 15.

17 Ibid.

18 Hilla Becher, in conversation with the author, March 1998.

19 For this exhibition, they grouped single photographs in serial form for the first time.

20 Bernd and Hilla Becher (trans. Richard Bairstow), 'Anonyme Skulpturen,' *Kunst-Zeitung* 2, January 1969, n.p.

21 Although their photographic research has resulted in an enormous archive of now demolished structures, 'Preservation wasn't the motivation. It's a side effect.' See Bernd and Hilla Becher, 'Interview par James Lingwood: Bernd et Hilla Becher – la petite musique des hauts fourneaux/The Music of the Blast Furnaces,' *Art Press*, vol. 209, January 1996, p. 23.

22 See Bernd and Hilla Becher, 'Anonyme Skulpturen.'

23 See Grauerholz and Ramsden, 'Photographing Industrial Architecture,' p. 18, regarding the Bechers' preference for display situations that permit them to present the printed image directly on the wall rather than necessitating reproduction in book form. Nonetheless, they have produced roughly two dozen publications devoted to specific types of structures such as water towers, framework houses, and mineheads.

24 Carl Andre, 'A Note on Bernhard and Hilla Becher,' *Artforum* 11, 4, December 1972, p. 59.

25 See *Bernd und Hilla Becher*, 1981, p. 99, for an illustration of this category (Objects of Different Function). *Coal Bunker-House-Gas Holder-Transformator- Hightension Pylon-Storage Bin-Water Tower-Cooling Tower-Winding Tower*, listed in the collection of Carl Andre, consists of nine photographs, in an overall square format of three rows of three, which were taken between 1961 and 1972.

26 Bernd Becher, in Seth Siegelaub, 'The Context of Art/The Art of Context,' *Kunst & Museumjournaal* 7,1–3, 1996, p. 66.

27 See I. Michael Danoff, introduction to *Photographs of Hilla and Bernhard Becher* (exh. cat.), Milwaukee, Wis.: Milwaukee Art Center, 1978, regarding the logistical demands of the Bechers' working methods, which involve transporting and setting up a large-format camera, obtaining permission to enter the premises of a working plant, and having to wait for proper weather and lighting conditions as well as for moments without much or any human activity in the vicinity.

28 Grauerholz and Ramsden, 'Photographing Industrial Architecture,' p. 18.

29 Ibid., p. 15.

30 Bernd and Hilla Becher, in Lynda Morris, 'Introduction,' in *Bernd & Hilla Becher* (exh. cat.), London: The Arts Council of Great Britain, 1974, n.p.

31 Ibid.

32 Grauerholz and Ramsden, 'Photographing Industrial Architecture,' p. 18.

33 Bernd Becher, 'Interview par James Lingwood,' p. 25.

34 See Weston Naef, 'The Art of Bernd and Hilla Becher,' in Bernd and Hilla Becher, *Watertowers*, Cambridge, Mass.: The MIT Press, 1988, p. 10, regarding the Bechers' relationship to – and initial lack of awareness of – the photographs of earlier German photographers. According to Hilla Becher, in conversation with the author in March 1998, she had known the work of Renger-Patzsch since childhood, and learned of the work of Sander in the 1960s, but was not familiar with Americans such as Walker Evans until later.

35 Both illustrated in Klaus Honnef, Rolf Sachsse, and Karin Thomas (eds), *German Photography 1870–1970*, Cologne: Dumont Buchverlag, 1997, p. 179.

36 For illustrated examples, see Ann and Jürgen Wilde, *Albert Renger-Patzsch: Ruhrgebiet-Landschaften, 1927–1935*, Cologne: DuMont Buchverlag, 1982.

37 See Suzanne Lange, 'August Sander, Karl Blossfeldt, Albert Renger-Patzsch, Bernd and Hilla Becher: Comparative Concepts,' in *August Sander, Karl Blossfeldt, Albert Renger-Patzsch, Bernd und Hilla Becher: Vergleichende Konzeptionen* (exh. cat.), Cologne: Photographischen Sammlung/SK Stiftung Kultur and Munich: Schirmer/Mosel, 1997, pp. 139–45.

38 Ibid., p. 147: Gabriele Conrath-Scholl, 'August Sander: People of the 20th Century – A Work Emerges.'

39 Hilla Becher, in Andre, 'A Note on Bernhard and Hilla Becher,' p. 59.

40 See 'Interview par James Lingwood,' p. 25, where Hilla Becher draws a parallel with portraiture and states that 'you have to show the skin and the structure' while trying not 'to make very glamorous pictures with these forms.'

41 Grauerholz and Ramsden, 'Photographing Industrial Architecture,' p. 18.

42 Jan Dibbets, in Rudi Fuchs, 'Jan Dibbets: Seeing is Believing,' *Art News* 86, 7, September 1987, p. 67.

43 The exhibition, 'Dies alles Herzchen, wird einmal Dir gehören,' or '19:45–21:55,' for which a catalogue exists, was organized by Paul Maenz, who established his gallery in Cologne in 1970. See *1970–1975: Paul Maenz Köln*, Cologne, 1975.

44 See Lucy Lippard (ed.), *Six Years: The Dematerialization of the Art Object from 1966 to 1972*, New York: Praeger, 1973, p. 30 and conversation with the author, November 2000.

45 Jan Dibbets, in ibid., p. 59.

46 Bruce Boice, 'Jan Dibbets: The Photograph and the Photographed,' *Artforum* 11, 8, April 1973, p. 45.

47 'Jan Dibbets in Conversation with Charlotte Townsend,' *ArtsCanada* vol. 158–159, Aug./Sept. 1971, p. 50.

48 See *The Tate Gallery 1972–74: Biennial Report and Illustrated Catalogue of Acquisitions*, London: The Tate Gallery, 1975, p. 126.

49 John Baldessari, in *John Baldessari: Works 1966–1981* (exh. cat.), Eindhoven: Stedelijk Van Abbemuseum and Essen, Museum Folkwang, 1981, p. 6.

50 Ibid.

51 Baldessari, *Works 1966–81*, p. 6.

52 See Baldessari, in 'Interview with John Baldessari,' in *John Baldessari: National City*, p. 90: 'I was intrigued by the idea that you could teach art, because I was rapidly coming to the idea that it couldn't be taught.'

53 Ibid., p. 87.

54 Ibid., p. 97.

55 Ibid.

56 Baldessari, *Works 1966–81*, p. 6.

57 Baldessari, in Jeanne Siegel, 'John Baldessari: Recalling Ideas,' in Siegel (ed.), *Art Talk: The Early 80s*, New York: Da Capo Press, Inc., 1988, p. 38.

58 Baldessari, in van Bruggen, *John Baldessari*, p. 62.

59 Ibid., p. 35.

60 Baldessari, in a lecture given to The Society of Contemporary Art, The Art Institute of Chicago, 1984.

61 Baldessari, *Works 1966–81*, p. 49.

62 Ibid. See also James R. Hugunin, 'Cluing in to Baldessari,' *New Art Examiner*, September 1990, p. 27, regarding this work's 'move beyond Saussure's strict, symmetrical model of sign production toward the poststructural model of the infinite play of difference, the endless play of signifiers; here the Saussurean distinction between signifier (form) and signified (content) is itself problematized.'

63 Ibid.

64 *January 5–31, 1969* (exh. cat.), New York: Seth Siegelaub Gallery, 1969, n.p.

65 See Frederik Leen, 'Seth Siegelaub: Conceptual Art; Exhibitions,' in *Forum International* 2, 9, September 1991, p. 66. Siegelaub is quoted as saying that 'for the Huebler show, the pieces were lying in the closet. There was nothing on the wall. As a matter of fact, we did have some people that came up to the door… maybe two or three people a week who walked in from the street, or called up.'

66 *Primary Structures: Younger American and British Sculptors* (exh. cat.), New York: The Jewish Museum, 1966, n.p.

67 Huebler, in a letter to the author, 22 September 1994.

68 Huebler, in conversation with the author, June 1994. Many different ideas were implemented simultaneously during this period.

69 Published in *Douglas Huebler* (exh. cat.), Eindhoven: Van Abbemuseum Eindhoven, 1979, n.p.

70 Huebler, lecture at the Block Gallery, Northwestern University, Evanston, Illinois, 21 January 1993.

71 Huebler, conversation with the author, June 1994.

72 See 'Douglas Huebler,' *bulletin 39*, Amsterdam: Art & Project, 1971.

73 Michael Auping, 'Talking with Douglas Huebler,' *Journal*, 15, The Los Angeles Institute of Contemporary Art, July–August 1977, p. 38.

74 See, for example, *Douglas Huebler 'Variable', Etc.* (exh. cat.), Limoges: FRAC Limousin, 1992, p. 133.

75 Huebler, 'Art Without Space Symposium,' WBAI-FM, New York, 2 November, 1969, in Lippard (ed.), *Six Years*, p. 130.

76 Gilbert, in Robert Violette and Hans-Ulrich Obrist (eds), *The Words of Gilbert and George*, USA and Canada: Violette Editions, 1997, p. 176.

77 Gilbert and George, in Martin Gayford, 'Interview,' in *Gilbert & George* (exh. cat.), Bologna: Galleria d'Arte Moderna di Bologna and Milan: Edizioni Charta, 1996, pp. 49 and 51.

78 Gilbert and George, in Calvin Tomkins, 'Review of the Singing Sculpture at Sonnabend 1971,' *The New Yorker*, 9 October 1971, in Carter Ratcliff and Robert Rosenblum, *Gilbert & George: The Singing Sculpture*, New York: Anthony McCall, 1993, p. 57.

79 Gilbert and George, 'We Met in London Last Year,' in *Studio International*, 179, 922, May 1970, pp. 218–21. Illustrated in *Gilbert & George 1968–1980* (exh. cat.), Eindhoven: Municipal Van Abbemuseum, 1980, p. 51.

80 'A Conversation between Gilbert and George and Démosthène Davvetas,' in *Gilbert & George: The Charcoal on Paper Sculptures 1970–1974* (exh. cat.), Bordeaux: Musée d'art contemporain de Bordeaux, 1986, p. 14.

81 See *Gilbert & George*, 1980, p. 61, for an illustration.

82 *Gilbert & George* 1986, p. 13.

83 *Gilbert & George* 1996, p. 77.

84 Ibid., p. 79.

85 Ibid., p. 135.

86 'What Our Art Means,' in *Gilbert & George: The Complete Pictures 1971–1985*, New York: Rizzoli, 1986, p. vii.

87 Tony Godfrey, 'Sex, Text, Politics: An Interview with Victor Burgin,' *Block* vol. 7, 1982, p. 7.

88 Burgin, 'Art, Common Sense and Photography,' *Camerawork* vol. 3, July 1976, p. 1.

89 Godfrey, 'Sex, Text, Politics,' p. 3.

90 Burgin, 'Situational Aesthetics,' *Studio International* 178, 915, October 1969, p. 120.

91 Ibid.

92 Ibid.

93 Ibid., p. 121.

94 These three works are published in Burgin, *Work and Commentary*, London: Latimer New Dimensions Ltd., 1973.

95 Burgin, 'Art, Common Sense and Photography,' p. 2.

96 Godfrey, 'Sex, Text, Politics,' p. 5.

97 See Burgin, *Between*, London: Basil Blackwell Ltd., 1986 for illustration of the entire series.

98 Burgin, 'Art, Common Sense and Photography,' p. 1.

99 Ibid. See Burgin, *The End of Art Theory: Criticism and Postmodernity*, Atlantic Highlands, New Jersey: Humanities Press International, Inc., 1986, p. 16.

100 Burgin, *Work and Commentary*.

101 Burgin, *Between*, p. 24.

102 Statement accompanying *Location Piece # 2, New York City – Seattle, Washington*, July 1969. Published by Multiples, Inc., New York 1970.

103 Huebler, in Gerd de Vries (ed.), *On Art: Artists' Writings on the Changed Notion of Art after 1965*, Cologne: M. Dumont Schauberg, 1974, p. 118.

[Four] **Systems, Seriality, Sequence**

1 Sol LeWitt, 'Paragraphs on Conceptual Art,' *Artforum* 5, 10, Summer 1967, p. 80. Republished in Adachiara Zevi (ed.), *Sol LeWitt Critical Texts*, Rome: I Libri di AEIOU, Editrice Inonia, 1994, p. 79.

2 LeWitt, in *Sol LeWitt* (exh. cat.), New York: The Museum of Modern Art, 1978, p. 50.

3 Ibid., p. 52.

4 Ibid.

5 According to LeWitt in conversation with the author on 1 November 1999, he saw this work in Flavin's studio as well as at the Green Gallery in 1964.

6 LeWitt, 'Serial Project #1, 1966' in *Aspen Magazine* 17, 5–6, Fall–Winter 1967, n.p. LeWitt's text is one of a number of contributions to this multimedia issue, guest edited by Brian O'Doherty and contained in a box. A subscription letter from the magazine's editor, Phillis Johnson, described how the box format spared the publication from being 'restricted to a bunch of pages stapled together.' LeWitt's text is reprinted in Zevi (ed.), *Sol LeWitt Critical Texts*, p. 75–77.

7 Ibid.

8 *Sol LeWitt* 1978, p. 88.

9 See Lawrence Alloway, 'Sol LeWitt: Modules, Walls, Books,' *Artforum* 13, 8, April 1975, p. 38. Alloway notes that 'LeWitt demonstrates the possibility of drawing as pure ratiocination' versus 'the notion of drawing as graphological disclosure.'

10 Quoted in 'Don Judd: An Interview with John Coplans,' *Don Judd* (exh. cat.), Pasadena: Pasadena Art Museum, 1971, p. 41.

11 Steve Reich, 'Music as a Gradual Process, 1968,' *Writings about Music*, Halifax: The Press of the Nova Scotia College of Art and Design, and New York: New York University Press, 1974, p. 9.

12 For a brief summary of Reich's methods, see 'Steve Reich,' in John T. Paoletti (ed.), *No Title: The Collection of Sol LeWitt* (exh. cat.), Middletown, Conn.: Wesleyan University in association with the Wadsworth Atheneum, Hartford, 1981, pp. 85–87. See also 'Philip Glass,' pp. 55–57, regarding the use of serial systems in music production of the late 1960s and 1970s.

13 See Adrian Piper, 'Xenophobia and the Indexical Present II: Lecture,' in *Out of Order, Out of Sight*, Cambridge: The MIT Press, 1996, vol. I, p. 255, where she states that her 'area of interest is xenophobia and racism' and that 'xenophobia is about fear of the other considered as an alien.'

14 Ibid., p. 4–5. See also p. 241, where she writes, 'Sol's sensibility in general has influenced me enormously. I see less connection with other conceptual artists working at that time. For me my earliest conceptual work succeeded insofar as it illuminated the contrast between abstract atemporality and the indexical, self-referential present.'

15 Ibid., p. 19.

16 Ibid.

17 Piper, *Out of Order, Out of Sight*, vol. I, p. 262.

18 Ibid.

19 Ken Johnson, 'Being and Politics,' *Art in America*, September 1990, pp. 158–59. Johnson suggests that Piper's background as a professor of philosophy (p. 159) reinforced her ability to present a logical argument in hopes 'that some kind of new (morally enlightened) behavior will or ought to follow from this cogitation' (p. 156).

20 Piper, *Out of Order, Out of Sight*, vol. II, p. 213.

21 Ibid., p. 214.

22 See Klaus Honnef, 'Art Encyclopedias of Culture: Klaus Honnef on Hanne Darboven,' in *Hanne Darboven: Primitive Zeit / Uhrzeit* (exh. cat.), Philadelphia: Goldie Paley Gallery, Moore College of Art, 1990, p. 7. In the daily process of

recording her appointments and keeping track of her activities in her diary, Darboven noticed the numerical progressions occurring with each day's change in date.

23 This translation by Horst Schastok.

24 Darboven, quoted in Eva Keller, 'I. Konstruktionen 1966/67,' in *Hanne Darboven* (exh. cat.), Basel: Kunsthalle Basel, 1991, p. 3. This translation by Horst Schastok.

25 In 'Artists on their Art,' *Art International*, 12, 4, April 20, 1968, p. 55.

26 See *Austellungen bei Konrad Fischer, Düsseldorf Oktober 1967–Oktober 1992*, Bielefeld: Edition Marzona, 1993, p. 14. See also Konrad Fischer, quoted in Georg Jappe, 'Interview with Konrad Fischer,' *Studio International* 181, 930, February 1971, p. 70. According to Fischer, he would often 'rely on the judgement of… artists. For example: I once had to put off a show with Sol LeWitt, and he recommended the drawings of… Hanne Darboven.'

27 See *L'Art Conceptuel I* (exh. cat.), Bordeaux: CPAC Musée d'art contemporain, 1988, pp. 72–74; *L'art conceptuel, une perspective* (exh. cat.), Paris: ARC, Musée d'Art Moderne de la Ville de Paris, 1989, p. 148.

28 Johannes Cladders (trans. Richard Bairstow), in 'Hanne Darboven: 6 Manuscripte "69",' *Kunst-Zeitung* 3, July 1969, n.p.

29 Darboven, 'Artists on their Art,' p. 55.

30 Darboven, in Amine Haase (trans. by Michael Schultz), 'An Interview with Hanne Darboven,' in *Hanne Darboven: Primitive Zeit/Urzeit*, p. 13.

31 Darboven, quoted in Ingrid Burgbacher-Krupka, 'On "the Concept of Time," A Conversation with Hanne Darboven,' *Hanne Darboven: The Sculpting of Time*, Ostfildern, Germany: Cantz Verlag, 1994, p. 72.

32 Darboven, in Lucy R. Lippard, 'Hanne Darboven: Deep in Numbers,' *Artforum* 12, 2, October 1973, p. 35.

33 Ibid., pp. 35–36.

34 Darboven, 'Artists on their Art,' p. 55.

35 Coosje van Bruggen, 'Afterword: Today Crossed Out,' in *Hanne Darboven*, p. 3.

36 In copies seen by the author, there is a mistake in the binding of the page sequences from 144 to 161 – a minor technical defect that does not detract from the awesome effect of the overall work.

37 See Isabelle Graw, 'Marking Time: Time and Writing in the Work of Hanne Darboven,' *Artscribe* 79, January–February 1990, pp. 68–71.

38 Darboven, in *Hanne Darboven: Primitive Zeit/Urzeit*, p. 13.

39 Unpublished letter to LeWitt in the Sol LeWitt Collection, Wadsworth Atheneum, Hartford, Connecticut, 19 October 1973.

40 In conversation with the author, July 1997.

41 Onomastics (the study of proper names) is treated in Justin Kaplan and Anne Bernays, *The Language of Names*, New York: Simon & Schuster, 1997. This book studies the importance of the proper name in the creation of fictional characters. Kawara's names, however, are not fictional.

42 This work may be resumed. See *On Kawara: continuity/discontinuity, 1963–1979* (exh. cat.), Stockholm: Moderna Museet, 1980, p. 105.

43 For a published selection of telegrams sent between 1970

and 1977, see *I AM STILL ALIVE: On Kawara*, Berlin: René Block, 1978. The quantity of telegrams sent on any one day or the quantity sent to any one person was not determined systematically.

44 The beginning and concluding dates vary according to the year in which Kawara began work on a particular edition. *One Million Years – Past* exists in twelve editions, while editions of *One Million Years – Future* are still in progress, about nine having been completed to date.

45 Paul Luttik, 'Realiteit in de kunst van de jaren '60,' in *Actie, werkelijkheid en fictie in de kunst van de jaren '60 in Nederland* (exh. cat.), Rotterdam: Museum Boymans-van Beuningen, 1979, p. 84. This translation by Alex Krikhaar. See also Harry Ruhé, *Fluxus. The Most Radical Experimental Art Movement of the Sixties*, Amsterdam: 'A,' 1979, n.p., for a partial list of Brouwn's 'actions,' which the artist defined as 'something anonymous, where the spectator – if present – completely unprepared becomes involved with it or not.' According to Ruhé, 'although Brouwn… doesn't want to be associated anymore with Fluxus, he took part in some of the manifestations.'

46 Quoted in Paul Witteman, 'Naar de weg vragen kunstwerk: Stanley Brouwn graaft paden in hele wereld,' *De Tyd*, May 30, 1969. This translation by Alma Koppedraijer.

47 Ibid.

48 Brouwn, *This way Brouwn, 25-2-61/26-2-61, Zeichnungen 1*, Cologne and New York: Verlag Gebr. König, 1971, n.p.

49 Ibid.

50 Ibid.

51 These were shown as a group in 1964 at the René Block Gallery, Berlin. According to Block (in conversation with the author, 1999), Brouwn had been working in this manner for several years.

52 This translation by Alma Koppedraijer.

53 Both works are illustrated in *stanley brouwn, la biennale di venezia 1982* (exh. cat.), Amsterdam: Visual Arts Office for Abroad, 1982, n.p. A third work, dated 1962, no. 13 in the catalogue checklist, is described: 'a walk through a grassfield exactly on the same line a–b; everyday during a full year (365x).'

54 Brouwn, in *Gerry Schum* (exh. cat.), Amsterdam: Stedelijk Museum, 1979/80, p. 30.

55 This and the park project generated interest in the local press, including Betty van Garrel, 'de padhonger van avantgardist brouwn,' *Haagse Post*, June 14, 1969. She writes, 'In the back of the garden of "Art & Project"… the lawn is interrupted by an earthen path 40 centimeters by 10 meters, which continues in the vicinity of the "Academy" in Copenhagen, and will be continued in Nairobi. A "This way Brouwn."' See also Martin Ruyter, 'Het Begon met Expositie van Schoenenzaken: De paden van Stanley Brouwn op, *de Volkskrant*, Dinsdag, 7 Oktober 1969. He writes: 'To someone who is willing to spend seventy guilders, Stanley Brouwn will sell a nicely printed certificate, which will give someone the right to consider a square of nine street tiles in front of the Art & Project house as the starting point of a personal This way Brouwn.' Ruyter continues that one can order a path at ten guilders per meter from anywhere in the world.

56 See Witteman, 'Naar de weg vragen kunstwerk,' who quotes Brouwn: 'When recently with students in Delft during a presentation of a film on space travel I showed with a pointer various spots in the universe, on Mars and Venus, which could be starting points for a This way Brouwn.'

57 The title of this exhibition refers to the city's population in the same manner as the exhibitions '557,087' and '955,000,' organized by Lucy Lippard for the Seattle Art Museum and the Vancouver Art Gallery, held in 1969/70. Brouwn was included only at this last venue of the exhibition.

58 See 'stanley brouwn at prospect69,' *art & project bulletin 11*, 9 September–12 October, 1969.

59 See Johannes Cladders, 'door kosmische stralen lopen,' *museumjournaal* 16, 3, July 1971, p. 135.

60 On pages 48–52 of the exhibition catalogue *18 PARIS IV.70*, Brouwn stipulated: 'A street 1000 lightyears long;' 'A street 1000.01 lightyears long;' 'A street 1000.02 lightyears long;' 'A street 1000.03 lightyears long;' 'A street 1000.04 lightyears long.' In this case, small numerical adjustments, rather than additions of zeros, represent 'astronomical' differences in the length of an imaginary street in outer space.

61 *Gerry Schum*, p. 30.

62 Rini Dippel, in *stanley brouwn, la biennale di venezia 1982* (brochure), Amsterdam: Visual Arts Office for Abroad, 1982, n.p.

63 See *stanley brouwn* (exh. cat.), Eindhoven: Stedelijk van Abbemuseum, 1976, nos. 93–99; and *stanley brouwn, la biennale di venezia 1982* (brochure), no. 17.

64 Jan Debbaut in *stanley brouwn: la biennale di venezia 1982*, n.p.

65 A book by Brouwn called *construction* (1972), for example, consists of ten pages of step measurements arranged in the format of a grid with one hundred steps per page. The first step in the book is 877 mm, and the last is 865 mm, but many other figures contribute to the representational variety that contrasts with the strict, evenly spaced compositional layout of the square pages.

66 For the range of variables see *stanley brouwn*, 1976, which features a checklist of 270 works made between 1960 and 1976.

67 Bochner, in 'Mel Bochner,' *Data* II, 2, February 1972, p. 64.

68 Ibid.

69 Bochner, in conversation with the author, November 1993.

70 'Mel Bochner,' p. 64.

71 In *Mel Bochner: Thought Made Visible 1966–1973* (exh. cat.), New Haven: Yale University Art Gallery, 1995, p. 48.

72 Ibid.

73 Ibid., p. 49.

74 See Bruce Boice, 'Mel Bochner: The Axiom of Indifference,' *Arts Magazine* 47, 6, April 1973, pp. 66–68.

75 Letter to the author, June 1995.

76 Ibid.

77 Christine Kozlov moved to England in 1978 to pursue the activities she had begun several years before in association with Art & Language in New York.

78 Kozlov, in *Non-Anthropomorphic Art by Four Young Artists: Joseph Kosuth, Christine Kozlov, Michael Rinaldi, Ernest Rossi* (exh. cat.), New York: Lannis Gallery, 1967, n.p.

79 Compare, for example, Sol LeWitt, in Andrew Wilson, 'Sol LeWitt Interviewed,' *Art Monthly* 164, March 1993, p. 7. LeWitt states: 'In the course of your mental meanderings through the day you reject a lot of ideas that come through your mind…. You throw them out as you go along. When you finally come to something that you think is fairly interesting, then you want to do that.'

80 Kozlov, in conversation with the author, April 1997.

81 As suggested by the title of *A Mostly Painting (Red)*, Kozlov has left open the option to create paintings that refer to colors other than red.

82 The text is an integral part of the work and, if no tape recorder is available, may be displayed alone.

83 *Mel Bochner: Thought Made Visible*, p. 55.

84 Ibid., p. 54.

[Five] **Subject as Object**

1 See *The Avant-Garde in Russia, 1910–1930, New Perspectives* (exh. cat.), Los Angeles: Los Angeles County Museum of Art, 1980, p. 186. The title of Lissitzky's first public lecture on his theories was 'Prouns: a Changing-Trains between Painting and Architecture.'

2 See Nancy Troy, *The De Stijl Environment*, Cambridge, Mass., and London: The MIT Press, 1983, pp. 124–26. According to Lissitzky: 'One keeps on moving round in an exhibition. Therefore the room should be so organized that of itself it provides an inducement to walk around in it.'

3 Quoted in *The Avant-Garde in Russia, 1910–1930*, p. 94.

4 Quoted in Adrian Henri, *Total Art: Environments, Happenings, and Performance*, New York, and Washington, D.C.: Praeger , 1974, p. 90.

5 Kaprow, 'Notes on the Creation of a Total Art,' in Jeff Kelley (ed.), *Essays on the Blurring of Art and Life: Allan Kaprow*, Berkeley, and Los Angeles: University of California Press, 1993, pp. 11–12.

6 Robert Morris, 'Notes on Sculpture, Part II,' in Gregory Battcock (ed.), *Minimal Art: A Critical Anthology*, New York: E. P. Dutton & Co., Inc., 1968, p. 232.

7 For further discussion of the issue of the spectator in the discourse surrounding Minimal Art, see Frances Colpitt, *Minimal Art: The Critical Perspective*, Seattle: University of Washington Press, 1993, pp. 67–99. Colpitt quotes Morris, p. 87: 'I wish to emphasize that things are in a space with oneself, rather than a situation where one is in a space surrounded by things.'

8 See Kathy Halbreich, 'Social Life,' in Joan Simon (ed.), *Bruce Nauman* (exh. cat., cat. raisonné), Minneapolis: Walker Art Center, 1994, p. 101: 'Nauman compared [this sculpture] to "choreographing a dance, but first the dancer's shoe is nailed to the floor."'

9 See notes to cat. no. 183, in Simon (ed.), *Bruce Nauman*, p. 247.

10 Ibid., notes to cat. no. 113, p. 223.

11 Bruce Nauman, in Ian Wallace and Russell Keziere, 'Bruce Nauman Interviewed,' *Vanguard* 8, 1, February 1979, p. 18.

12 Dan Graham, 'Subject Matter,' in *Dan Graham: Articles*, Eindhoven: Stedelijk van Abbemuseum, 1978, p. 65.

13 Quoted in Lucy R. Lippard (ed.), *Six Years: The Dematerialization of the Art Object from 1966 to 1972*, New York: Praeger, 1973, p. 158.

14 Graham, in conversation with the author, December 1995.

15 See Anne Rorimer, 'Reevaluating the Object of Collecting and Display,' *The Art Bulletin*, 77, 1, March 1995, pp. 21–24. Paradoxically, three decades later, this work has necessarily become scarce – and thus valuable – by virtue of its initial disposability and circulation outside of the art gallery system.

16 See Alexander Alberro, 'Reductivism in Reverse,' in *Tracing Cultures: Art History, Criticism, Critical Fiction*, ISP Documents #5, New York: Whitney Museum of American Art, 1994, pp. 9–29.

17 Benjamin H. D. Buchloh, 'Moments of History in the Work of Dan Graham,' in *Dan Graham: Articles*, p. 73.

18 Graham, 'Income Piece,' in *For Publication: Dan Graham* (exh. cat.), Los Angeles: Otis Art Institute of Los Angeles County, 1975, n.p.

19 Dan Graham, 'Lax/Relax,' in *Dan Graham: Theatre*, Ghent: Anton Herbert, 1978, n.p.

20 Ibid.

21 Graham, 'Body Press, 1970–1972, two 16 mm films, color,' in *Films: Dan Graham*, Geneva: Editions Centre d'Art Contemporain & Ecart Publications, 1977, p. 21.

22 Ibid., p. 9.

23 Graham, 'Essay on Video, Architecture and Television,' in Benjamin H. D. Buchloh (ed.), *Dan Graham: Video-Architecture-Television/Writings on Video and Video Works 1970–1978*, Halifax: The Press of the Nova Scotia College of Art and Design and New York: New York University Press, 1979, p. 62.

24 Graham, 'TV camera/monitor performance (1970),' in ibid., p. 2.

25 Graham, 'Present continuous past(s) (1974),' in ibid., p. 7.

26 Graham, 'Essay on Video, Architecture and Television,' in ibid., p. 64.

27 To date, this work remains in the form of a proposal only.

28 Graham, 'Notes on "Yesterday/today,"' in Buchloh (ed.), *Dan Graham*, p. 46.

29 Ibid., p. 45.

30 See, for example, *Dan Graham: Models to Projects*, New York: Marian Goodman Gallery, 1996, with an essay by Alexander Alberro.

31 Graham, 'Public Space/Two Audiences,' in Brian Wallis (ed.), *Rock My Religion, Writings and Art Projects, 1965–1990/Dan Graham*, Cambridge, Mass.: The MIT Press, 1993, p. 19.

32 Graham, 'Homes for America,' *Arts Magazine* 41, 3, December–January 1966–67, pp. 21–22.

33 This interdisciplinary magazine included contributions by writers, poets, performers, and visual artists. Its seven issues (nos. 1–6, and the supplement to no. 6) were published between April 1967 and July 1969.

34 See Vito Acconci, quoted in Achille Bonito Oliva, *Dialoghi d'artista: Oncontri con l'arte contemporanea 1970–1984*, Milan: Electa, 1984, p. 127: 'What I was concerned with in poetry wasn't so much meaning of words, but the act of reading from left to right, on a page, from up to down on a page, from one page to another. So what was of interest to me in writing was activity on a page.'

35 Acconci, 'Installment (Installation): Move, Remove,' in Maria Diacono, *Vito Acconci: Dal Testo-Azione al Corpo come Testo*, New York: Out of London Press, 1975, p. 98.

36 Acconci, in *Vito Acconci: A Retrospective: 1969 to 1980* (exh. cat.), Chicago: Museum of Contemporary Art, 1980, p. 10.

37 *Vito Acconci: Photographic Works 1969–1970* (exh. cat.), Chicago: Rhona Hoffman Gallery et al., 1988, n.p.

38 Ibid.

39 See John Perreault, 'Critique: Street Works,' *Arts Magazine* 44, 3, December 1969/January 1970, p. 18: 'Street Works began as a series of "group shows" co-ordinated by Marjorie Strider, Hannah Weiner and myself.' The first three were held on 15 March, 18 April, and 25 May 1969.

40 Sponsored by the Architectural League, New York, and held 3–25 October 1969.

41 Acconci, in Florence Gilbard, 'An Interview with Vito Acconci: Video Works 1970–78,' *Afterimage* 12, 4, November 1984, p. 9.

42 See Acconci, 'Following Piece,' in *Vito Acconci*, 1980, p. 13.

43 Acconci, 'Fall,' *Avalanche* 6, Fall 1972, p. 7.

44 Acconci, 'Rubbing Piece,' ibid., p. 9.

45 Acconci, 'Openings,' ibid., p. 22.

46 Acconci, 'Room Piece,' ibid., p. 16.

47 Acconci, 'Service Area,' ibid., p. 17.

48 Acconci, 'Untitled Project for Pier 17,' ibid., p. 42.

49 Acconci, in an interview with Martin Kunz, 'Interview with Vito Acconci about the Development of His Work since 1966,' in *Vito Acconci* (exh. cat.), Lucerne: Kunstmuseum Luzern, 1978, n.p.

50 Ibid.

51 Kate Linker, *Vito Acconci*, New York: Rizzoli, 1994, p. 56.

52 Acconci, in an unpublished note accompanying photo documentation at Rhona Hoffman Gallery, Chicago.

53 Ibid.

54 See *Vito Acconci: Think/Leap/Re-think/Fall* (exh. cat.), Dayton, Ohio: University Art Galleries, Wright State University, 1976, n.p.

55 Acconci, 'The Peoplemobile,' in *Vito Acconci*, 1980, p. 38.

56 Gillo Dorfles, 'Mono-Dialogue by James Coleman,' in *Irish Exhibition of Living Art* (exh. cat.), Dublin: Project Art Centre, 1972, p. 14.

57 Coleman maintains that this work may be updated by the creation and recording of additional descriptive texts. In conversation with the author, February 1994.

58 Coleman, in conversation with the author, April 1985.

59 See Jean Fisher, 'James Coleman,' in *James Coleman* (exh. cat.), Dublin, Douglas Hyde Gallery, 1982, p. 13.

60 Ibid., p. 34.

61 Jean Fisher, 'The Place of the Spectator in the Work of James Coleman,' *Open Letter* 5, 5–6, Summer–Fall 1983, p. 59.

62 Maria Nordman, in conversation with the author, September 1997. Subsequent quotes from Nordman not otherwise acknowledged in this chapter are excerpted from this interview or from ensuing telephone conversations.

63 Ibid.

64 Nordman, *DE SCULPTURA II: City Sculpture*, Ostfildern-Ruit: Cantz Verlag, and Essen: Museum Folkwang, 1997, p. 116.

65 Ibid.

66 Nordman asks that her work be described in the present tense, since she considers each piece to be ongoing although curtailed by practical considerations.

67 Nordman's terms 'known' and 'unknown' encapsulate such ideas as a person's cultural point of reference and/or prior knowledge, or not, of a work's context.

68 See Nordman, *DE MUSICA: New Conjunct City Proposals*, Münster: Westfälisches Landesmuseum, Lucerne: Kunstmuseum Luzern, New York: Public Art Fund Inc. and Dia Center for the Arts, Hamburg: Kulturbehörde, and Rennes: FRAC Bretagne, 1993, pp. 19–21, for a description and illustration of this work. The book itself was 'prepared as a sculpture' (p. 12) to shed light on different facets of her oeuvre while resisting chronological 'ordering.'

69 Germano Celant, 'Urban Nature: The Work of Maria Nordman,' *Artforum* 18, 7, Mar. 1980, p. 64.

70 Nordman, *DE SCULPTURA: Works in the City*, Munich: Schirmer/Mosel, 1986, p. 15.

71 Nordman continues to use the camera to record her work as a series of 'inter-images,' as she refers to them. In this way, documentation becomes 'a part of the work's making and not an outside process definitively imposed on it.' She considers verbal description and critical analysis by others also to be part of a work.

72 Nordman, *DE MUSICA*, p. 33.

73 See Nordman, *DE SCULPTURA II*, for descriptive information concerning a number of different works produced at her Pico Boulevard studio in the early 1970s.

74 The methods followed in this work were used again in November 1983 for another work, *Untitled: 165 N. Central*, which was shown during a series of exhibitions sponsored by The Museum of Contemporary Art, Los Angeles. Although circumstances do not usually allow for her works to be permanent, each possesses the potential for continuity with subsequent works realized under similar conditions.

75 See Nordman, *DE MUSICA*, p. 44.

76 A connected work was made for 'Reconsidering the Object of Art,' held at the Museum of Contemporary Art, Los Angeles. *Untitled: Alameda* (1995) was located behind the museum at Alameda and Temple streets. According to a text placed inside the museum, the work was open 'to people who pass by chance and to people who pass by choice.' The concave wedge built into the back of the museum differed in scale from that in Newport, and was seen in relation to an open urban expanse.

77 Nordman, 'Maria Nordman at Irvine,' *Avalanche* 8, Summer 1973, p. 68.

78 Ibid.

79 See *73rd American Exhibition* (exh. cat.), Chicago: The Art Institute of Chicago, 1979, p. 36. On her catalogue page, Nordman writes: 'In consideration of a place for at least 1,000 persons at a time, from a location of South Michigan and East Adams, Chicago, Illinois....' In this exhibition, organized by A. James Speyer and Anne Rorimer, related drawings were displayed in a wooden file cabinet.

80 See Benjamin H. D. Buchloh, 'Memory Lessons and History Tableaux: James Coleman's Archeology of Spectacle,' in *James Coleman: Projected Images: 1972–1994*, New York: Dia Center for the Arts, 1995, p. 56: 'The presentational format of the slide projection emerges then as an ideal device to sustain the dialectics between the pictorial and the photographic, between narrativity and stasis, between language in the performative and in the theatrical mode.' See also Coleman, in Richard Kearney, 'Interview with James Coleman,' *The Crane Bag* 6, 2, 1982, p. 130. Coleman states that in 1968 he began to define the idea for himself that 'art can never totally be reduced to a concept of simple acts of self-expression.'

81 Marcel Duchamp, 'The Creative Act,' lecture for the American Federation of Arts, Houston, 1957, in M. Sanouillet and E. Peterson (eds), *Salt Seller, The Writings of Marcel Duchamp (Marchand du Sel)*, New York: Oxford University Press, p. 140.

[Six] Context as Content: Surveying the Site

1 Kurt Schwitters, quoted in John Elderfield, *Kurt Schwitters*, New York: Thames and Hudson, 1985, p. 156. See Chapter 7 regarding the development of the *Merzbau* over a thirteen-year period.

2 See Nancy J. Troy, 'Mondrian's Designs for the *Salon de Madame B...*, à Dresden,' *The Art Bulletin* 62, 4, December 1980, pp. 640–47.

3 Quoted in 'Mondrian's Paris Atelier 1926–1931,' in Mildred Friedman (ed.), *De Stijl: 1917–1931: Visions of Utopia*, New York: Abbeville Press, and Minneapolis: Walker Art Center, 1982, p. 82.

4 According to Germano Celant, 'Artspaces,' *Studio International* 190, 977, September/October 1975, p. 120, at the exhibition of *The Void*, Klein stated: 'I burst into monochrome space, into the All, into the incommensurable pictorial sensibility...I felt myself outside all propositions and dimensions in the All.'

5 Dan Flavin, in *Dan Flavin: Pink and 'Gold'* (exh. cat.), Chicago: Museum of Contemporary Art, 1967, n.p. The 'catalogue' took the form of a computer printout, which visitors printed themselves using early IBM equipment installed during the exhibition.

6 Sol LeWitt, in *Sol LeWitt* (exh. cat.), New York: The Museum of Modern Art, 1978, p. 130.

7 Cat. no. 181, in *Sol LeWitt Wall Drawings: 1868–1984* (exh. cat.), Amsterdam: Stedelijk Museum; Eindhoven: Van Abbemuseum; and Hartford: Wadsworth Athenaeum, 1984, p. 171.

8 Quoted in *Sol LeWitt*, 1978, p. 139.

9 In 'Remarks on my Sculpture 1966–1986,' *Fred Sandback: Sculpture 1966–1986* (exh. cat.), Munich: Kunsthalle Mannheim, 1986, p. 12.

10 Ibid., p. 13.

11 Giovanni Anselmo, in *Giovanni Anselmo* (exh. cat.), Paris: Galerie Sonnabend, October 1969, n.p. The first paragraph of a longer statement by the artist reads: 'Moi, le monde, les choses, la vie – nous sommes des situations d'energie. L'essentiel est de ne pas cristaliser ces situations: de les maintenir ouvertes et vivantes en tant que fonctions de la vie.'

12 *Gordon Matta-Clark* (exh. cat.), Chicago: Museum of Contemporary Art, 1985, p. 112.

13 Quoted in *Gordon Matta-Clark* (exh. cat.), Antwerp:

International Cultureel Centrum, 1977, p. 10.

14 See Judith Russi Kirshner, 'Non-uments,' *Artforum* 24, 2, October 1985, pp. 103–8.

15 See Robert Hobbs, *Robert Smithson: Sculpture*, Ithaca and London: Cornell University Press, 1981, pp. 191–97. Smithson's estate has donated this work to the Dia Center for the Arts, New York. Dia already owns De Maria's *Lightning Field* in Quemado, New Mexico, and has supported Heizer's Nevada desert works and *Roden Crater* by James Turrell, which is located near Flagstaff, Arizona.

16 Cindy Nemser, 'An Interview with Stephen Kaltenbach,' *Artforum* 9, 3, November 1970, p. 52.

17 In *Richard Artschwager: Complete Multiples*, New York: Brooke Alexander Editions, 1991, n.p.

18 'Iain Baxter/N. E. THING CO., 'Interview by Robin White,' in *View*, Oakland, Calif.: Crown Point Press, 1979, p. 1.

19 Marcel Broodthaers, 'Gare au défi: Pop Art, Jim Dine and the Influence of René Magritte,' in Benjamin H. D. Buchloh (ed.), *Broodthaers: Writings, Interviews, Photographs*, October 42, Fall 1987, p. 34.

20 Ibid., 'Ten Thousand Francs Reward,' p. 43.

21 Ibid., p. 46.

22 See Douglas Crimp, 'This is Not a Museum of Art,' in *Marcel Broodthaers* (exh. cat.), Minneapolis: Walker Art Center, 1989, pp. 70–91.

23 Buchloh, 'Formalism and Historicity: Changing Concepts in American and European Art since 1945,' in *Europe in the Seventies: Aspects of Recent Art* (exh. cat.), Chicago: The Art Institute of Chicago, 1977, p. 98.

24 Broodthaers, 'Section des Figures,' in *Der Adler vom Oligozän bis heute* (exh. cat.), Düsseldorf: Städtische Kunsthalle, 1972, vol. II, p. 18. This translation by Angela Greiner.

25 See Rainer Borgemeister, '*Section des Figures*: The Eagle from the Oligocene to the Present,' in Buchloh (ed.), *Broodthaers*, p. 139.

26 See Broodthaers, 'Methode,' in *Der Adler vom Oligozän bis heute* (exh. cat.), Düsseldorf: Städtische Kunsthalle, 1972, vol. I, p. 13. See also Buchloh, 'The Museum Fictions of Marcel Broodthaers,' in A. A. Bronson and Peggy Gale (eds), *Museums by Artists*, Toronto: Art Metropole, 1983, pp. 45–56.

27 Broodthaers, 'Sections des Figures,' in *Der Adler vom Oligozän bis heute* (exh. cat.), p. 18.

28 Ibid.

29 Ibid., p. 19.

30 The exhibition, curated by Yves Gevaert, was entitled 'Carl Andre, Marcel Broodthaers, Daniel Buren, Victor Burgin, Gilbert & George, On Kawara, Richard Long, Gerhard Richter.'

31 Gevaert, in conversation with the author, April 1998.

32 On the occasion of the opening of the exhibition, a live camel from the Brussels zoo was led into the halls of the Palais des Beaux-Arts. Broodthaers's six-minute film, *Un Jardin d'Hiver (ABC)*, 1974, includes footage of the camel outside the museum. According to Gevaert (in conversation with the author, April 1998) Broodthaers requested a zebra (with reference to the stripes of Buren, perhaps?), but the zoo sent a camel instead.

33 Quoted in Birgit Pelzer, 'Recourse to the Letter,' in Buchloh (ed.), *Broodthaers*, p. 166.

34 Broodthaers, 'Ten Thousand Francs Reward,' in ibid., p. 40.

35 Daniel Buren, 'Beware,' in *Five Texts*, New York: The John Weber Gallery, and London: The Jack Wendler Gallery, 1973, p. 15.

36 Buren, in Rudi Fuchs (ed.), *Discordance/Coherence* (exh. cat.), Eindhoven: Stedelijk Van Abbemuseum, 1976, p. 4.

37 Ibid., p. 5.

38 Buren, 'L'art de la voile' et 'La toile devoilée,' in *Voile/Toile, Toile/Voile*, Berlin: Berliner Kunstlerprogramm und der Galerie Folker Skulima, 1975, n.p.

39 Buren, 'On Statuary,' in *Daniel Buren: around 'Ponctuations'*, Lyon: Le Nouveau Musée, 1980, n.p.

40 Buren, 'Function of the Museum,' *Artforum* 12, 1, September 1973, p. 68.

41 Ibid

42 Michael Asher in collaboration with Benjamin H. D. Buchloh, *Writings 1973–1983 on Works 1969–1979*, Halifax: The Press of the Nova Scotia College of Art and Design, and Los Angeles: The Museum of Contemporary Art, 1983, p. 89.

43 Ibid., p. 100.

44 Asher, printed handout, the Museum of Contemporary Art, Chicago, June 1979.

45 Ibid.

46 Asher and Buchloh, *Writings 1973–1983*, p. 199. This work was conceived for the permanent collection of The Museum of Contemporary Art, Los Angeles, before the relocation of the museum made the work inoperative.

47 Baumgarten, from an unpublished interview with the author, December 1999. This is the source of all other quotes by Baumgarten which follow unless otherwise identified.

48 Lothar Baumgarten and M. Oppitz, *T'E-NE-T'E: Eine mythologische Vorführung*, Düsseldorf: Konrad Fischer Gallery, 1974, details how the eagle feather has actually been used by different North American societies.

49 Baumgarten developed this work in *Die Namen der Bäume*, which functioned as an exhibition in 1982 at the Stedelijk Van Abbemuseum, Eindhoven. For the full title of *Tropenhaus*, which includes reference to *Zwei Reisen nach Brasilien 1548–1549 und 1550–1555* by the sixteenth-century musketeer Hans Staden, see p. 380, no. 55.

50 Baumgarten, in conversation with the author, June 1989.

51 The equipment was rented from the school, which led to the invitation to exhibit at the gallery.

52 The book's title is: *A special note of gratitude must be expressed towards the fact that the work was completed in considerably less time than had been allotted*.

53 A note on the back of the card reads: 'The color selection was taken from the Campbells' master bathroom tile.'

54 Hans Haacke in *Conceptual Art and Conceptual Aspects* (exh. cat.), New York: The New York Cultural Center, 1970, p. 32.

55 Haacke, statement of 7 January 1962 in 'Essays, Texte, Interviews von 1962–1971,' in Edward F. Fry (ed.), *Hans Haacke: Werkmonographie*, Cologne: DuMont Schauberg, 1972, p. 23. This translation by Claudia Mesch. See also Jeanne Siegel, 'Hans Haacke: Systems Aesthetics,' in

Artwords: Discourse on the 60s and 70s, Ann Arbor, Mich.: UMI Research Press, 1985, p. 213, where Haacke states that these pieces also 'evaded being an object.'

56 Ibid.

57 Haacke, in Siegel 'Hans Haacke: Systems Aesthetics,' p. 214.

58 Haacke, in Fry (ed.), *Hans Haacke*, p. 24. Printed in English on the mailer for the artist's *Wind and Water* exhibition at the Howard Wise Gallery, New York, Jan. 1966, and for his exhibition at the Hayden Gallery, Massachusetts Institute of Technology, October/November 1967. Also printed in *Hans Haacke: 'Obra Social,'* Barcelona: Fundació Antoni Tàpies, 1995, p. 31.

59 Haacke, in Fry (ed.), *Hans Haacke*, p. 25. In English in *Hans Haacke: 'Obra Social,'* p. 36.

60 Haacke, quoted in 'Schedule for Hans Haacke Exhibition, October 24–November 26,' press release, Office of Public Relations, Massachusetts Institute of Technology, Cambridge, Mass., 17 October 1967, p. 2.

61 Ibid.

62 Haacke, quoted in Jack Burnham, *Great Western Salt Works: Essays on the Meaning of Post-Formalist Art*, New York: George Braziller, Inc., 1974, pp. 31, 33.

63 See Howard S. Becker and John Walton, 'Social Science and the Work of Hans Haacke,' in Haacke, *Framing and Being Framed: 7 Works 1970–75*, Halifax: The Press of the Nova Scotia College of Art and Design, and New York: New York University Press, 1975, pp. 145–53.

64 'Interview by Robin White,' p. 12.

65 Haacke, catalogue text from 'Art into Society–Society into Art,' Institute of Contemporary Art, London, 1974, in *Hans Haacke, Volume I*, Oxford: Museum of Modern Art, and Eindhoven: Stedelijk Van Abbemuseum, 1978, p. 77.

66 See Haacke, 'Working Conditions,' in *Hans Haacke, Volume II/Works 1978–1983*, London: Tate Gallery, and Eindhoven: Stedelijk Van Abbemuseum, 1984, p. 94: 'Art is in fact a minor – although… not entirely negligible – agent in the formation of our consciousness.' Text originally published in *Artforum* 19, 10, Summer 1981, pp. 56–61.

67 Broodthaers, 'To be a straight thinker or not to be. To be blind,' in *Le Privilège de l'Art* (exh. cat.), Oxford: Museum of Modern Art, 1975, p. 35.

68 Broodthaers, in Ludo Bekkers, 'Gesprek met Marcel Broodthaers,' *Museumjournaal* 15, 2, April 1970, p. 67. This translation by Alma Koppedraijer.

69 Buren, 'On the Autonomy of the Artwork' in *Daniel Buren: around 'Ponctuations'*, n.p.

70 Baumgarten, 'Status quo,' *Artforum* 26, 7, March 1988, p. 108.

Select Bibliography

This material is mostly supplementary to the endnotes, with emphasis on more recent publications.

General

Alexander Alberro and Patricia Norvell, *Recording Conceptual Art: Early Interviews with Barry, Huebler, Kaltenbach, LeWitt, Morris, Oppenheim, Siegelaub, Smithson, and Weiner by Patricia Norvell*, Berkeley: University of California Press, 2001

Alexander Alberro and Blake Stimson (eds), *Conceptual Art: A Critical Anthology*, Cambridge, Mass.: The MIT Press, 1999

Bruce Altshuler, *The Avant-Garde in Exhibition: New Art in the 20th Century*, Berkeley and Los Angeles: University of California Press, 1994 [esp. chapters 12–13]

Michael Archer, *Art Since 1960*, London: Thames and Hudson Ltd, 1997

L'art conceptuel I (exh. cat.), Bordeaux: CPAC Musée d'art contemporain, 1988

L'art conceptuel, une perspective (exh. cat.), Paris: Musée d'Art Moderne de la Ville de Paris, 1989

Austellungen bei Konrad Fischer, Düsseldorf Oktober 1967–Oktober 1992, Bielefeld: Edition Marzona, 1993

Benjamin H. D. Buchloh, 'Conceptual Art 1962–1969: From the Aesthetic of Administration to the Critique of Institutions,' *October* 55, Winter 1990, pp. 105–43

———, *Neo-Avantgarde and Culture Industry: Essays on European and American Art from 1955 to 1975*, Cambridge, Mass.: October Books, 2001

Carolyn Christov-Bakargiev, *Arte Povera*, London: Phaidon Press Ltd, 1999

CIRCA 1968 (exh. cat.), Serralves, Portugal: Museu de Arte Contemporanea, and Porto: Fundação de Serralves, 1999

Thomas E. Crow, *The Rise of the Sixties: American and European Art in the Era of Dissent*, New York: Harry N. Abrams, 1996

Europe in the Seventies: Aspects of Recent Art (exh. cat.), Chicago: The Art Institute of Chicago, 1977

Jonathan Fineberg, *Art Since 1940: Strategies of Being*, New York: Harry N. Abrams, Inc., 1995.

Global Conceptualism: Points of Origin, 1950s–1980s (exh. cat.), New York: Queens Museum of Art, and DAP/Distributed Art Publishers, 1999

Tony Godfrey, *Conceptual Art*, London: Phaidon Press Ltd, 1998

RoseLee Goldberg, *Performance: Live Art Since 1960*, New York: Harry N. Abrams, 1998

Doug Hall and Sally Jo Fifer, *Illuminating Video: An Essential Guide to Video Art*, San Francisco: Aperture, in association with the Bay Area Video Coalition, 1990

John G. Hanhardt, *Video Culture*, Rochester, NY: Visual Studies Workshop Press, 1990

Charles Harrison, 'Modernism,' in Robert S. Nelson and Richard Schiff, *Critical Terms for Art History*, Chicago: The University of Chicago Press, 1992

Lucy Lippard (ed.), *Six Years: The Dematerialization of the Art Object from 1966 to 1972*, New York: Praeger, 1973.

Robert C. Morgan, *Art into Ideas: Essays on Conceptual Art*, New York: Cambridge University Press, 1996

———, *Between Modernism and Conceptual Art: A Critical Response*, Jefferson, NC: McFarland & Co., 1997

Michael Newman and Jon Bird (eds), *Rewriting Conceptual Art*, London: Reaktion Books, 1999

No Title: The Collection of Sol LeWitt (exh. cat.), Middletown, Conn.: Wesleyan University, in association with the Wadsworth Atheneum, 1981

Out of Actions: Between Performance and the Object, 1949–1979
(exh. cat.), Los Angeles: The Museum of Contemporary Art,
and London: Thames and Hudson 1998
Reconsidering the Object of Art: 1965–1975 (exh. cat.),
Los Angeles: The Museum of Contemporary Art; and
Cambridge, Mass., and London: The MIT Press, 1995
Howard Risatti (ed.), *Postmodern Perspectives: Issues
in Contemporary Art*, Englewood Cliffs, NJ:
Prentice-Hall, Inc., 1990
Irving Sandler, *Art of the Postmodern Era: From the Late 1960s
to the Early 1990s*, New York: Icon Editions, 1996
Gian Enzo Sperone, *Torino–Roma–New York: 35 Anni di
Mostra tra Europe e America*, 2 vols, Turin: Hopefulmonster
Editore, 2000
Brian Wallis (ed.), *Art After Modernism: Rethinking Representation*,
New York: The New Museum of Contemporary Art, 1984
Frazer Ward, 'Some Relations Between Conceptual and
Performance Art,' *Art Journal* 56, Winter 1997, pp. 36–40
Wide White Space, 1966–1976 (exh. cat.), Brussels: Palais des
Beaux-Arts, 1994

Introduction
Lesley K. Baier (ed.), *Eva Hesse: A Retrospective* (exh. cat.),
New Haven, Yale University Art Gallery: Yale University
Press, 1992
Sally Banes, *Greenwich Village 1963*, Durham and London:
Duke University Press, 1993, pp. 28–29, 52, 67
Maurice Berger, *Labyrinths: Robert Morris, Minimalism,
and the 1960s*, New York: Harper & Row, 1989
Frances Colpitt, *Minimal Art: The Critical Perspective*, Seattle:
University of Washington Press, 1993
Douglas Crimp, 'Serra's Public Sculpture: Redefining Site
Specificity,' in *Richard Serra/Sculpture* (exh. cat.), New York:
The Museum of Modern Art, 1986, pp. 40–55
Lucio Fontana, 1899–1968: A Retrospective (exh. cat.), New York:
The Solomon R. Guggenheim Museum, 1977
Barbara Haskell, *Blam! The Explosion of Pop, Minimalism,
and Performance 1958–1964*, New York: Whitney Museum
of American Art, W. W. Norton & Company, 1984
Thomas Kellein, *Fluxus*, London: Thames and Hudson Ltd,
1995, pp. 19–22
Michael Kirby, *Happenings*, New York: E. P. Dutton & Co., Inc.,
1965
———, *Art of Time: Essays on the Avant-Garde*, New York:
E. P. Dutton & Co., Inc., 1969
Donald B. Kuspit, *Clement Greenberg, Art Critic*, Madison:
The University of Wisconsin Press, 1979
Sol LeWitt (exh. cat.), New York, The Museum of
Modern Art, 1978
Adachiara Zevi (ed.), *Sol LeWitt Critical Texts*, Rome:
I Libri de AEIOU, Editrice Inonia, 1994
Sol LeWitt: A Retrospective (exh. cat.), San Francisco:
San Francisco Museum of Modern Art, and New Haven: Yale
University Press, 2000
James Sampson Meyer, *Minimalism: Art and Polemics in the
Sixties*, New Haven and London: Yale University Press, 2001
John O'Brian (ed.), *Clement Greenberg: The Collected Essays and
Criticism*, 4 vols, Chicago: The University of
Chicago Press, 1986

Piero Manzoni (exh. cat.), London: Serpentine Gallery,
and Milan: Charta, 1998
Sadie Plant, *The Most Radical Gesture: The Situationist
International in a Postmodern Age*, London: Routledge, 1992
'Roundtable: Conceptual Art and the Reception of Duchamp,'
October 70, Fall 1994, pp. 127–46
Owen F. Smith, 'Fluxus: A Brief History and Other Fictions,' in
In the Spirit of Fluxus (exh. cat.), Minneapolis: Walker Art
Center, 1993
———, Fluxus: The History of an Attitude, San Diego, Calif.:
San Diego State University Press, 1999
Tony Smith: Architect, Painter, Sculptor (exh. cat.), New York:
The Museum of Modern Art, distributed by
Harry N. Abrams, 1998
Nancy Spector, 'A Temporary Blindness,' in *Piero Manzoni* (exh.
cat.), Paris: Musée d'Art Moderne de la Ville de Paris, 1991
David Thistlewood (ed.), with bibliography by Anne MacPhee,
Joseph Beuys: Diverging Critiques, Tate Gallery Liverpool
Critical Forum Series, vol. 2, Liverpool: Liverpool University
Press, 1995
Sarah Whitfield, *Lucio Fontana* (exh. cat.), London: Hayward
Publishing, 1999 [published on the occasion of the exhibition
'Lucio Fontana,' Hayward Gallery, London, 14 October
1999–9 January 2000]

[One] Painting at Issue after 1965
Coosje van Bruggen, 'Gerhard Richter: Painting as
a Moral Act,' *Artforum* 23, 9, May 1985, pp. 82–91
Benjamin H. D. Buchloh, 'Atlas Archive,' in Alex Coles (ed.), *The
Optic of Walter Benjamin*, vol. 3, *de-, dis-, ex-*, 1999, pp. 12–35
Benjamin H. D. Buchloh (trans. Claude Gintz), *Niele Toroni:
L'Index de la Peinture*, Brussels: Editions Daled, 1985,
pp. 13–23
Michel Claura, 'Actualité,' *VH101*, 5, Printemps 1971, pp. 40–47
Xavier Douroux and Franck Gautherot (eds), *On Kawara: Whole
and Parts, 1964–1995*, Dijon: Les presses du réel, 1996
Helmut Friedel and Ulrich Wilmes (eds.), *Gerhard Richter:
Atlas of the Photographs, Collages and Sketches*, New York:
DAP/Distributed Art Publishers, Inc., in association with
London: the Anthony d'Offay Gallery, and New York:
Marian Goodman Gallery, 1997
Jürgen Harten, 'The Romantic Intent for Abstraction,' in
Gerhard Richter: Bilder/Paintings 1962–1985 (exh. cat.),
Städtische Kunsthalle Düsseldorf (and others), 1986
On Kawara 1964, Paris–New York drawings (exh. cat.), St Gallen,
Switzerland: Kunstverein St Gallen Kunstmuseum, 1997
Hans-Ulrich Obrist (ed., trans. David Britt), *Gerhard Richter:
The Daily Practice of Painting, Writings and Interviews
1962–1993*, Cambridge, Mass.: The MIT Press in association
with the Anthony d'Offay Gallery, London, 1995
Palermo (exh. cat. and catalogue raisonné), 2 vols, Stuttgart:
Bonn Kunstmuseum in association with Stuttgart,
Oktagon, 1994
Giulio Paolini: Von Heute Bis Gestern, Da Oggi a Ieri (exh. cat.)
Graz: Neue Gallerie im Landesmuseum Joanneum,
in association with Cantz, 1998
Birgit Pelzer, 'The tragic desire,' *Parkett* 35, 1993, pp. 66–71
Gerhard Richter (exh. cat. and catalogue raisonné), 3 vols,
Bonn Kunst- und Ausstellungshalle der Bundesrepublik

Deutschland, Ostfildern: Edition Cantz, 1993
Dieter Schwarz, Gerhard Richter, and Birgit Pelzer,
 Gerhard Richter: Drawings: 1964–1999 (catalogue raisonné),
 Winterthur: Kunstmuseum Winterthur, and Düsseldorf:
 Richter Verlag, 1999

[Two] Medium as Message/Message as Medium
Terry Atkinson, *The Indexing, The World War I Moves and the
 Ruins of Conceptualism*, Belfast: Circa Publications,
 Manchester: Cornerhouse, and Dublin: The Irish Museum
 of Modern Art, 1992
———, *Work 1974: In Leaving Art and Language* (exh. cat.),
 Milan: Archivio di Nuova Scrittura, 1994
Art & Language in Practice (exh. cat.), 2 vols, Barcelona:
 Fundació Antoni Tàpies, 1999
Jack Flam (ed.), *Robert Smithson: The Collected Writings*,
 The Documents of Twentieth Century Art, Berkeley
 and Los Angeles: University of California Press, 1996
Charles Harrison, *Essays on Art & Language*, Oxford:
 Basil Blackwell, Ltd, 1991
Robert Carleton Hobbs, with contributions by Lawrence
 Alloway, John Coplans, and Lucy R. Lippard, *Robert Smithson
 – Sculpture*, Ithaca: Cornell University Press, 1981
David Lamelas: A New Refutation of Time (exh. cat.), Munich:
 Kunstverein, and Rotterdam: Witte de With, Center for
 Contemporary Art, 1997
Bartomeu Mari (ed.), *Show (&) Tell: The Films & Videos
 of Lawrence Weiner* (exh. cat.), Ghent: Imschoot,
 Uitgevers, 1992
Bruce Nauman (exh. cat. and catalogue raisonné),
 Minneapolis: Walker Art Center, 1994
Ed Ruscha (exh. cat.), joint publication of Washington, D.C.:
 Hirshhorn Museum and Sculpture Garden, Smithsonian
 Institution, Oxford: Museum of Modern Art, and Zurich-
 Berlin-New York: Scalo, 2000
Dieter Schwarz (ed.), *Lawrence Weiner: Books 1968–1989*
 (exh. cat.), Cologne: Walther König, 1989
Robert Smithson Retrospective: Works 1955–1973 (exh. cat.),
 Oslo: National Museum of Contemporary Art,
 and Stockholm: Moderna Museet, 1999
Lawrence Weiner: Posters November 1965–April 1986
 (exh. cat.), Halifax: The Press of the Nova Scotia College
 of Art and Design, 1987

[Three] Photography: Restructuring the Pictorial
John Baldessari (exh. cat.), New York: Rizzoli, 1990
 [published on the occasion of the retrospective
 exhibition organized by The Museum of Contemporary Art,
 Los Angeles]
Bernd und Hilla Becher (exh. cat.), Eindhoven:
 Van Abbemuseum Eindhoven, 1981
Burgin, Victor, *Between*, London: Basil Blackwell Ltd and
 Institute of Contemporary Arts, 1986
Victor Burgin: Passages (exh. cat.), Villeneuve d'Ascq:
 Musée d'art moderne de la Communauté Urbaine
 de Lille, 1991
Hugh M. Davies and Andrea Hales (eds), *John Baldessari:
 National City* (exh. cat.), San Diego: Museum of
 Contemporary Art, 1996

Jan Dibbets (exh. cat.), essays by M. M. M. Vos and R. H. Fuchs,
 Minneapolis: Walker Art Center, 1987
Jan Dibbets – Interior Light: Works on Architecture, 1969–1990,
 New York: Rizzoli, 1991
Rini Dippel, *Perspective in the Work of Jan Dibbets* (exh. cat.),
 Amsterdam: Stedelijk Museum, 1972
Thierry du Duve, 'Bernd et Hilla Becher ou la Photographie
 Monumentale,' *Les cahiers du musée nationale d'art moderne*
 39, Printemps 1992, pp. 118–29
Douglas Huebler: 'Variable', etc. (exh. cat.), Limoges: FRAC
 Limousin, 1992
Joseph Jacobs, 'The New Photography,' in *This Is Not a
 Photograph: Twenty Years of Large-Scale Photography
 1966–1986* (exh. cat.), Sarasota, Fla.: The John and Mable
 Ringling Museum of Art, 1987, pp. 1–14
Wolf Jahn (trans. David Britt), *The Art of Gilbert & George*,
 New York: Thames & Hudson Inc., 1989
Richard Long: Circles Cycles Mud Stones (exh. cat.), Houston:
 Contemporary Arts Museum 1996
Dennis Alan Nawrocki, 'Gilbert & George: *Parked* in Nature,'
 in *Bulletin of the Detroit Institute of Arts* 65, 1, 1989
Dennis Oppenheim: Selected Works 1967–90 (exh. cat.), New York:
 The Institute for Contemporary Art, 1992
*The Paintings (with Us in the Nature) of Gilbert & George the
 Human Sculptors 1971* (exh. cat.), Edinburgh:
 The Fruitmarket Gallery, 1986
Derrick Price and Liz Wells, 'Thinking About Photography:
 Debates, Historical and Now,' in Liz Wells (ed.), *Photography:
 A Critical Introduction*, London and New York: Routledge,
 1997, pp. 11–51
Barbara Reise, 'Notes[1] on Jan Dibbets's[2] Contemporary[3]
 Nature[4] of Realistic[5] Classicism[6] in the Dutch[7] Tradition[8],'
 Studio International, vol. 183, June 1972, pp. 248–55
Jock Reynolds, 'Framing Time,' in *Motion and Document,
 Sequence and Time: Eadweard Muybridge and Contemporary
 American Photography* (exh. cat.), Andover, Mass.: Addison
 Art Gallery of American Art, 1991, pp. 21–32
Brenda Richardson, *Gilbert & George* (exh. cat.), Baltimore:
 The Baltimore Museum of Art, 1984
Blake Stimson, 'Bad Water,' in *Water: The Renewable Metaphor*
 (exh. cat.), Eugene: University of Oregon Museum of Art,
 1997, p. 21
Jeff Wall, '"Marks of Indifference": Aspects of Photography In,
 or As, Conceptual Art (Preface),' in *Reconsidering the Object
 of Art 1965–1975* (exh. cat.), Los Angeles: The Museum
 of Contemporary Art, and Cambridge, Mass.: The MIT
 Press, 1995, pp. 246–67

[Four] Systems, Seriality, Sequence
Claudia Barrow, 'Adrian Piper: Space, Time and Reference,
 1967–1970,' in *Adrian Piper* (exh. cat.), Birmingham:
 Ikon Gallery, and Manchester Cornerhouse, 1991
Mel Bochner: Thought Made Visible 1966–1973 (exh. cat.),
 New Haven: Yale University Art Gallery, 1995
Jean-Pierre Bordaz, 'Hanne Darboven or the Dimension
 of Time and Culture,' *Parkett* 10, 1986, pp. 109–11
Lynne Cooke, 'Hanne Darboven: *Kulturgeschichte 1980–1983*,
 1980–1983' (exh. brochure), New York: Dia Center for
 the Arts, 1996

——— and Karen Kelly (eds), *Robert Lehman Lectures on Contemporary Art, no. 2*, New York: Dia Center for the Arts, in press [esp. Michael Newman lecture on Darboven]

Hanne Darboven: Rainer Werner Fassbinder (1982/83): Concept Art Melodrame – ein Bilderstreit (exh. cat.), Munich: Kunstraum München, 1988, pp. 4–17

Hanne Darboven: Primitive Zeit/Uhrzeit (exh. cat.), Philadelphia: Goldie Paley Gallery, Moore College of Art, 1990

Hanne Darboven (exh. cat.), Basel: Kunsthalle Basel, 1991

Christel Hollevoet, 'Wandering in the City, *Flânerie* to *Dérive* and After: The Cognitive Mapping of Urban Space,' in *The Power of the City/The City of Power*, New York: Whitney Museum of American Art, 1992

On Kawara: 1973 Produktion eines Jahres/One Year's Production (exh. cat.), Bern: Kunsthalle Bern, 1974

On Kawara: continuity/discontinuity, 1963–1979 (exh. cat.), Stockholm: Moderna Museet, 1980

Roman Opalka (exh. cat.), New York: John Weber Gallery, 1978

Adrian Piper: A Retrospective (exh. cat.), Baltimore: Fine Arts Gallery, University of Maryland, 1999

Adrian Piper, *Out of Order, Out of Sight*, 2 vols, Cambridge, Mass.: The MIT Press, 1996

Christine Savinel, Jacques Roubaud, and Bernard Noël, *Roman Opalka*, Paris: Editions Dis Voir, 1996

[Five] Subject as Object

Alexander Alberro (ed.), *Two-Way Mirror Power: Selected Writings by Dan Graham on His Art*, Cambridge, Mass.: The MIT Press, in association with New York, Marian Goodman Gallery, 1999

James Coleman: Projected Images: 1972–1994 (exh. cat.) New York: Dia Center for the Arts, 1995

Walker Evans & Dan Graham (exh. cat.), Rotterdam: Witte de With, Center for Contemporary Art, and New York: Whitney Museum of American Art, 1992

Dan Graham (exh. cat.), Santiago de Compostela: Centro Galego de Arte Contemporáneo, 1997

Kate Linker, *Vito Acconci*, New York, Rizzoli, 1994

Christine Poggi, 'Vito Acconci's Bad Dream of Domesticity,' in Christopher Reed (ed.), *Not at Home: The Suppression of Domesticity in Modern Art and Architecture*, London: Thames and Hudson Ltd, 1996, pp. 237–52

Brian Wallis (ed.), *Rock My Religion, Writings and Art Projects, 1965–1990/Dan Graham*, Cambridge, Mass.: The MIT Press, 1993

Adachiara Zevi (ed.), *Dan Graham: Selected Writings and Interviews on Art Works, 1965–1995*, Rome: I Libri di Zerynthia, 1996

[Six] Context as Content: Surveying the Site

Alexander Alberro, 'The Turn of the Screw: Daniel Buren, Dan Flavin, and the Sixth Guggenheim International Exhibition,' *October* 80, Spring 1997, p. 57–83

Giovanni Anselmo (exh. cat.), Santiago de Compostella: Centro Galego de Arte Contemporáneo, 1995

Michael Asher, in collaboration with Benjamin H. D. Buchloh, *Writings 1973–1983 on Works 1969–1979*, Halifax: The Press of the Nova Scotia College of Art and Design, and Los Angeles: The Museum of Contemporary Art, 1983

Anne Baldassari and Daniel Buren, *Daniel Buren: Entrevue*, Paris: Musée des Arts Décoratifs et Flammarion, 1973, pp. 48–51

Marcel Broodthaers (exh. cat.), Minneapolis: Walker Art Center, and New York: Rizzoli, 1989

Marcel Broodthaers: Cinéma (exh. cat.), Barcelona: Fundació Antoni Tàpies, 1997

Benjamin H. D. Buchloh, 'Michael Asher and the Conclusion of Modernist Sculpture,' in Chantal Pontbriand (ed.), *Performance, Text(e)s & Documents*, Montreal: Parachute, 1980, pp. 55–65

———, 'The Museum and the Monument,' in *Daniel Buren: Les Couleurs: sculptures, Les Formes: peintures*, Halifax: The Press of the Nova Scotia College of Art and Design, and Paris: Centre Georges Pompidou, 1981, pp. 16–20

——— (ed.), *Marcel Broodthaers: Writings, Interviews, Photographs*, with essays by Dieter Schwarz, B. H. D. Buchloh, Anne Rorimer et al., Cambridge, Mass.: The MIT Press, 1988 [originally published in *October* 42, Fall 1987]

Daniel Buren: Photos–Souvenirs 1965–1988, Villeurbanne: Art Edition, 1988

Germano Celant, *Ambiente/Arte dal Futurismo alla Body Art*, Venice: Edizioni 'La Biennale di Venezia,' 1977

———, 'Artspaces,' *Studio International* 190, 977 September/October 1975, pp. 115–23

Marie L. Fleming, 'Baxter and N. E. THING CO., 1965–1970,' in *Baxter²: Any Choice Works* (exh. cat.), Toronto: Art Gallery of Ontario, 1982

Yves Gevaert, 'Un Jardin d'Hiver,' in *Marcel Broodthaers: Oeuvre Graphique Essais*, Geneva: Centre Genevois de Gravure Contemporaine, 1991, pp. 81–94

Hans Haacke: Obra social (exh. cat.), Barcelona: Fundació Antoni Tàpies, 1995

Adrian Henri, *Total Art: Environments, Happenings, and Performance*, New York: Praeger, 1974

John Knight: Treize travaux (exh. cat.), Villeurbanne: Le Nouveau Musée, and Rotterdam: Witte de With, Centre for Contemporary Art, 1989

Miwon Kwon, 'One Place After Another: Notes on Site Specificity,' *October* 80, Spring 1997, p. 85–109

Pamela M. Lee, *Object to be Destroyed: The Work of Gordon Matta-Clark*, Cambridge, Mass.: The MIT Press, 2000

Gordon Matta-Clark: A Retrospective (exh. cat.), Chicago: Museum of Contemporary Art, 1985

Nicolas de Oliveira et al., *Installation Art*, with texts by Michael Archer, London: Thames and Hudson Ltd, 1994

Anne Rorimer, 'Context as Content/Subject as Object,' in *Art at The Armory: Occupied Territory* (exh. cat.), Chicago: Museum of Contemporary Art, 1992

Fred Sandback Sculpture (exh. cat.), New Haven: Yale University, 1991

Pierre Théberge, 'N.E.Thing Company in Ottawa,' in *Works by Iain and Ingrid Baxter* (exh. cat.), Vancouver: UBC Fine Arts Gallery, 1993

Bitite Vinklers, 'Hans Haacke,' *Art International* 13, 7, September 1969, pp. 44–49, 56

Brian Wallis (ed.), *Hans Haacke: Unfinished Business*, New York: The New Museum of Contemporary Art, and Cambridge, Mass.: The MIT Press, 1986

List of Illustrations

plaster, painted with enamel, 17.8 x 37.5 x 21.8 (7 x 14 ¾ x 8 ⅝). The Museum of Modern Art, New York. Philip Johnson Fund. Photograph © 2001 The Museum of Modern Art, New York **31** Allan Kaprow, *Pose: Carrying Chairs through the City…*, 1969. One of 7 loose sheets in Manila envelope, 27.3 x 19.9 (10 ¾ x 7 ⅞), with photos by Carol Bowen and Bill Fares. Published by Multiples Inc., New York, 1970. Photo: Michael Tropea **33** La Monte Young, 'Compositions,' 1960. Reproduced with permission from *An Anthology* (New York 1970), La Monte Young (ed.) © La Monte Young 1963, 1970. Second edition, published by Heiner Friedrich, 1970 **36** Giulio Paolini, *174*, 1965. Photograph on canvas, 150 x 120 (59 x 47), Galleria Civica d'Arte Moderna, Turin. Photograph courtesy of the artist **38** Robert Mangold, *½ Manila Curved Area*, 1967. Oil on composition board, 182.9 x 365.8 (72 x 144). Whitney Museum of American Art, New York. Purchase with funds from the Friends of the Whitney Museum of American Art. Accession number: 68.14. © ARS, NY and DACS, London 2001 **39** (above) Jo Baer, *Untitled*, 1962/1962/1963. 3 works, oil on canvas, each 182.9 x 182.9 (72 x 72). Installation, Rhona Hoffman Gallery, Chicago, October 13–November 11, 1989. Photo courtesy Rhona Hoffman Gallery, Chicago. Photo: Michael Tropea. (below) Jo Baer, *Brilliant Yellow #9*, 1964–65. Oil on canvas, 122 x 152 (48 x 60). The Art Institute of Chicago. Joel and Carole Bernstein gift, 1981.70. Photograph © 2000, The Art Institute of Chicago, All Rights Reserved **40** (above) Brice Marden, *Rodeo*, 1971. Oil and beeswax on two canvases, 243.8 x 243.8 (96 x 96). The Art Institute of Chicago. Ada S. Garrett Prize Fund; Katherine Kuh Estate; through prior gift of Mrs. Henry C. Woods; gift of Lannan Foundation, 1997.160. © ARS, NY and DACS, London 2001. Photograph © 2000, The Art Institute of Chicago, All Rights Reserved. Photo: Tom Vinetz. (below) Brice Marden, *Red, Yellow, Blue Painting #1*, 1974. Oil and wax on canvas, 188 x 182.9 (74 x 72). Albright-Knox Art Gallery, Buffalo, New York. James S. Ely Fund, 1974. © ARS, NY and DACS, London 2001 **41** (above) Brice Marden, *The Dylan Painting*, 1966. Oil and wax on canvas, 152.4 x 304.8 (60 x 120). © ARS, NY and DACS, London 2001. Photograph courtesy of Matthew Marks Gallery, New York, © Brice Marden, 1966. Photo: James Dee. (below) Jasper Johns, *Tennyson*, 1958. Encaustic and canvas collage on canvas, 186.7 x 122.5 (73 ½ x 48 ¼). Purchased with funds from the Coffin Fine Arts Trust; Nathan Emory Coffin Collection of the Des Moines Art Center, 1971.4. © Jasper Johns/VAGA, New York/DACS, London 2001 **42** Robert Ryman, *Untitled*, 1959. Oil paint on stretched cotton canvas, 111.1 x 111.1 (43 ¾ x 43 ¾). Photograph by Gordon Riley Christmas. Courtesy Pace Wildenstein. Private Collection. © 1959 Robert Ryman **43** Niele Toroni, *Imprints of a no. 50 brush repeated at regular intervals of 30 cm*, 1967. Glossy paint on oilcloth, 500 x 140 (197 x 55). Musée nationale d'art moderne, Centre Georges Pompidou, Paris. Installation, permanent collection (between works by Donald Judd and Michel Parmentier), c.1985–86. Photo: A. Rorimer. **44** Niele Toroni, *Imprints of a no. 50 brush repeated at regular intervals of 30 cm*, 1972. Acrylic on oilcloth, 200 x 140 (79 x 55). Van Abbemuseum Eindhoven. Photo: v. d. Bichelaer **47** (above) Gerhard Richter, *Christa and Wolfi*, 1964. Oil on canvas 150 x 130 (59 x 51), The Art Institute of Chicago. Joseph Wintherbotham Collection, 1987.276. Photograph © Gerhard Richter. Photo: A. Rorimer. (below) Gerhard Richter, *Woman Descending the Staircase*, 1965. Oil on canvas, 200.7 x 129.5 (78 ¾ x 51), The Art Institute of Chicago. Roy J. and Frances R. Friedman Endowment; Gift of Lannan Foundation, 1997.176. Photograph © 2000, The Art Institute of Chicago and Gerhard Richter **48** (above) Gerhard Richter, *Mustang Squadron*, 1964. Oil on canvas, 88 x 165 (34 ½ x 65). Collection of Mr. and Mrs. Robert Lehrman, Washington, D. C. Photograph courtesy of the artist and Marian Goodman Gallery, New York, © Gerhard Richter. (below) Gerhard Richter, *Eight Student Nurses*, 1966. Oil on 8 canvases, each 95 x 70 (37 x 27 ½). Private Collection, Zurich. Photograph courtesy of the artist and Marian Goodman Gallery, New York, © Gerhard Richter **49** Gerhard Richter, *Window*, 1968. Oil on canvas, 200 x 400 (78 ¾ x 157 ½). Kunstmuseum Düsseldorf. Photograph courtesy of the artist and Marian Goodman Gallery, New York, © Gerhard Richter **50** Gerhard Richter, *Four Panes of Glass*, 1967. Glass and iron, 4 parts, each 190 x 100 (75 x 39). Collection of

the artist. Photograph courtesy of the artist and Marian Goodman Gallery, New York, © Gerhard Richter **51** (above) Gerhard Richter, *Townscape Madrid*, 1968. Oil on canvas, 277 x 292 (109 x 115). Städtisches Kunstmuseum Bonn. Longterm loan Grothe. Photograph courtesy of the artist and Marian Goodman Gallery, New York, © Gerhard Richter. (below) Gerhard Richter, *Sea Piece (Wave)*, 1969. Oil on canvas, 200 x 200 (79 x 79). Kunsthalle zu Kiel. On loan from Sammlung Onnasch, Berlin. Photograph courtesy of the artist and Marian Goodman Gallery, New York, © Gerhard Richter **52** (above) Gerhard Richter, *Grey*, 1973; 256 Colors, 1974. Installation, 'Europe in the Seventies: Aspects of Recent Art,' The Art Institute of Chicago, 1977. Photograph courtesy of The Art Institute of Chicago, © Gerhard Richter. (below) Gerhard Richter, *Grey*, 1975. Oil on 8 canvases, each 225 x 175 (89 x 69). Städtisches Museum Abteiberg, Mönchengladbach. Photograph courtesy of the artist and Marian Goodman Gallery, New York, © Gerhard Richter **53** Gerhard Richter, *Annunciation after Titian*, 1973. Oil on canvas, 150 x 250 (59 x 98). Private Collection, Zurich. Photograph courtesy of the artist and Marian Goodman Gallery, New York, © Gerhard Richter **54** On Kawara exhibition, installation at Moderna Museet, Stockholm, 1980. Photograph © 1980, Moderna Museet, Stockholm, courtesy of the artist **55** (above) On Kawara exhibition, installation at Van Abbemuseum, Eindhoven, 1981. Photograph © 1981, Van Abbemuseum, Eindhoven, courtesy of the artist. (centre) Claude Monet, *Haystacks*, 1890–91. Installation, The Art Institute of Chicago, 1984–85. Photograph courtesy of The Art Institute of Chicago. (below) Jasper Johns, *0–9*, 1959. 51.1 x 88.9 (20 ⅛ x 35). Collection Ludwig, Aachen. © Jasper Johns/VAGA, New York/DACS, London 2001. Photograph courtesy of the Leo Castelli Gallery, New York **56** On Kawara, Cardboard box and newspaper for *Oct. 31, 1978, 'TODAY' Series:* 'Tuesday', 1978. The Art Institute of Chicago. Twentieth Century Purchase Fund, 1980.2. Photo: A. Rorimer **57** (above) Pablo Picasso, *Bottle of Vieux Marc, Glass, Newspaper*, 1913. Charcoal and pasted papers, 62.6 x 46.9 (24 ⅝ x 18 ½). Musée nationale d'art moderne, Centre Georges Pompidou, Paris. © Succession Picasso/DACS 2001 (below) Andy Warhol, *129 Die in Jet (Plane Crash)*, 1962. Synthetic polymer paint on canvas, 254 x 183 (100 x 72). Museum Ludwig, Cologne. © The Andy Warhol Foundation for the Visual Arts, Inc./ARS, NY and DACS, London 2001. Photograph courtesy of the Rheinisches Bildarchiv, Cologne **59** (left) Blinky Palermo, *Totes Schwein (Dead Pig)*, 1965. Acrylic and charcoal on muslin and wood, 155 x 110 x 6 (61 x 43 ⁵⁄₁₆ x 2 ⅜). Bayerische Staatsgemäldesammlungen, Staatsgalerie Moderner Kunst, Munich. © DACS 2001 (right) Blinky Palermo, *Kissen mit schwarzer Form* (Cushion with Black Form), 1967. Oil and fabric on foam rubber, 52 x 42 x 10 (20 ⁷⁄₁₆ x 16 ⁹⁄₁₆ x 3 ¹⁵⁄₁₆). Bayerische Staatsgemäldesammlungen, Staatsgalerie Moderner Kunst, Munich. © DACS 2001 (right) Blinky Palermo, *Tagtraum II* (Daydream II), 1966. Casein, silk on wood, 168 x 125 x 3.5 (66 ⅛ x 49 ⁹⁄₁₆ x 1 ⅜). Bayerische Staatsgemäldesammlungen, Staatsgalerie Moderner Kunst, Munich. © DACS 2001 **61** Blinky Palermo, *Stoffbild, rosa-orange-schwarz* (Fabric Painting, pink-orange-black), 1968. Cotton stretched on muslin, 200 x 170 (78 ³⁄₄ x 66 ¹⁵⁄₁₆). Hallen für Neue Kunst, Schaffhausen. Sammlung Crex. © DACS 2001 **62** Blinky Palermo, *Treppenhaus I* (Staircase I), 1970. Silkscreen print in an edition of 200, 60 x 100 (24 x 39). Published by Heiner Friedrich Gallery, Munich in connection with 'Wandzeichnung Treppenhaus,' Konrad Fischer Gallery, Düsseldorf, 1970. © DACS 2001 **63** (above) Blinky Palermo, *Wall Drawing and Painting*, Kunstverein Hamburg, 1973. Restoration of original installation prior to building's destruction, 1992. © DACS 2001. Photo: A. Rorimer. (right) Blinky Palermo, *Wall Drawing and Painting*, Kunstverein Hamburg, 1973. Restoration of original installation prior to building's destruction, 1992. © DACS 2001. Photo: A. Rorimer **64** Giulio Paolini, *Disegno Geometrico*, 1960. Tempera and ink on canvas, 40 x 60 (16 x 24). Collection A. Paolini Piva, Turin. Photograph courtesy of the artist **65** (above) Giulio Paolini, *Senza Titolo* (Untitled), 1962. 3 canvas backs set inside one another, 60 x 50 (24 x 20). Cochrane Collection, Turin. Photograph courtesy of Marian Goodman Gallery. (below) Giulio Paolini, *Senza Titolo* (Untitled), 1961. Paint can behind polyethylene stapled to wooden frame, 21 x 21 (8 x 8). Collection of the artist. Photograph courtesy of the artist.

Photo: Paolo Mussat Sartor, Turin **66** Giulio Paolini, *Delfo*, 1965. Photograph on canvas, 180 x 95 (71 x 37). Cochrane Collection, Turin. Photograph courtesy of the artist **67** (above) Giulio Paolini, *Giovane che guarda Lorenzo Lotto* (Young Man who is looking at Lorenzo Lotto), 1967. Photograph on canvas, 30 x 24 (12 x 9). F.E.R. Collection, Laupheim. (below) Giulio Paolini, *Quattro Immagini Uguali* (Four Equal Images), 1969. Ink on canvas, each 40 x 40 (16 x 16). Photograph courtesy of the artist **68** Giulio Paolini, *Apoteosi di Omero* (Apotheosis of Homer), 1970–71. 32 folders with photographs and one text displayed on 33 music stands, dimensions of installation variable. Annick and Anton Herbert Collection, Ghent. Photograph courtesy of the artist. Photo: Antonia Mulas, Milan. **70** Joseph Kosuth, *Titled (Art as Idea as Idea)*, [*Image*], 1966. Photographic enlargement, 122 x 122 (48 x 48). Collection of Billy Copley and Patricia Brundage. © ARS, NY and DACS, London 2001. Photograph courtesy of Leo Castelli Gallery, New York. Photo: © 1988, Dorothy Zeidman. **72** (above) Ed Ruscha, *Actual Size*, 1962. Oil on canvas, 170.2 x 182.9 (67 x 72). Los Angeles County Museum of Art, M.63.14. Anonymous Gift through the Contemporary Art Council. Photograph © 2000 Museum Associates/LACMA. (below) Stuart Davis, *Lucky Strike*, 1924. Oil on paperboard, 46 x 61 (18 x 24), Hirshhorn Museum and Sculpture Garden, Smithsonian Institution, Museum Purchase, 1974. © Estate of Stuart Davis/VAGA, New York/DACS, London 2001. Photo Lee Stalworth **73** (above) Bruce Nauman, *Run from Fear, Fun from Rear*, 1972. Neon tubing with clear glass tubing suspension frames, two parts, 20.3 x 116.8 x 5.7 (8 x 46 x 2 ¼) and 18.4 x 113 x 5.7 (7 ¼ x 44 ½ x 2 ¼). Edition of six. © ARS, NY and DACS, London 2001. Collection Gerald S. Elliott, Chicago (below) Bruce Nauman, *Waxing Hot* (from the portfolio Eleven Color Photographs), 1966–67. Chromogenic development print, 50.6 x 50.6 (20 x 20). Collection of the Museum of Contemporary Art, Chicago. Gift of Gerald S. Elliott Collection. © ARS, NY and DACS, London 2001 **74** Robert Smithson, *A Heap of Language*, 1966. Pencil on paper, 16.5 x 56 (6 1/2 x 22). Museum Overholland, Nieuwersluis. © Estate of Robert Smithson/VAGA, New York/DACS, London 2001. Photograph courtesy of the Estate of Robert Smithson, James Cohan Gallery, New York **76** David Lamelas, *Publication*, 1970 (cover and page by Martin Maloney). 32-page book, 21 x 15 (8 ¼ x 5 ¾). Published by Nigel Greenwood Inc., Ltd., London, 1970, in an edition of 1000 **78** (above) Lawrence Weiner, *Propeller Painting*, 1964. Gouache, ink, varnish on canvas, wood frame, 20 x 17 (8 x 6 ¾). Collection of the artist. © ARS, NY and DACS, London 2001. Photo: A. Rorimer. (below) Lawrence Weiner, *Untitled*, 1967. Pencil, ink, staples on graph paper, 27 x 21 (10 ¾ x 8 ¼). Collection of the artist. © ARS, NY and DACS, London 2001. Photo: A. Rorimer. **79** Early works by Lawrence Weiner. Installation, 'L'art conceptuel, une perspective,' ARC Musée d'Art Moderne de la Ville de Paris, 1989. © ARS, NY and DACS, London 2001. Photo: A. Rorimer. **80** (above left) Lawrence Weiner, ONE QUART EXTERIOR GREEN INDUSTRIAL ENAMEL THROWN ON A BRICK WALL, 1968 (#002). Installation, New York, 1971. Photograph courtesy of Moved Picture Archive. © ARS, NY and DACS, London, 2001. Photo: R. Landry (centre left) Lawrence Weiner, MANY COLORED OBJECTS PLACED SIDE BY SIDE TO FORM A ROW OF MANY COLORED OBJECTS, 1979 (#462). Acrylic paint, pen, typing, cellotape on brown paper, approx. 45 x 60 (18 x 24). Private Collection. © ARS, NY and DACS, London 2001. Photo: Jerry Kobylecki. (below left) Lawrence Weiner, FROM MAJOR TO MINOR/FROM SMALL TO LARGE [OFTEN FOUND WITHIN THE CONTEXT OF EFFECTIVENESS], 1974 (#395). Installation, Claire Copley Gallery, Los Angeles, 1974. © ARS, NY and DACS, London 2001. Photograph courtesy of Moved Picture Archive. Photo: Alice Zimmerman (above right) Lawrence Weiner, OVERDONE. DONEOVER. AND OVERDONE. AND DONEOVER, 1971 (#252). Installation, 30th Anniversary Exhibition, Leo Castelli Gallery, New York, 1987. © ARS, NY and DACS, London 2001. Photograph courtesy of Moved Picture Archive. (centre right) Lawrence Weiner, MANY COLORED OBJECTS PLACED SIDE BY SIDE TO FORM A ROW OF MANY COLORED OBJECTS, 1979 (#462). Installation, Leo Castelli Gallery, New York, 1979. © ARS, NY and DACS, London 2001. Photograph courtesy of Moved Pictures Archive. Photo:

Alice Zimmerman. (below right) Lawrence Weiner, BROKEN OFF, 1971 (#251). Installation, matchbook in ashtray, Chicago, 1987. © ARS, NY and DACS, London 2001. Photo: H. H. Mills **83** Robert Barry, *Untitled*, 1964. Tempera and gesso on canvas, 36 x 35.5 (14 ¼ x 14 ⅛). Photograph courtesy of Leo Castelli Gallery, New York Photo: Dorothy Zeidman. **84** Robert Barry, *Wire or Cord Installation Between Three or More Trees*, 1968. Ink on lined paper, 21.5 x 28 (8 ½ x 11). Private Collection. Photograph courtesy of the artist **85** (above) Robert Barry, Page from 'March 1969' catalogue, 1969. Photograph courtesy of the artist. (below) Robert Barry, *Inert Gas Series: Helium (2 cubic feet)*, 1969. Photographic documentation of helium being released in Mojave Desert, California, March 5, 1969. Collection Paul Maenz Gallery, Berlin. Photograph courtesy of the artist **87** Robert Barry, *One Million Dots* (detail), 1968. 40,000 dots on one of twenty-five pages in the Xerox Book 'exhibition' organized/published by Seth Siegelaub and John Wendler, 1968. Photo: Michael Tropea **88** (above) Robert Barry, *The Space Between Pages 29 & 30* and *The Space Between Pages 74 & 75*, 1969. Contents page of the magazine *0 TO 9*, Number Six, July 1969. Photo: Michael Tropea (below) Robert Barry, Solo exhibition at the Leo Castelli Gallery, New York, April 27–May 8, 1971. Photograph courtesy of the artist and Leo Castelli Gallery, New York. Photo: Eric Pollitzer **89** Robert Barry, *Untitled*, 1976. Transfer type on translucent graph paper, 28 x 21.7 (11 x 8 ½). Private Collection. Photo: Michael Tropea **90** (above) Robert Barry, *Words and Circles* (detail), 1975. Slide projection. Oeffentliche Kunstmuseum Basel. Photograph courtesy of the artist . (below) Ian Wilson, *Circle on the Floor*, 1968. Chalk on floor, approx. 183 (72) in diameter. Photograph courtesy of the artist. Limited Edition. **94** (above) Joseph Kosuth, *Clear Square Glass Leaning*, 1965. 4 glass plates with silkscreened lettering, each 91.4 x 91.4 (36 x 36). Solomon R. Guggenheim Museum, New York. Panza Collection, Extended Loan. © ARS, NY and DACS, London 2001. Photograph © The Solomon R. Guggenheim Foundation, New York. Photo: David Heald. (below) Joseph Kosuth, *One and Eight – A Description*, 1965. Neon tubing (white), 386 (152) long. Edition of 3. © ARS, NY and DACS, London 2001. Photograph courtesy of the artist and Sean Kelly Gallery, New York **95** Joseph Kosuth, *One and Three Hammers*, 1965. Photographic enlargements and hammer. Dimensions variable. © ARS, NY and DACS, London 2001. Photograph courtesy of Leo Castelli Gallery, New York. Photo: Rudolph Burckhardt **96** (above) Joseph Kosuth, *The Second Investigation (Art as Idea as Idea)*, 1968–69. Newspaper pages on wall. Installation at Leo Castelli Gallery, 1969. © ARS, NY and DACS, London 2001. Photograph courtesy of the artist and Sean Kelly Gallery, New York (below) Joseph Kosuth, *The Second Investigation (Art as Idea as Idea)*, 1968–69. Page from the Daily Mirror, November 5, 1969. © ARS, NY and DACS, London 2001. Photo: A. Rorimer **99** Joseph Kosuth, *The Seventh Investigation (Art as Idea as Idea)*, Context B: Public-General, Chinatown, New York, 1969. © ARS, NY and DACS, London 2001. Photograph courtesy of the artist and Sean Kelly Gallery, New York **100** (above) Joseph Kosuth, *Information Room*, Kunstbiblioteket Lyngby, Denmark, April–May, 1970. © ARS, NY and DACS, London 2001. Photograph courtesy of the artist and Sean Kelly Gallery, New York. (below) Joseph Kosuth, *The Eighth Investigation, Proposition 3 (A.A.I.A.I.)*, Leo Castelli Gallery, New York, 1971. © ARS, NY and DACS, London 2001. Photograph courtesy of the artist and Sean Kelly Gallery, New York. Photo: Geoffrey Clements **101** Art & Language, *Secret Painting*, 1968. Liquitex on canvas and photostat, 152.5 x 152.5 (60 x 60) and 77.5 x 77.5 (30 ½ x 30 ½). Photograph courtesy of the artists and Lisson Gallery, London. Photo: John Riddy **102** Art & Language, *100% Abstract*, 1968. Acrylic on canvas, 90.6 x 80.1 (36 x 31). Private Collection, Brussels. Photograph courtesy of the artists and Lisson Gallery, London **103** (above) Art & Language, *Untitled Painting*, 1965. Mirror mounted on canvas, 25.4 x 184.7 x 5 (10 x 73 x 2). Photograph courtesy of the artists and Lisson Gallery, London. (below) Ian Burn, *Undeclared Glasses*, 1967. Letterpress on paper 57 x 73.8 (22 x 29) and 2 sheets of glass, each 99.9 x 65.9 (39 x 26). Edition of 15. Photograph courtesy of A&L and Lisson Gallery, London **104** Art & Language, *Six Negatives*, 1968–69. Ink marker, tape, and collage on paper in 8 parts, each 28 x 21.7 (11 x 8 ½). Photograph courtesy of the artists and

Project #1 (ABCD), 1966. Baked enamel on aluminum, 50.8 x 414 x 414 (20 x 163 x 163). The Museum of Modern Art, New York. Gift of Agnes Gund and purchase (by exchange). Installation, Kunsthalle Bern, 1972. © ARS, NY and DACS, London 2001. Photo © Sol LeWitt. Photo: Leonardo Bezzola **159** Sol LeWitt, *Wall Markings*, 1968. Ink on paper, 40.6 x 40.6 (16 x 16). Whereabouts unknown. © ARS, NY and DACS, London 2001. Photo © Sol LeWitt **160, 161** Adrian Piper, *Untitled page work for 0 TO 9*, 1969. Typing and grid with numbers in 0 TO 9 Number Six (July 1969), pp. 79–81, 28 x 21.5 (11 x 8 ½). Photo: Michael Tropea **162** (above) Adrian Piper, *Catalysis III*, 1970. Street performance, August 19, 1970, New York City. Photograph courtesy of the artist. Photograph: Rosemary Mayer. (below) Adrian Piper, *Catalysis IV*, 1970–71. Street performance, New York City. Photograph courtesy of the artist. Photograph: Rosemary Mayer **163, 164** Roman Opalka, *Opalka 1965/1–∞ Detail 1896176–1916613*, 1965– . Acrylic on canvas, 196 x 135 (77 x 53). Exhibited at John Weber Gallery, March 1989. © ADAGP, Paris and DACS, London 2001. Photograph courtesy of John Weber Gallery, New York **165** Hanne Darboven, *Untitled*, 1966–67. Pencil and ink on graph paper, 28 x 21.5 (11 x 8 ½). Wadsworth Atheneaum, Hartford, Connecticut. LeWitt Collection. Photo: David Stansbury **166** Hanne Darboven, *Untitled*, 1968. Ink on graph paper, 28 x 21.5 (11 x 8 ½). Wadsworth Atheneaum, Hartford, Connecticut. LeWitt Collection **167** Hanne Darboven, *24 Gesänge – B. Form* (24 Songs – B Form), 1974. Ink on paper, 120 parts: 48 at 128.6 x 30.5 (50 ⅝ x 12); 72 at 43.2 x 178.8 (17 x 70 ⅜). Stedelijk Museum Amsterdam **168** Hanne Darboven, *Index: 1 x 100 → 00 → 99 → 2 → 61*, 1978. Ink on paper, 44 x 32 (17 ¼ x 12 ½). Wadsworth Atheneaum, Hartford, Connecticut. LeWitt Collection **169** Hanne Darboven, Page from *'ATTA TROLL' nach Heinrich Heine in: Zahlenworte [abgezählte Worte] wieder aufgeschrieben*, 1972. Book published by the Kunstmuseum Lucerne and Gian Enzo Sperone, Turin, 1975 in connection with the artist's exhibition, May–June, 1972. Photo: Michael Tropea **170, 171** Hanne Darboven, *Homers Odyssee*, 1971. Ink on vellum, 14 framed panels, each 43 x 150 (17 x 59), each containing five sheets, 42 x 29 (16 ½ x 11 ½). Photograph courtesy of Leo Castelli Gallery, New York **172** On Kawara, *I Read* (detail), 1966/68. News clippings in looseleaf notebook, 23 May 1968. Photograph courtesy of the artist. Photo: Hiro Ihara **173** On Kawara, *I Went* (detail), 1968/69. Red ink line on printed map in looseleaf notebook, 22 February 1969. Photograph courtesy of the artist **174** On Kawara, *I Met* (detail), 1968. Typed list of names in looseleaf notebook, 1 July 1968. Photograph courtesy of the artist **175** (above and below left) On Kawara, *I Got Up At 9:56*, 1968/73. Rubber-stamped ink on postcard mailed to Konrad Fischer 18 October 1973. Photograph courtesy of the artist. Photo: Hiro Ihara (above right) On Kawara, *I Am Still Alive*, 1970. Telegram sent to Sol LeWitt on 5 February, 1970. Photograph courtesy of the artist. (below right) On Kawara, *I Am Still Alive*, 1970/78. Telegram sent to Maurizio Nannucci on 26 December, 1978. Photograph courtesy of the artist **176** On Kawara, *One Million Years – Past* (detail), 1969. Typed pages from one notebook of a ten-volume set, each page 28 x 21.5 (11 x 8 ½). Photograph courtesy of the artist. Photo: Hiro Ihara **177** Stanley Brouwn, *This way Brouwn*, 1960. Pink highlighter and ink stamp on paper, 24.4 x 31.8 (9 ½ x 12 ½). Private Collection. Photo Michael Tropea **183** Mel Bochner, *36 Photographs and 12 Diagrams*, 1966. 36 photographs and 12 ink drawings mounted on board, 29 x 22 (73 x 55). Städtische Galerie im Lenbachhaus, Munich. Photograph courtesy of the artist and Sonnabend Gallery, New York **185** Mel Bochner, *Measurement: Room*, 1969. Tape and Letraset on wall, dimensions variable. The Museum of Modern Art, New York, purchase. Photograph courtesy of the artist and Sonnabend Gallery, New York **186** (above) Mel Bochner, *Theory of Sculpture #1 (Unleveling)*, 1970. Wood on floor and charcoal on wall 30.5 x 488 (12 x 192). Private Collection, Turin. Photograph courtesy of the artist and Sonnabend Gallery, New York. (below) Mel Bochner, *Theory of Sculpture #2 (Counting): Cardinal versus Ordinal 5*, 1970. Stones and chalk on floor, approx. 610 x 610 (240 x 240). Photograph courtesy of the artist and Sonnabend Gallery, New York **187** Mel Bochner, *Axiom of Exhaustion*, 1971. Colored inks on masking tape on floor, oriented to compass. Photograph courtesy of the artist and Sonnabend Gallery, New York

189 Christine Kozlov, *Sound Structure*, 1965. White on black photocopy, 28 x 21.5 (11 x 8 ½). Collection of the artist. Photograph courtesy of the artist **190** Christine Kozlov, *Self Portraits*, 1968–69. Photo booth photos. Collection of the artist. Photograph courtesy of the artist. Photo: Jay Cantor, NYC **191** Christine Kozlov, *Neurological Compilation* (detail), 1969. Nine notebooks with typed pages concerning research on the brain, each 28 x 21.5 (11 x 8 ½). Collection of the artist. Photograph courtesy of the artist **194** Dan Graham, *Public Space/Two Audiences*, 1976. Enclosed room with two doors, painted wood, mirror, soundproof glass, fluorescent lights, approx. 244 x 610 x 305 (96 x 240 x 120). Annick and Anton Herbert Collection, Ghent. Photo: A. Rorimer **195** El Lissitzky, *Prounenraum* (Proun Room), 1923. Reconstruction 1965. 32 x 36.5 x 36.2 (12 ⅝ x 14 ⅜ x 14 ¼). Collection Van Abbemuseum, Eindhoven, Holland. © DACS 2001. Photograph Peter Cox **196** Allan Kaprow, *An Apple Shrine*, 1960. Mixed media. Installation at the Judson Gallery, Judson Memorial Church, New York, 1960. Photo: Robert R. McElroy, © Robert R. McElroy/VAGA, New York/DACS, London 2001 **197** Robert Morris, *Untitled*, 1965/71. Mirror plate glass on wood, 4 cubes, each 91.5 x 91.5 x 91.5 (36 x 36 x 36). The Tate Modern, London. © ARS, NY and DACS, London 2001. Photograph © 1998 Tate Gallery, London **198** (above) Bruce Nauman, *Lighted Centerpiece*, 1968. Four lamps 1000 watts each and aluminum plate, 106.7 x 106.7 (42 x 42). Solomon R. Guggenheim Museum, New York. Panza Collection, 1992. © ARS, NY and DACS, London 2001. Photograph © The Solomon R. Guggenheim Foundation, New York. Photo: David Heald (below) Bruce Nauman, *Device to Stand In*, 1966. Steel, blue lacquer, 22.2 x 43.8 x 69.2 (8 ¾ x 17 x 27 ¼). Solomon R. Guggenheim Museum, New York. Panza Collection, Extended Loan. © ARS, NY and DACS, London 2001. Photograph courtesy of Leo Castelli Gallery, New York. **199** Bruce Nauman, *Live-Taped Video Corridor*, 1970. Wallboard, video camera, two video monitors, videotape player, videotape, variable dimensions, approx. 365.8 x 975.4 x 50.8 (144 x 384 x 20). The Solomon R. Guggenheim Collection, New York. Panza Collection, 1992. © ARS, NY and DACS, London 2001. Photograph courtesy Leo Castelli Gallery, New York. Photo Rudolf Burckhardt **201** Dan Graham, *Schema (March, 1966)*, 1966. A work for the pages of magazines as it appears in Ursula Meyer, *Conceptual Art*, New York, 1972, pp. 128–29. Photograph courtesy of the artist **202** Dan Graham, *Figurative*, 1965. Published in *Harper's Bazaar*, March 1968, p. 90. Photograph courtesy of the artist **203** Dan Graham, *Common Drug/Side Effect*, 1966. Offset on paper, 117 x 76 (46 x 29 ⅞). Daled Collection, Brussels. Photograph courtesy of the artist **204** (above) Dan Graham, *Homes for America*, 1966–67. *Arts Magazine* December 1966–January 1967. Photograph courtesy of the artist. (below) Dan Graham, *Income Piece*, 1969. A work for the pages of magazines. Photograph courtesy of the artist **206** Dan Graham, *Picture Window Piece* (proposal), 1974. Photograph courtesy of the artist **208** (above) Dan Graham, model for *Pavilion/Sculpture for Argonne*, 1978–81. Wood, plexiglass, and mirrored plexiglass, 244 x 244 x 244 (96 x 96 x 96). The Art Institute of Chicago, Gift of the Society for Contemporary Art, 1982.404. Installation, 'Dan Graham: Buildings and Signs,' The Renaissance Society at the University of Chicago, 1981. Photo: A. Rorimer (below) Dan Graham, *Pavilion/Sculpture for Argonne*, 1978–81. Two-way mirror, transparent glass, steel, 229 x 458 x 458 (90 x 180 x 180). Collection of Argonne National Laboratory, Argonne, Illinois. Photo: A. Rorimer **211** Calendar of Events (detail) for 'Street Works IV,' 1969. First of four stapled pages of text, 21.5 x 28 (8 ½ x 11). Photo: Michael Tropea **212** Vito Acconci, *Following Piece*, 1969. Activity, 'Street Works IV, Architectural League, New York. Photograph courtesy of the artist. Photo: Betsy Jackson **213** (above) Vito Acconci, *Trademarks*, 1970. Activity, September 1970. Photographs courtesy of the artist. Photo: Bill Beckley. (below) Vito Acconci, *Room Piece*, 1970. Activity/installation, Gain Ground Gallery, New York: home furnishings, housewares, cardboard boxes, and note sheets, 152.4 x 91.4 x 304.8 (60 x 36 x 120). Photograph courtesy of the artist. Photo: Kathy Dillon **214** Vito Acconci, *Service Area*, 1970. Activity/installation, June–September 1970, 'Information,' The Museum of Modern Art: Plastic table, plexiglass box, paper calendar and mail. Photographs courtesy of the artist. Photos: Kathy Dillon **215** Vito

Acconci, *Round Trip (A Space to Fall Back On)*, 1975. Corner installation: Stools and stereo speakers, height of given wall. Indianapolis Museum of Art. Installation, Rhona Hoffman Gallery, Chicago 1988. Photo courtesy of Rhona Hoffman Gallery, Chicago. Photo: Michael Tropea **218** James Coleman, *Playback of a Daydream*, 1974. Projected 16mm black and white film, continuous cycle. Photograph courtesy of James Coleman © and Marian Goodman Gallery, New York **219** James Coleman, *Clara and Dario*, 1975. Projected images with synchronized audio narration. Installation, Studio Marconi, Milan, 1975. Photograph courtesy of James Coleman © and Marian Goodman Gallery, New York **220** James Coleman, *So Different… and Yet*, 1980. Video installation, performance by Olwen Fouere and Roger Doyle. Photograph courtesy of James Coleman © and Marian Goodman Gallery, New York **222** Maria Nordman, *Found Room Series*, Mountainair, New Mexico, 1967. Two rooms, each 274 x 427 x 244 (108 x 168 x 96) open to any person passing 24 hours a day. Photo-fragment negatives, each 20 x 20 (8 x 8). Photograph and caption courtesy of the artist **225** Maria Nordman, *Untitled*, 1973– . First realization Newport Beach, California. A work open to any person passing a loading dock. Photo-fragments and caption courtesy of the artist **226** Maria Nordman, *Public Proposals for an Open Place*, 1978. Five drawings, each recto: 38 x 95 (15 x 37 ½); verso: 95 x 38 (37 ½ x 15), installation in wooden file drawers, '73rd American Exhibition,' The Art Institute of Chicago, 1979. Photo: Rusty Culp **228** John Knight, *One Inch to a Foot*, 1971. Projection. Installation, 'John Knight,' Riko Mizuno Gallery, Los Angeles, 1973. Photograph courtesy of Frank J. Thomas Archives. Photo: Frank J. Thomas **230** Piet Mondrian, *Salon de Mme. B…, à Dresden*, 1926. Room based on Mondrian's open-box-plan drawing, formica on wood, 305 x 610 x 427 (120 x 240 x 168). Installation at Pace Gallery, New York, 1970. © 2001 Mondrian/Holtzman Trust c/o Beeldrecht, Amsterdam, Holland & DACS, London. Photograph courtesy of Pace Gallery. Photo: Ferdinand Boesch **231** Dan Flavin, *Pink and Gold*, 1967. Fluorescent light. Installation, the Museum of Contemporary Art, Chicago, 1967–68. © ARS, NY and DACS, London 2001. Photo: David Van Riper **232** Sol LeWitt, *All Combinations of Arcs from Corners and Sides; Straight Lines, Not-Straight Lines, and Broken Lines*, 1973. Room installation, white chalk on blue walls, 'Sol LeWitt,' the Museum of Contemporary Art, Chicago, 1979. © ARS, NY and DACS, London 2001 **233** Sol LeWitt, *The Location of Three Figures*, 1974. Ink on paper, 43 x 43 (17 x 17). Collection M.J.S., Paris. © ARS, NY and DACS, London 2001. Photograph © Sol LeWitt **234** Fred Sandback, *Untitled*, 1979. Colored yarn. Installation, '73rd American Exhibition,' The Art Institute of Chicago, 1979. Photo: Rusty Culp **235** Giovanni Anselmo, *Untitled*, 1968. Granite, vegetable, copper wire, and sawdust, 60 x 25 x 25 (24 x 10 x 10). Sonnabend Collection, New York. Photograph courtesy of Gian Enzo Sperone and the artist. Photo: Paolo Mussat Sartor **236** (above) Giovanni Anselmo, *Particolare* (Detail), 1972/75. One of multiple projections: corner. Installation, Galleria Sperone, Turin, 1975. Photograph courtesy of the artist and Marian Goodman Gallery, New York. Photo: Paolo Mussat Sartor. (centre) Giovanni Anselmo, *Particolare* (Detail), 1972/95. One of multiple projections: projector support. Installation, 'Reconsidering the Object of Art: 1965–1975,' Museum of Contemporary Art, Los Angeles, 1995. Photo: Fredrik Nilsen. (below) Giovanni Anselmo, *Particolare* (Detail), 1972/74. One of multiple projections: radiator. Installation, Galleria Sperone, Rome, April 1974. Photograph courtesy of the artist and Marian Goodman Gallery, New York. Photo: Mimmo Capone **237** (above) Gordon Matta-Clark, *Circus or The Caribbean Orange* (detail), 1978. Installation, Museum of Contemporary Art, Chicago, 1978. © ARS, NY and DACS, London 2001. (below) Robert Smithson, *Nonsite: Franklin, New Jersey*, 1968. Five painted wooden bins and limestone; photographs and typescript on paper with pencil and transfer letters mounted on mat board. Bins: 41.9 x 208.9 x 261.1 (16 ½ x 82 ¼ x 103); board: 101.8 x 76.4 (40 ⅛ x 30 ¹⁄₁₆). The Museum of Contemporary Art, Chicago. Gift of Susan and Lewis Manilow. © Estate of Robert Smithson/VAGA, New York/DACS, London 2001 **238** Stephen Kaltenbach, *Sidewalk Plaques: Fire, Air, Skin, Water*, 1968. Cast bronze plaques to be set in concrete. Fire: 9.5 x 19.7 x 0.6 (3 ¾ x 7 ¾ x ¼); Air: 9.5 x 16.8 x 0.6 (3 ¾ x 6 ⅝ x ¼); Skin: 10.2 x 21.6 x 0.6

(4 x 8 ½ x ¼); Water: 9.5 x 27.9 x 0.6 (3 ¾ x 11 x ¼). Photographs courtesy of the artist and Lawrence Markey Gallery, New York **239** Richard Artschwager, *Locations*, 1969. Container/sculpture with five multiples for variable installation. The Art Institute of Chicago. Twentieth Century Purchase Fund. © ARS, NY and DACS, London 2001. Photograph © 2000, The Art Institute of Chicago, All Rights Reserved **240** (above) Marcel Broodthaers, Covers of the two-volume catalogue for Museum of Modern Art, Department of Eagles, Figure Section (The Eagle from the Oligocene to the Present), 1972. © DACS 2001. (below) Marcel Broodthaers, *Museum of Modern Art, Department of Eagles, 19th-Century Section*, 1968. Installation of shipping crates and postcards, residence of the artist, 1968. © DACS 2001. Photograph © Maria Gilissen **241** Marcel Broodthaers, Pages from the catalogue for Museum of Modern Art, Department of Eagles, Figure Section (The Eagle from the Oligocene to the Present), 1972. © DACS 2001 **242** (above) Marcel Broodthaers, Pages from the catalogue for Museum of Modern Art, Department of Eagles, Figure Section (The Eagle from the Oligocene to the Present), 1972. © DACS 2001 (below) Marcel Broodthaers, *Un Jardin d'Hiver* (A Winter Garden), 1974. Installation, 'Europe in the Seventies: Aspects of Recent Art,' The Art Institute of Chicago, 1977. © DACS 2001. Photo: Rusty Culp **244** (above) Marcel Broodthaers, *Un Jardin d'Hiver* (detail), 1974. Black and white enlargement of color engraving. © DACS 2001 (below) Camel entering the Palais des Beaux-Arts, Brussels, 1974. © DACS 2001. Photograph Yves Gevaert, Brussels **245** Marcel Broodthaers, *Les Animaux de la Ferme* (Farm Animals), 1974. One of two offset color prints on cardboard, each 82 x 60.3 (32 x 24). Edition of 100. Published by Edition Staeck, Heidelberg. © DACS 2001 **246, 247** (left) Daniel Buren, *Affichages sauvages* (wild signboards), 1968. A work in situ. White and green striped paper glued on approx. 200 signboards in Paris and its suburbs (detail). © ADAGP, Paris and DACS, London 2001. Photograph courtesy of the artist. Photo: Daniel Buren **247** (right) Daniel Buren, *Les Hommes Sandwiches* (Sandwich Men), 1968. A work in situ. White and green striped paper glued on advertising placards worn during the 'Salon de Mai' exhibition, Musée d'Art Moderne de la Ville de Paris, April 1968. © ADAGP, Paris and DACS, London 2001. Photograph courtesy of the artist. Photo: Bernard Boyer **248, 249** Daniel Buren, *Travail in situ*, 1969. A work in situ realized in different years at the Wide White Space Gallery, Antwerp using different colored stripes each time. © ADAGP, Paris and DACS, London 2001. Photograph courtesy of the artist. Photo: Daniel Buren **250** (above left) Daniel Buren, *A partir de là* (Starting from there), 1975. A work in situ. Striped linen glued on walls of the Städtisches Museum Mönchengladbach: white and blue (first floor); white and brown (staircase); and white and red (second floor). © ADAGP, Paris and DACS, London 2001. Photograph courtesy of the artist. Photo: Daniel Buren. (above right) Daniel Buren, *Voile/Toile, Toile/Voile* (Sail/Canvas, Canvas/Sail), Part One, 1975. A work in situ. A regatta of boats with differently colored striped sails on the Wannsee, Berlin, September 1975. Collection of Selman Selvi. © ADAGP, Paris and DACS, London 2001. Photograph courtesy of the artist. Photo: Daniel Buren. (below) Daniel Buren, *Voile/Toile, Toile/Voile* (Sail/Canvas, Canvas/Sail), Part Two, 1975. A work in situ. Installation of striped canvas sails at the Akademie der Künste, Berlin. © ADAGP, Paris and DACS, London 2001. Photograph courtesy of the artist. Photo: Daniel Buren **251** Daniel Buren, *Up and Down, In and Out, Step by Step: A Sculpture*, 1977. A work in situ. White and colored striped paper glued to the steps of the Grand Staircase, The Art Institute of Chicago. Installation (white and green), 'Europe in the Seventies: Aspects of Recent Art,' 1977. © ADAGP, Paris and DACS, London 2001. Collection of The Art Institute of Chicago. Twentieth Century Discretionary Fund. Photo: Rusty Culp **252** Daniel Buren, *Watch the Doors Please* (view from the interior of the museum), 1980–82. A work in situ and motion. White and colored (red, blue, yellow, green, and purple) stripes printed on weatherproof vinyl adhered to the doors of 165 commuter trains. © ADAGP, Paris and DACS, London 2001. Installation, October 1980–May 1982 with permission of the Illinois Central Gulf Railroad and the Regional Transportation Authority, and the South Suburban Mass Transit District. Photo: Luis Medina.

Index